NATURAL SURFACES

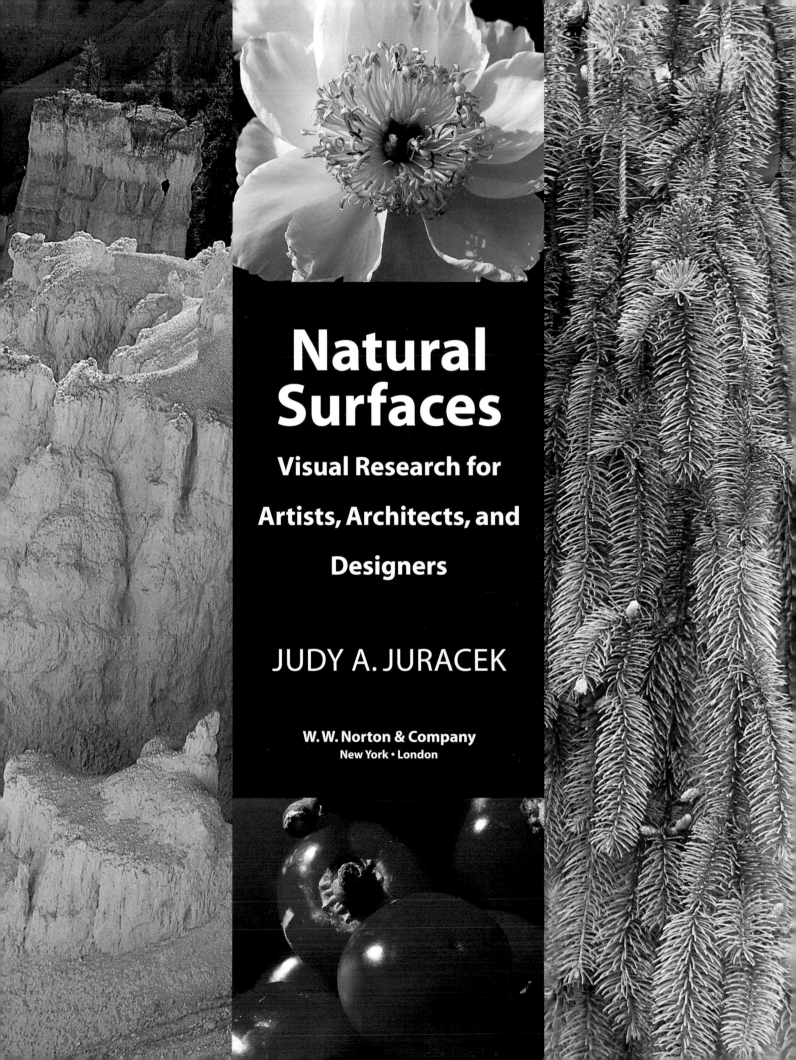

Natural
Surfaces

Visual Research for

Artists, Architects, and

Designers

JUDY A. JURACEK

W. W. Norton & Company
New York · London

For information about permission to reproduce selections from this book, write to
Permissions, W. W. Norton & Company Inc., 500 Fifth Avenue, New York, NY 10110

This book is composed in Myriad
Manufacturing by Colorprint Offset
Book design and composition by Gilda Hannah
Drawings by Dawn Peterson
Production manager: Leeann Graham

Library of Congress Cataloging-in-Publication Data

Juracek, Judy A.
Natural surfaces : visual research for artists, architects, and designers / Judy A. Juracek.
p. cm.
Includes bibliographical references and index
ISBN 0-393-83081-6
1. Environment (Art)—Themes, motives—Pictoral works. 2. Nature
(Aesthetics—Themes, motives—Pictoral works. I. Title.

N6494.E6 J87 2002 704.9'43—dc21
2001044249

W. W. Norton & Company, Inc., 500 Fifth Avenue New York, NY 10110
www.wwnorton.com
W. W. Norton & Company Ltd., Castle House, 75/76 Wells Street, London W1T 3QT

1 3 5 7 9 0 8 6 4 2

Dedicated to Guy Gurney

and to Anna Hlavaty's garden

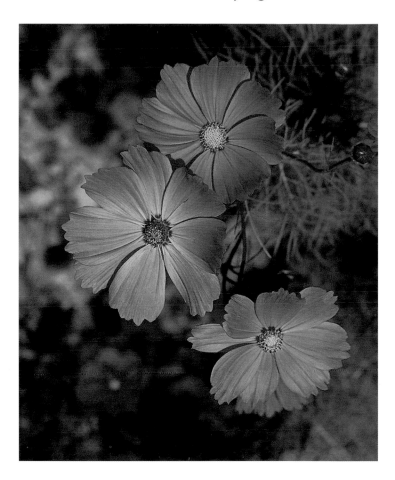

CONTENTS

TREES & SHRUBS

FLOWERS

FOLIAGE

GRASS

FRUITS, VEGETABLES, FUNGI

STONE, SAND, LAND

WATER, ICE, SNOW

SKY & CLOUDS

WORKING PAPERS

ACKNOWLEDGMENTS

Photographing for *Natural Surfaces* made me aware of the difficulty of finding subjects in nature free of background distractions and reminded me of the importance of gardens that have been enjoyed for centuries and natural sites that have been protected for generations. It is not an overstatement to say that this book was made possible by the individuals and organizations that restore and maintain public and private historical gardens, parks, botanical gardens, and wilderness areas.

I am grateful in particular to the Bartlett Arboretum; Brooklyn Botanic Garden; The Horticultural Society of New York; Longwood Gardens; Iford Manor; New York Botanical Garden; The Preservation Society of Newport; Royal Botanic Gardens, Kew; Stonecrop Garden; Queens Botanical Garden; and to the other parks, gardens, and horticultural facilities listed in the source sections. I thank Robert Beeby, Peter Berg, Dagny Du Val, Gordon Hayward, and Beth Lieberman, who allowed me to photograph their private gardens. Others who were generous with their time, gave me information, and helped me gain access to locations are Stuart Appell, Rosminah Brown, Dagny Du Val, Jackie Fazio, Greg Redwood, Todd Steadman, Alan Veits, and Roger Wells. Gordon Hayward not only directed me to locations, but also shared his expertise as a garden designer and writer.

Identification of the hundreds of botanical photos was made possible by the following professionals: Melanie Riggs identified the flowers, Dr. Carl Lewis of the Fairchild Tropical Garden the palms, and Susan Aument of the Brooklyn Botanic Garden the cacti and succulents.

Michael Harvey, Director of Horticulture at the Bartlett Arboretum, identified the trees and shrubs, and helped greatly by providing material to photograph and general information. Scott Appell, garden writer and taxonomist with the Horticultural Society of New York, identified the foliage, advised on the glossary, and helped me wade through a myriad of details.

I thank geologist Skip Hobbs, who allowed me to photograph his mineral collection, and assisted me in identifying parts of the stone section, and Patrick Schmidt of O&G Industries, who identified the building stone. Karen and Frank Armitage provided me with an invaluable itinerary of the southwestern United States, and Bill Stevens at Evolution: Natural History in Soho gave me access to his inventory of natural objects. Special thanks go to Dawn Peterson for her drawings, Michael Garff and Duane Langenwalter for the images they contributed, and Guy Gurney, who not only continues to advise me on equipment and exposures, but also made his photo archives available to me for this book.

Laurie Olin, Christabel King, and John Gwynne graciously allowed me to interview them for the Working Papers section to give insight into their professions, and the conversations guided me in shooting and editing the images.

And as with all the *Surfaces* books, I am indebted to Nancy Green, for her guidance and patience throughout the process, to Gilda Hannah, whose designs contribute so much to this series, to the careful eye of Leeann Graham, and to the continual encouragement of Barbara Braun.

INTRODUCTION

"All gardening is landscape painting," said William Kent, an eighteenth-century landscape designer. A walk through Claude Monet's garden at Giverny, where the visitor is surrounded by the subjects of familiar paintings and aware of all the canvases the artist planted rather than painted, reveals the connection between art and nature. The landscape painter and the landscape designer are concerned with similar elements—conceptually and in the forms they use. Both manipulate a palette of textures and shapes derived from flowers, foliage, trees, and land to direct the eye around a particular space. At a certain point the requirements of their specific professions diverge, but for both nature is generally the primary source of inspiration and the subject of their art.

The work of other artists may not so directly involve flora and the land, but nature has been a part of art for as long as people have painted, sculpted, built structures, and designed and decorated objects. The shapes, proportions, colors, and visual organization found in nature are basic to the vocabulary of design. Sometimes the influence is obvious. Can we think of the textile designs of William Morris without seeing flowers and foliage, or study western architecture without encountering the acanthus leaf? Often the relationship is more subtle: the columns and arches that support Gothic cathedrals follow structural principles observed in great trees.

It is not surprising, then, that subjects from nature form major sections in the picture files and libraries of those who work in the visual arts. Leonardo da Vinci's library included a botanical section, and he explored the structures and details of plants with the same intensity he studied the human body. For most of us, the visual material we gather will not find its way into a great work of art, but the more visual information we have about a subject, the better we can draw or use the subject in a design.

As with my earlier books, the choice of images in *Natural Surfaces* reflects, in part, the needs of my work in scenic design for film and theater. I have had to find research necessary to render flowers and foliage, construct ancient oak trees, depict clouds and sunsets, create faux slate paths, and replicate snowy scenes. Landscaping has played an important role in films: think, for example, of the landscapes and signature surroundings for Tara designed both on locations and on sound stages by Florence Yoch for *Gone With the Wind*.

The demands of scenic research may seem broader than most, but actually they parallel the needs of many professionals—illustrators and graphic designers, textile and interior designers, landscape architects and garden designers, as well as fine artists. When first gathering the necessary information to create, say, a lily pond, the end result, be it a painting or an actual garden pool, is almost incidental. What is important is that the designer find enough information to understand the essential elements of a pond and to define what is specific to the required pond. Sometimes this understanding jumps out at us, but more often it emerges as we explore a subject and gather research. What we find gives us material to develop ideas, aids in illustrating those ideas to clients and coworkers, and helps us choose what contributes to the design and to eliminate the things that detract.

How do artists and designers find source material about elements of nature? A very useful network of botanical gardens, national parks, and preserved historical residences and gardens exists in the United States, England, Europe, and Asia. In these places one can photograph, draw, or paint in locations free of the visual clutter of the modern world. Some sites give us the experience of grand formal gardens or simply designed landscapes dedicated to contemplation, others offer untouched wilderness. Many of these places can be visited on the Internet. They often identify the plants by their botanical names, and maintain libraries and herbariums. They also provide access to horticulturists and taxonomists who can answer a range of questions—everything from suggesting horticultural references specifically for the artist to providing the botanical names of the flowers in a Flemish still-life painting.

The places I photographed in this book are listed in Photo Locations at the back of the book. The Bibliography and Research Sources section offers additional institutions and organizations, and topical sources including periodicals, dictionaries, identification handbooks, and guidebooks, a great aid in finding locations with specific features.

The importance of correct botanical nomenclature varies with one's needs. Most of us know plants by their common names, but often that name is truly vernacular—a function of specific location and culture—and may differ dramatically from region to region. A botanical name is the scientific manner of identification, and although the Latin words may seem awkward, they are understood internationally. This nomenclature is vital to professionals, but it also has meaning for anyone who wants accurate information about a plant. For example, what people in one place call a snake plant is known as mother-in-law's tongue somewhere else. But if the botanical name *Sanseveria* is used, no confusion arises. Thus, in identifying the trees, shrubs, flowers, foliage, and grass I have given the botanical names as well as the generally accepted common names whenever possible.

Stone and rock formations would seem easier to identify than plants. However, once past basic categories, the vernacular still rules, and here there is not quite the structure of botanical names to fall back on. So for identification purposes in some sections I have done what one does when purchasing building and decorative stone—use the name given by the supplier. In other cases the name given in the caption is a generally accepted industry or geological term. Keep in mind that fieldstone by definition is not quarried but is collected locally, so it is composed of whatever is the most common variety where the picture was taken—granite or sandstone or volcanic or any number of other types of rock.

The goal of the *Surfaces* series is to provide compact picture files of various topics. In *Natural Surfaces* the subjects seemed to demand a broader point of view than did building materials and fabrics, the subjects of *Surfaces* and *Soft Surfaces*. When artists and designers examine sources, they often explore with a zoom lens, and with

natural subjects the range is wide. For example, a wallcovering may be based on the texture of an orange peel, which calls for a close view. Animators who turn trees with gnarled branches and shaggy bark into creatures with knothole eyes and witchlike fingers need several views. Landscape and garden designers use groups of foliage and flowers as textures, but this effect is often not apparent until the viewer gains some distance, yet the designer can probably tell you the shape of every leaf and petal in the planting.

Most of this book is pictorial, but in Working Papers three artists and designers, Laurie Olin, Christabel King, and John Gwynne, talk about their professions as landscape architect, botanical illustrator, and wildlife exhibition designer, respectively. During these conversations I was struck how, through their work, they have refined their senses of observation and abilities to organize the research they collect. They all have a command of the particulars necessary to their projects, but as they discuss their work, something else is apparent—they use the process of discovering and collecting the information as a creatively exciting and vital part of their art.

NOTES
The identifications for the images in *Natural Surfaces* were compiled with the help of specialists and with additional information from a variety of sources. Since most identifications were made only from photographs, responsibility for any inaccuracies lies with the author.

The images in *Natural Surfaces* are listed in the index by subcategory, specific name (when possible), and key descriptive words. For example, a picture of a sugar maple tree in fall color may be found in the following entries: temperate and tropical trees, *Acer saccharum*, sugar maple, and fall color.

Where relevant, the locations where many of the photographs were taken are given adjacent to the picture. Images taken in these gardens and parks may not be used commercially without the permission of the credited institution or individual. Contact information is listed in Photo Locations in the back of the book, or you may contact the author at www.stocksurfaces.com.

RESEARCH AND GARDEN DESIGN
BY GORDON HAYWARD

When a client asks me to design a garden, I begin a process the stages of which rarely change. First I visit the site to meet the people, see the architecture and walk the land. Once I have a good understanding of all three, my design sequence involves distinct kinds of research: background research into the clients, their home, and its surrounding landscape; research to inspire overall design ideas; technical research into appropriate plants and materials. Each of these stages helps me and the client focus on an increasingly clearer image of what the overall garden will look like, and how its parts will relate to the whole. Throughout, my role is to draw clients, architecture, and landscape together into one harmonious whole.

The very earliest research for a landscape or garden design revolves around getting to know the clients. Do they have children or parents living with them? How is their home furnished? Is it formal or informal? What colors predominate? What kind of art, if any, do they appreciate? How will they use the garden? Are they sun- or shade-loving? Will they maintain the garden themselves or hire help? Do they want to raise vegetables? Cut flowers? Do they want a swimming pool or tennis court? The list goes on, but the point is that a garden designer needs to know clients well and how they will live in and use their garden and its outdoor living spaces. Based on that research, I design a garden for them, not for myself.

I also look at the clients' house because it is usually the center of the garden. Its age, style, materials, and lines are key sources from which initial inspiration derives. Doors suggest the beginning of paths into the garden. Windows help the garden designer see views that call for framing or screening. The proportions and dimensions of exterior walls provide clues to the shape and size of an adjacent terrace, patio, or garden. The color of those walls might suggest a color for furniture, ornamentation, and garden structures as well as flower and foliage in the outdoor living spaces. The nature of the volume of space between the house and garage or another outbuilding can provide cues to how to develop the space in the light of how it will be used.

I walk the land to all boundary lines, with my clients and later without them, to fully understand the whole property: its dimensions and proportions relative to the house and its windows and doors and outdoor living spaces. I also want to understand its relationship to the neighbors and to the nearby and distant natural world. What native plants abound, and what do they reveal about the nature of the soil and the climate? Are there bedrock outcroppings? Boulders? Sand, gravel, water? Where are there potential or existing view lines? Which areas are shaded? Sunny? Dry? Moist? What is ugly and what is beautiful? Which areas have spirit and which are bland? What are the inherent qualities of each part of the property and where are the rough boundary lines between each of them? I constantly ask myself two questions: What can I do in this area that I can't do anywhere else? Where will paths go that will help me link all of these disparate parts into one coherent whole along one easily understood itinerary?

With this background research in mind, I turn to sources for inspiration to help me develop the overarching design ideas for the property. If I found boulders and bedrock, I think back to gardens I've visited that also had massive stones incorporated into the garden. If the property has striking views, I think of wonderful treatments, both designed and naturally occurring, that I've seen.

Also useful here are books with design ideas that are timeless and universal, more timely articles and images in recently published books and magazines, and my own collection of slides and photographs of nature and designed gardens. I look to photos of natural streams to see how to mimic nature when designing a garden stream. When considering how to site a garden sculpture, I go to pictures of gardens where the designer used sculpture to draw people along a series of connected paths. For ideas about how to create an appropriate outdoor sitting area near an eighteenth-century Vermont farmhouse, I may use images of historical gardens in New England, the Pacific Northwest, or Britain.

It is a particularly important experience to visit gardens

locally and around the world. Garden designers need to see first-hand gardens of many traditions and cultures, of a wide range of styles in a wide range of climates, cultures, and countries. Visiting historical and contemporary gardens and researching the designers who made them within specific cultural or historical traditions also helps inform the design process.

When visiting gardens, I always take my camera. Photographs are important sources of inspiration, valuable not only for design ideas but also as records of plant combinations, juxtaposition of materials, designs around buildings, the location of terraces and patios, the use of furniture or painted surfaces, the uses to which boulders and bedrock can be put, and so on. But these pictures must be cataloged to be useful, so I organize my slides in specific drawers for specific countries, each subdivided into regions of the country (for example, United States: Pacific Northwest, Southwest, Southeast, Midwest, Northeast). Then I file twenty-slide sheets alphabetically by garden name.

An up-to-date library is essential. Mine includes books and magazines that keep me abreast of changes going on in England, Europe, and across America. Highly focused articles help me develop specific techniques or plant combinations, while books on cutting-edge design might challenge ideas I previously thought sacrosanct. Going to online booksellers is an easy way to research new titles. Images from my library also help clarify ideas that might be hard for clients to visualize as we develop plans for their garden.

There are other indirect sources of inspiration for the designer. Classical music, fine painting and architecture, photography, and sculpture all have the power to excite my design sensibilities. Talking with other designers or attending design symposia are equally powerful but in very different ways.

A deeper source of inspiration surfaces at the most surprising times—childhood memories. The mossy boulders and bedrock outcroppings that punctuated the Connecticut woods and the stone walls that bordered the orchards where I grew up influence me. Part of my inspiration as a designer comes from paying attention to those deep memories.

Having developed the framework for a design, I turn to technical research to help me make good decisions regarding plants and materials, pots and furniture, ornaments and artifacts. Books and magazines, of course, are crucial as are nursery catalogs. CD-ROMs are especially useful when it comes to plant choice. They are infinitely more flexible and immediate than books when it comes to getting specific information regarding plant choice and combinations for your zone and it is handy to print out pictures for clients, or provide them with slide shows of selected plants right on the computer screen. For example, if I want to develop a list of pink-flowering shrubs that are 4 to 6 feet high in zone 4 that will be planted in moist, shaded soil, I highlight the appropriate icons for each of those variables on the main page and up comes a list cross-referenced to background material and a photograph of each one. These horticultural CD-ROMs are complemented by those in the landscape architecture field that provide instant digital access to construction details for hardscaping and planting techniques as well as estimating and costing information. See the Resource Section for a listing of available titles.

The Internet has also become a vast and instantaneous source of technical information. Select key words such as garden mulches, stone garden paving, garden furniture, landscape design, or stonemasons, and hundreds of entries appear on your screen, often including those of related organizations. Nurseries often have Web sites that contain important plant information.

Through the Internet, professional groups such as the Association of Professional Landscape Designers (APLD) have initiated sites where members can share design information, make suggestions regarding plant combinations and design alternatives to gardens pictured on their Web site. Chat rooms and similar Web sites that individual designers could develop among themselves provide a wide range of possibilities for shared research.

Cable and satellite television have also opened up a broad range of television stations that carry valuable, timely gardening information.

Finally, perhaps the most important research that any garden designer could do is in his or her own garden. It is in your own garden that you experiment at ground level, and it provides you with knowledge that eventually informs and solidifies all other sources of inspiration and research.

GORDON HAYWARD has been writing for *Horticulture* magazine since 1979, has written for *Fine Gardening* and most recently for *The Gardener Magazine*. He has also written three books on garden design, the most recent of which is *Stone in the Garden* (W. W. Norton, 2001). You can visit his website at haywardgardens.com.

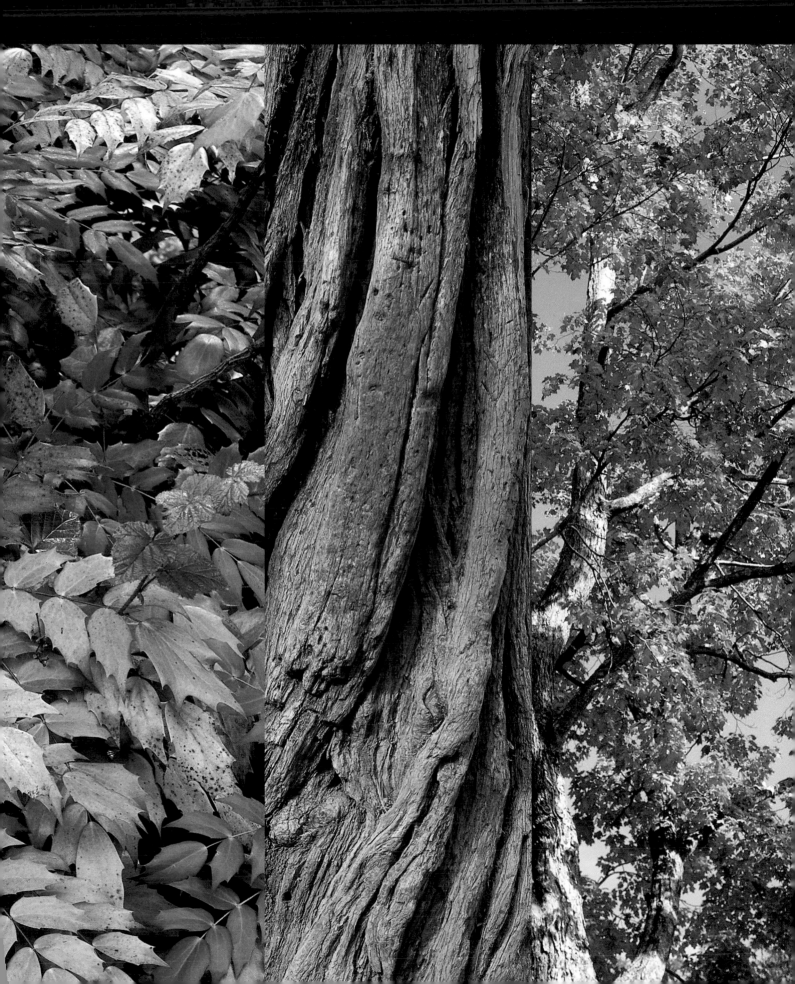

TREES AND SHRUBS

The name is followed by the terms descriptive of type, shape, and margin. Leaf type is simple unless noted otherwise.

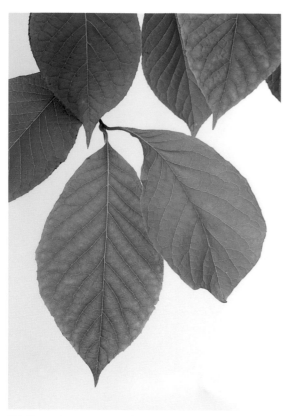

T-1 *Stewartia ovata*, mountain stewartia; ovate to elliptic, fine-serrate (serrulate). Deciduous

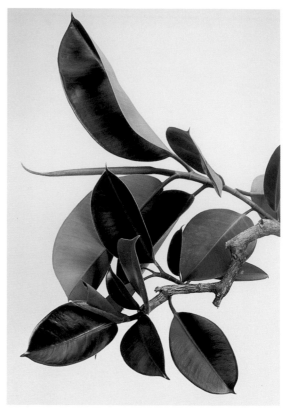

T-2 *Ficus benjamina*, rubber tree; ovate to elliptic. Tropical evergreen

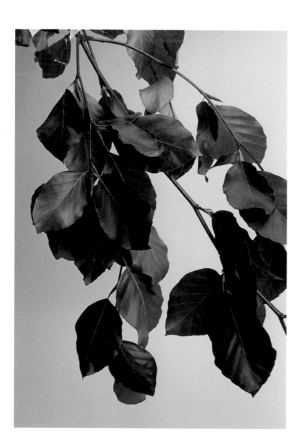

T-3 *Fagus sylvatica* 'Pendula,' weeping European beech; ovate, repand. Deciduous.

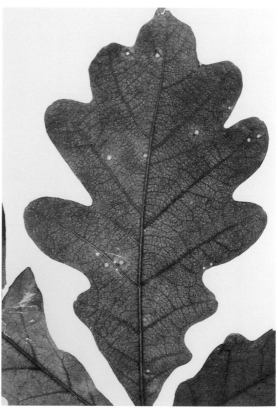

T-4 *Quercus alba*, white oak; cleft with 5 to 9 rounded lobes. Deciduous

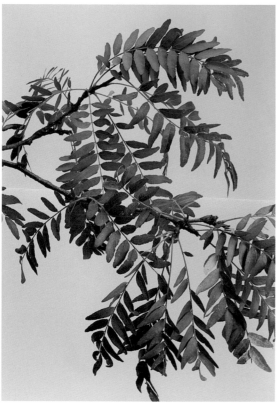

T-5 *Gleditsia triacanthos*, honey locust, compound with 7 to 19 oblong, entire leaflets. Deciduous

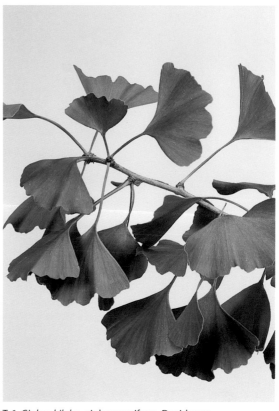

T-6 *Ginkgo biloba*, ginkgo; reniform. Deciduous

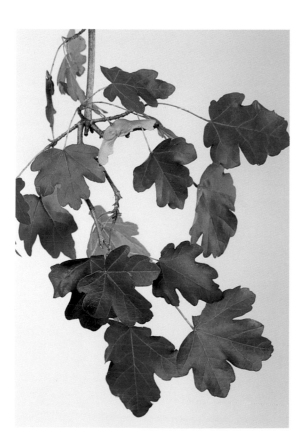

T-7 *Acer campestre*, hedge maple; palmately lobed. Deciduous

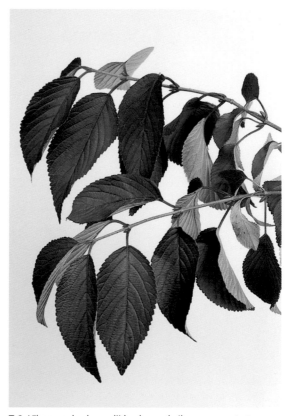

T-8 *Viburnum burkwoodii*, burkwood viburnum; ovate to elliptic, fine-serrate (serrulate). Evergreen or semi-evergreen.

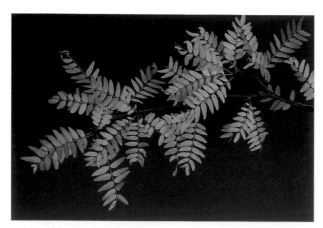

T-9 *Gleditsia triacanthos*, honey locust; compound with 7 to 19 oblong, entire leaflets. Deciduous. Fall color

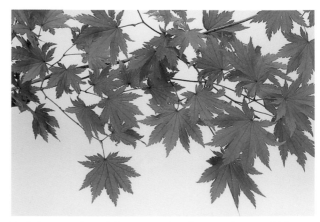

T-10 *Acer japonicum, full moon maple*; palmate with pointed lobes. Deciduous

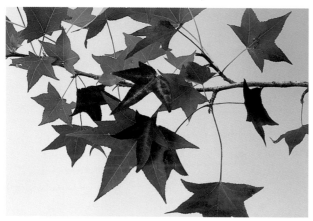

T-11 *Liquidambar styraciflua*, American sweetgum, palmate with pointed lobes. Deciduous. Fall color

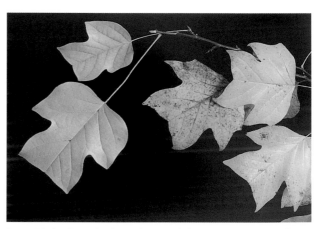

T-12 *Liriodendron tulipifera*, tulip tree; cleft to lobed with a broad truncate apex, and a lobe on each side. Deciduous. Fall color

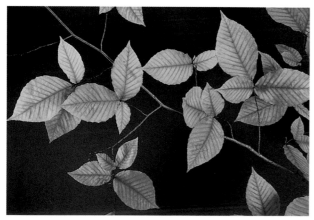

T-13 *Fagus grandiflora,* American beech; ovate, serrate. Deciduous

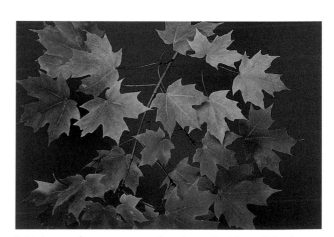

T-14 *Acer saccharum,* sugar maple; palmate. Deciduous. Fall color

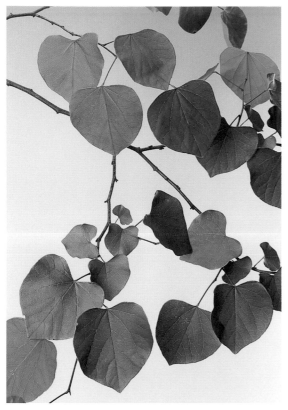

T-15 *Cercis canadensis*, Eastern redbud; cordate, entire. Deciduous. Ornamental flowering

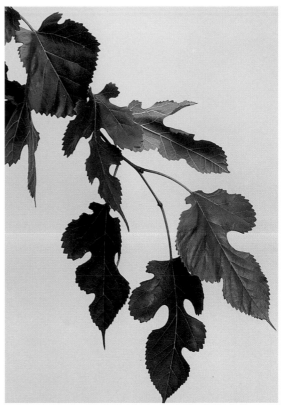

T-16 *Broussonetia papyrifera*, paper mulberry; polymorphic (shape can vary), generally ovate to broad-ovate, cleft. Deciduous

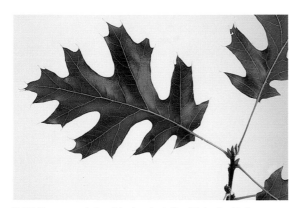

T-17 *Quercus velutina*, black oak; cleft with barbed lobes. Deciduous

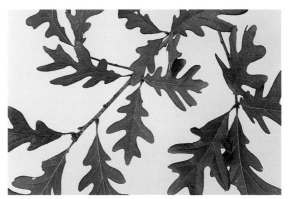

T-18 *Quercus alba*, white oak; cleft with 5 to 9 rounded lobes. Deciduous

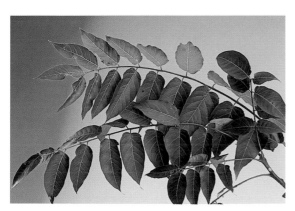

T-19 *Juglans sp.*, walnut; pinnately compound. Deciduous

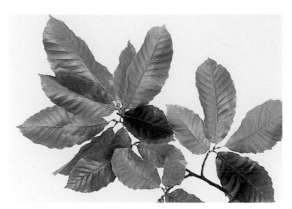

T-20 *Castanea mollissima*, chestnut; digitately compound with leaflets ovate to elliptic, dentate. Deciduous

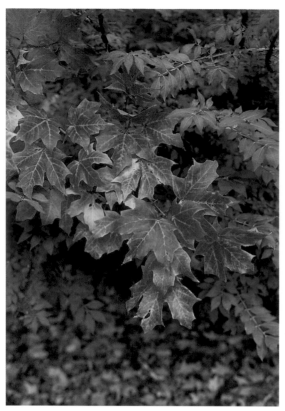

T-21 *Acer saccharum*, sugar maple; palmate (orange);
Euonymus alatus, winged euonymus; elliptic to obovate
(green). Both are deciduous

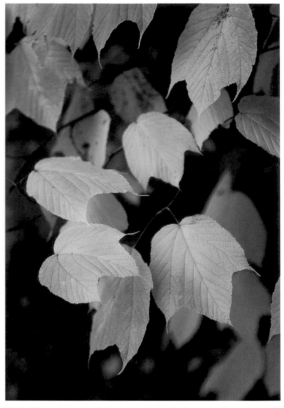

T-22 *Viburnum acerifolium*, maple-leaf viburnum; lobed

T-23 *Eucalyptus sp.*, eucalyptus; elliptic, entire. Tender
broadleaf evergreen

T-24 *Fagus grandifolia*, American beech; ovate to elliptic,
serrate. Deciduous

T-25 *Coffea arabica*, arabica coffee; elliptic, repand. Tropical

T-26 *Fagus grandifolia*, American beech; ovate to oblong; dentate. Deciduous. Fall color

T-27 *Diospyros virginiana*, persimmon; ovate to elliptic. Fall color

T-28 *Filicium decipiens*; pinnately compound. Tropical shrub

T-29 *Mahonia aquifolium*, Oregon or holly grape; pinnately compound, with 9 to 13 spiny ovate to oblong-leaflets. Broadleaf evergreen

T-30 *Quercus* x, black oak hybrid; cleft with 7 to 9 barbed lobes. Deciduous. Fall color

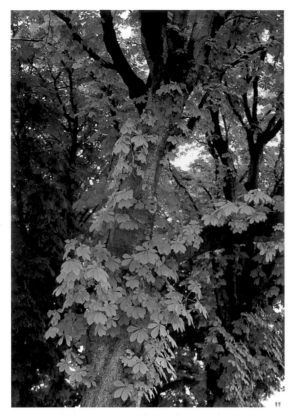

T-31 *Aesculus hippocastanum*, horse chestnut; digitately compound with ovate to elliptic leaflets. Deciduous

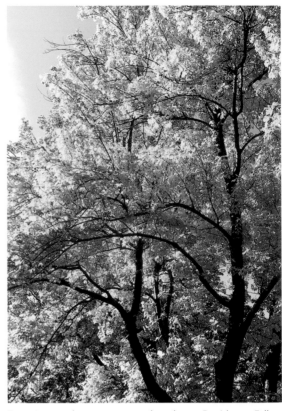

T-32 *Acer saccharum*, sugar maple; palmate. Deciduous. Fall color

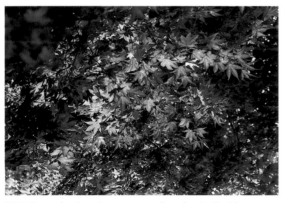

T-33 *Acer palmatum*, Japanese maple; palmate. Deciduous. Fall color

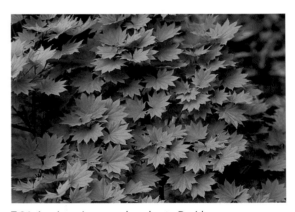

T-34 *Acer japonicum*, maple; palmate. Deciduous

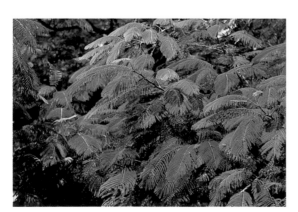

T-35 Possibly *Pithecellobium dulce;* pinnately compound

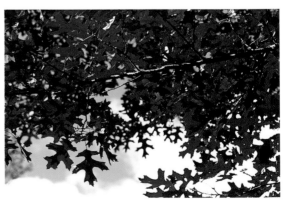

T-36 *Quercus rubra*, red oak; cleft, with 7 to 10 pointed lobes. Deciduous. Fall color

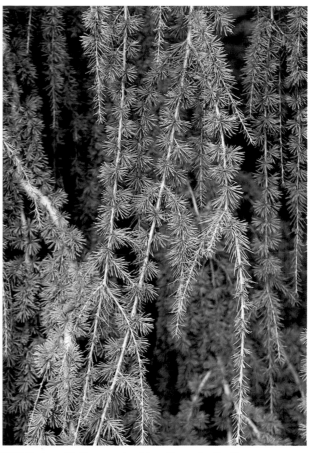

T-37 *Chamaecyparis pisifera*, Japanese false cypress; needles ovate to lanceolate. Coniferous evergreen

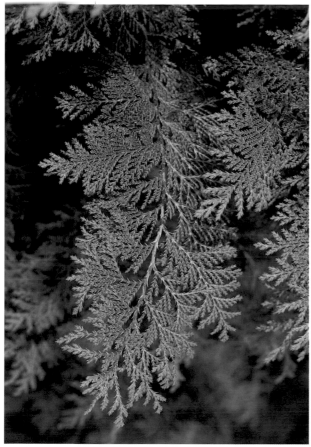

T-38 *Cedrus atlantica*, weeping blue atlas cedar. Coniferous evergreen

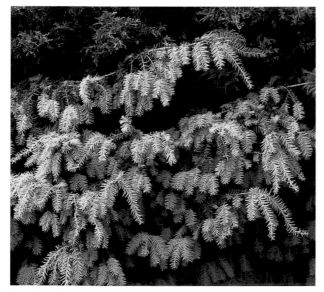

T-39 *Taxus baccata*, spreading English yew; linear needle. Coniferous evergreen

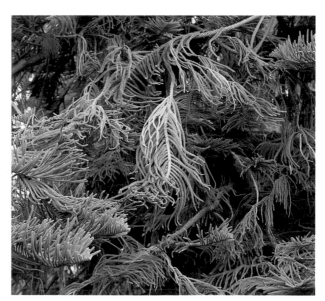

T-40 *Sequoia sempervirens*; redwood; needles are awl-shaped with a taper

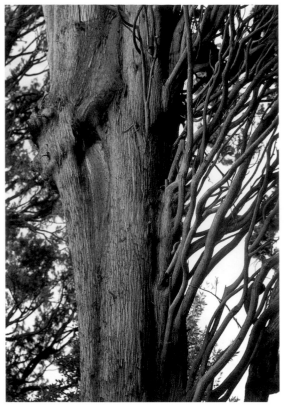

T-41 *Chamaecyparis pisifera*, Japanese false cypress. Coniferous evergreen

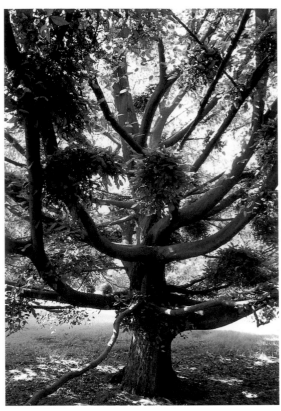

T-42 Deciduous tree with clumps of foliage (witches' brooms)

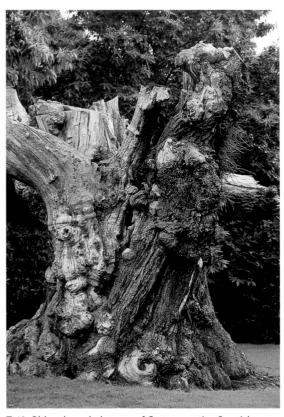

T-43 Old and gnarled stump of *Castanea sativa*, Spanish or sweet chestnut

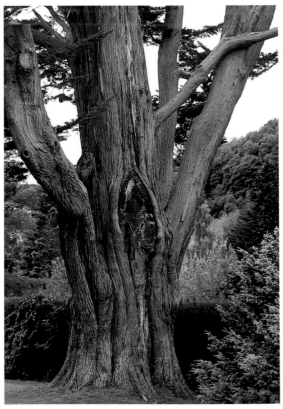

T-44 *Cedrus libani*, cedar of Lebanon

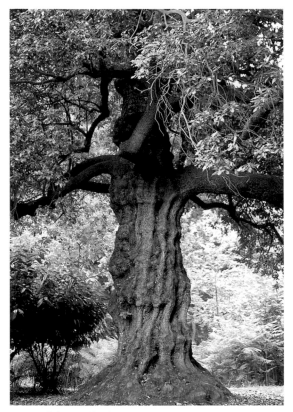

T-45 Well-fissured bark

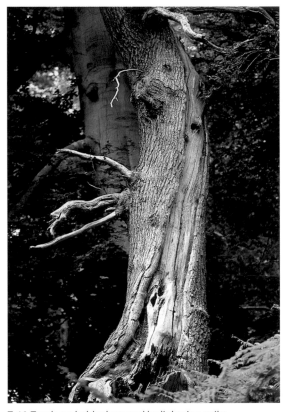

T-46 Trunk, probably damaged by lightning strike

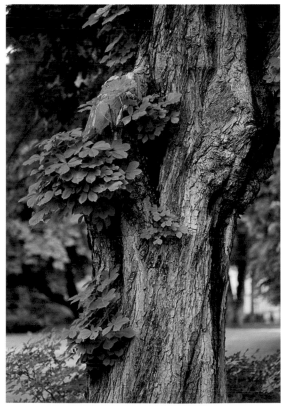

T-47 *Aesculus hippocastanum*, horse chestnut buckeye, with foliage

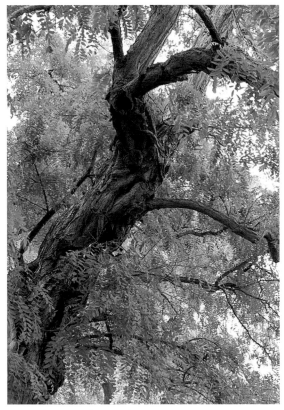

T-48 *Robinia pseudoacacia*, locust tree, summer aspect

BRANCHES, TRUNKS, ROOTS

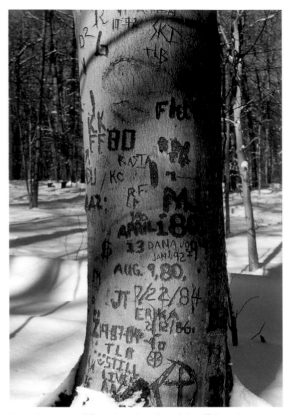

T-49 *Fagus grandiflora*, American beech (graffiti tree)

T-50 *Carya ovata*, shagbark hickory

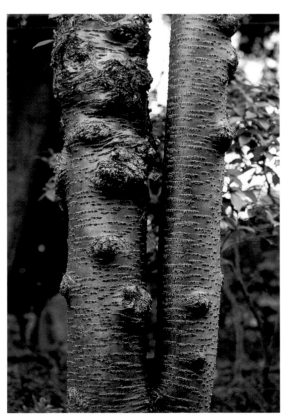

T-51 *Prunus*, cherry, with cankers

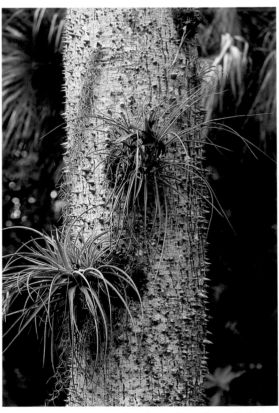

T-52 *Ceiba pentandra*, kapok, with epiphytes (bromeliads)

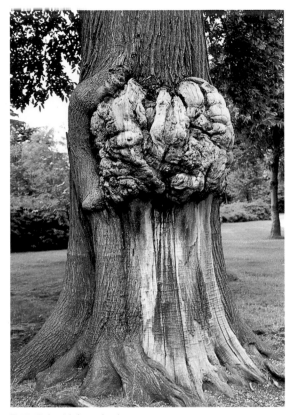

T-53 Oak with large burl

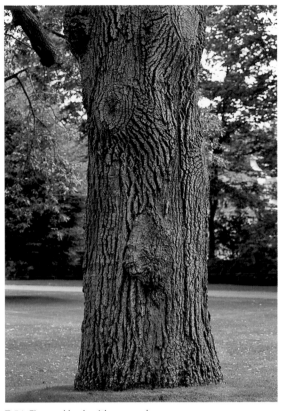

T-54 Fissured bark with green algae

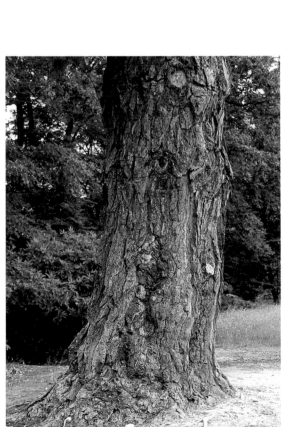

T-55 Bark of *Pinus*, pine

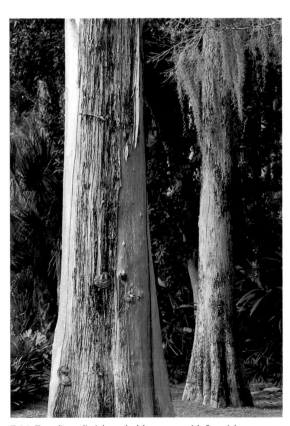

T-56 *Taxodium distichum*, bald cypress, with Spanish moss

BRANCHES, TRUNKS, ROOTS

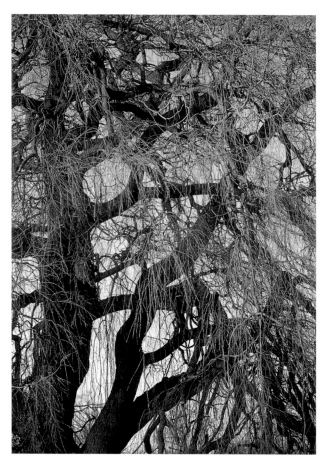

T-57 *Salix alba*, common willow

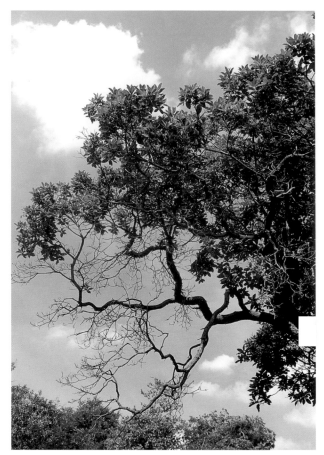

T-58 Branches of a mature deciduous forest tree

T-59 Branches of a mature deciduous forest tree

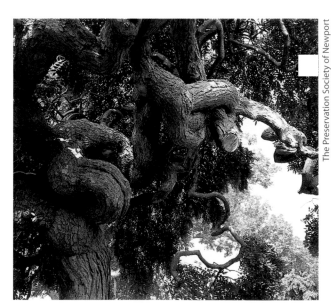

T-60 *Sophora japonica*, 'Pendulum,' weeping Japanese pagoda tree or Chinese scholar tree

The Preservation Society of Newport

BRANCHES, TRUNKS, ROOTS

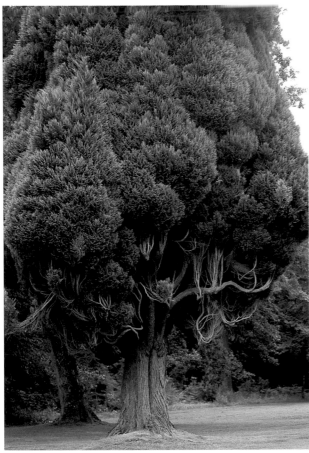

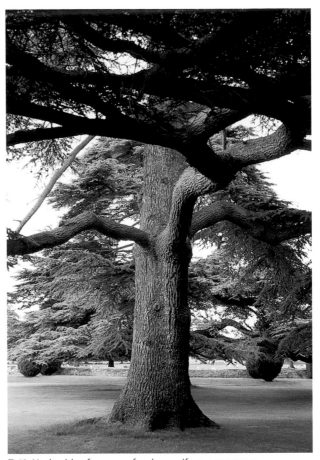

T-61 *Thujopis dolobrata*, false arborvitae, conical, coniferous evergreen

T-62 Underside of canopy of cedar, coniferous evergreen

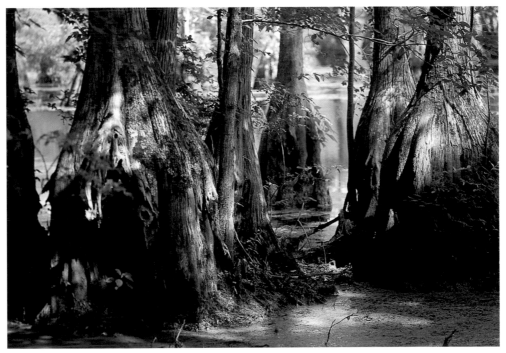

T-63 Group of *Taxiodium distichum*, bald cypress, in a swamp

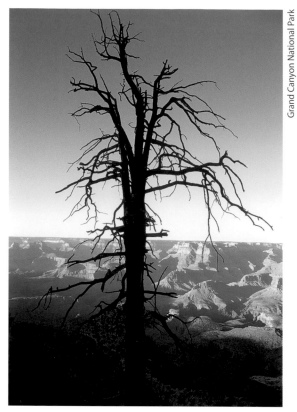

Grand Canyon National Park

T-64 Dead pine tree with canyon background

T-65 Bark of *Chamaecyparis pisifera*

Sheffield Park Garden

T-66 *Sequoiadendron giganteum*, giant sequoia

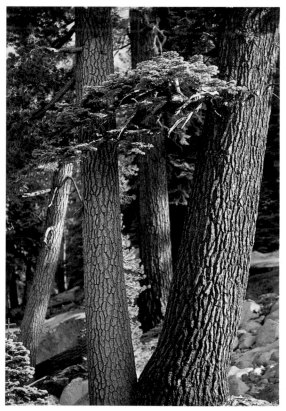

T-67 Bark of *Abies*, fir trees

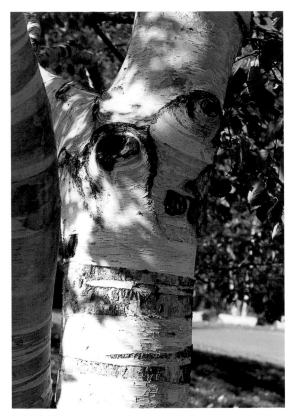

T-68 Bark of *Betula papyrifera,* paper birch

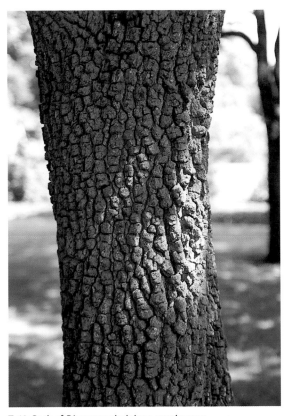

T-69 Bark of *Diospyros virginiana,* persimmon

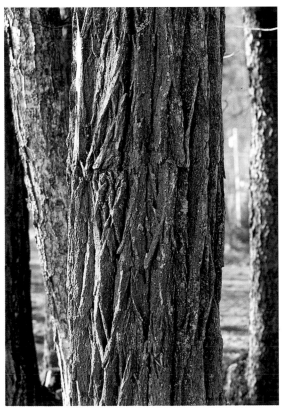

T-70 Bark of *Robinia pseudoacia,* black locust

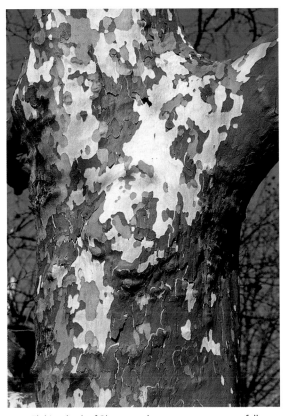

T-71 Flaking bark of *Platanus,* plane tree or sycamore, fall aspect

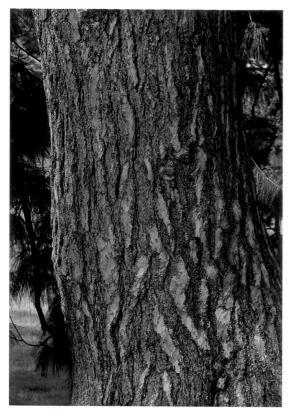

T-72 Pine bark with "ski trails"

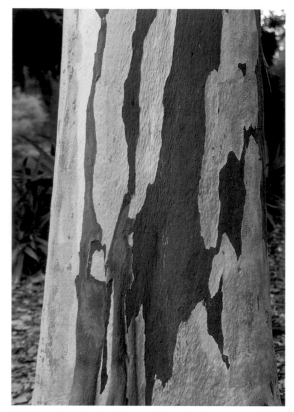

T-73 Eucalyptus bark with very thin scaly plates

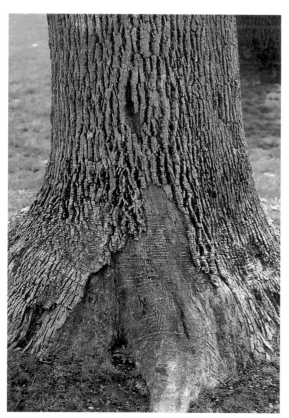

T-74 Typical furrowed bark

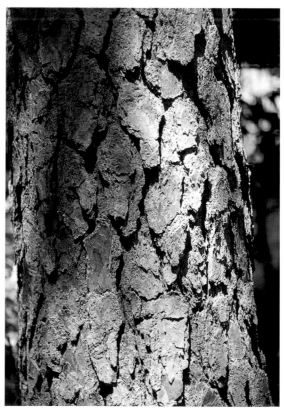

T-75 Scaly pine bark

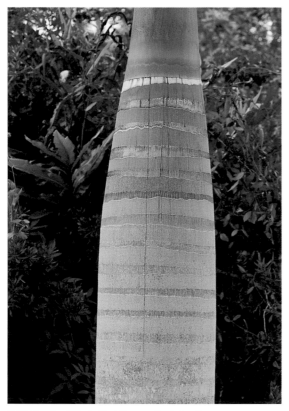

T-76 Trunk of *Wodyetia bifurcara*, foxtail palm

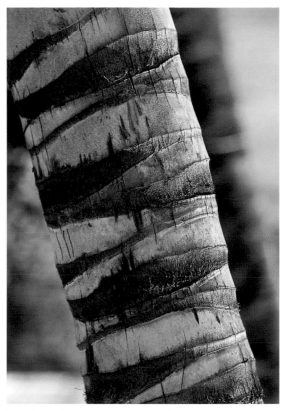

T-77 Trunk of *Cocos nucifera*, coconut palm

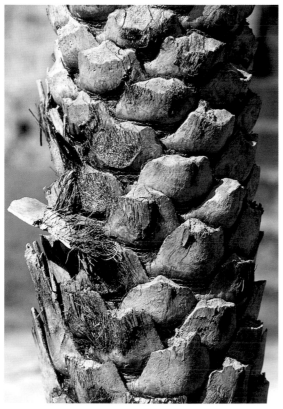

T-78 Trunk of *Phoenix sp.*, date palm

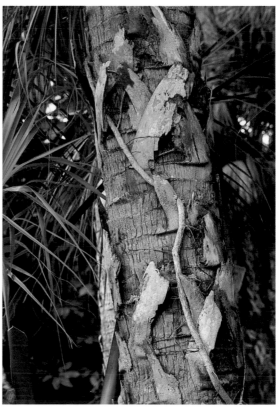

T-79 Trunk of *Sabal mexicana* with exfoliating bark

BRANCHES, TRUNKS, ROOTS

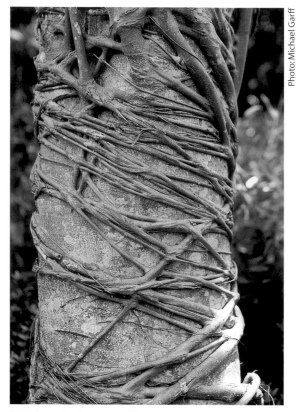

T-80 Strangler *Ficus* around host tree

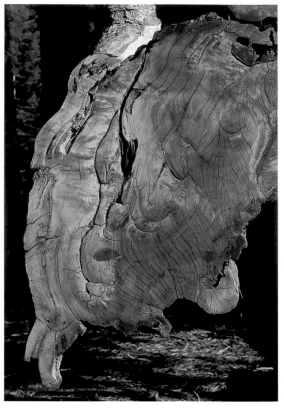

Photo: Michael Garff

T-81 Cross section of tree trunk

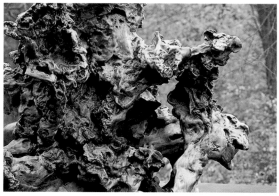

T-82 Ancient Chinese scholar tree, detail

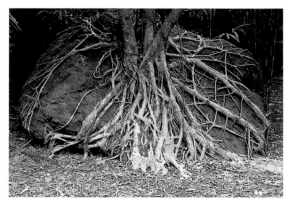

T-83 Root structure covering rock

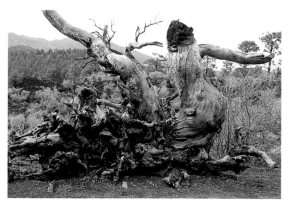

T-84 Roots of dead tree

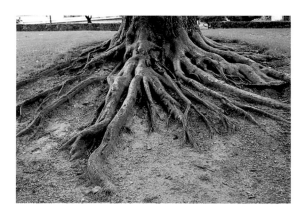

T-85 Typical spread of surface roots and eroded soil

BRANCHES, TRUNKS, ROOTS

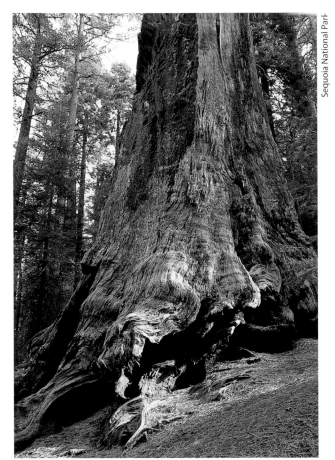

Sequoia National Park

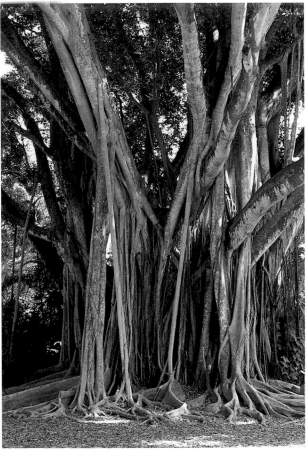

T-86 *Sequoiadendron giganteum*, giant sequoia

T-87 Large *Ficus benghalensis*, banyan, with expansive aerial root structure

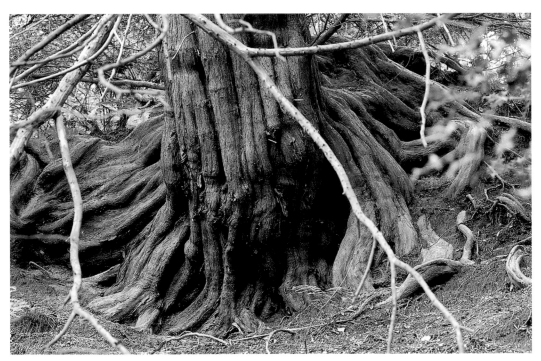

T-88 Roots of *Sequoiadendron giganteum*, giant sequoia

BRANCHES, TRUNKS, ROOTS

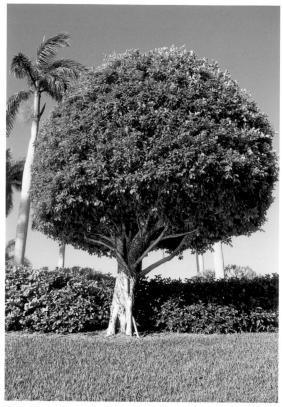

T-89 Clipped *Ficus* in tropical residential landscape

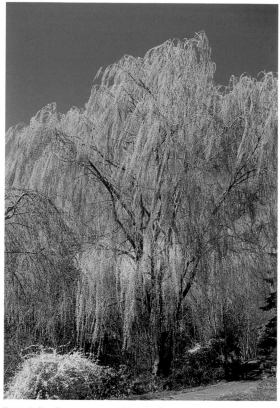

T-90 *Salix alba*, common willow, in flower

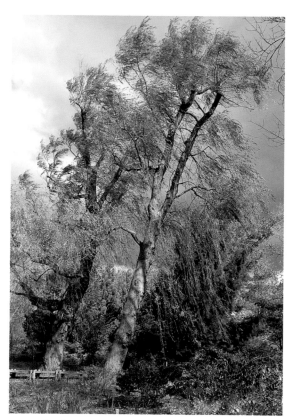

T-91 *Salix alba*, common willow, fall aspect

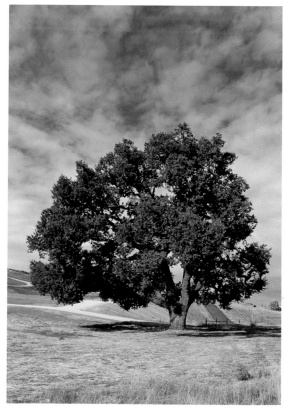

T-92 *Quercus agrifolia*, live-oak; large spreading canopy shade tree

T-93 Oval-shaped canopy

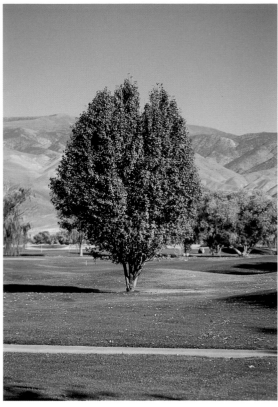

T-94 Shrubby canopy in park landscape

T-95 Pollarded *Tilia linden*, lime or linden

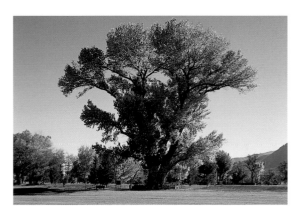

T-96 *Populus*, cottonwood, in park landscape

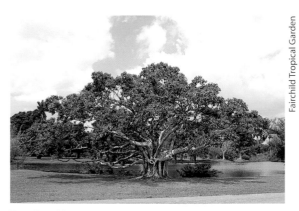

T-97 Possibly *Ficus sp.* or *Albizzia lebbeck*; broad spreading canopy

T-98 *Quercus robur*, English oak, pyramidal canopy

Fairchild Tropical Garden

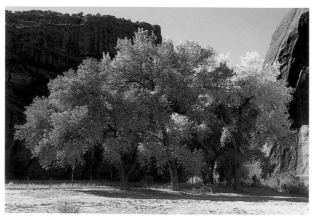

T-99 *Populus*, cottonwood, in natural habitat

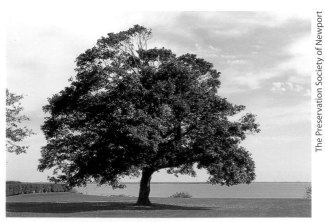

T-100 *Acer platanoides,* Norway maple, in landscaped grounds

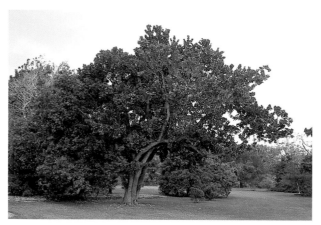

T-101 Possibly *Terminalia sp.,* tropical tree with spreading canopy

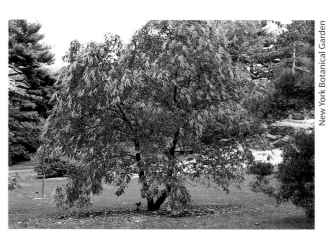

T-102 *Oxydendrum arboreum,* sourwood

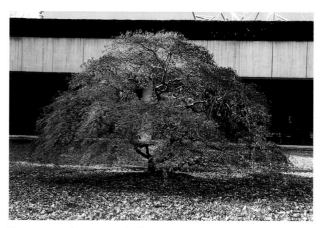

T-103 *Acer palmatum,* cut-leaf Japanese maple, fall color

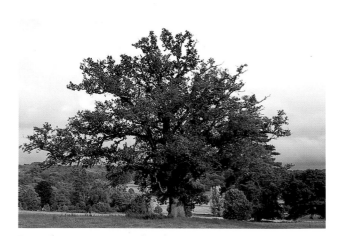

T-104 *Quercus petraea,* sessile oak

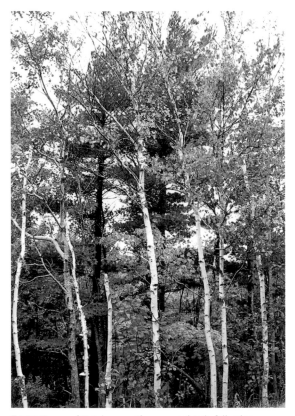

T-105 Grove of *Betula papyrifera*, paper birch, fall color

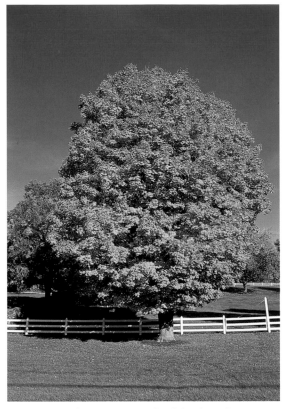

T-106 *Acer saccharum*, sugar maple; globe-shaped specimen tree, fall color

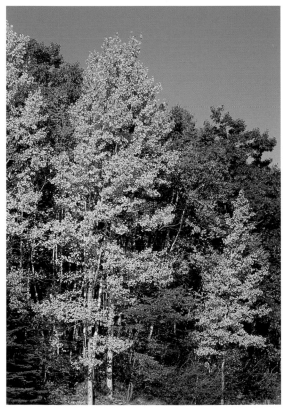

T-107 Stand of *Populus*, quaking aspen, fall color

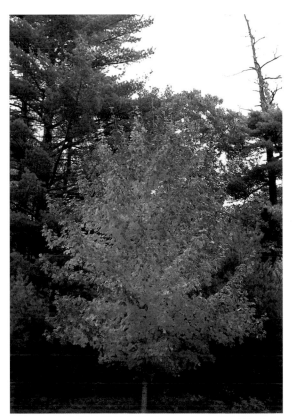

T-108 *Acer saccharum*, sugar maple, specimen tree, fall color

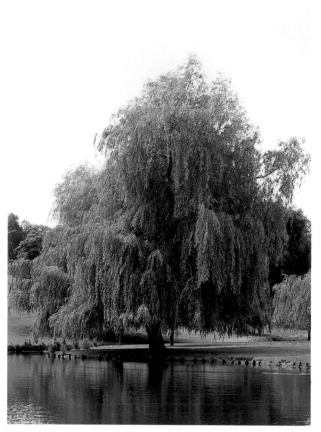

T-109 *Salix alba,* willow, by pond

Royal Botanic Gardens, Kew

T-110 *Castanea sativa,* sweet chestnut, juvenile specimen in summer aspect

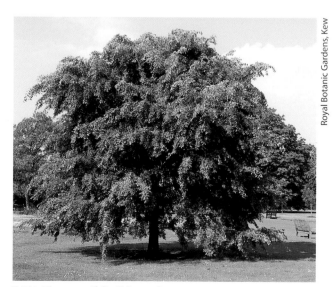

Royal Botanic Gardens, Kew

T-111 *Ulmus parvifolia,* Chinese elm, summer aspect

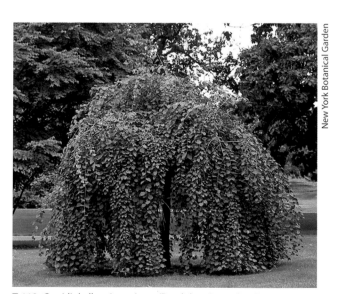

New York Botanical Garden

T-112 *Cercidiphyllum japonicum,* 'Pendulum,' weeping Katsura tree, summer aspect

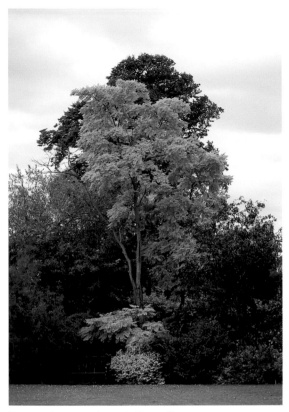

T-113 *Robinia pseudoacacia*, 'Aurea,' locust

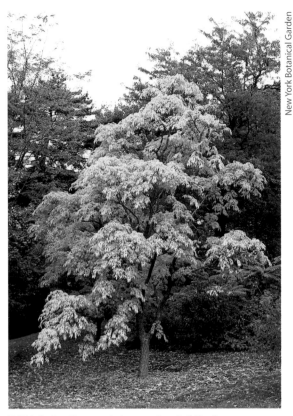

New York Botanical Garden

T-114 *Sorbus*, 'Aucuparia,' mountain ash, fall color

New York Botanical Garden

T-115 *Betula maximowiczi*, monarch birch

T-116 *Populus nigra*, 'Italica,' Lombardy poplar, along a country road

TEMPERATE & TROPICAL TREES

T-117 Deciduous tree in snow

T-118 *Paulownia tomentosa*, empress tree

T-119 Deciduous shade trees, in late fall aspect

T-120 *Acer*, maple, in snow

T-121 *Platanus x acerifolia,* London plane tree or sycamore, in field

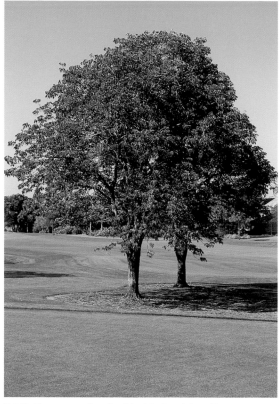

T-122 *Quercus marilandica,* black jack oak in golf course landscape

Royal Botanic Gardens, Kew

T-123 *Catalpa bignoniodes,* Indian bean–Southern catalpa, summer aspect

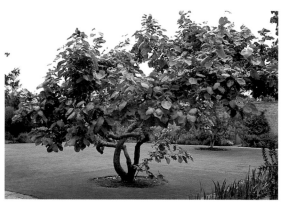

T-124 *Magnolia* in courtyard garden

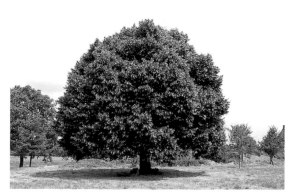

T-125 Globe-shaped shade tree in flower

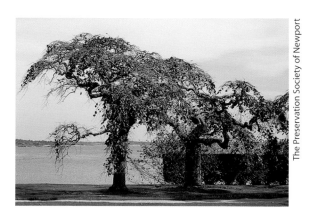

The Preservation Society of Newport

T-126 *Ulmus glabra,* 'Camperdownii,' camperdown elm in estate landscape

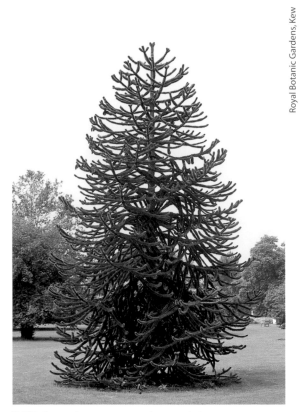

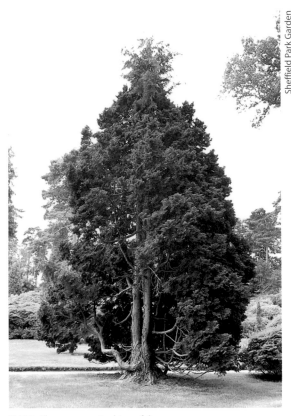

T-127 *Araucaria araucana,* monkey puzzle tree

T-128 *Chamaecyparis obtusa,* false cypress

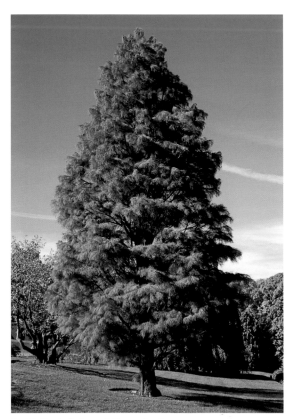

T-129 Conical-shaped *Pinus, pine,* in summer aspect

T-130 *Juniperus,* juniper

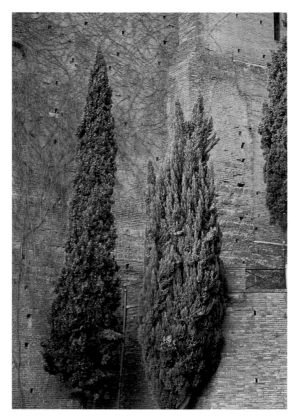

T-131 *Cupressus sempervirens,* cypress, in urban setting

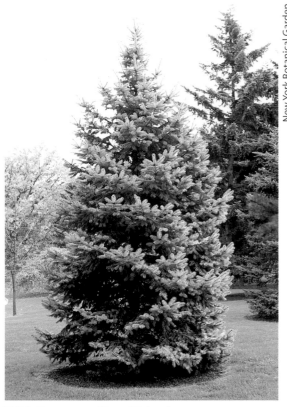

New York Botanical Garden

T-132 *Picea pungens* 'Koster,' Colorado spruce

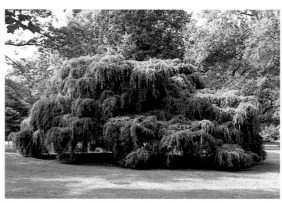

T-133 *Tsuga canadensis,* weeping hemlock

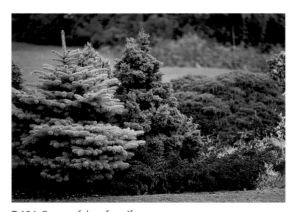

T-134 Group of dwarf conifers

T-135 *Cedrus atlantica,* 'Glauca,' cedar (foreground) and *Acer saccharum,* sugar maple, in fall color

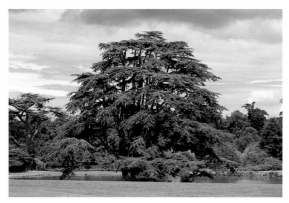

T-136 *Cedrus libani,* cedar of Lebanon in landscape garden

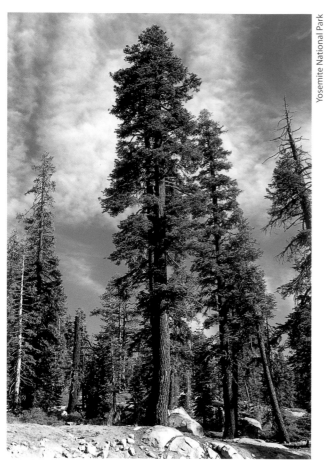

Yosemite National Park

T-137 Pine trees in forest habitat

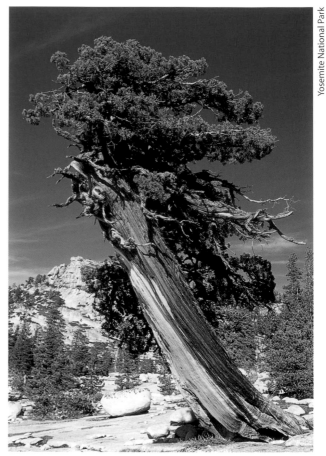

Yosemite National Park

T-138 Wind-shaped pine growing on mountain top

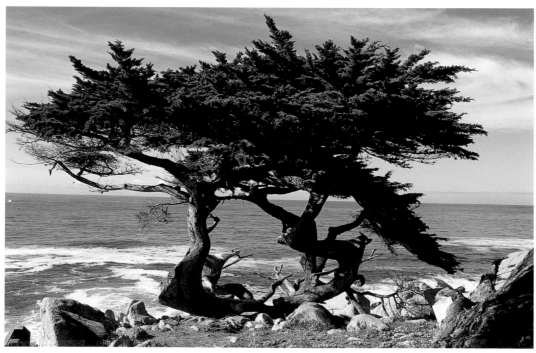

T-139 *Cedrus macrocarpa*, Monterey cypress, or *Pinus radita*, Monterey pine, on rocky cliff

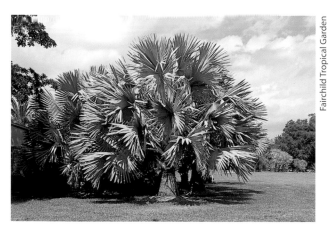

Fairchild Tropical Garden

T-140 *Bismarckia nobilis*

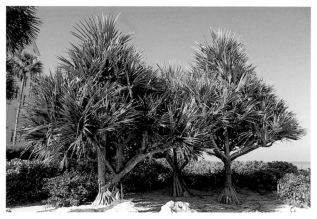

T-141 *Pandanus sp.*, pandan or screw pine, as beach planting

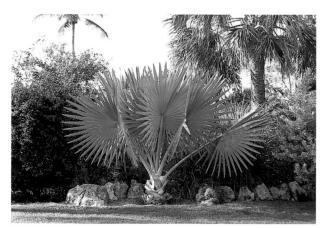

T-142 *Bismarckia nobilis* in tropical residential landscape

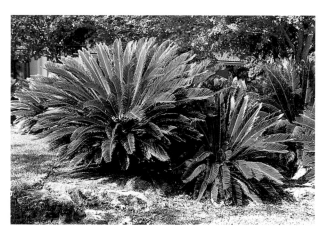

T-143 *Cycas sp.*, sago palm, in tropical residential landscape

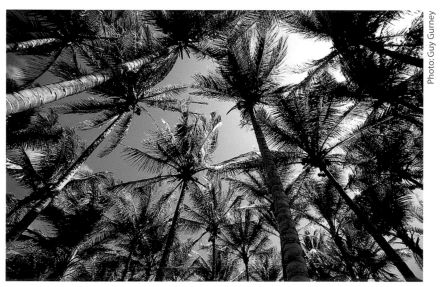

Photo: Guy Gurney

T-144 Grove of *Cocos nucifera*, coconut palms

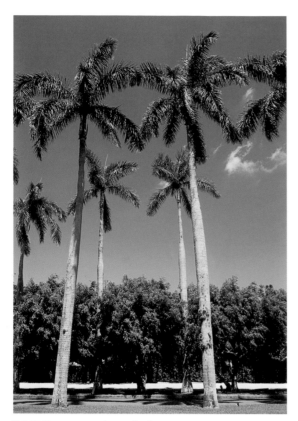

T-145 *Roystonea regia*, royal palm

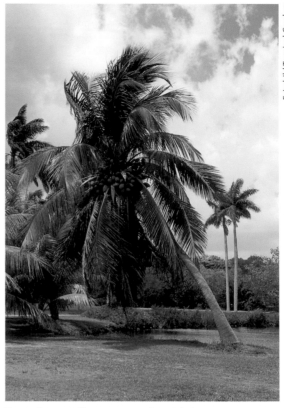

T-146 *Cocos nucifera*, coconut palm, with *Roystonea regia* in background

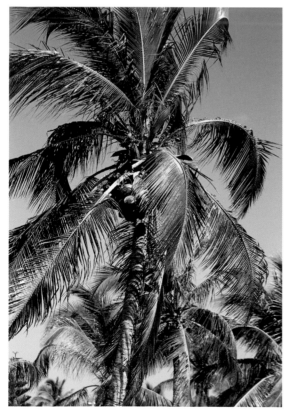

T-147 *Cocos nucifera*, coconut palm, with fruit

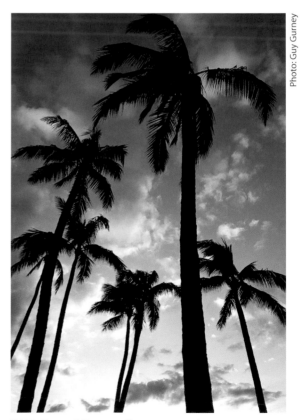

T-148 Grove of *Cocos nucifera*, coconut palm

Fairchild Tropical Garden

Photo: Guy Gurney

TEMPERATE & TROPICAL TREES

T-149 *Phoenix roebelenii,* pygmy date palm

T-150 *Cycas sp.,* sago palm, in courtyard

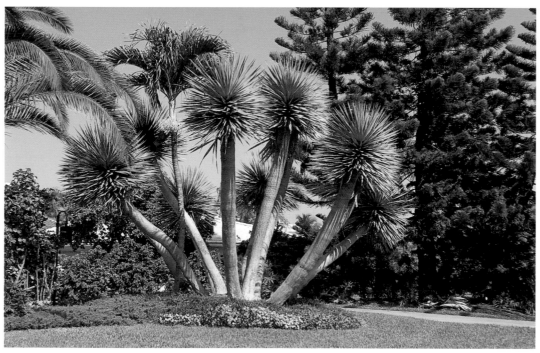

T 151 *Draceana draco,* dragon tree, in residential landscape

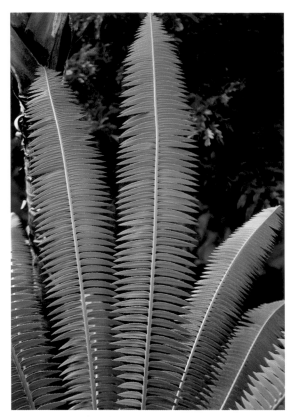

T-152 *Dioon sp.*, frond

T-153 *Cocos nucifera*, coconut palm, frond

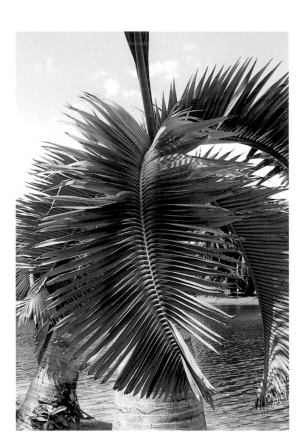

T-154 *Cocos nucifera*, coconut palm, frond

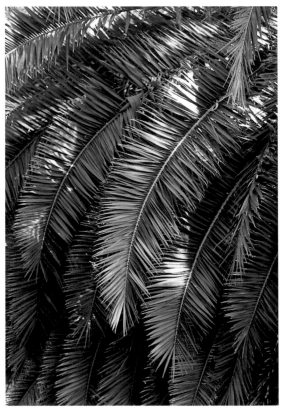

T-155 *Phoenix sp.*, date palm, frond

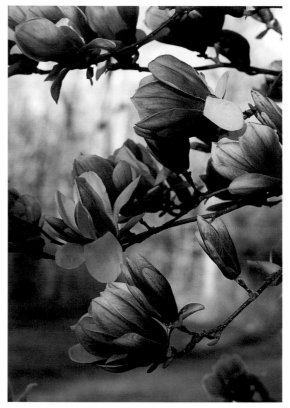

T-156 *Magnolia* x *soulangiana*, saucer magnolia, blossoms

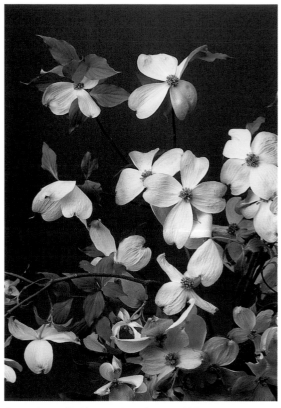

T-157 *Cornus florida*, American dogwood, blossoms

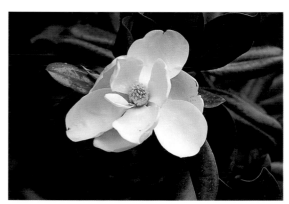

T-158 *Magnolia grandiflora*, southern magnolia, blossom

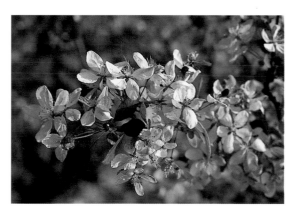

T-159 *Malus*, apple, blossoms

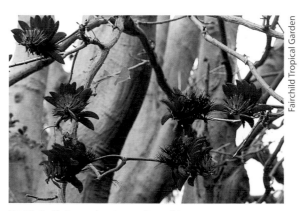

T-160 *Erythrina variegata*, coral tree, blossoms

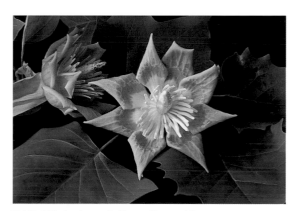

Fairchild Tropical Garden

T-161 *Liriodendron tulipifera*, tulip tree, blossom

FLOWERING TREES

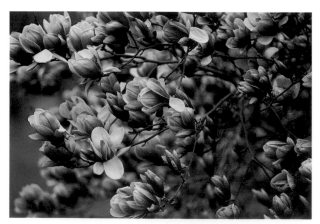

T-162 *Magnolia* x *soulangiana*, saucer magnolia, blossoms

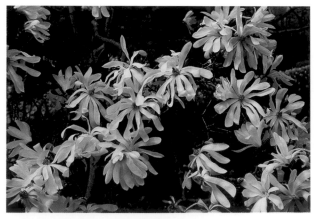

T-163 *Magnolia korbus,* 'Stella Royal Star,' star magnolia, blossoms

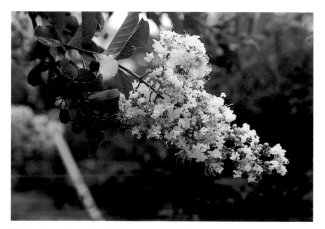

T-164 *Lagerstroemia,* 'Indica,' crape myrtle, blossoms

T-165 *Syringa reticulata*, Japanese tree lilac, in blossom

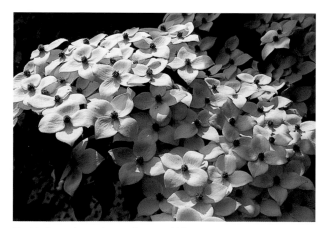

T-166 *Cornus kousa*, kousa dogwood, blossoms

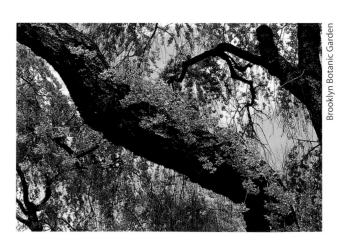

T-167 *Prunus subhirtella,* weeping cherry, in blossom

Brooklyn Botanic Garden

FLOWERING TREES

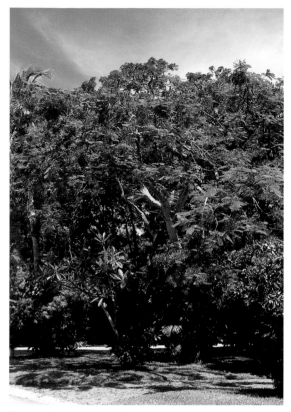

T-168 *Delonix regia*, Flamboyant Tree, in blossom

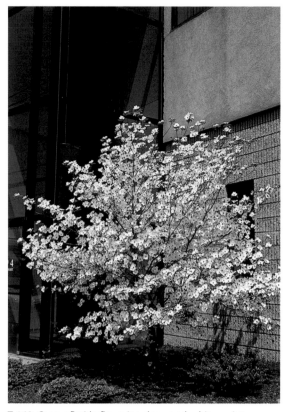

T-169 *Cornus florida*, flowering dogwood, white variety

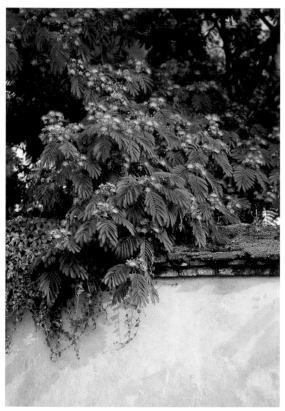

T-170 *Albizia julibrissin*, mimosa tree, in blossom

T-171 *Laburnum x watereri*, golden chain or trumpet tree, in blossom in residential landscape

T-172 *Tabebuia chrysantha*, trumpet tree, tropical tree in blossom

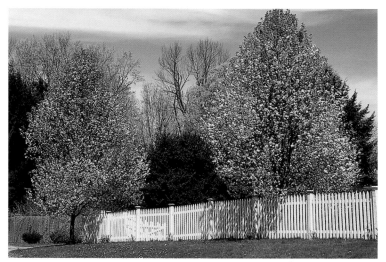

T-173 *Pyrus calleryana,* 'Bradford,' Bradford pear trees in blossom by picket fence

T-174 *Malus,* 'Red Jade,' red jade crabapple

New York Botanical Garden

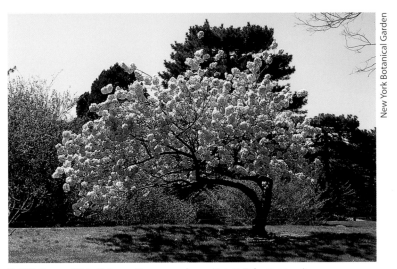

T-175 *Cotinus coggygria*, smoke tree (pink variety)

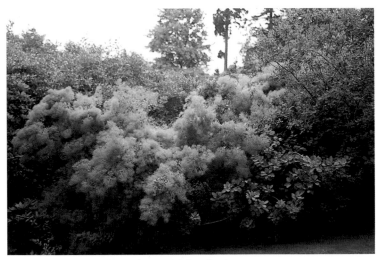

New York Botanical Garden

T-176 *Prunus*, 'ShiroT-fugen,' Japanese cherry (SatoT-Zakura group)

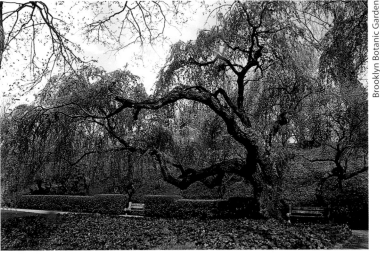

Brooklyn Botanic Garden

T-177 *Prunus subhirtella*, weeping cherry

FLOWERING TREES

T-178 *Juniperus*, common juniper

T-179 Pruned shrubs in contrasting colors as hedges

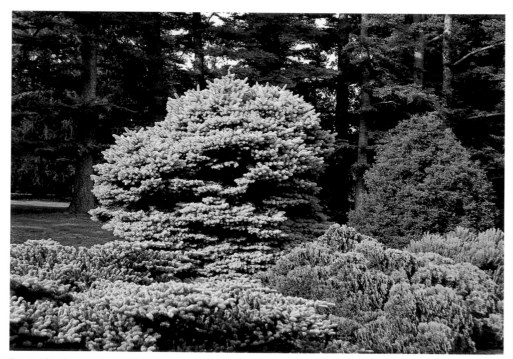

T-180 *Abies korean*, dwarf Korean fir; *Thuja occidentalis*, arborvitae; *Pinus sylvestris*, Scots pine; *Picea pungens*, dwarf blue spruce

SHRUBS & HEDGES

T-181 A tropical shrub pruned into a hedge

T-182 *Euonymus fortunei*, 'Emerald 'n Gold,' wintercreeper euonymus, planted at base of tree

T-183 *Podocarpus macrophyllus*, southern or Japanese yew, used as hedge

T-184 *Paeonia*, shrub peony

T-185 *Rhododendron sp.,* summer aspect

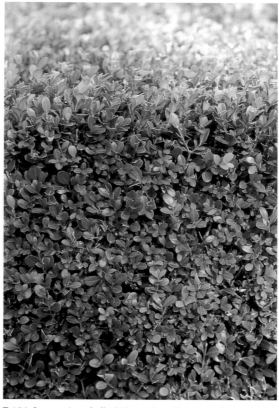

T-186 *Buxus microphylla,* 'Winter Gem,' Japanese boxwood, as clipped hedge

T-187 *Ilex aquifolium,* 'Silver Queen,' holly

T-188 *Rhododendron* foliage

T-189 *Ilex cornuta,* Chinese holly

T-190 *Clusia rosea,* tropical shrub

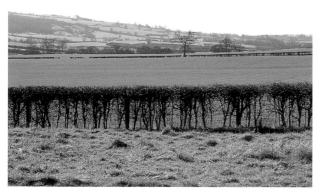

T-191 Hedgerow in English countryside

T-192 *Euonymus alatus,* winged euonymus, fall colors

T-193 *Rhododendron sp.,* azalea

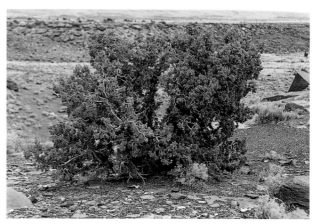

T-194 *Juniperus monosperma,* one-seeded juniper, in desert habitat

T-195 *Juniperus,* juniper, used as ground cover

T-196 Multiple tropical shrubs clipped into hedges

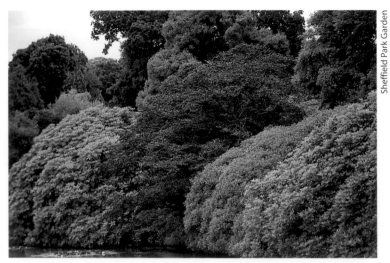

Sheffield Park Garden

T-197 *Rhododendron* framing maple in landscape garden

T-198 (front to back) *Begonia semperflorens,* cv.; *Chamaecyparis filifera aurea;*
Juniperus horizontalis cv.; *Berberis thunbergii,* 'Atropurpurea,' barberry; *Pinus mugo*

T-199 *Podocarpus,* southern or Japanese yew, pruned as hedge

T-200 *Choiysa ternata,* Mexican orange

Longwood Gardens

T-201 Three types of junipers used as ground cover

T-202 Pine pruned as hedge

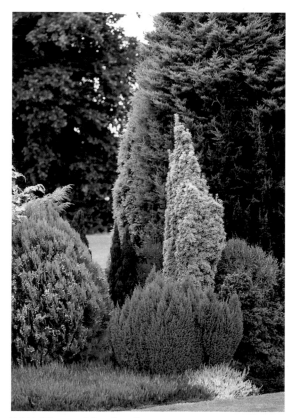

T-203 Mixture of dwarf conifers: junipers, yew, arborvitae, spruce; and *Calluna vulgaris,* heather

SHRUBS & HEDGES

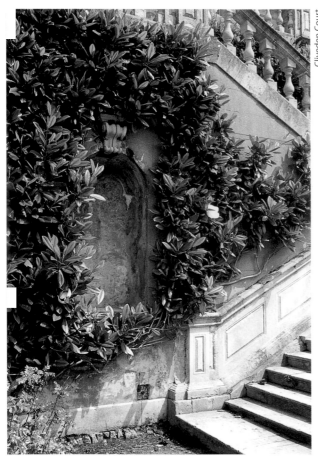

Cliveden Court

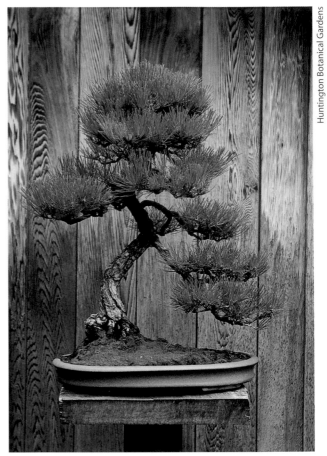

Huntington Botanical Gardens

T-204 *Magnolia* x *soulangiana*, saucer magnolia trained as wall shrub along formal garden staircase

T-205 Pine, semi-cascade form, trained as bonsai

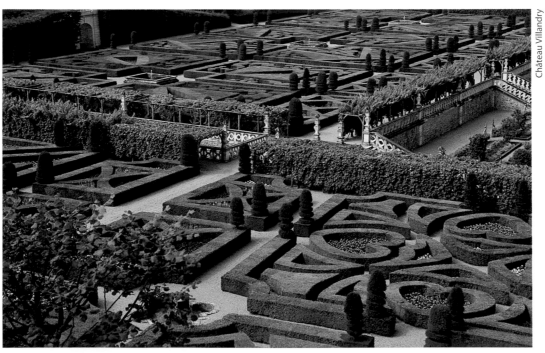

Château Villandry

T-206 Boxwood parterre with central axis defined by grape arbors

BONSAI, TOPIARY, PARTERRE

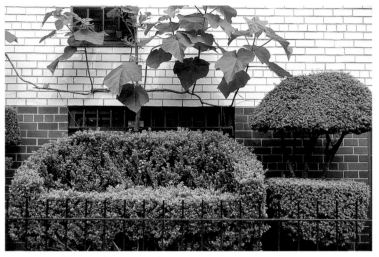

T-207 *Buxus*, boxwood topiary, sculpture

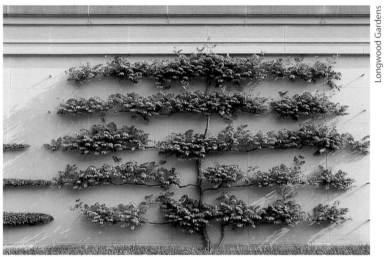

Longwood Gardens

T-208 Formal espalier

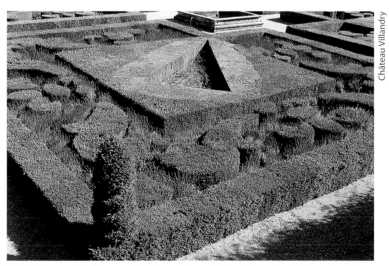

Château Villandry

T-209 Parterre detail: tapestry hedge of boxwood and lavender with yew forming topiary finial

BONSAI, TOPIARY, PARTERRE

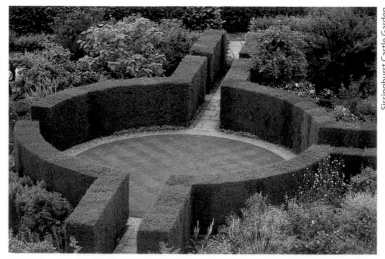

Sissinghurst Castle Garden

T-210 Boxwood hedge forming circular garden room

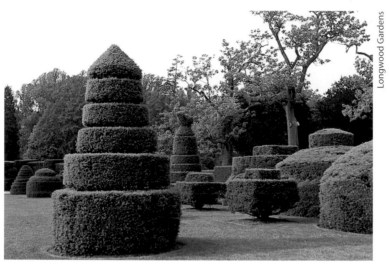

Longwood Gardens

T-211 Yew pruned into topiary shapes

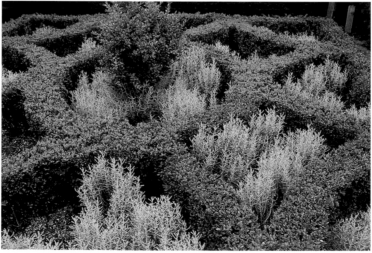

T-212 Knot garden of *Santolina cupressoides* and boxwood

BONSAI, TOPIARY, PARTERRE

T-213 Dwarf conifers with annuals and perennials in urban park

Bowood House

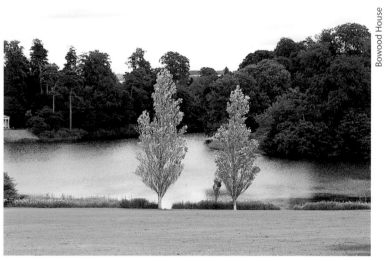

T-214 *Populus sp.* by lake in English landscape garden

Sheffield Park Garden

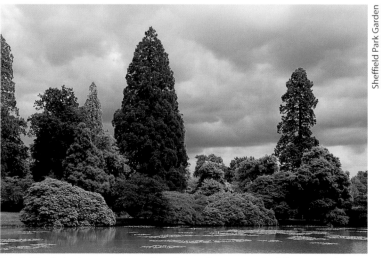

T-215 *Rhododendron* and assorted conifers and evergreens by lake in English landscape garden

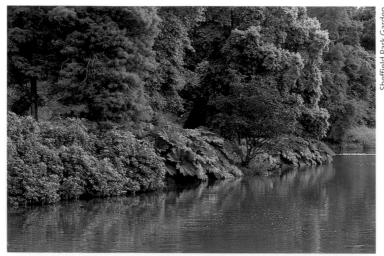

Sheffield Park Garden

T-216 *Rhododendron*, Japanese maple, and *Gunnera* by lake in English landscape garden

T-217 *Lixora coccinea* in bloom and clipped as tropical hedge

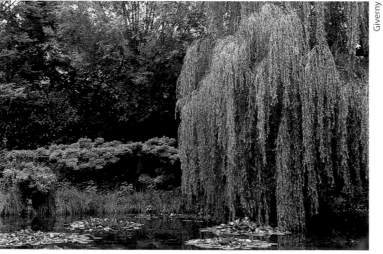

Giverny

T-218 Willow tree and assorted water plants in garden pond setting

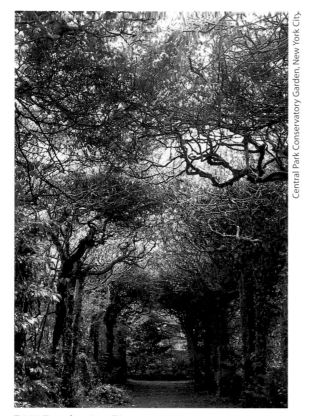

T-219 Trees forming allée

Central Park Conservatory Garden, New York City

T-220 Residential landscape with deciduous shade trees and conifers, fall colors

T-221 Strolling garden with *shrubs and Nepeta sp., catmint,* in bloom

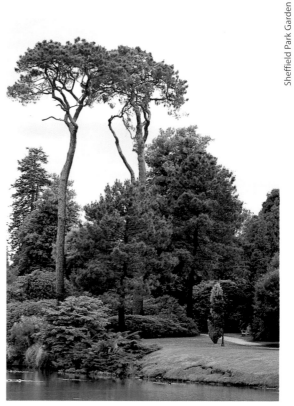

Sheffield Park Garden

T-222 *Pinus sylvestris,* Scotch pine, or *P. bungeana;* lacebark pine, or *P. nigra,* Austrian pine, with other conifers and evergreens in English landscape garden

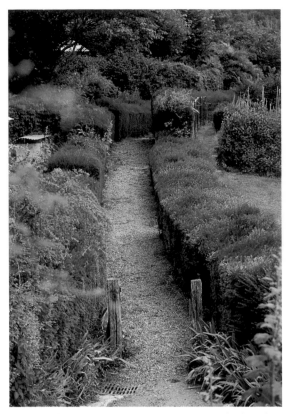

T-223 Garden path bordered by clipped tapestry hedge of gold and common yew

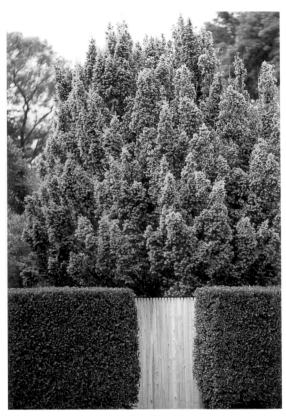

T-224 Wooden gate framed by clipped privet or boxwood with *Taxus baccata,* 'Aurea,' common yew in back

Central Park Conservatory Garden, New York City

T-225 Layers of clipped privet or boxwood hedge (front) and *Wisteria* in strolling garden

T-226 *Cydonia,* quince, bordered by clipped yew hedge

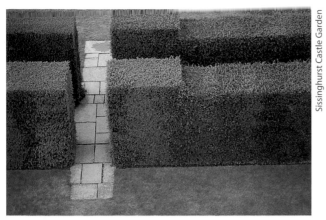

Sissinghurst Castle Garden

T-227 Clipped boxwood bordering stone walk in formal garden

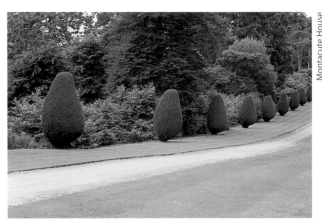

Montacute House

T-228 Irish yew topiary defining estate entrance

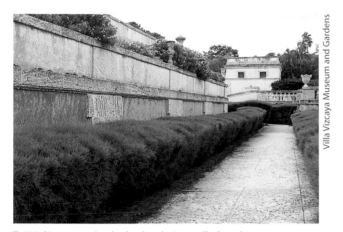

Villa Vizcaya Museum and Gardens

T-229 Pine pruned as hedge bordering walled garden

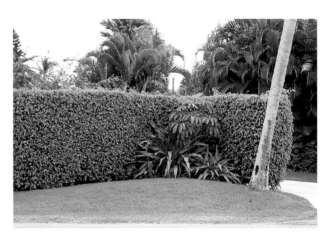

T-230 Clipped *Ficus* hedge

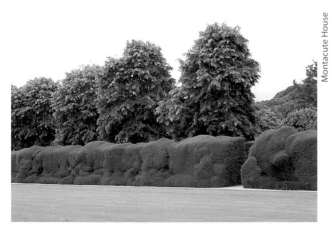

Montacute House

T-231 Clipped yew "higgledy-piggledy" hedge

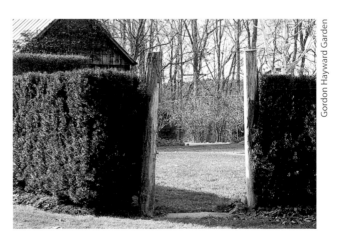

Gordon Hayward Garden

T-232 Garden entrance with clipped yew hedge and black locust posts

Villa Vizcaya Museum and Gardens

T-233 *Protocarpus* as background for garden sculpture and staircase

T-234 Clipped yew and English ivy as background for garden sculpture

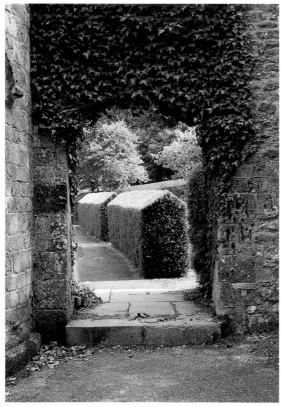

T-235 Clipped yew hedge seen through stone arch covered with ivy

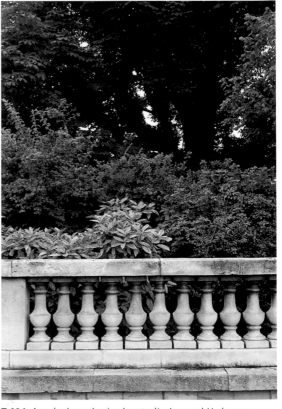

T-236 *Aucuba japonica* (variegated), pine, and *Hydrangea paniculata,* background for stone balustrade

T-237 Clipped *Ficus* topiary in commercial tropical landscape

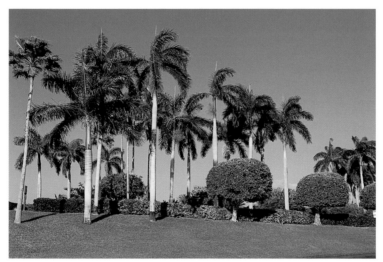

T-238 *Roystonea regia*, royal palm (Washingtonia *sp.* at left), with clipped *Ficus* in commercial tropical landscape

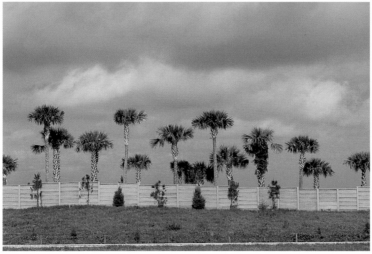

T-239 *Sabal palmetto*, palmetto, with wooden fence, tropical highway landscape

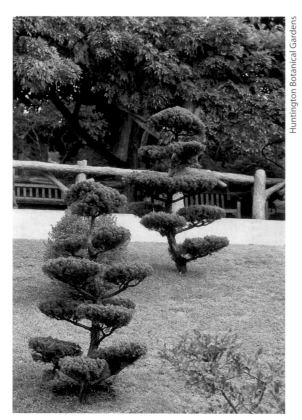

Huntington Botanical Gardens

T-240 *Pinus* topiary specimens in Japanese-style garden

T-241 Palm in residential landscape

T-242 Tropical shrubs in commercial landscape

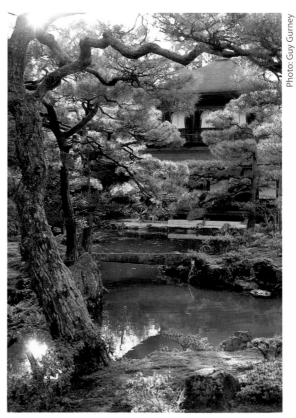

Photo: Guy Gurney

T-243 Deciduous and evergreen trees in Japanese temple garden

T-244 Container-planted trees, *Robina pseudoacacia,* locust, in urban open space.

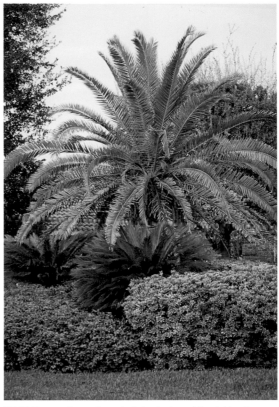

T-245 Sago palm and tropical shrubs in residential landscape

Villa Vizcaya Museum and Gardens

T-246 Clipped pine hedges around fountain in tropical formal garden

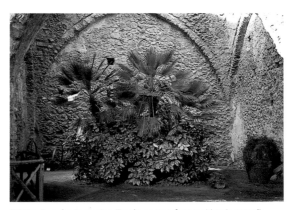

T-247 *Aucuba japonica, Trachycarpus fortunei* (variegated), and cycads in stone courtyard

T-248 Shrubs cascading over stone wall

T-249 Urban tree planting along river

Iford Manor

T-250 Juniper, clipped yew, *Bergenia cordifolia,* bordering stone steps and as background for garden architecture

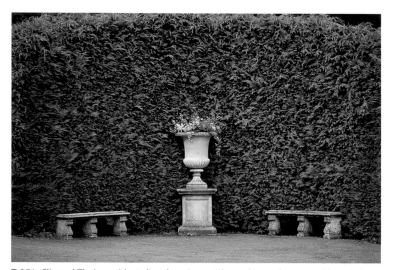

T-251 Clipped *Thuja occidentalis,* arborvitae, with garden sculpture and benches

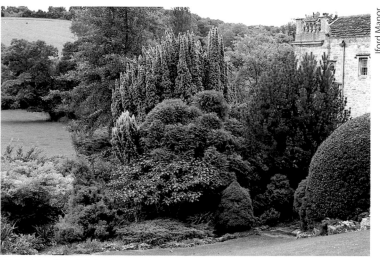

Iford Manor

T-252 Mixed English landscape planting with pine, spruce, yew, and rhododendron

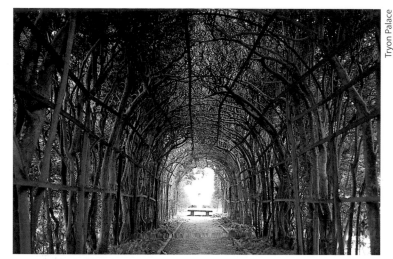

Tryon Palace

T-253 Well-established arbor

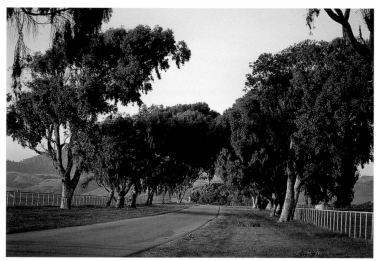

T-254 *Eucalyptus sp.* along estate entrance

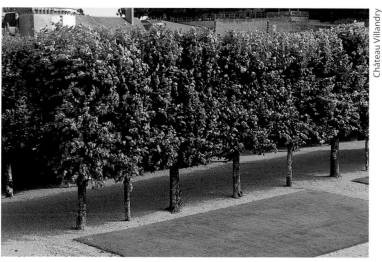

Château Villandry

T-255 Pollarded trees in standard shape along courtyard walk

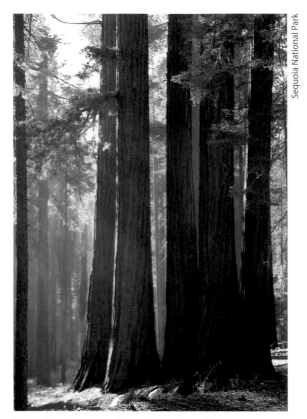

Sequoia National Park

T-256 *Sequoia sempervirens*, redwood, stand

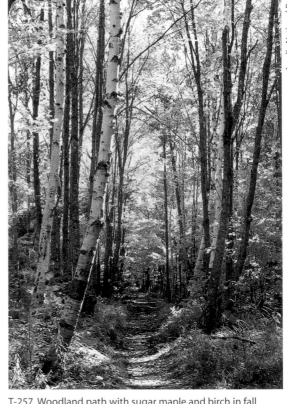

Acadia National Park

T-257 Woodland path with sugar maple and birch in fall colors

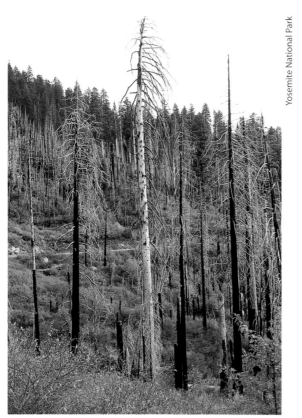

Yosemite National Park

T-258 Burned forest

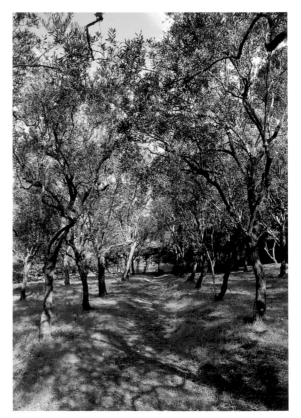

T-259 Olive grove

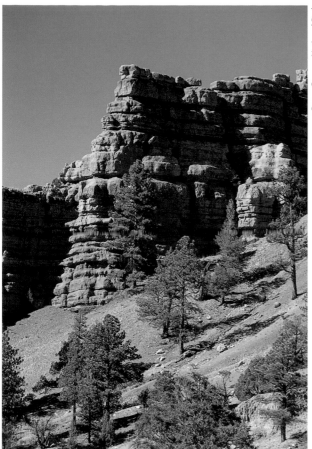

Bryce Canyon National Park

T-260 *Pinus arista,* bristol cone pine, or ponderosa pine growing on canyon slope

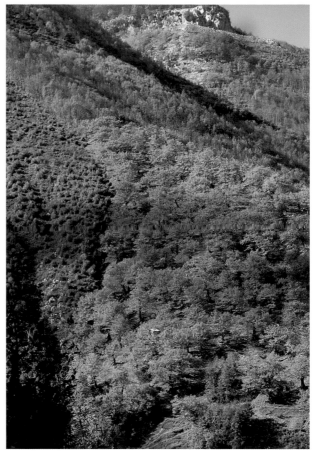

T-261 Forest covering mountainside in fall aspect

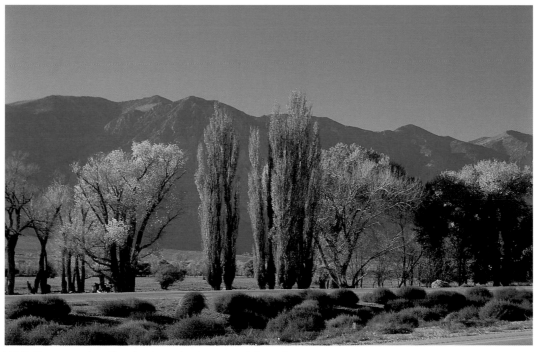

T-262 Cottonwood and Lombardy poplar along mountain road

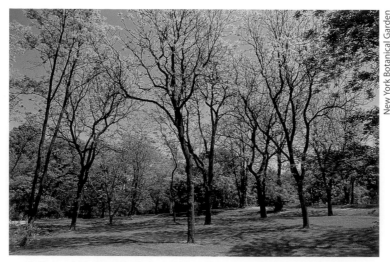

T-263 Grove of shade trees, early spring aspect

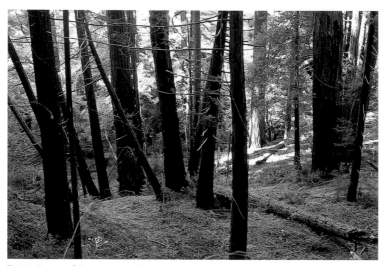

T-264 Forest of *Conium maculatum*, hemlock

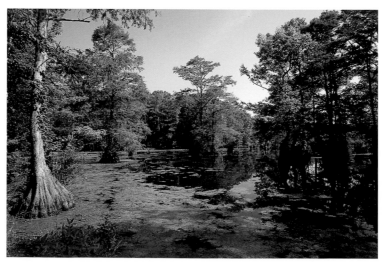

T-265 *Taxodium distichum*, bald cypress, with buttressed trunks, in swamp

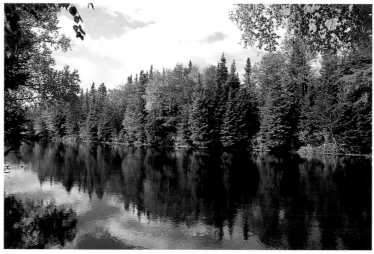

T-266 Sugar maple and spruce in fall color along New England river

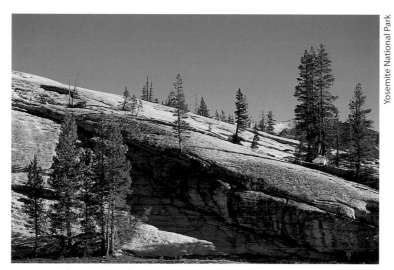

Yosemite National Park

T-267 Bristol cone or ponderosa pine on granite mountain

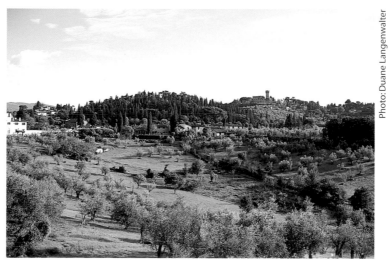

Photo: Duane Langenwalter

T-268 Cypress in olive grove In Tuscan countryside landscape

GROVES, FORESTS, SWAMPS

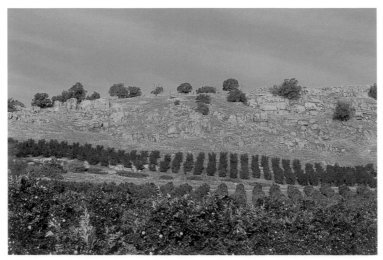

T-269 Orange groves

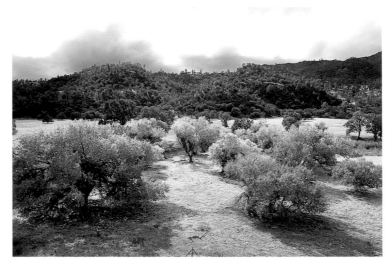

T-270 Grove of shade trees in prairie landscape, fall color.

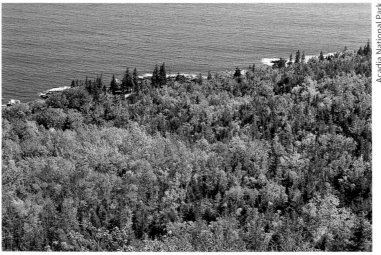

Acadia National Park

T-271 Deciduous and coniferous forest in fall color

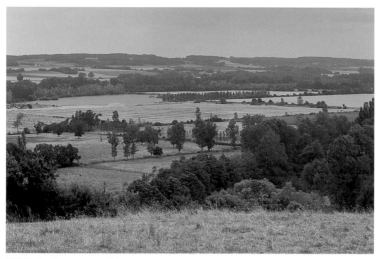

T-272 English countryside

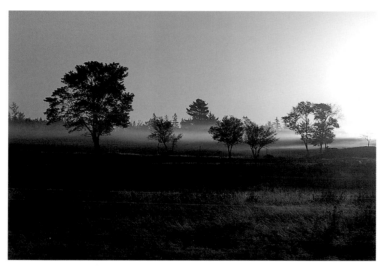

T-273 Deciduous trees in early morning fog

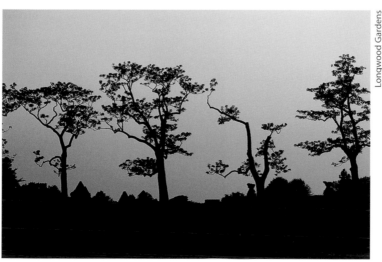

Longwood Gardens

T-274 Silhouette of trees in early evening

TREES IN THE LANDSCAPE

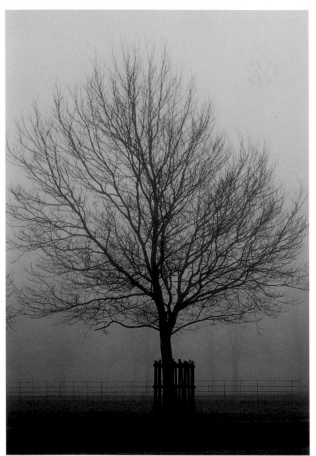

T-275 Deciduous tree in winter aspect in fog

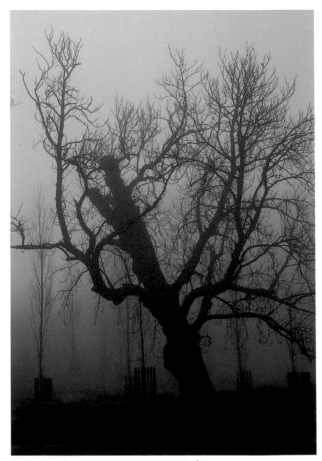

T-276 Deciduous tree in winter aspect in fog

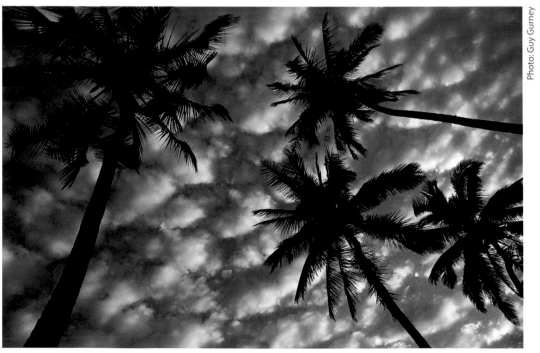

T-277 Silhouette of palm trees against clouds and blue sky

Photo: Guy Gurney

FLOWERS

FL-1 *Delphinium*

FL-2 *Campanula medium*, Canterbury bells, biennial

FL-3 *Helianthus annuus*, sunflower

FL-4 *Platycodon grandiflorus*, balloon flower

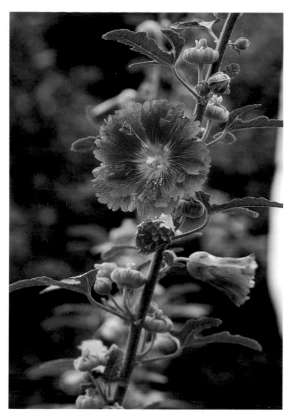

FL-5 *Alcea rosea*, hollyhock

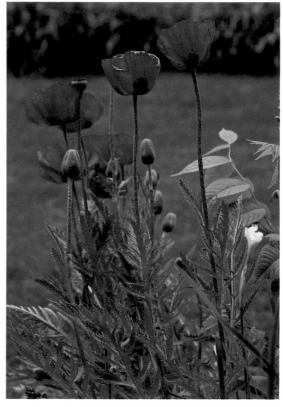

FL-6 *Papaver orientale*, Oriental poppy

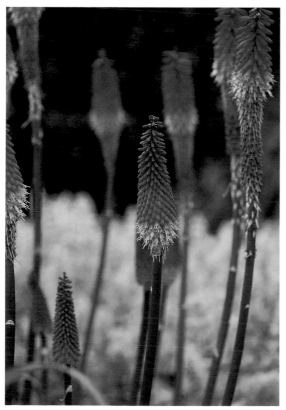

FL-7 *Kniphofia sp.*, red hot poker

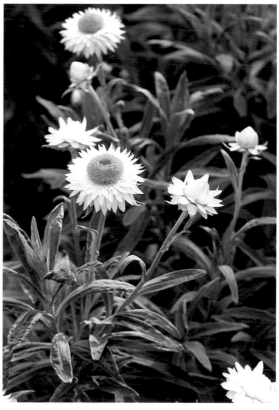

FL-8 *Helichrysum bracteatum*, strawflower

ANNUALS & PERENNIALS

FL-9 *Eryngium giganeum*, *'Miss Willmott's Ghost,'* sea holly

FL-10 *Cosmea bipinnatus*, 'Sensation'; cosmos

FL-11 *Gerbera*, African or Gerbera daisy

FL-12 *Romneya coulteri*, matilija poppy

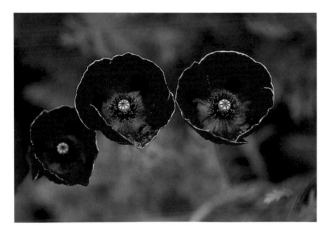

FL-13 *Papaver*, poppy

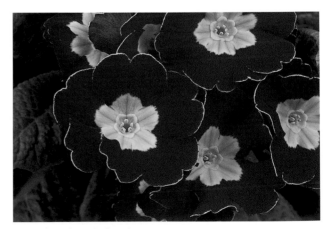

FL-14 *Primula auricula*, primrose

FL-15 *Anemone tomentosa*, 'Robustissima,' anemone

FL-16 Perennial in blossom, possibly *Thunbergia sp.*

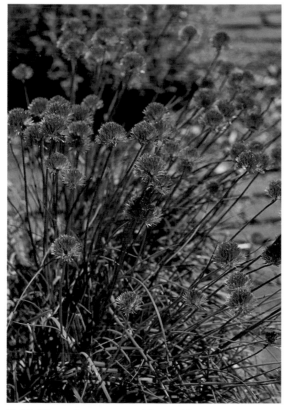

FL-17 *Allium schoenoprasum*, chives, in blossom

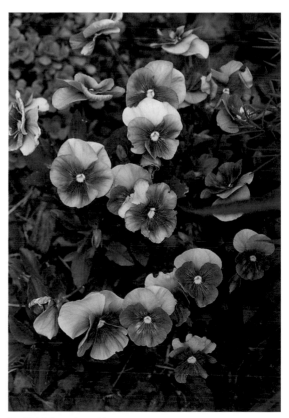

FL-18 *Viola* x *wittrockiana*, pansy

FL-19 *Pelargonium*, geranium

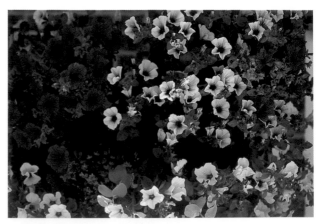

FL-20 *Petunia*

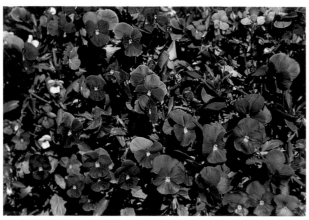

FL-21 *Viola* x *wittrockiana*, 'True Blue' pansy

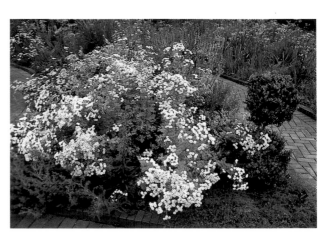

FL-22 *Tanacetum parthenium*, feverfew

FL-23 *Santolina viridis*, santolina

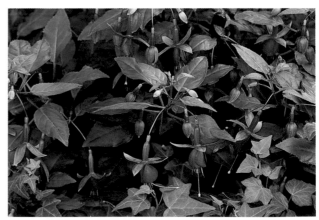

FL-24 *Fuchsia*

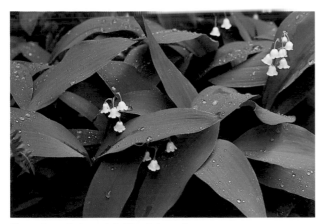

FL-25 *Convallaria majalis*, lily-of-the-valley

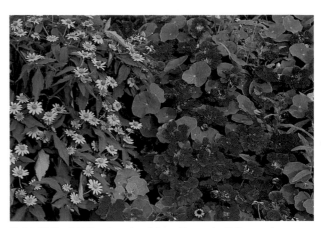

FL-26 (Yellow) *Heliopsis scabra*, fall sunflower; (red) *Tropaeolum majus*, nasturtium; (blue) *Campanula*, bell flower

FL-27 *Tradescantia*, spider wort

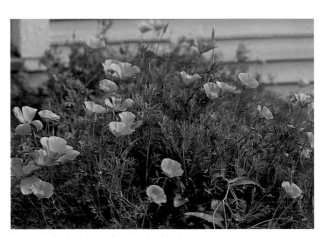

FL-28 *Eschscholzia californica*, California poppy

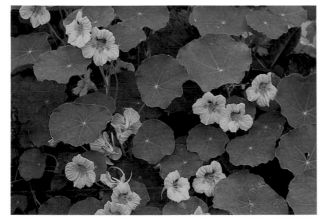

FL-29 *Tropaeolum majus*, nasturtium, strawberry ice

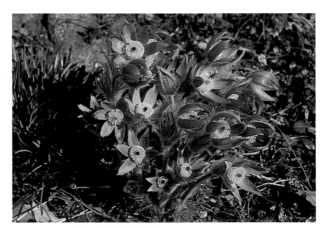

FL-30 *Pulsatilla vulgaris*, pasqueflower

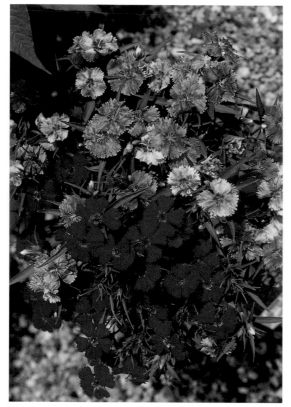

FL-31 Mixed *Dianthus chinesis*, 'China Pink,' carnations

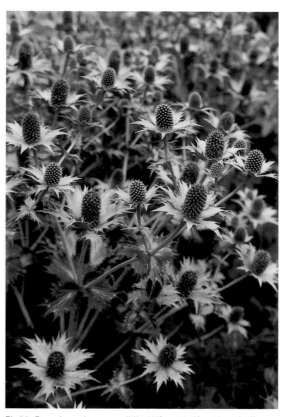

FL-32 *Eryngium giganeum*, 'Miss Wilmott's Ghost,' sea holly

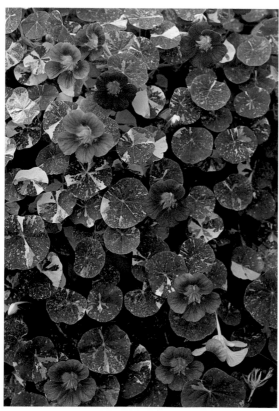

FL-33 *Tropaeolum majus*, 'Alaska,' nasturtium'

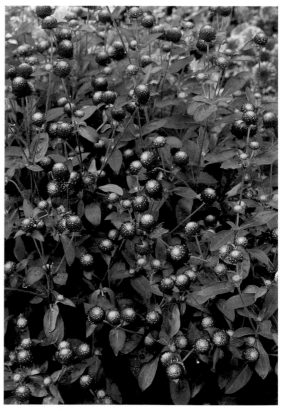

FL-34 *Gomphrena*, 'Lavender Lady,' globe amaranth

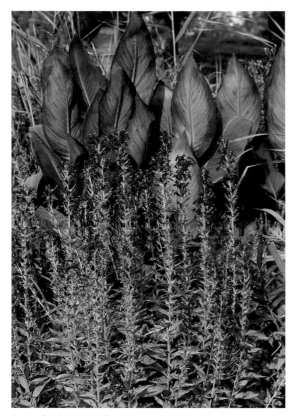

FL-35 (back) *Canna*; (front) *Lobelia*

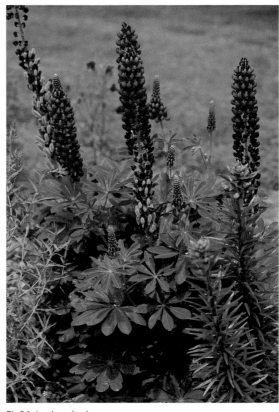

FL-36 *Lupinus*, lupine

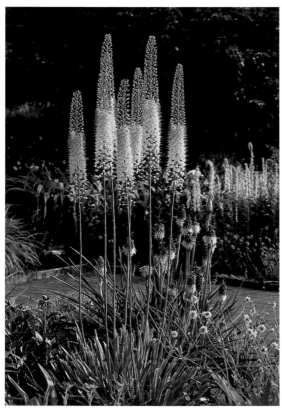

FL-37 *Eremurus*, desert candle or foxtail lily

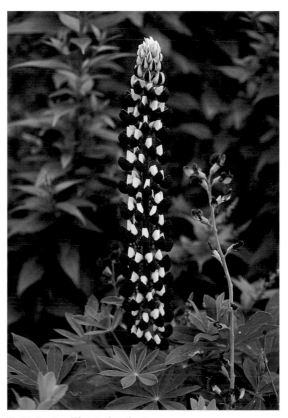

FL-38 *Lupinus* 'Blue Jacket,' lupine

FL-39 *Bouvardia ternifolia*

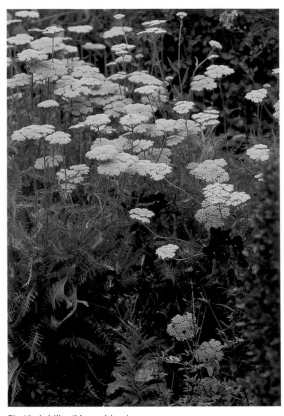

FL-40 *Achillea* 'Moonshine,' yarrow

FL-41 (back) *Kniphofia sp.*, red hot poker; (front) *Lysimachia punctata* 'Alexander,' whorled loosestrife

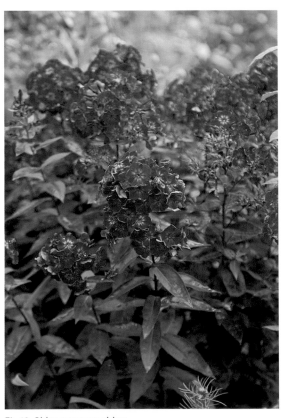

FL-42 *Phlox*, summer phlox

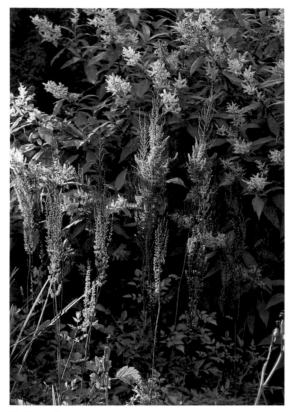

FL-43 *Astilbe sp.*, spirea

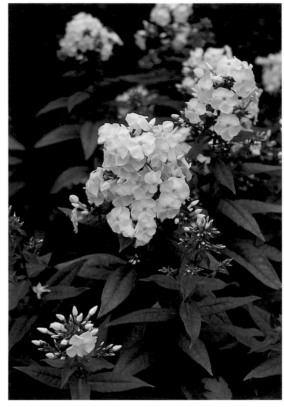

FL-44 *Phlox paniculata*, 'David,' summer phlox

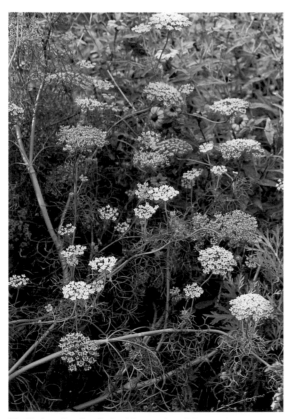

FL-45 *Ammi majus*, florists' Queen Anne's lace

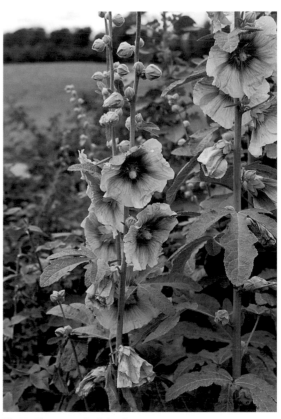

FL-46 *Alcea rosea*, hollyhock

FL-47 *Zinnia*

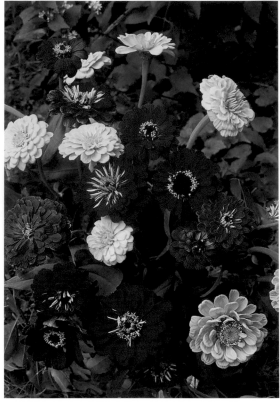

FL-48 *Zinnia*

FL-49 *Rudbeckia hirta*, 'Green Eyes'

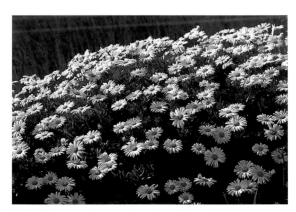

FL-50 *Nipponanthemum nipponicum*, Montauk daisy

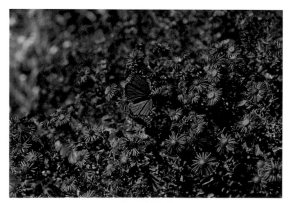

FL-51 *Aster novi-belgii*, New York aster

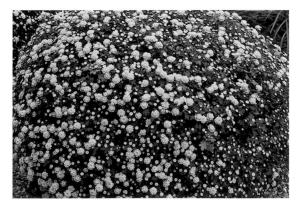

FL-52, *Chrysanthemum*, 'Ugetsu'

FL-53 *Dendranthema zawadskii*, Korean chrysanthemum

FL-54 *Erigeron* cv, fleabane

FL-55 *Helianthus annuus*, sunflower

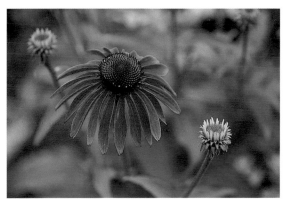

FL-56 *Echinacea purpurea*, pink coneflower

FL-57 *Cosmos*, 'Sensation,' and zinnias

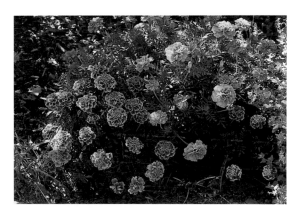

FL-58 Dwarf marigold, double French type

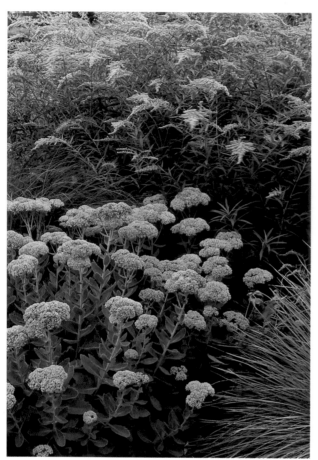

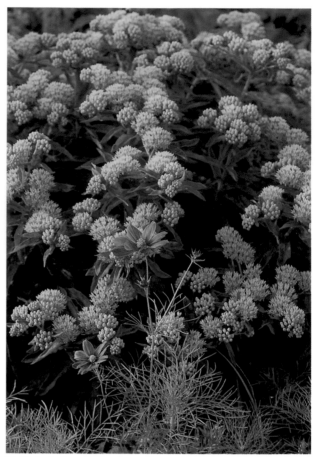

FL-59 (back) *Solidago virgaurea*, 'Le Raft,' European goldenrod; (left) *Sedum*; (right) *Helictotrichon sempervirens*, blue oat grass

FL-60 *Asclepias tuberosa*, butterfly weed (yellow); *Cosmos* (pink)

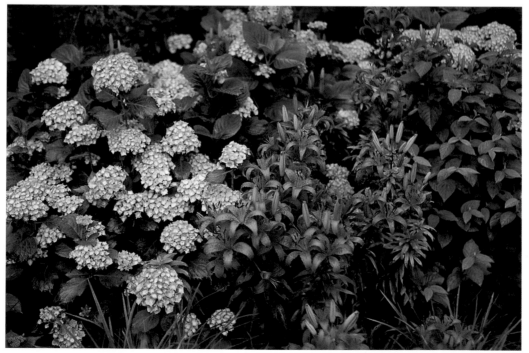

FL-61 (Orange) *Lilium*, 'Red Lehigh,' Asiatic lily hybrid; *Hydrangea macrophylla*, Big Leaf hydrangea, 'Nikko Blue'

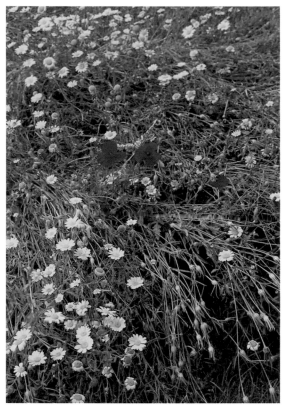

FL-62 *Centaurea cyanis*, cornflower (blue); *Papaver rhoeas*, corn poppy (red); *Chrysanthemum segetum*, 'Corn Marigold'; *Agrostemma githago*, corn cockle

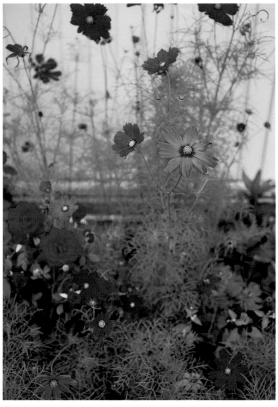

FL-63 *Cosmos bipinnatus*, 'Versailles Palace,' cosmos; red roses

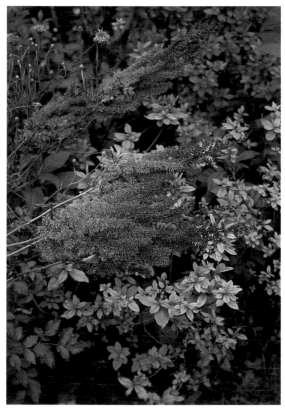

FL-64 *Astilbe chinensis* var. *taquetii*, 'Superba,' spirea (pink)

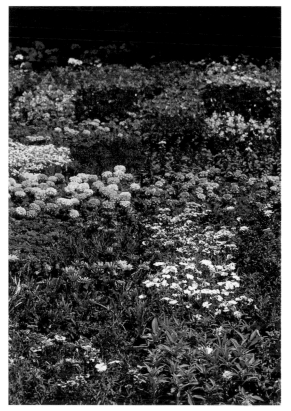

FL-65 (bottom to top) *Dianthus* (red-pink); *Avatotis* (orange); *Dianthus* (white); French marigold (yellow-orange); darkleaf begonia (red)

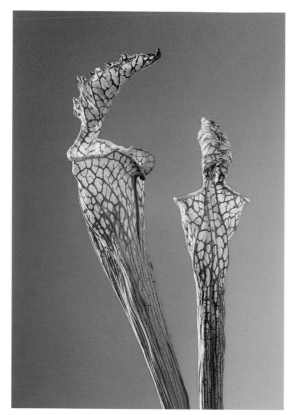

FL-66 *Sarracenia flava*, yellow pitcher plant, dried

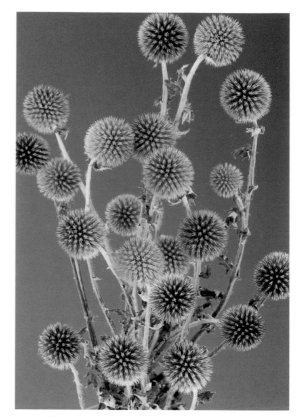

FL-67 *Echinopsis*, globe thistle, dried

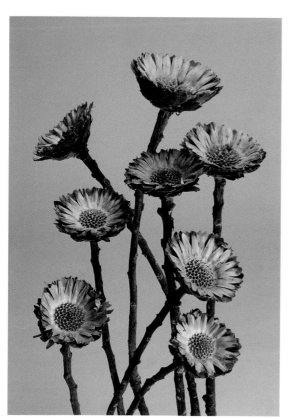

FL-68 *Compositae*, dried

FL-69 *Banksia*, dried

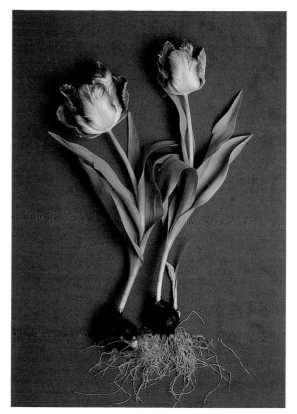

FL-70 *Tulipa*, parrot-type tulip

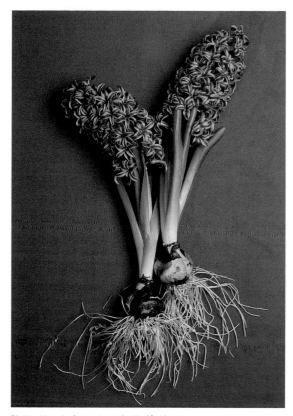

FL-71 *Hyacinthus orientalis*, 'Delft Blue'

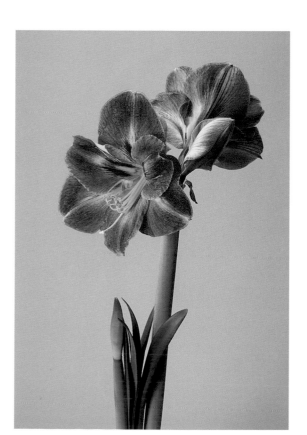

FL-72 *Hippeastrum*, 'Sandra,' amaryllis

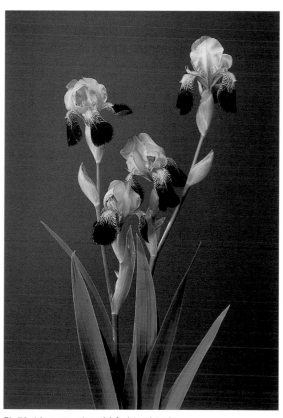

FL-73 *Iris germanica*, old-fashion bicolor

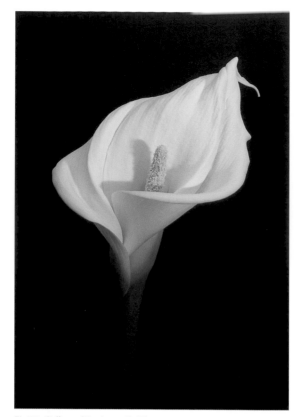

FL-74 *Calla aethiopica*, calla lily

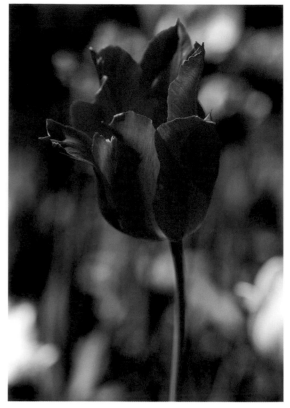

FL-75 *Tulipa*, tulip

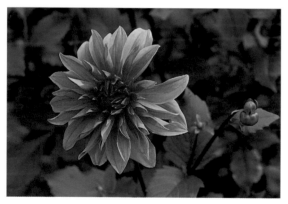

FL-76 *Dahlia*, decorative type

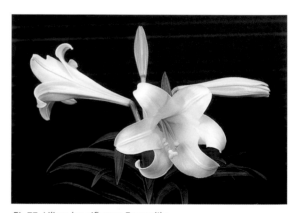

FL-77 *Lilium longiflorum*, Easter lily

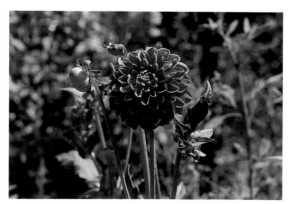

FL-78 *Dahlia*, decorative type

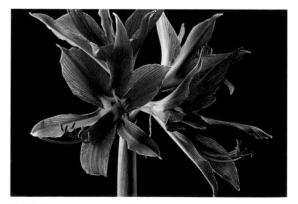

FL-79 *Hippeastrum*, amaryllis

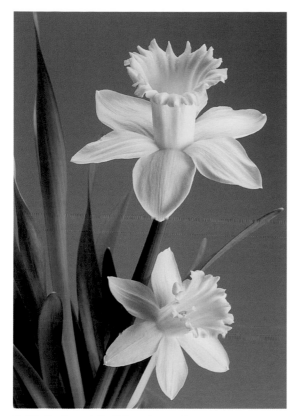

FL-80 *Narcissus*, daffodil, large trumpet

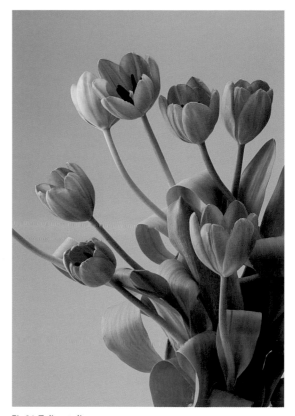

FL-81 *Tulipa*, tulip

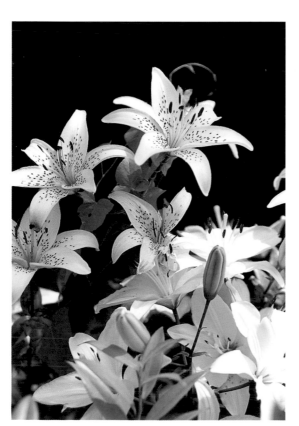

FL-82 *Lilium*, 'Nepal, 'Asiatic lily

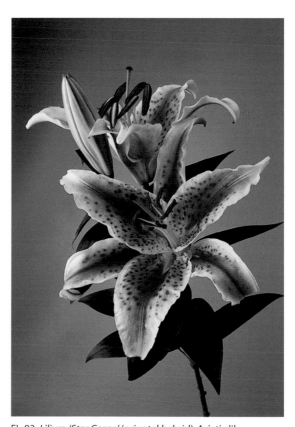

FL-83 *Lilium*, 'Star Gazer,' (oriental hybrid), Asiatic lily

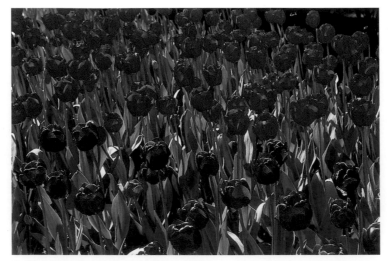

FL-84 *Tulipa*, tulip, purple and red in garden

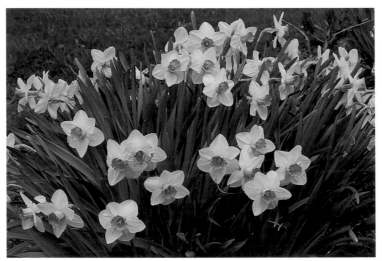

FL-85 *Narcissus*, orange trumpet in lawn planting

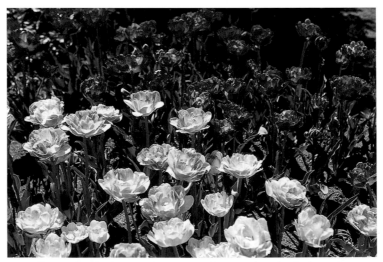

FL-86 (front to back) Tulip, 'Angelique' (peony flower); tulip, 'Lilac Perfection'

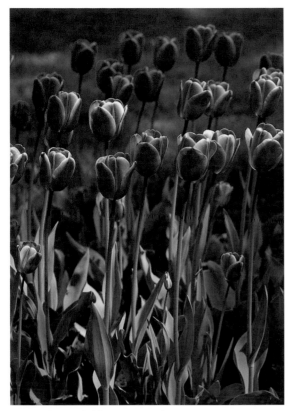

FL-87 Tulip, single blossom in garden

FL-88 *Agapanthus,* 'African Blue,' lily

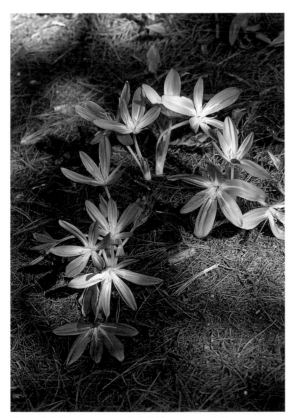

FL-89 *Colchicum autumnale,* fall-blooming colchicum

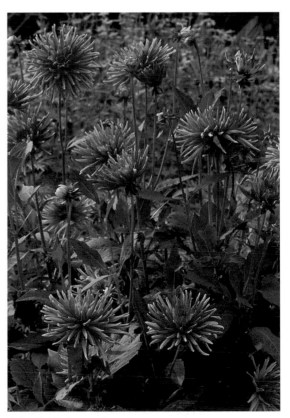

FL-90 Dahlia (cactus flower)

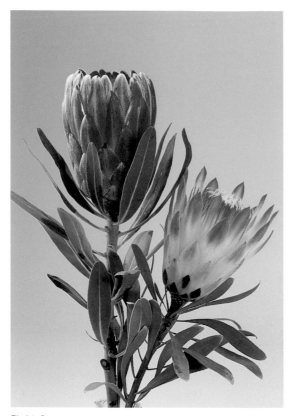

FL-91 *Protea*

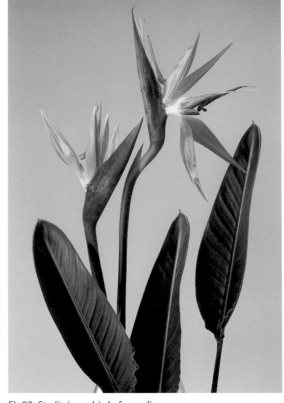

FL-92 *Strelitzia sp.*, bird of paradise

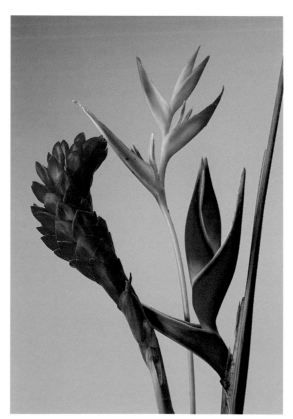

FL-93 (left to right) *Alpinia sp.* (shell ginger or shell flower); *Heliconia latispatha,* false bird of paradise; *Heliconia bihai,* lobster claw

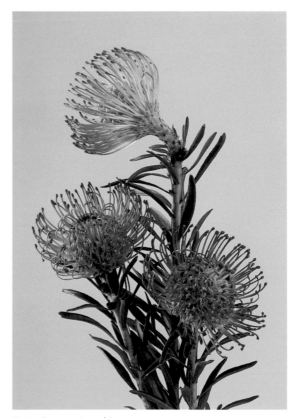

FL-94 *Protea*, pincushion

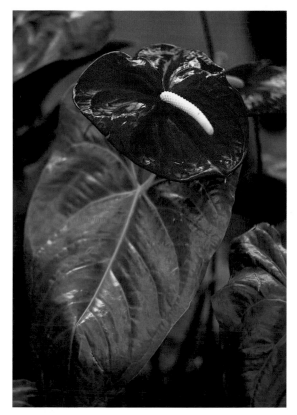

FL-95 *Anthurium andraeanum*, flamingo lily

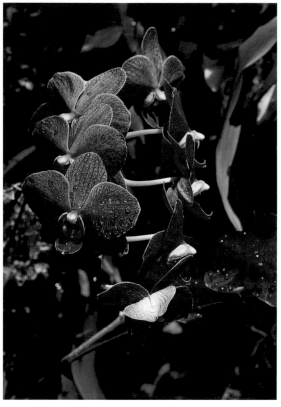

FL-96 *Vanda*, orchid

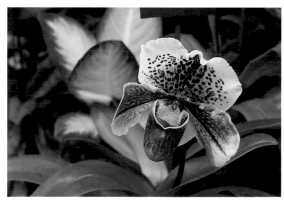

FL-97 *Paphiopedilum*, 'Paph John Bourne,' Spotglen x Millmore, orchid

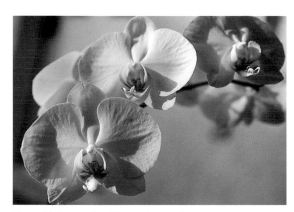

FL-98 *Phalaenopsis*, white moth orchid

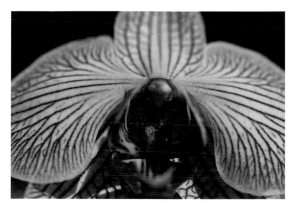

FL-99 *Phalaenopsis*, moth orchid

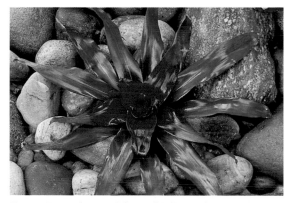

FL-100 *Neoregelia* or *Nidularium*, bird's nest, bromeliad

FL-101 A group of fully open red roses

FL-102 *Rosa,* 'Pearl Drift'

FL-103 Hybrid yellow tea roses

FL-104 Red-orange rose

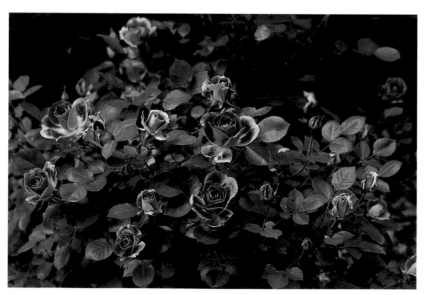

FL-105 *Rosa,* 'Carefree Wonder,' in garden setting

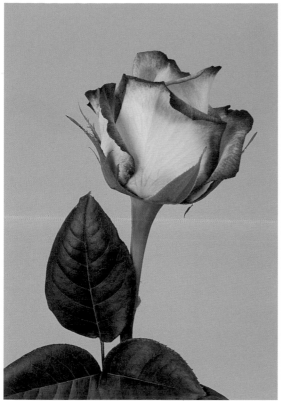

FL-106 Bicolor rose bud

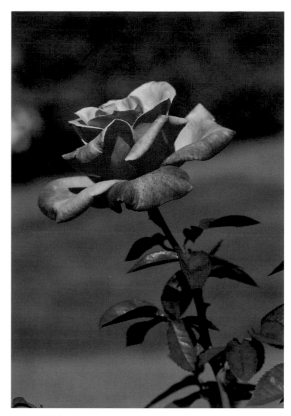

FL-107 Pink roses

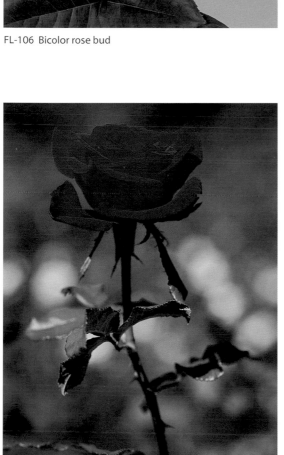

FL-108 Red rose

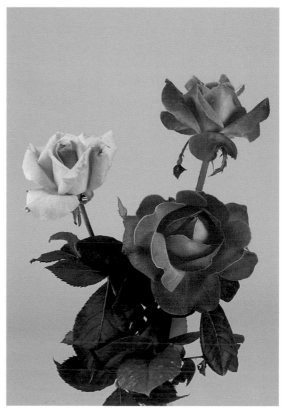

FL-109 Pink roses

FL-110 *Fuchsia magellanica*

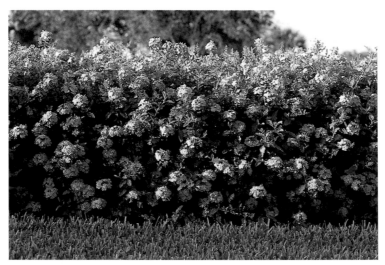

FL-111 *Plumbago auriculata,* plumbago; tropical shrub used as hedge

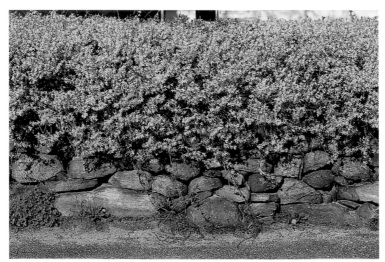

FL-112 *Forsythia*; deciduous shrub clipped into hedge

FL-113 *Euphorbia milii splendens*, crown-of-thorns

FL-114 *Nerium oleander*, oleander; tender evergreen shrub

FL-115 *Rhododendron*, azalea; evergreen shrub

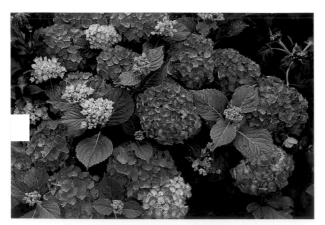

FL-116 *Hydrangea macrophylla*, 'Nikko Blue'; hardy perennial

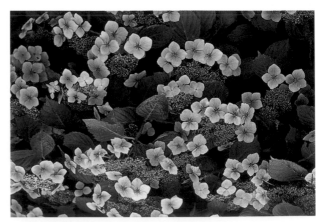

FL-117 *Hydrangea macrophylla*, pink lace cap, hydrangea; hardy perennial

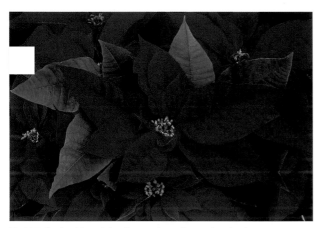

FL-118 *Euphorbia pulcherrima*, poinsettia, tender shrub

FL-119 *Hydrangea macrophylla*, embroidered ball hydrangea, 'Lanarth White'; hardy perennial

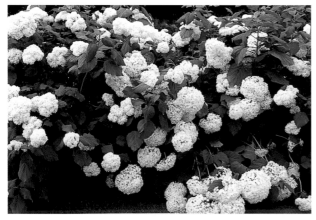

FL-120 *Hydrangea arborescens*, 'Anna belle'; hardy shrub

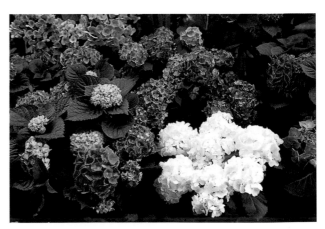

FL-121 *Hydrangea macrophylla*; hardy shrub

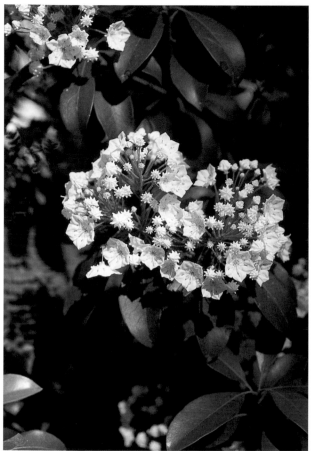

FL-122 *Kalmia latifolia*, mountain laurel; evergreen shrub

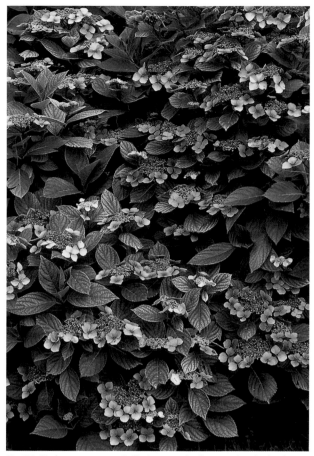

FL-123 *Hydrangea macrophylla*, lace cap hydrangea; hardy shrub

FL-124 *Rhododendron*, azalea; evergreen shrub

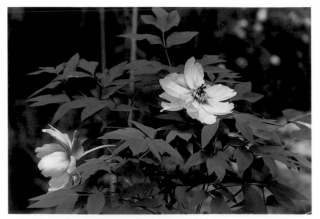

FL-125 *Paeonia suffruticosa*, 'Lotus that shrinks in the sun,' tree peony; hardy perennial

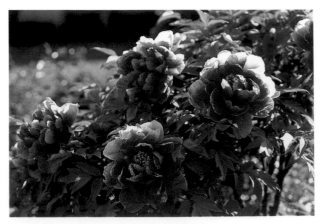

FL-126 *Paeonia*, tree peony; hardy perennial

FL-127 *Ixora coccinea*, flame-of-the-woods; tropical shrub

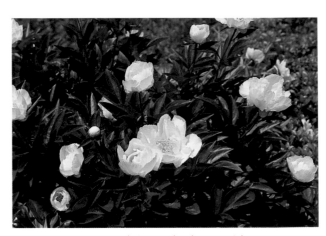

FL-128 *Paeonia*, 'A La Mode,' peony; hardy perennial

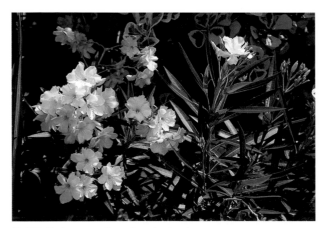

FL-129 *Nerium sp.*, yellow oleander; tender evergreen

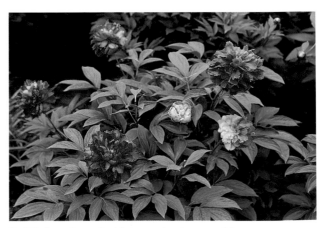

FL-130 *Paeonia sp.*, double peony; hardy perennial

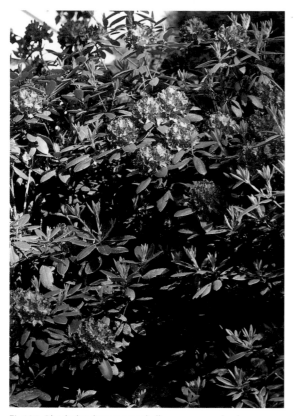

FL-131 *Rhododendron macrophylla*; evergreen shrub

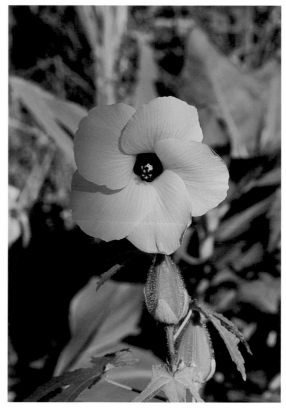

FL-132 *Abelmoschus sp.*, 'Cream Cup,' hibiscus

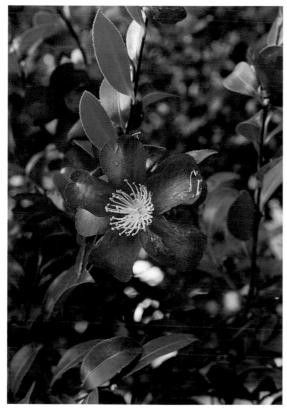

FL-133 *Camellia*, single flower camellia; tender evergreen shrub

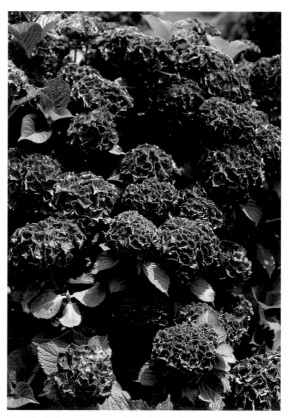

FL-134 *Hydrangea macrophylla*, big leaf hydrangea; hardy shrub

FLOWERING SHRUBS & VINES

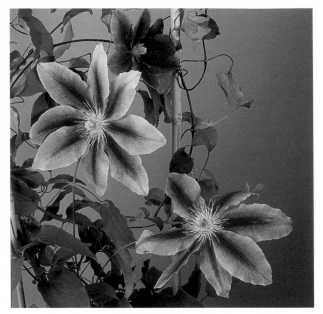

FL-135 *Clematis patens* hybrid, 'Nelly Moser'; deciduous climber

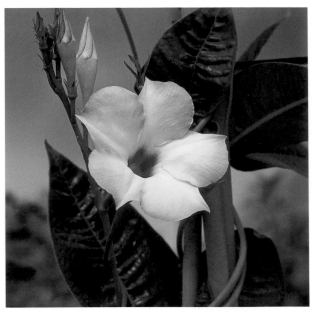

FL-136 *Mandevilla* x *amabilis*, 'Summer Snow'; tropical climber

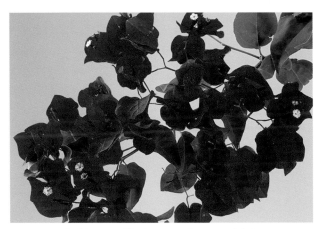

FL-137 Detail of *Bougainvillea* bract; tender perennial vine

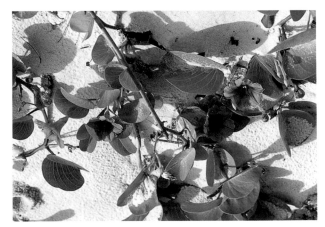

FL-138 *Ipomoea pes-caprae*, beach morning glory, goat pea, or railroad vine; tender herbaceous vine

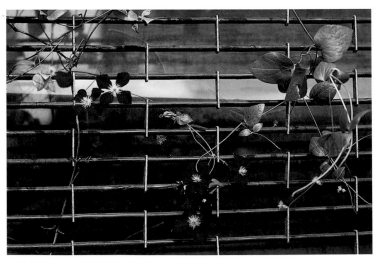

FL-139 *Clematis*; deciduous climber

FLOWERING SHRUBS & VINES

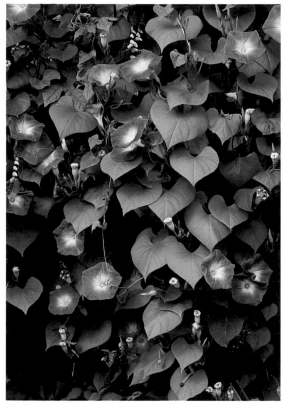

FL-140 *Ipomoea*, 'Heavenly Blue,' morning glory; tender herbaceous vine

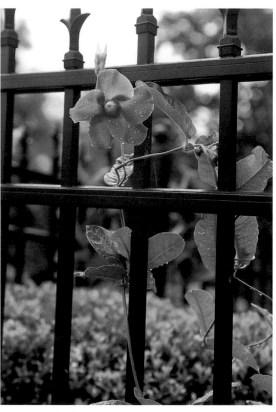

FL-141 *Mandevilla*, 'Alice du Pont' (ice pink) ,on wrought-iron fence; tropical climber

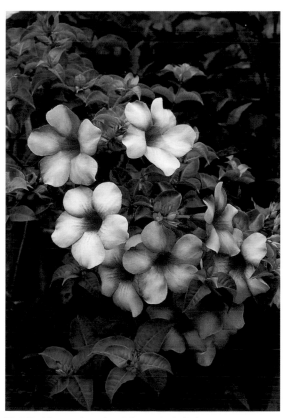

FL-142 *Allamanda catharticfa*; tropical climber

FL-143 *Clematis terniflora*, autumn clematis; deciduous climber covering brick wall

FL-144 *Campsis radicans*, trumpet creeper, on stone building

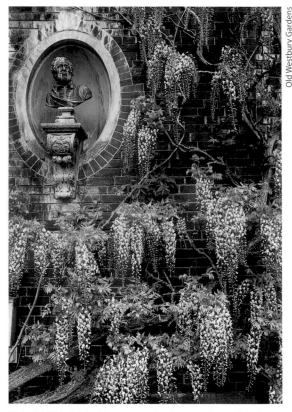

Old Westbury Gardens

FL-145 *Wisteria*, deciduous woody vine, on brick wall with sculptural details

FL-146 *Chaenomeles japonica*, Japanese flowering quince;

FL-147 *Bougainvillea*; tender perennial, vine on white lattice

FLOWERING SHRUBS & VINES

FL-148 (front) *Solenostemon*, 'Alabama Sunset,' coleus; (back) annual border with purple zinnia

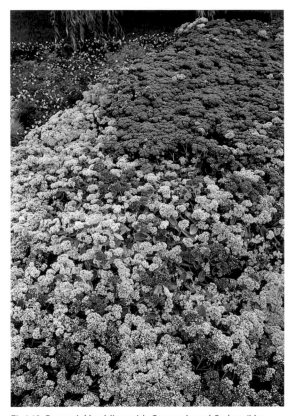

FL-149 Perennial bedding with *Coreopsis* and *Sedum*, 'Live Forever' or 'Stonecrop'

FL-150 Annual/perennial bed with *Salvia pratensis*, meadow

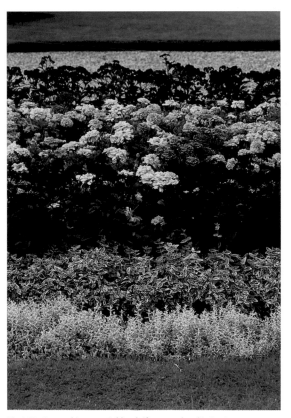

FL-151 Annual/perennial bed. (front to back) *Sagina*, pearlwort; *Artemisia*, *Vinca*, variegated; *Heliotrope* (purple); French marigolds (orange and yellow)

FL-152 Raised annual/perennial/evergreen bed. (front to back) *Liriope muscari*, big blue lilyturf ; *Artemisia stellerana*, dusty miller (white); *Begonia semperflorens*, bronze-leaf (red); *Salvia farinacea*, 'Victoria' (blue)

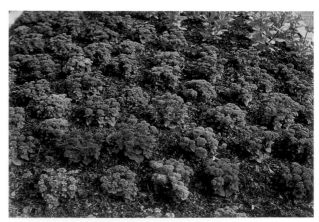

FL-153 *Ageratum houstonianum*, 'Blue Hawaii,' used as floral bedding

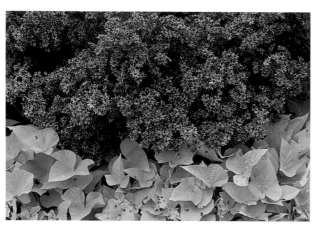

FL-154 Annual border with purple aster and *Ipomoea batatas*, 'Margarita,' sweet potato vine

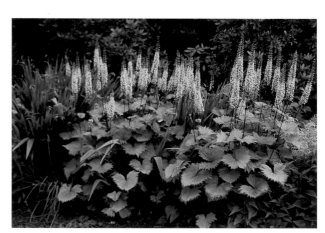

FL-155 *Ligularia stenocephala*, 'The Rocket,' used as border

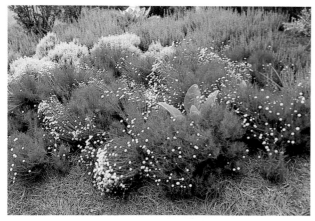

FL-156 *Santonia chamaecyparissus* (white foliage) and *Santolina rosmarinifolia* (syn) *S. virens* (green leaves, yellow flowers), used as border for brick path

FL-157 *Phlox*, moss phlox, in rock garden

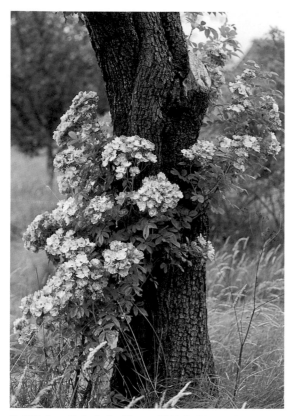

FL-158 *Rosa*, 'Ballerina' or 'Flower Girl,' climbing up tree

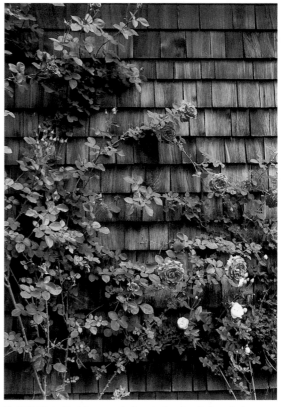

FL-159 Pink climbing rose in front of cedar shake–clad building

FL-160 *Pelargonium peltatum*, ivy leaf geranium, trailing over stone wall

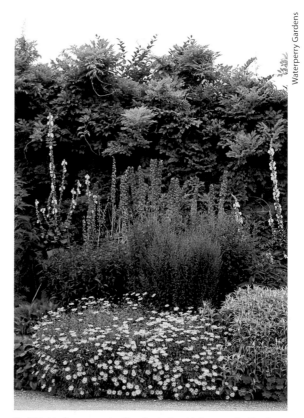

FL-161 Herbaceous planting featuring *Verbascum* (yellow); hardy biennial, and *Delphinium* (blue); perennial

Waterperry Gardens

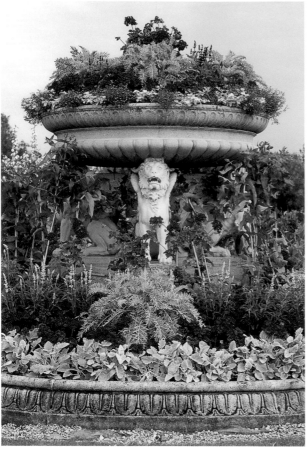

Iford Manor

FL-162 Victorian sculptural planter featuring geranium, dusty miller, eucalyptus, and *Salvia*

FL-163 *Lavandula sp.*, lavender, used with varieties of shrubs bordering stone steps in garden

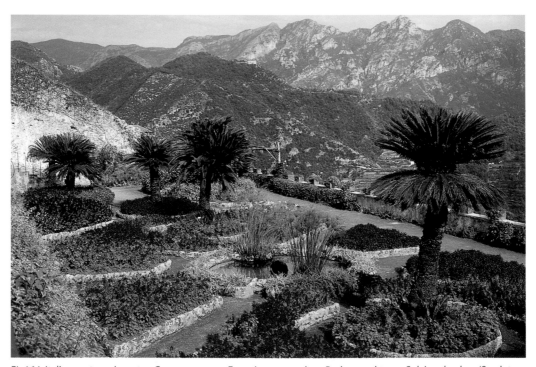

FL-164 Italian parterre. In water: *Cyperus papyrus*, Egyptian paper plant. Beds: cycad trees; *Salvia splendens*, 'Scarlet Queen'

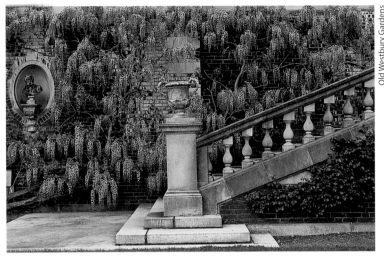

Old Westbury Gardens

FL-165 *Wisteria* on garden wall with stone staircase

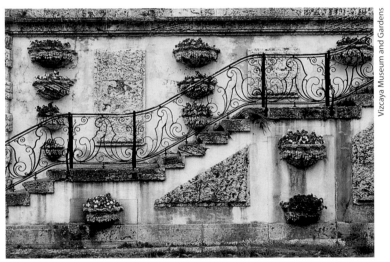

Vizcaya Museum and Gardens

FL-166 *Impatiens walleriana* (red and white) in wall planters of Italianate garden

FL-167 *Pelargonium*, ivy leaf geranium (pink) and *Vinca major variagata*, variegated periwinkle, trailing over stone wall

FL-168 Evergreen and annual raised bed. (back) *Chamaecyparis pisifera aurea nana,* yellow false cypress; bronze-leaf begonia (red); (front) *Berberis thunbergii,* 'Crimson Pygmy' barberry, surrounded by *Juniperus wiltonii,* 'blue rug juniper'

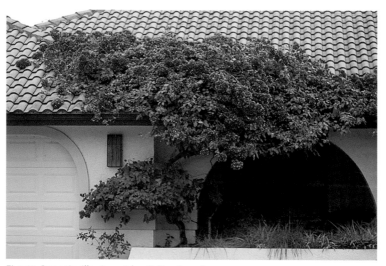

FL-169 *Bougainvillea* in residential landscaping

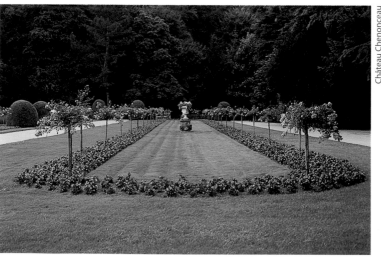

Château Chenonceau

FL-170 Formal garden with rose standards, 'Fairy' (pink), bordered by bronze-leaf begonia (pink)

FLOWERS

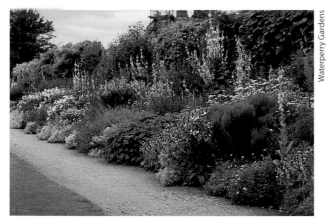

Waterperry Gardens

FL-171 Mixed herbaceous planting featuring *Verbascum* (yellow); *Delphinium* (blue); *Alchemilla mollis*, lady's mantle (lime green); *Nepeta cataria*, catnip (blue/purple)

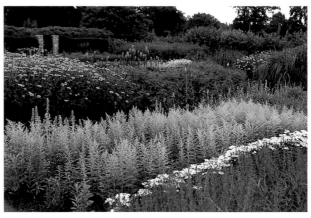

FL-172 Mixed herbaceous planting featuring *Heliopsis* (yellow); *Salvia* (purple); *Stachybyzantina*, lamb's ear (silver leaves); *Solidago*, goldenrod; daisies

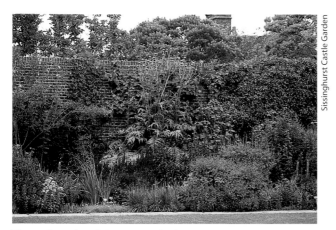

Sissinghurst Castle Garden

FL-173 Formal English perennial bed

FL-174 Field with *Solidago*, native goldenrod, and split rail fence

FL-175 Varieties of bougainvillea

FLOWERS

FL-176 Mixed herbaceous planting featuring pink and purple asters

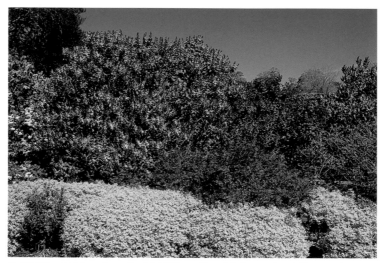

FL-177 (front) *Spiraea japonica*, 'Gold Mound,' and *Syringa vulgaris*, lilac, used as hedge

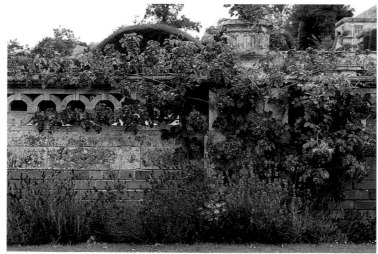

FL-178 Rambler rose climbing up stone wall; *Lavandula*, lavender, border

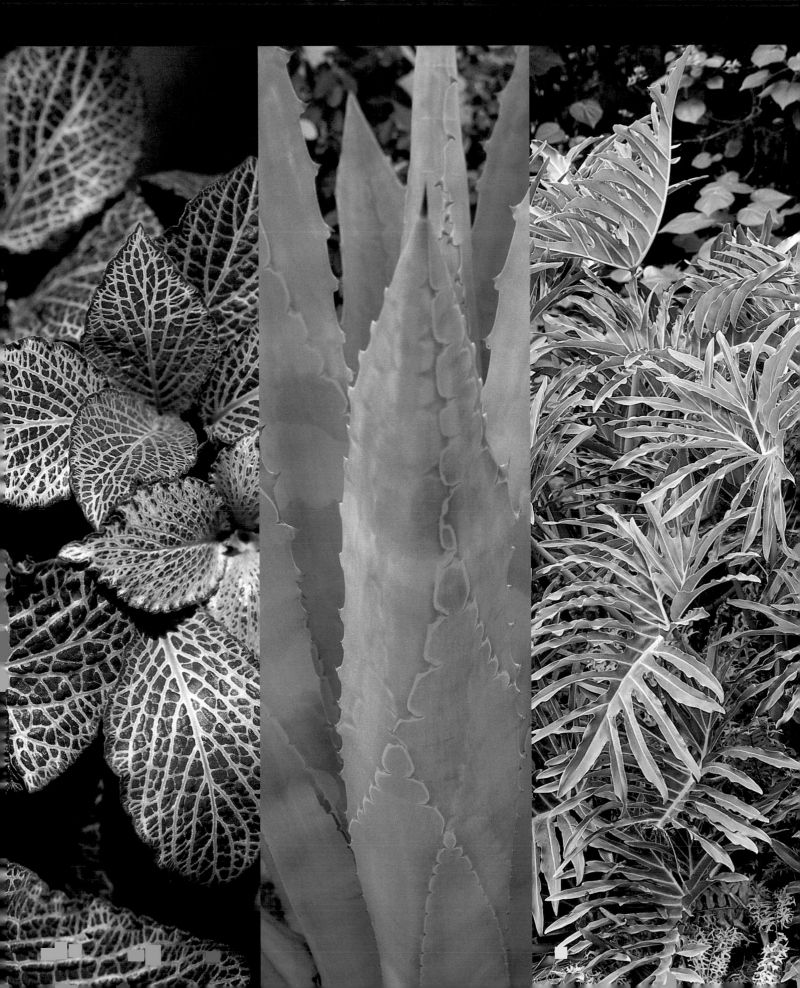

FOLIAGE

The plant name is followed by the terms describing leaf type, shape, and margin

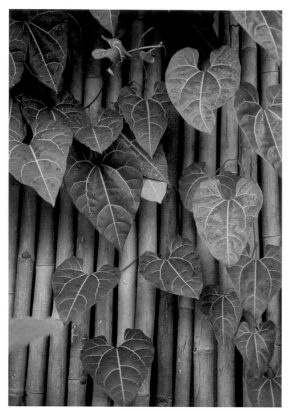

F-1 *Aristolochia sp.,* birthwort; cordate, entire. Herbaceous climber

F-2 *Epipremnum aureum,* pothos or devil's ivy; cordate, irregularly pinnatisect. Climbing vine

F-3 *Ficus elastica,* rubber tree; obovate, entire. Tropical

F-4 *Convolvulus sp.;* cordate to sagittate, entire. Twining vine

TYPES & SHAPES OF FOLIAGE

F-5 *Caladium*; cordate, entire. Tuberous

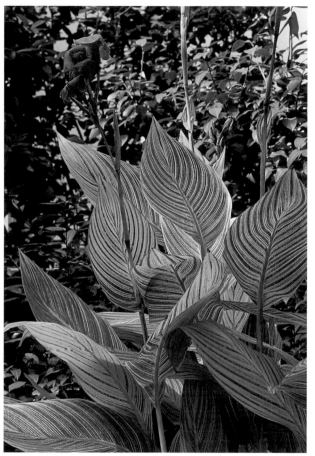

F-6 *Canna*, 'Praetorius'; obovate, entire. Tropical perennial

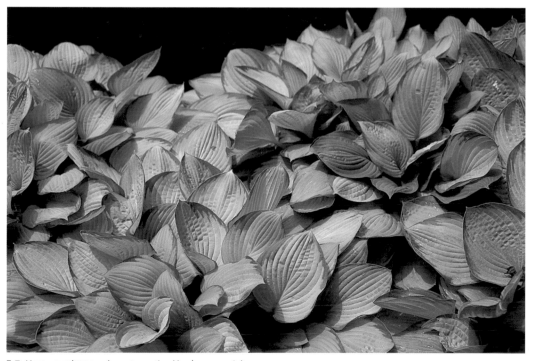

F-7 *Hosta*; cordate to obovate, entire. Hardy perennial

TYPES & SHAPES OF FOLIAGE

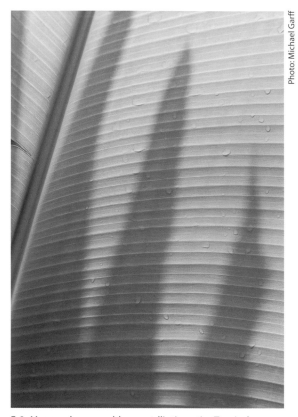

Photo: Michael Garff

F-8 *Musa sp.*, banana; oblong or elliptic, entire. Tropical

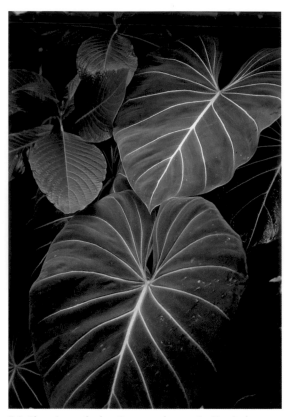

F-9 *Alocasia sp.*, elephant's ear; cordate, entire. Tropical

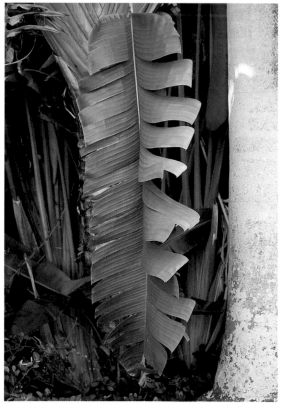

F-10 *Heliconia sp.*; oblong to elliptical, entire (margin broken with age). Tropical

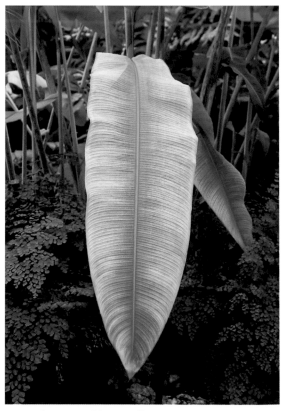

F-11 *Heliconia sp.*; oblong to elliptical, entire. Tropical

TYPES & SHAPES OF FOLIAGE

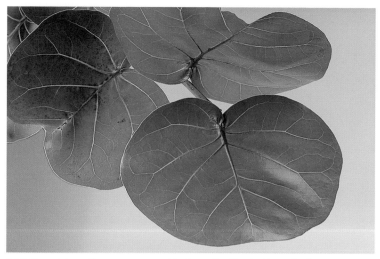

F-12 *Coccoloba uvifera*, sea-grape; orbicular, entire. Tropical broadleaf evergreen

F-13 *Asarum sp.*, wild ginger; rounded ovate, entire. Hardy perennial

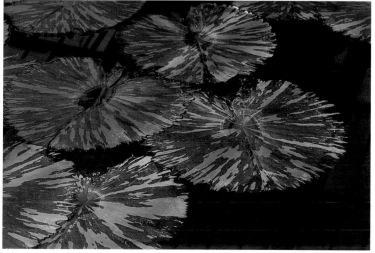

F-14 *Nymphaea,* 'Leopardess,' water lily; broadly ovate, crispate. Perennial aquatic

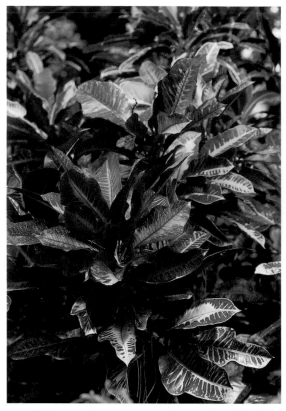

F-15 *Codiaeum variegatum*, croton; obovate, repand. Tender with varigated foliage

F-16 *Sanchezia speciosa*; obovate, entire. Tender with varigated foliage

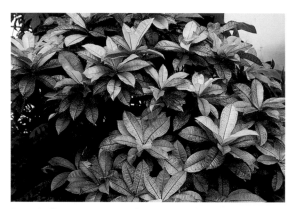

F-17 *Codiaeum sp.*, croton; obovate, crenulate. Tender shrub with varigated foliage

F-18 *Solenostemon*, coleus (red); obovate, crenulate, tropical with variegated foliage; *Sanchezia speciosa*; obovate, tender with varigated foliage

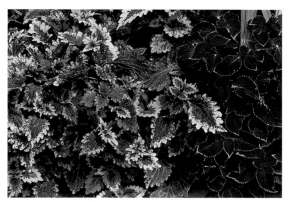

F-19 *Solenostemon*, coleus; obovate, crenate. Tropical with variegated foliage

F-20 *Solenostemon*, coleus, 'Pineapple Beauty'; obovate, entire. Tropical with variegated foliage

F-21 *Salvia officinalis,* sage or ramona; oblong to elliptic, entire

F-22 *Melissa officinalis,* balm; ovate, crenate; perennial herb (left) and *Geum*; reniform, repand, rosulate. Perennial

F-23 *Alternathera ficoidea,* Joseph's coat or copperleaf; ovate, entire. Perennial

F-24 *Salvia officinalis,* sage or ramona; oblong to elliptic, entire

F-25 *Helichrysum petiolare,* everlasting or immortelle; orbicular to ovate, perennial (left) and *Nepeta sp.*; crenate to serrate. Perennial herb

TYPES & SHAPES OF FOLIAGE

F-26 *Convallaria majus,* lily of-the-valley; ovate to lanceolate, entire; creeping perennial, and *Pachysandra terminalis,* Japanese spurge; serrate, whorled. Hardy perennial evergreen

F-27 *Plectranthus argentatus;* ovate, crenate to serrate, tomentose

F-28 *Alpinia zerumbet,* 'Variegata,' shell ginger; ovate to lanceolate, entire. Perennial herb

TYPES & SHAPES OF FOLIAGE

F-29 *Vitis sp.*, grape; lobed, dentate. Deciduous woody vine

F-30 *Philodendron sp.*; pinnate. Tropical evergreen climber

F-31 *Farfugium japonicum*, 'Crispata'; crispate, mucronate

F-32 *Acanthus*, bear's breech; pinnatifid. Perennial

F-33 *Hedera helix*, English ivy; palmately lobed. Evergreen woody vine

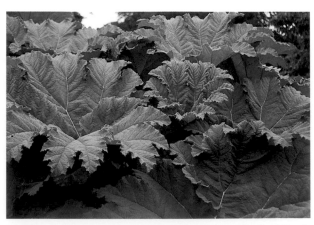

F-34 *Gunnera manicata*; ovate, often cordate, palmately lobed. Marsh plant

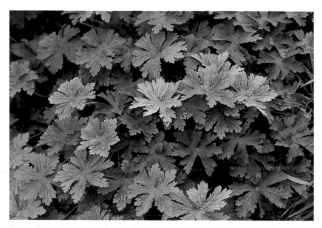

F-35 *Geranium sp.*; palmate. Herbaceous perennial or annual

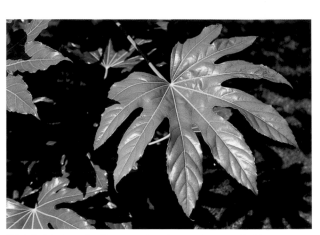

F-36 *Fatisia japonica*, Formosa rice plant or Japanese fatisia; palmately lobed. Broadleaf evergreen

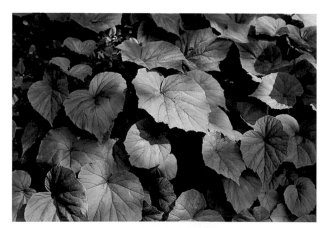

F-37 *Begonia grandis sp.*; obliquely ovate. Tender

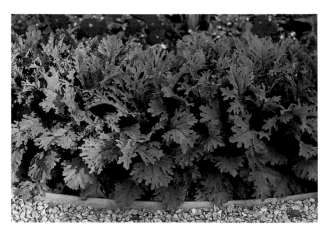

F-38 *Brassica oleracea sp.*; lobed

TYPES & SHAPES OF FOLIAGE

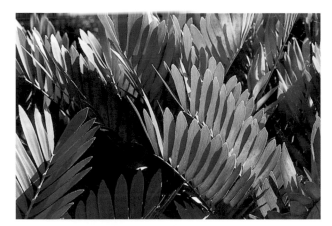

F-39 *Cycas sp.*; pinnately compound. Tropical

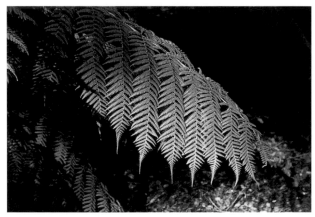

F-40 *Dicksonia sp.*, tree fern; pinnately compound. Tender

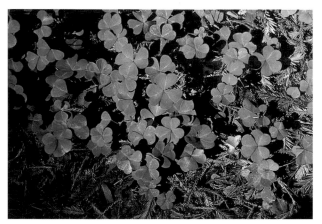

F-41 *Oxalis sp.*, clover; trifoliate compound with cordate leaflet

F-42 *Rodgersia sp.*; palmately compound. Perennial herb

F-43 *Aeonium sp.*; spatulate, entire

TYPES & SHAPES OF FOLIAGE

F-44 *Parthenocissus quinquefolia*, Virginia creeper; palmately compound. Deciduous vine

F-45 *Schefflera actinophylla sp.*, umbrella tree; palmately compound. Tropical

F-46 *Zamia sp.*, pinnately compound. Tropical

F-47 *Forsythia sp.*; ovate, entire, simple with leaves alternately arranged. Deciduous

TYPES & SHAPES OF FOLIAGE

F-48 *Polystichium sp.*; hardy fern, growing on tree

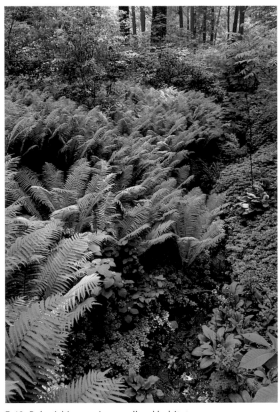

F-49 *Polystichium sp.* in woodland habitat

F-50 *Onoclea sp.*, sensitive fern; hardy

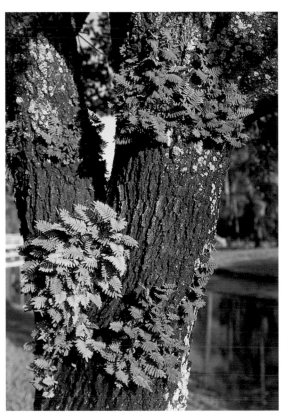

F-51 Tropical epiphytic fern growing on host tree

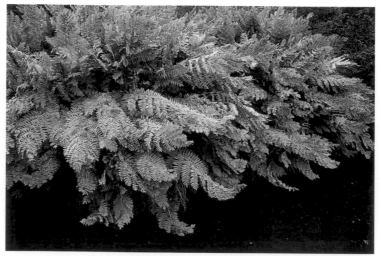

F-52 *Polystichium sp.* growing on the banks of a pond

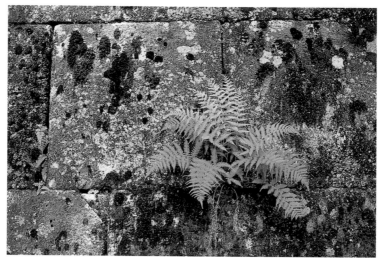

F-53 *Polystichium sp.* and moss on stone wall

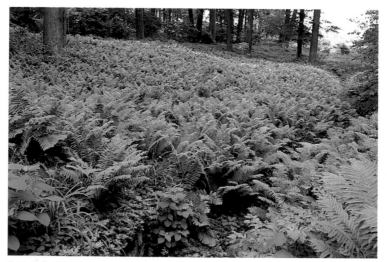

F-54 *Polystichium sp.* as ground cover

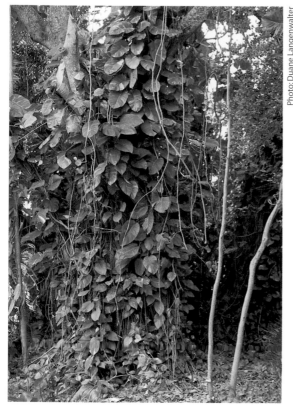

Photo: Duane Langenwalter

F-55 *Epipremnum aureum,* in mature foliage, climbing up host tree

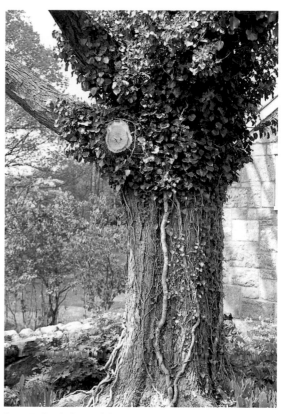

F-56 *Hedera helix,* English ivy; evergreen woody vine on tree

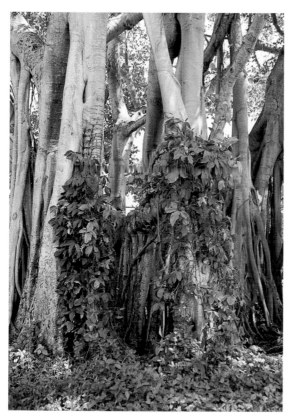

F-57 *Syngonium,* tropical vine on banyan tree

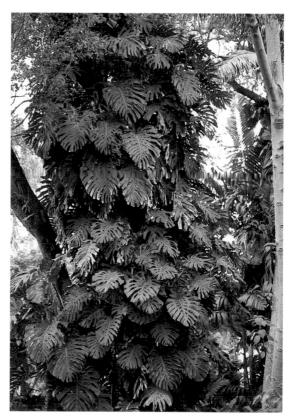

F-58 *Monstera,* windowleaf; epiphytic tropical climber, showing fenestration

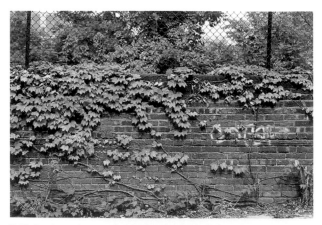

F-59 *Parthenocissus sp.*, hardy deciduous climber, on brick wall

F-60 *Ficus pumila*, tropical climber, on stucco wall

F-61 *Ficus pumila*, tropical climber, on concrete wall

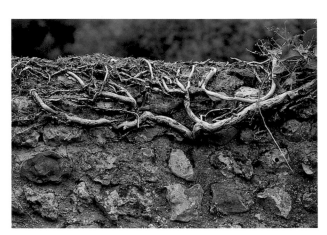

F-62 *Hedera helix*, English ivy, in winter aspect, showing trunks and aerial roots

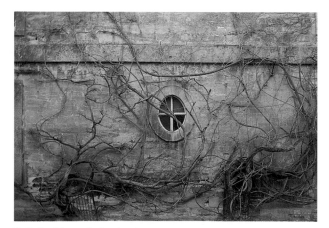

F-63 Decidous climber in winter aspect

F-64 *Parthenocissus*; hardy deciduous climber on brick wall with terra cotta garden sculpture

F-65 *Humulus lupulus*, hops; twining perennial (left), and *Aristolochia macrophylla.*, herbaceous perennial vines, on brick wall

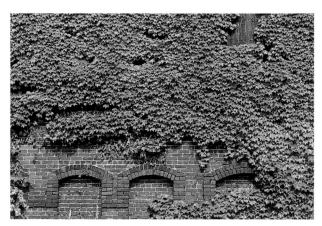

F-66 *Parthenocissus*, hardy deciduous climber on brick building

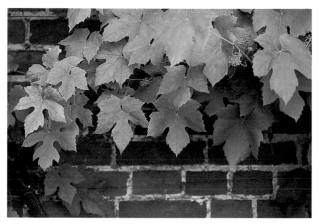

F-67 *Vitis*, grape vine, on brick wall

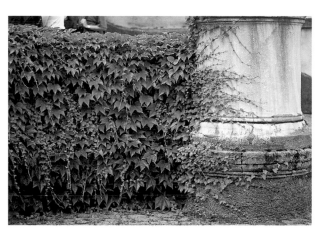

F-68 *Parthenocissus*; hardy deciduous climber, on column and covering wall

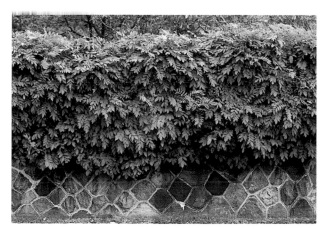

F-69 *Wisteria sp.*; deciduous woody vine, fedge on stone wall

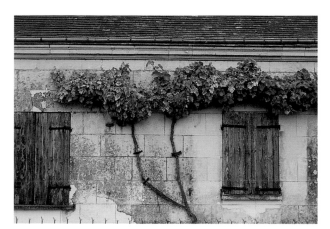

F-70 *Vitis*, grape vine, climbing on whitewashed wall

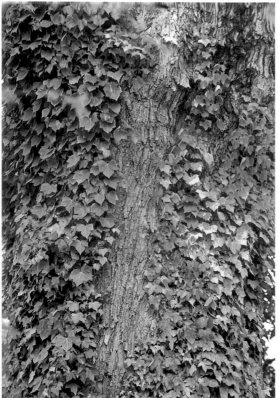

F-71 *Hedera sp.* cv., ivy, on tree

F-72 *Hedera sp.* cv., ivy, on wall with garden sculpture

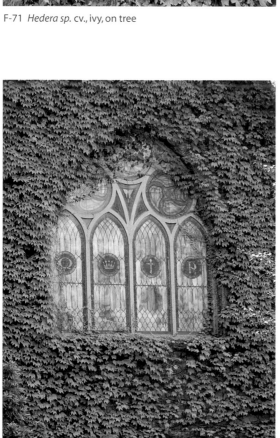

F-73 *Parthenocissus*, hardy deciduous climber, surrounding stained glass window

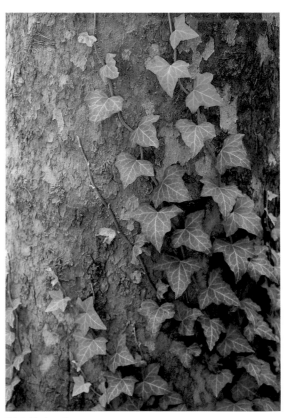

F-74 *Hedera*, ivy, on tree

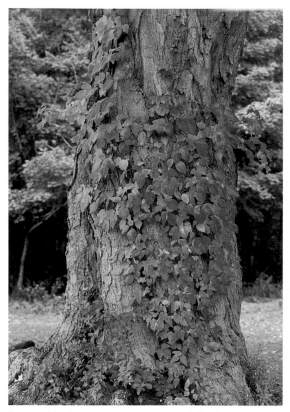

F-75 *Toxidendron radicans,* poison ivy, in fall color, growing on tree

F-76 *Parthenocissus,* hardy deciduous climber, in fall foliage on bamboo fence

F-77 *Parthenocissus,* hardy deciduous climber, in fall color, on tinted plaster wall

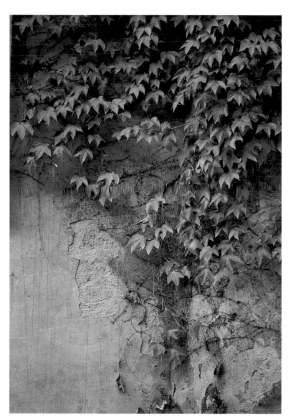

F-78 *Campsis scandens,* in fall color, on tinted plaster wall

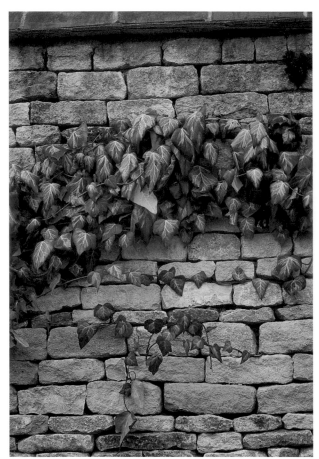

F-79 *Hedera helix*, English ivy, on brick wall

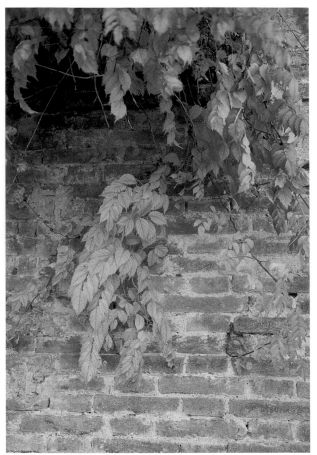

F-80 *Campsis radicans,* on brick wall

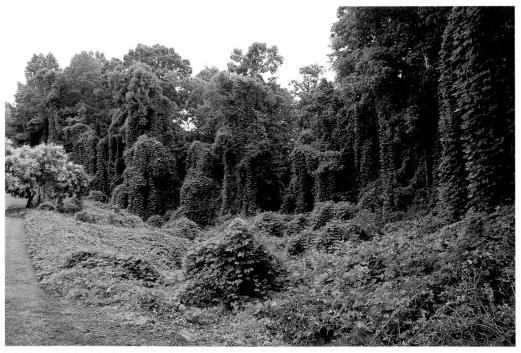

F-81 *Pueraria lobata,* kudzu; opportunistic tender vine. Alien species covering trees

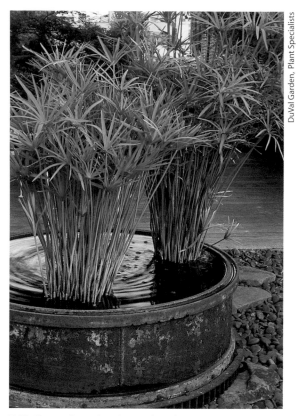

DuVal Garden, Plant Specialists

F-82 *Cyperus*, bog plant, in metal garden container

Villa d'Este

F-83 Mixed cryptogams surrounding sculptural garden fountain

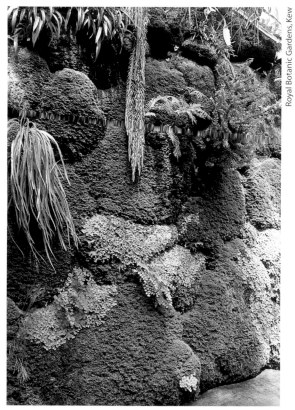

Royal Botanic Gardens, Kew

F-84 Collection of primitive tropical plants growing on rocks

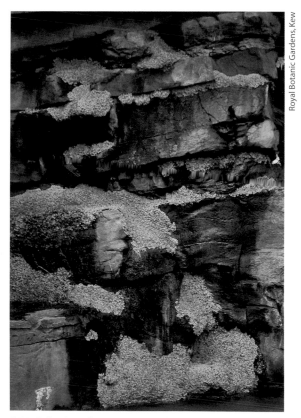

Royal Botanic Gardens, Kew

F-85 Collection of primitive tropical plants growing on rocks

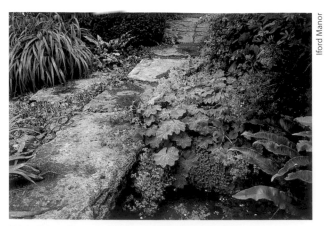

Iford Manor

F-86 *Alchemilla mollis,* lady's mantle, surrounding stone bordered garden pond

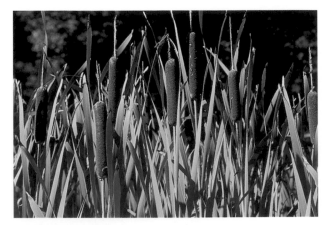

F-87 *Typha sp.,* cattails

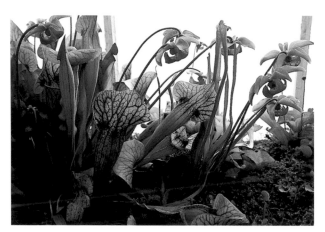

F-88 *Sarracenia,* pitcher plants in flower

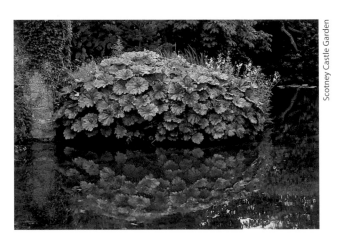

Scotney Castle Garden

F-89 *Darmera peltata* growing beside garden pond

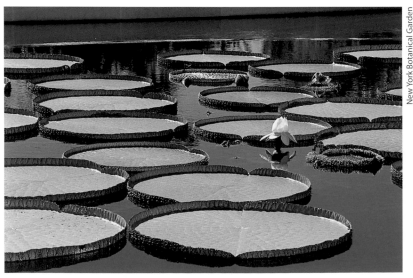

New York Botanical Garden

F-90 *Victoria amazonica,* giant water lily; tropical or annual

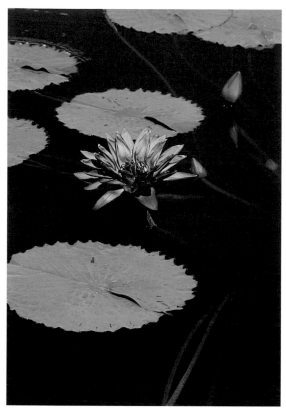

F-91 *Nymphaea* sp., water lily; tropical day bloomer with pink flower

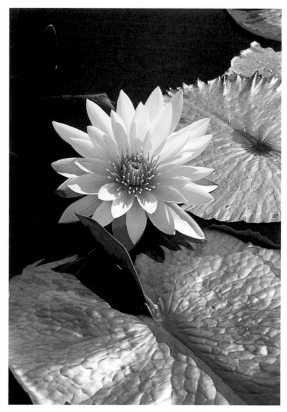

F-92 *Nymphaea sp.*, water lily; tropical day bloomer with white flower

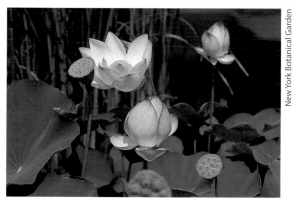

F-93 *Nelumbo nucifera*, lotus; hardy water lily in flower

New York Botanical Garden

F-94 *Nymphaea* sp., hardy water lily

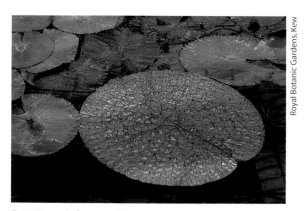

F-95 *Eurayale ferox*, prickly water lily or gorgon, tropical day bloomer

Royal Botanic Gardens, Kew

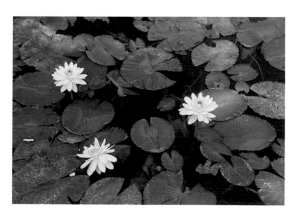

F-96 *Nymphaea* sp., water lily; tropical day bloomer with white flowers

F-97 Lichen on birch tree

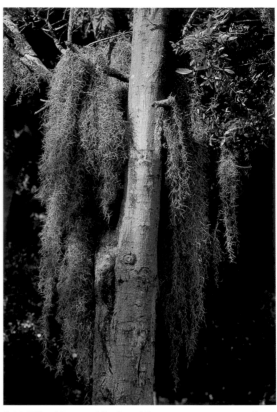

F-98 *Tillandsia usneoidus,* Spanish moss; not a true moss, but a tropical New World epiphytic bromeliad

F-99 Algae on tree

F-100 Lichen on conifers

MOSS, LICHEN, SEAWEED, ALGAE

Bowood House

F-101 Freshwater algae on rocks in landscape garden waterfall

F-102 Moss and primitive plants on rocks

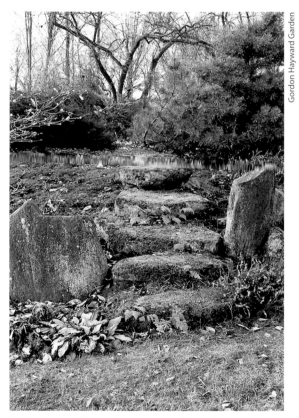

Gordon Hayward Garden

F-103 Moss and ferns along rustic garden path

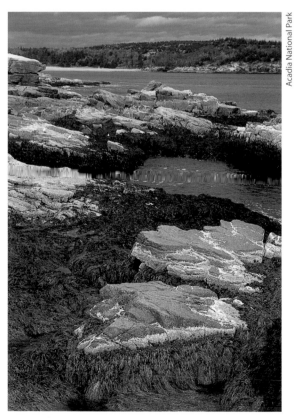

Acadia National Park

F-104 Saltwater algae on rocky granite shore

MOSS, LICHEN, SEAWEED, ALGAE

F-105 Lichen on rock

F-106 Moss on rock

F-107 Saltwater algae and seaweed on beach

F-108 Lichen on volcanic rocks

MOSS, LICHEN, SEAWEED, ALGAE

F-109 Mixed mosses and ferns on crumbling wall

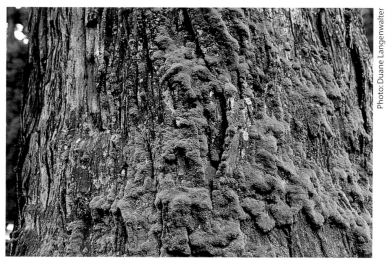

Photo: Duane Langenwalter

F-110 Moss on tree bark

F-111 Moss and algae between cracks of stone wall

MOSS, LICHEN, SEAWEED, ALGAE

Four Arts Garden

F-112 Lichen and moss on plaster wall of Chinese-style garden

F-113 Freshwater algae on partially submerged ancient statue

F-114 Moss on stone bench and garden path

F-115 Algae on brick path

F-116 Moss and opportunistic foliage on crumbling brick wall

F-117 Moss and opportunistic foliage on hexagonal asphalt paving blocks

MOSS, LICHEN, SEAWEED, ALGAE

FOLIAGE

F-118 *Rhododendron ungerii,* alpine rhododendron; tomentose foliage

F-119 *Sempervivum calcareum,* houseleek or live-forever; perennial succulent

F-120 *Euphorbia polychroma,* early blooming perennial

F-121 *Agave americana*, 'Variegata'

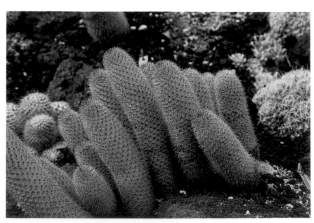

F-122 *Parodia leninghausii*, ball cactus

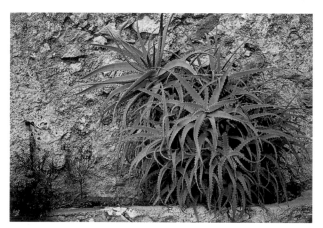

F-123 *Aloe arborescens*, in stone planter by garden wall

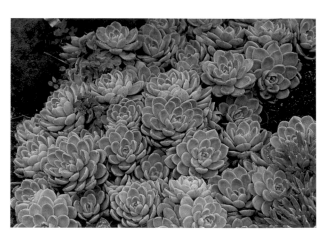

F-124 *Echeveria sp.*, rosette-forming Mexican succulent

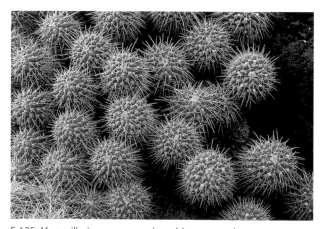

F-125 *Mammillaria compressa*, pincushion or strawberry cactus

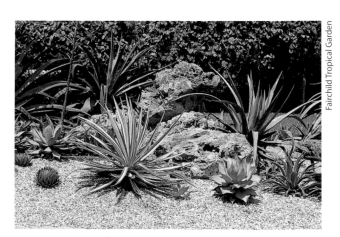

Fairchild Tropical Garden

F-126 A collection of *Agave spp.*

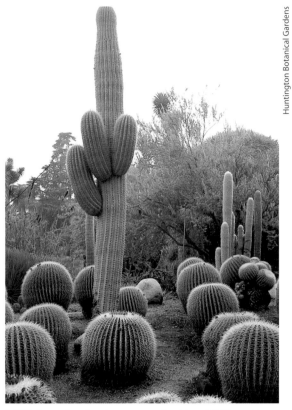

Huntington Botanical Gardens

F-127 *Carnegiea gigantea*, saguaro (back), and *Echinocactus grusonii*, barrel cactus

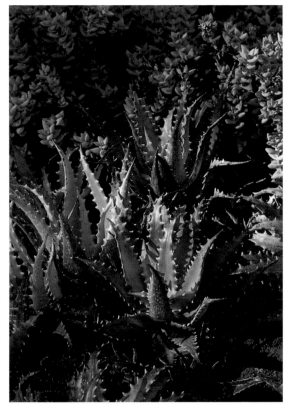

F-128 *Aloe sp.*

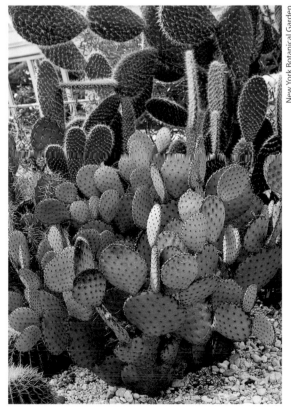

New York Botanical Garden

F-129 *Opuntia violacea*, prickly pear cactus

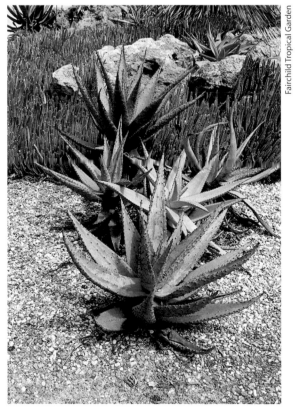

Fairchild Tropical Garden

F-130 *Aloe sp.*

FOLIAGE

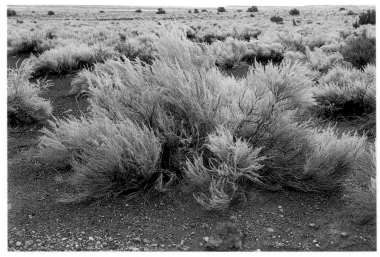

F-131 *Artemesia filifolia,* sand sagebrush

Sunset Crater Volcano National Monument

F-132 Desert foliage growing in volcanic sand and rubble

F-133 Sagebrush in red sand

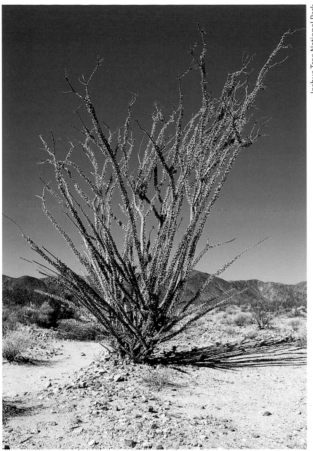

Joshua Tree National Park

F-134 *Fouquieria splendens*, ocotillo

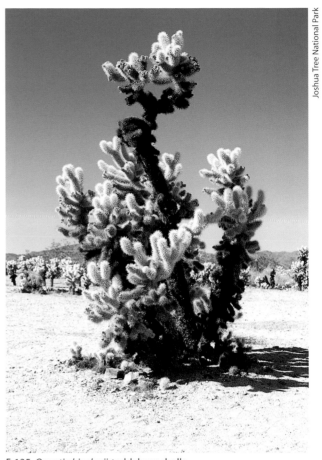

Joshua Tree National Park

F-135 *Opuntia bigelovii*, teddybear cholla

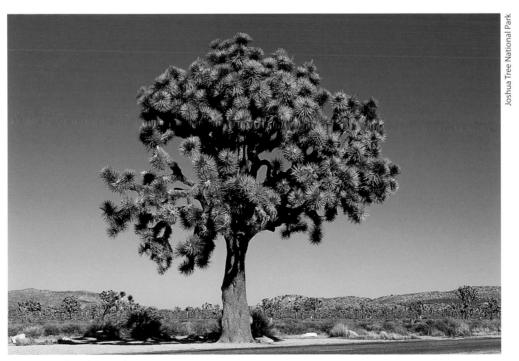

Joshua Tree National Park

F-136 *Yucca brevifolia*, Joshua tree

F-137 Patterned ground cover with *Ophiopogon*, lilyturf or mondo grass (center), and *Carex*, sedge, a perennial herb

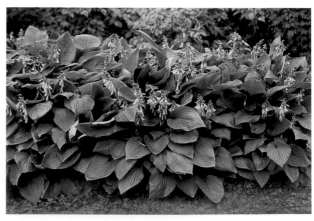

F-138 *Hosta* cv. used as border, in bloom

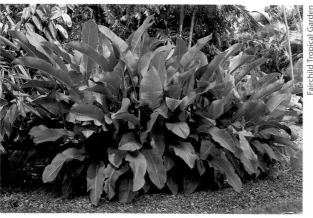

F-139 *Heliconia*, used as tall border

Fairchild Tropical Garden

F-140 *Centaurea cineraria*, centaurea, in annual border (left)

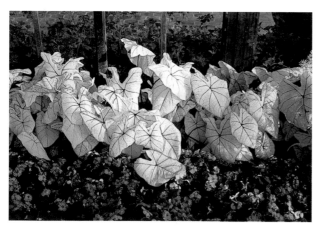

F-141 *Caladium* cv., tropical tuberous plant with pink *Impatiens* in garden border

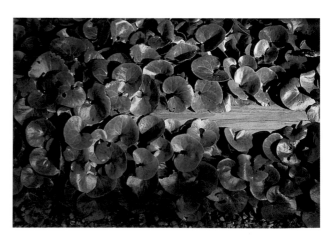

F-142 *Asarum europaeum*, European wild ginger; low-growing perennial used as ground cover in woodland garden

GROUND COVER, BEDDING, BORDERS

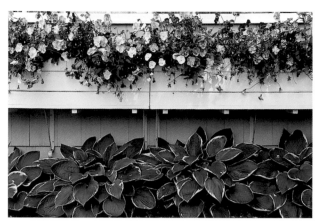

F-143 *Hosta* cv. border with purple *Viola*, pansies, in raised planter

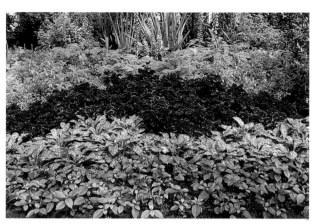

F-144 Mixed annual/perennial border. (front to back) *Alternanthera*, copperleaf; *Pulmonaria*, Jerusalem sage; *Solenostemon*, coleus; ferns

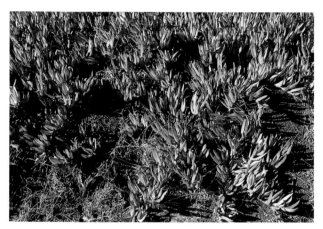

F-145 *Dorotheanthus sp.*; South African native growing wild in California as coastal ground cover

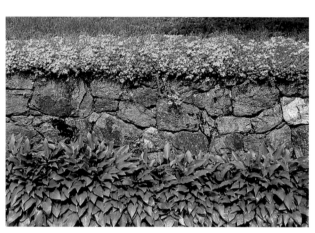

F-146 *Hosta sp.* used as border at base of stone retaining wall, with *Sedum sp.* planted on top

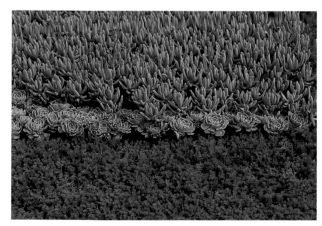

F-147 Foliage bedding planted in bands of (front to back) unknown; *Echeveria*, a succulent; and *Senecio*

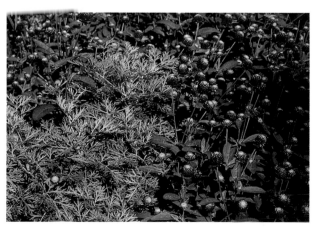

F-148 Mixed bedding with *Artemisia stellariana*, dusty miller, and *Gomphrena globosa*, globe amaranthus (pink and white flowers)

GROUND COVER, BEDDING, BORDERS

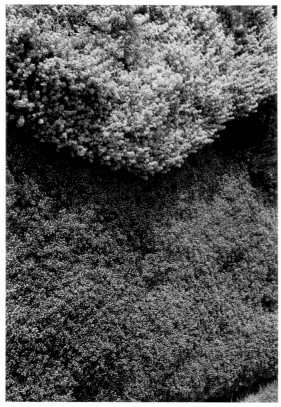

F-149 Patterned bedding with (front to back) *Origanum vulgare,* 'Aureum,' oregano, and *Thymus serphyllum,* thyme

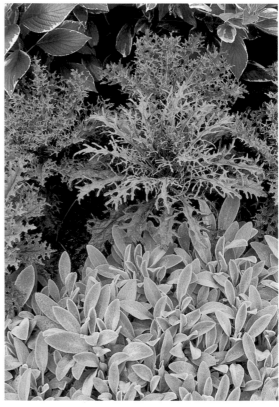

F-150 Layered bedding with (front to back) *Trichostema lanatum,* woolly blue curls; ornamental kale; variegated hydrangea

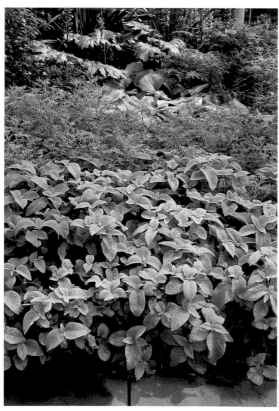

F-151 Annual border for shady area

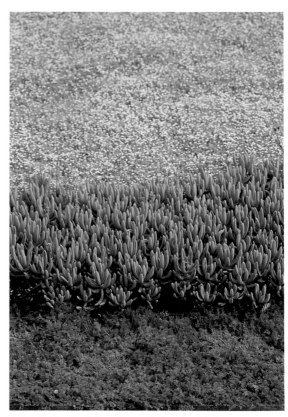

F-152 Foliage bedding planted in bands with *Senecio* at center

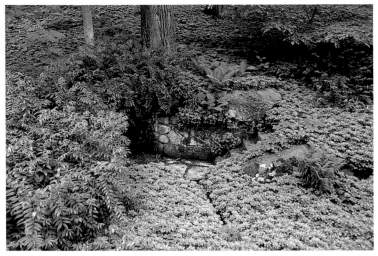

F-153 *Pachysandra terminalis,* Japanese spurge; hardy perennial evergreen used as ground cover in shady location

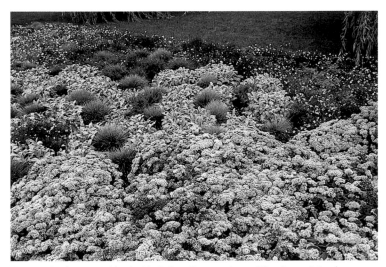

F-154 Mixed perennial bed with *Sedum; Festuca glauca,* 'Blue Fescue'; *Stachy byzantina,* lamb's ears

F-155 Mixed hardy perennial evergreen ground cover with *Pachysandra terminalis,* Japanese spurge, and *Juniperus sp.*

F-156 *Euphorbia myrsinites*, myrtle spurge, used as border for foliage bedding

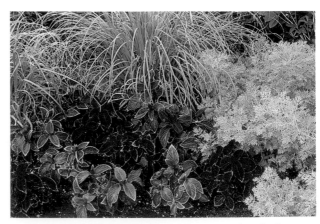

F-157 Mixed foliage bedding with *Solenostemon*, coleus (red), *Artemesia*, and (back) *Miscanthus*

F-158 *Veronica*, 'Sunshine,' speedwell or brooklime. A bedding plant used in rock gardens, and traditional to herb gardens

F-159 (left to right) *Geranium*, 'Brookside'; *Hakonechloa macra*

F-160 Mixed foliage bedding with: *Astilbe* x *rosea*, 'Peach Blossom,' false spira (top and left); *Euphorbia amygdaloides* var. *nobbiae*, Mrs. Robb's wood spurge

F-161 *Liriope muscari* cv., 'Lilac beauty,' lilyturf. An evergreen perennial ground cover

GROUND COVER, BEDDING, BORDERS

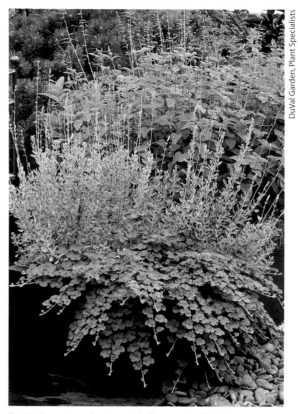

F-162 Container planting with (front to back) *Rubra phoenicolasius; Lavendula sp.*, lavender; *Salvia*

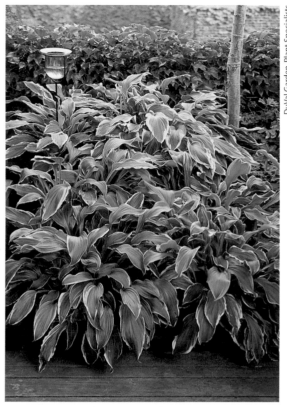

F-163 *Hosta* cv. used in container planting

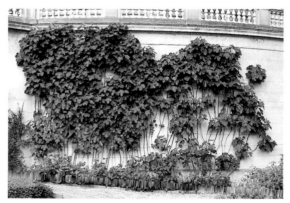

F-164 *Ficus carica*, common fig, trained as wall shrub

F-165 Perennial park garden with *Ipomea sp.*, sweet potato vine (front), *Solenostemon* cv., coleus , and pink *Impatiens*

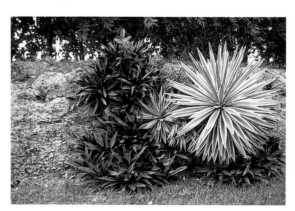

F-166 *Rheo discolor* and *Agave sp.* planted in front of garden wall

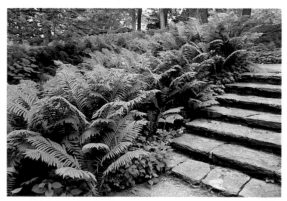

F-167 *Polystichium* ferns used as border for stone steps in woodland garden

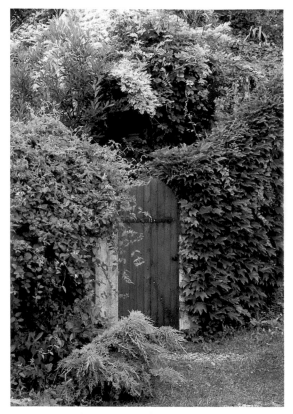

F-168 *Lonicera*, honeysuckle (left) and *Parthenocissus sp.*, hardy deciduous climber, on garden building

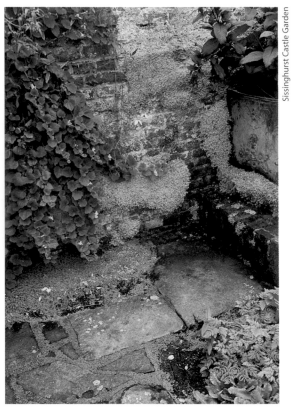

Sissinghurst Castle Garden

F-169 Small garden room with stone floor and *Rubus sp.* (top left), ferns, and primitive plants

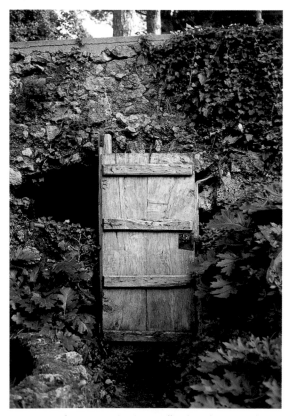

F-170 *Acanthus sp.* growing in woodland garden around rustic garden building

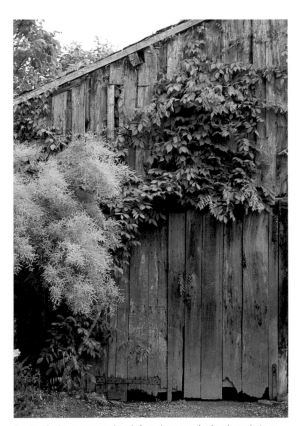

F-171 *Cotinus coggygria*, pink variety smoke bush and vines around old barn

GARDENS & LANDSCAPES

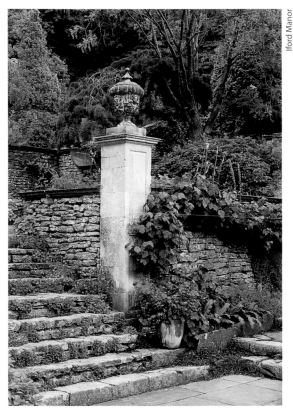

Iford Manor

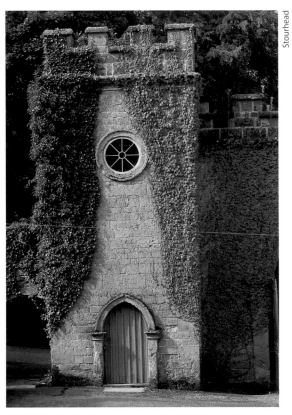

Stourhead

F-172 *Vitis*, grape vine; *Fuchsia*, and assorted shrubs and herbaceous plants around stone steps and wall in formal garden

F-173 Medieval-style tower covered with *Hedera* and *Parthenocissus* climbers

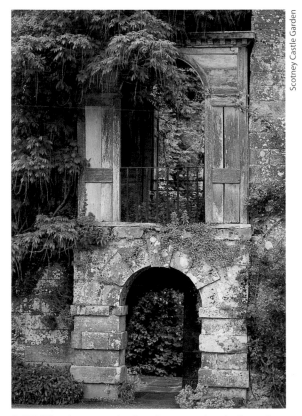

Scotney Castle Garden

Iford Manor

F-174 *Wisteria sp.* covering Renaissance-style ruins in garden courtyard

F-175 *Cotinus coggygria*, smoke bush (purple variety) and miscellaneous trees and shrubs form a background for garden architecture in formal garden

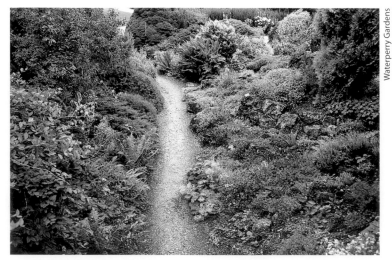

F-176 Garden path through mixed shade rockery planting

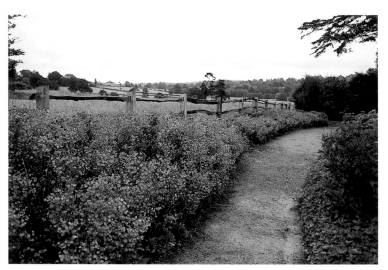

F-177 *Lunaria,* honesty or moonwort (left,) forming boundary of country garden path

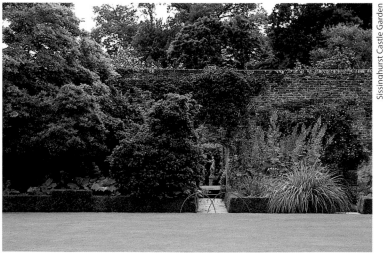

F-178 Formal English perennial bed

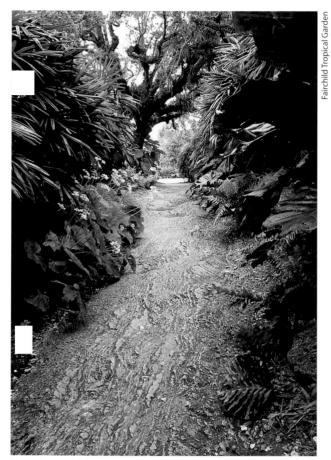

Fairchild Tropical Garden

F-179 Tropical foliage planting along rock path

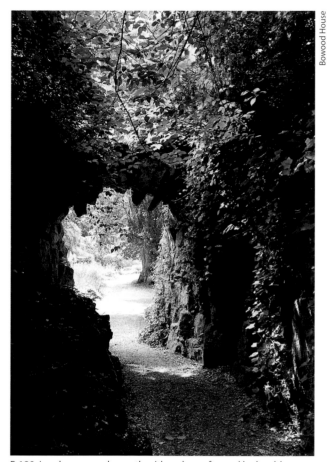

Bowood House

F-180 Landscape garden path with archway formed by boulders and foliage

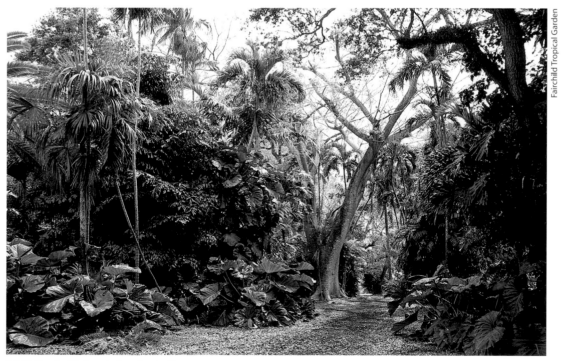

Fairchild Tropical Garden

F-181 Tropical foliage in jungle planting

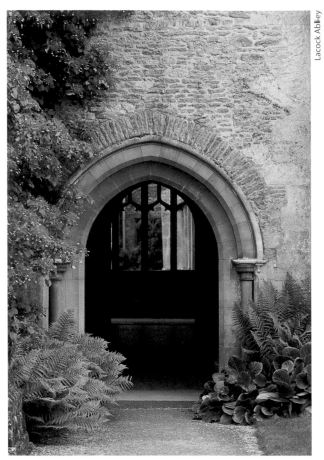

Lacock Abbey

F-182 Foliage surrounding door of medieval abbey

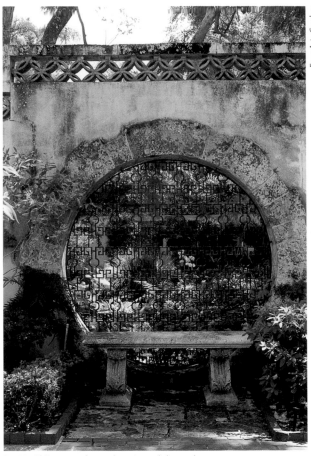

Four Arts Garden

F-183 Chinese-style garden viewed through moon gate

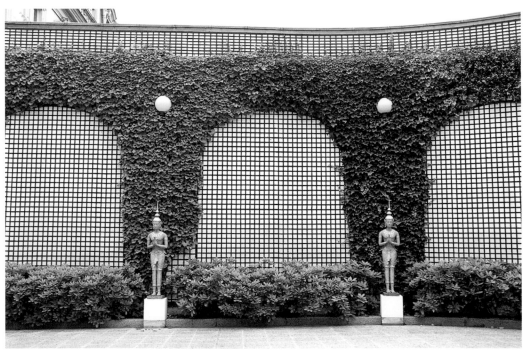

F-184 Formally clipped ivy with garden statues

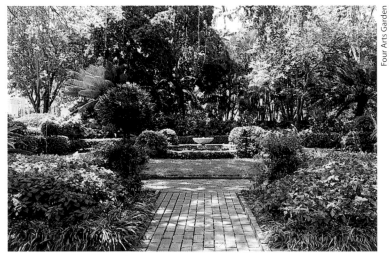

Four Arts Garden

F-185 Formal tropical garden

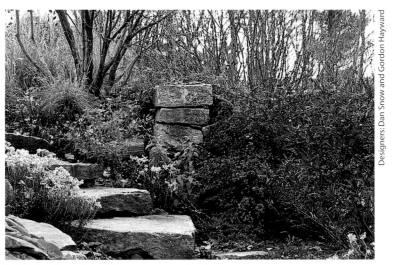

Designers: Dan Snow and Gordon Hayward

F-186 Rustic garden with stone steps and wall

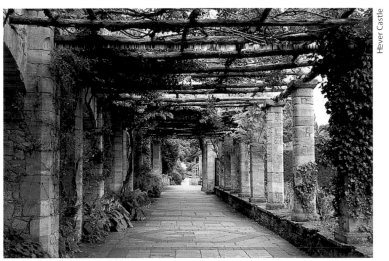

Hever Castle

F-187 Stone and wood pergola with vines and foliage

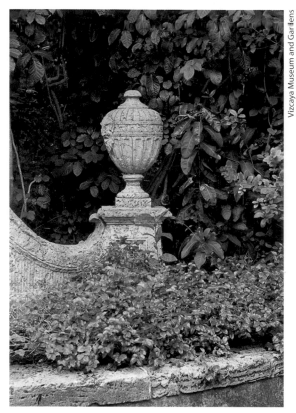

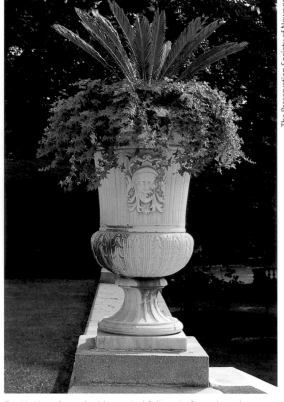

F-188 Classical garden architecture and foliage in formal tropical garden

F-189 Urn planted with tropical foliage in formal garden

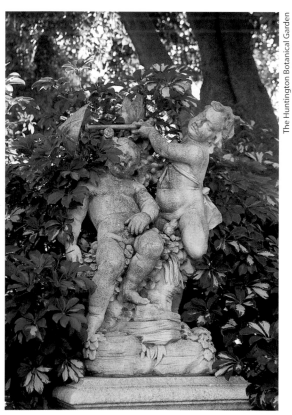

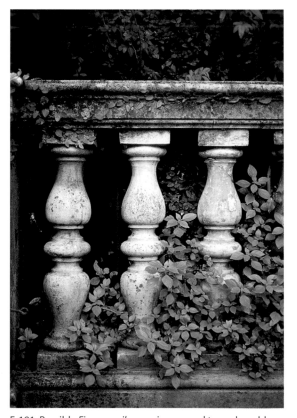

F-190 *Schefflera sp.* as a backdrop for garden statue of cherubs

F-191 Possibly *Ficus pumila* growing around turned marble balustrade

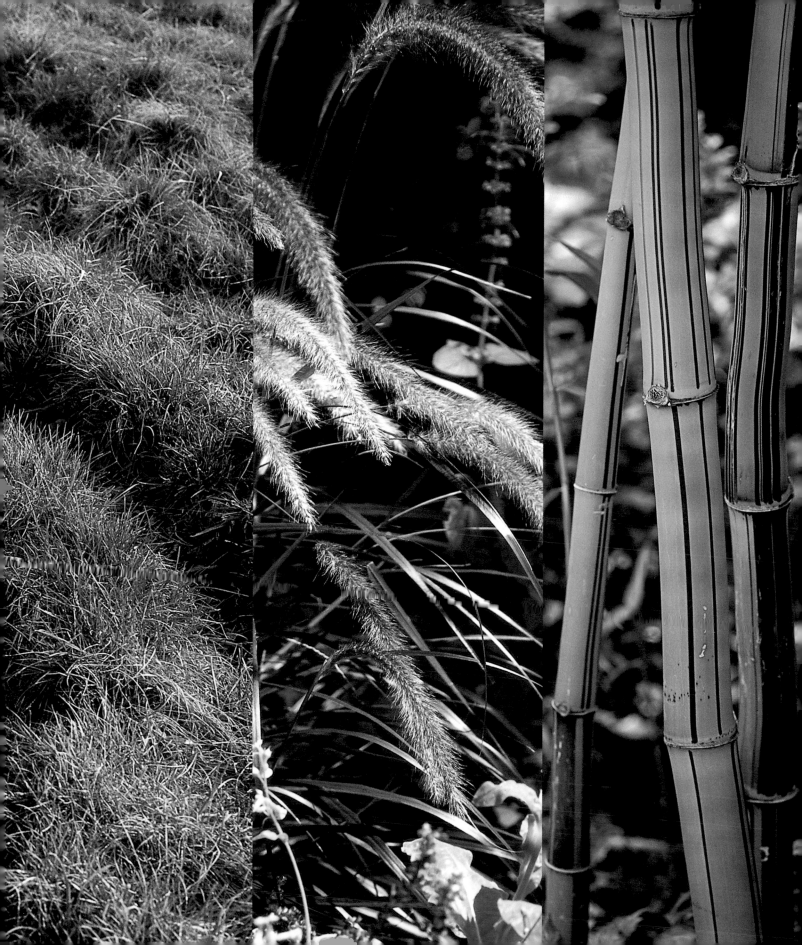

GRASS

G-1 Path crossing lawn formed by rectangular pavers outlined with grass

G-2 Grass lawn

G-3 Lawn with shadows from trees

G-4 Grass lawn with clover

G-5 Path crossing lawn formed by circular concrete pavers

G-6 Grass lawn with clipped yew and cut stone paved walk

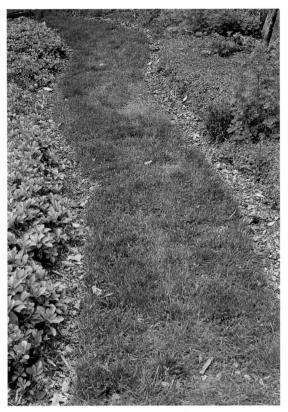

G-7 Grass path in garden with herbaceous border

Bowood House

G-8 Landscape garden lawn with gravel path and trees

G-9 St. Augustine grass with clipped edge along asphalt sidewalk

GRASS

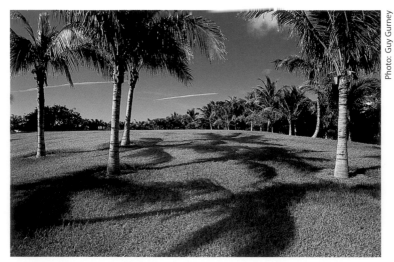

G-10 Palm trees on grass lawn

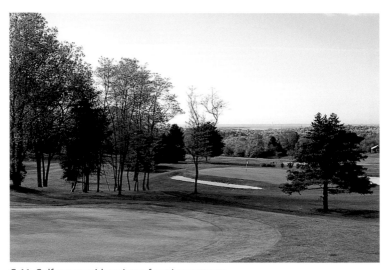

G-11 Golf course with variety of cutting patterns

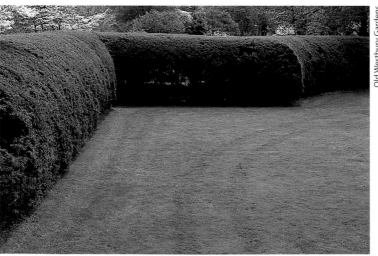

G-12 Grass lawn bordered by formal coniferous hedge

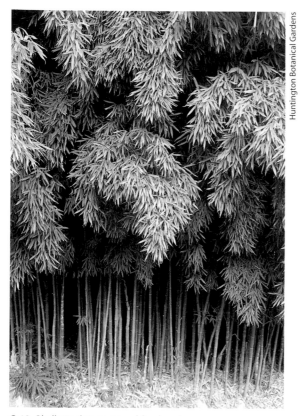

Huntington Botanical Gardens

G-13 *Phyllostachys aurea*, golden bamboo

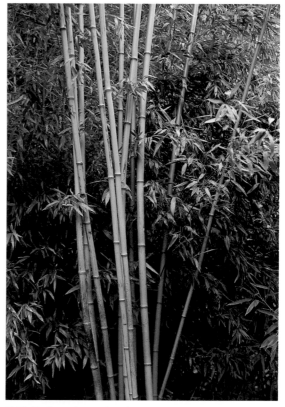

G-14 *Phyllostachys sp.*, bamboo

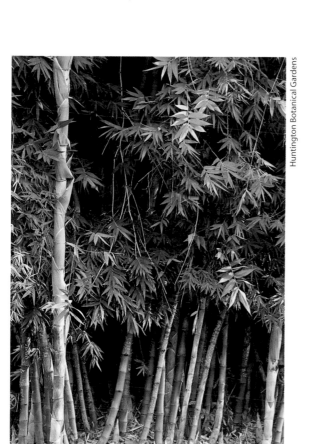

Huntington Botanical Gardens

G-15 *Phyllostachys sp.*, bamboo

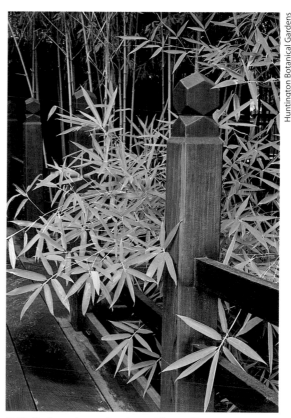

Huntington Botanical Gardens

G-16 *Phyllostachys sp.*, bamboo with wood bridge and post

BAMBOO

G-17 *Phyllostachys sp.*, bamboo

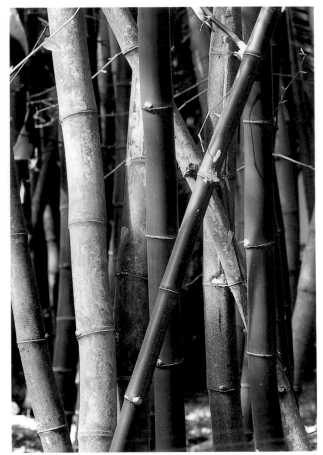

G-18 *Phyllostachys nigra*; 'Henonis,' bamboo

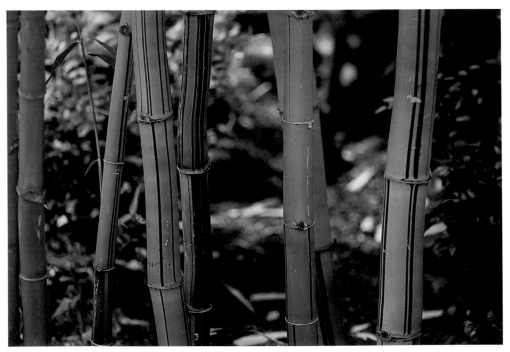

G-19 *Bambusa vulgaris*, 'Vittata,' green jade bamboo

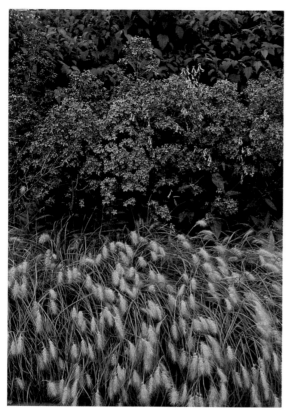

G-20 *Alopecurus sp.*, foxtail grass, as garden border

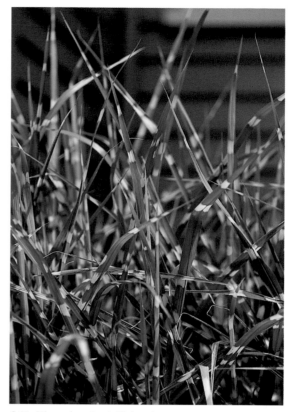

G-21 *Miscanthus sinesis,* 'Strictus'

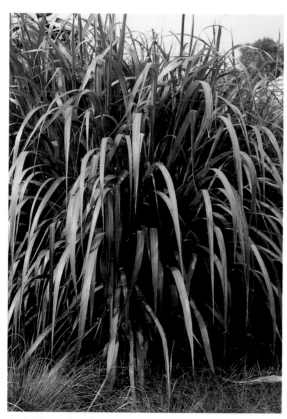

G-22 *Miscanthus giganteus*

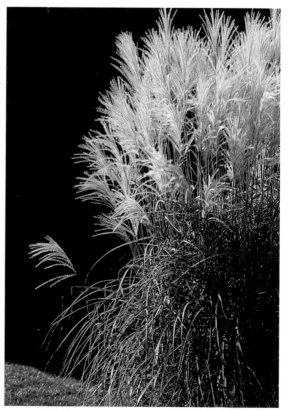

G-23 *Miscanthus sp.* in flower

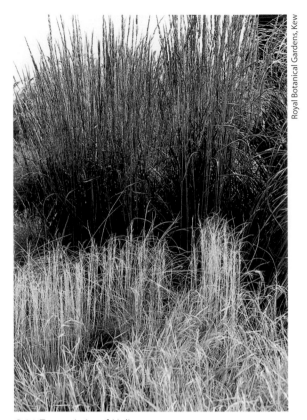

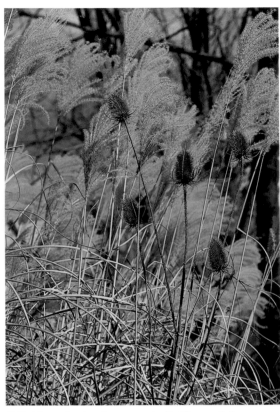

Royal Botanical Gardens, Kew

G-24 Two varieties of *Molina spp.*

G-25 *Miscanthus* in winter aspect with *Dipsacus fullonum*, teasel (with pricklyinflorescence)

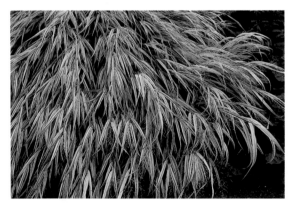

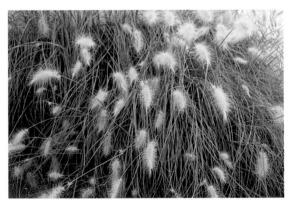

G-26 *Hakonechloa macra*, 'Aurea,' golden hakone grass

G-27 *Alopecurus sp.*, foxtail grass

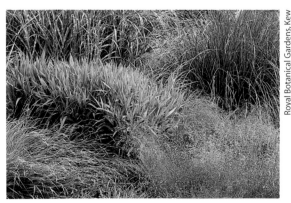

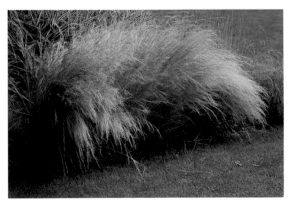

Royal Botanical Gardens, Kew

G-28 *Chasmanthium latifolium*, sea oats or bamboo grass; *Agrostis capillaris*, chalk false broom

G-29 *Stipa tenuissima*

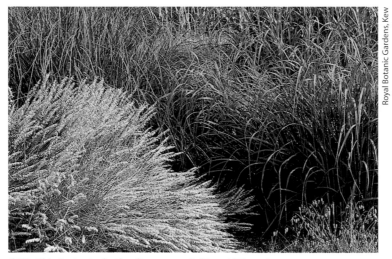

Royal Botanic Gardens, Kew

G-30 *Chloris virgata*, feather finger grass (left), and *Miscanthus sp.*

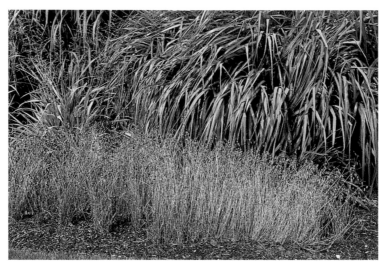

G-31 *Briza maxima*, quaking grass (front), and hortorum

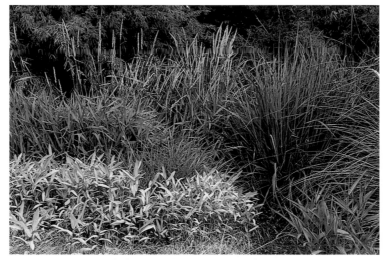

G-32 Mixed grasses including *Plebioblastus auricomus* (front) and *Bromus sterilus*, barren broom

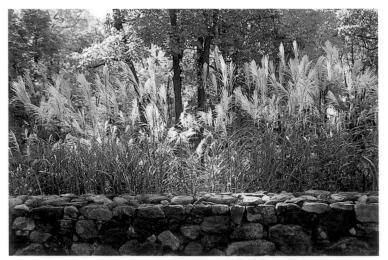

G-33 *Miscanthus sp*, in early summer aspect, planted behind stone wall

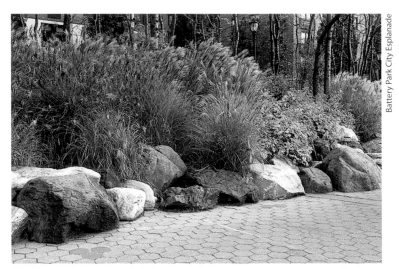

Battery Park City Esplanade

G-34 *Miscanthus sp.* in early fall aspect, planted among boulders in city park

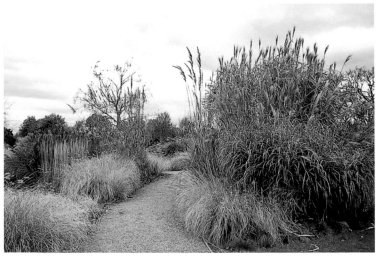

G-35 Multiple ornamental grasses in early winter aspect, used as borders, with gravel paths in corporate campus

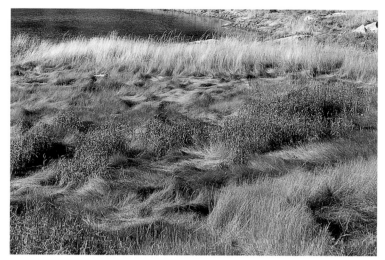

G-36 Meadow in the late fall

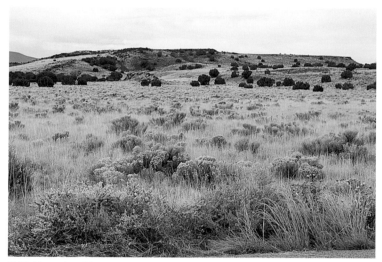

G-37 Natural prairie

G-38 Meadow

G-39 *Phragmites australis* in the early spring on U.S. coast.
Pernicious alien species

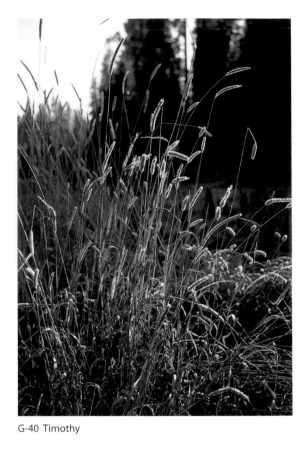

G-40 Timothy

G-41 Marsh grass in brackish swamp

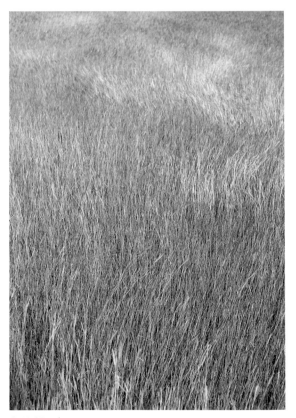

G-42 Meadow

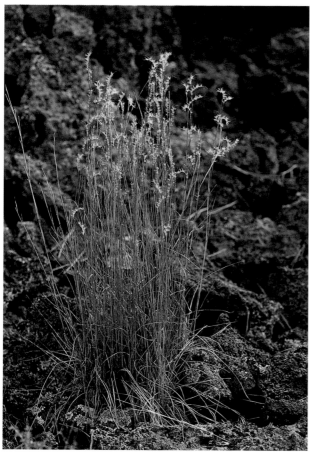

G-43 Opportunistic grass growing in volcanic rock

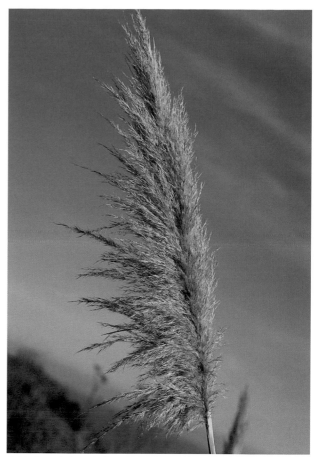

G-44 *Cortaderia sp.* inflorescence

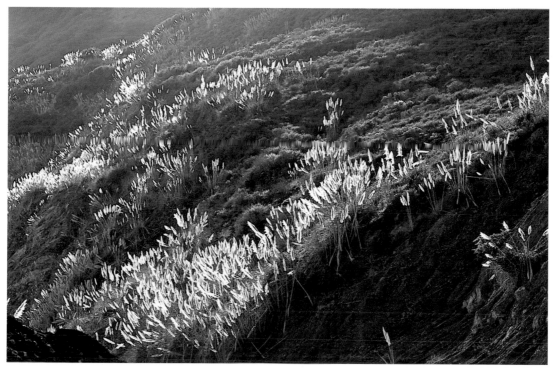

G-45 Waves of coastal grass in bloom

GRASS

G-46 Opportunistic grass growing in derelict outdoor tile floor

G-47 Beach grass in sand

G-48 Grass growing between square stone pavers

G-49 Tall beach grass

G-50 Aquatic grass growing in freshwater pond

G-51 Marsh grass growing along tidal river

G-52 Cornfield with other fields divided by trees

G-53 Mixed fields in early fall

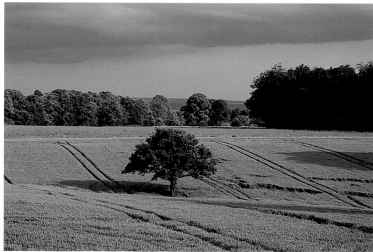

G-54 Barley field

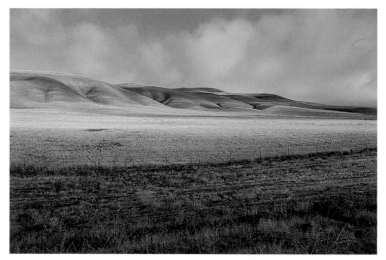

G-55 Natural grazing grassland, southwestern United States

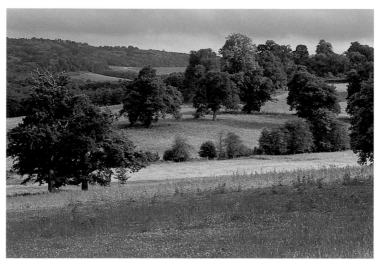

G-56 English pastures and grain field

G-57 Field rubble after harvest

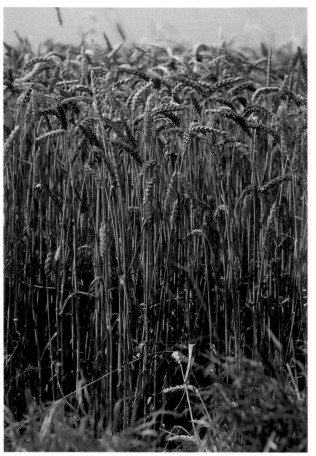

G-58 Barley

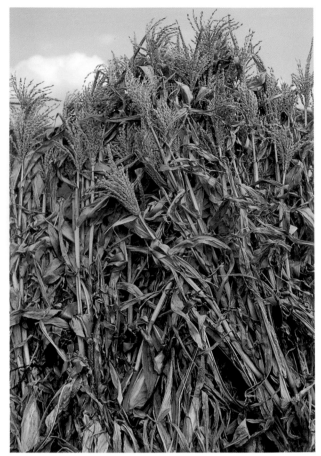

G-59 Cornstalks after harvest

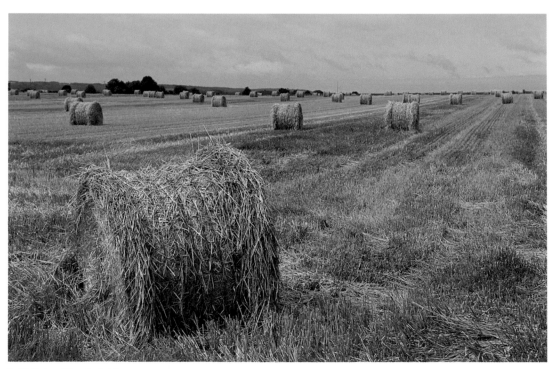

G-60 Bales of hay in field

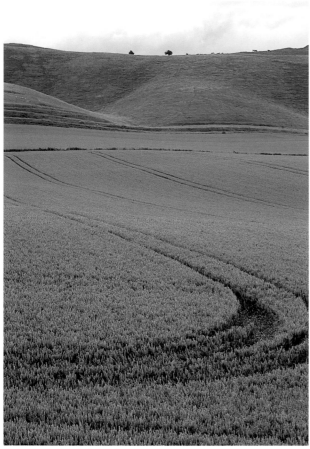

G-61 Field of grain in midsummer

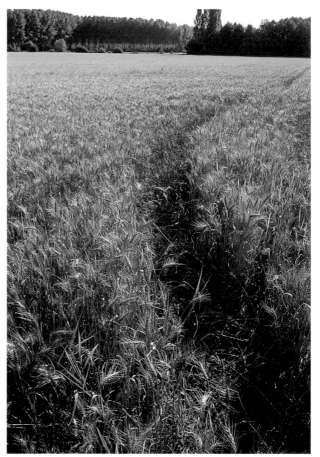

G-62 Wheat field

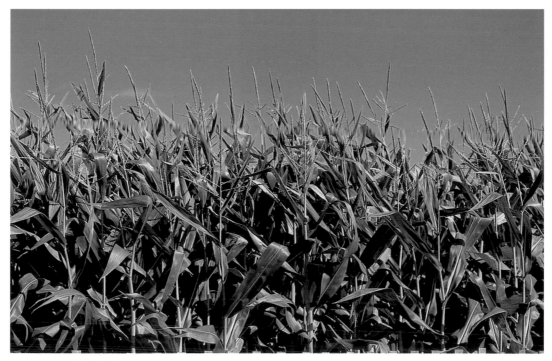

G-63 Cornstalks before harvest

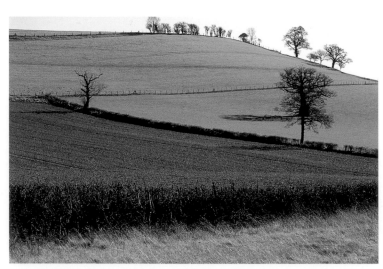

G-64 Fields with tilled soil and crops divided by hedgerows

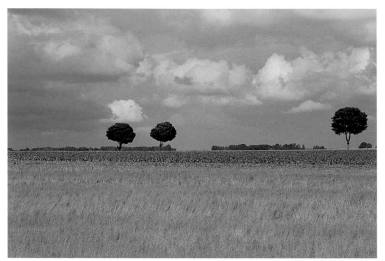

G-65 Field with trees in summer

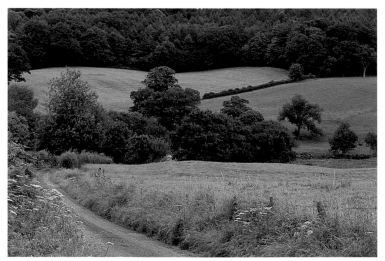

G-66 Pastures and fields divided by trees and country lane

FRUITS, VEGETABLES, FUNGI

Identified clockwise from top left or left to right unless otherwise indicated.

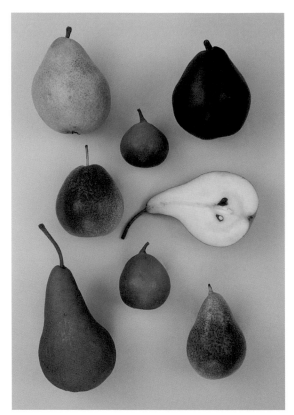

FV-1 Pears: Bartlett or Williams, Red Anjou, Bosc section, Fiorelle, Bosc, Comice, and Seckel (center)

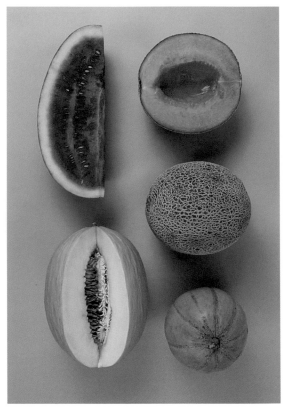

FV-2 Melons: watermelon, cantaloupe (two views), L'Antillais, Juan Canary

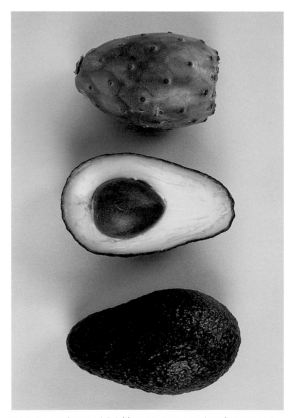

FV-3 (top to bottom) Prickly pear cactus (Indian fig), avocado section, avacado

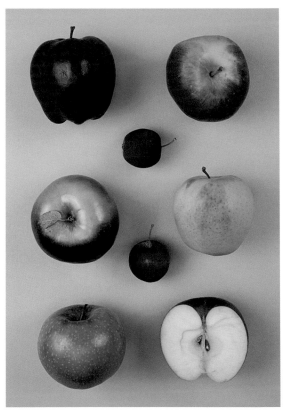

FV-4 Apples: Red Delicious, Braeburn, Golden Delicious, Macintosh section, Granny Smith, Macintosh, and crabapples (center)

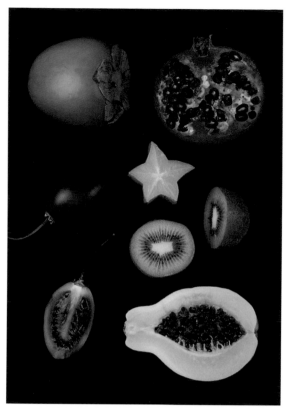

FV-5 Persimmon, pomegranate and carambola section , kiwi, papaya section, tamarillo or tree tomato (two views)

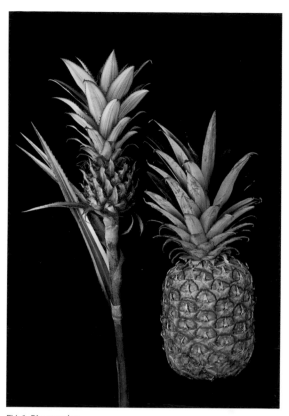

FV-6 Pineapples

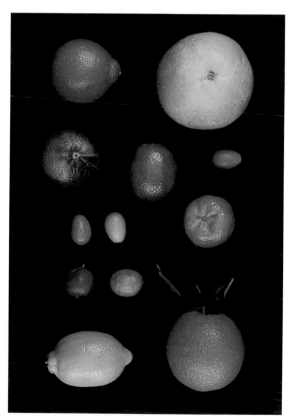

FV-7 Citrus fruit: Mineola orange, grapefruit, kumquat, tangerine, navel orange, lemon, Key limes, kumquats, blood orange, and lime (center)

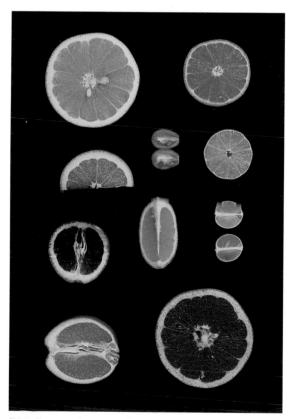

FV-8 Citrus sections: grapefruit, Mineola orange, lime, Key limes, Ruby Red grapefruit, Valencia orange, blood orange, navel orange, lemon and kumquats (center)

FRUITS

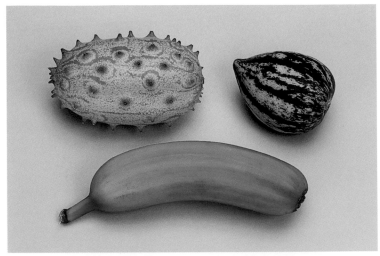

FV-9 Kiwano or horned melon (top right), Pepino melon (top left), plantain (bottom)

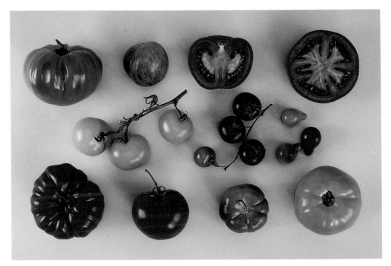

FV-10 Red, yellow, and green tomatoes

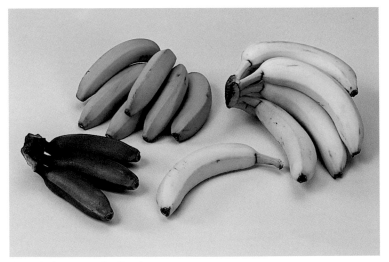

FV-11 Red, green, and yellow bananas

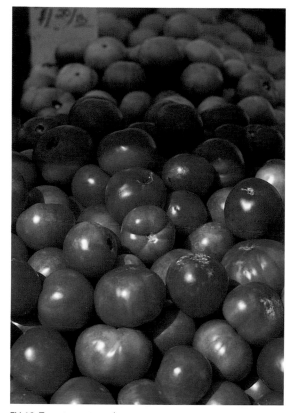

FV-12 Tomatoes at market

FV-13 Red and yellow tomatoes in crate

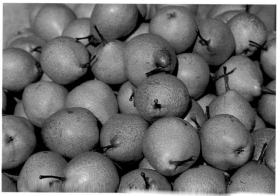

FV-14 Bartlett pears

FV-15 Red and Golden Delicious apples

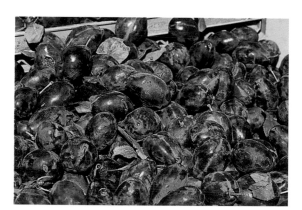

FV-16 Plums at market

FV-17 Osage oranges (hedge apple or bowwood) in basket

FV-18 Wine grapes

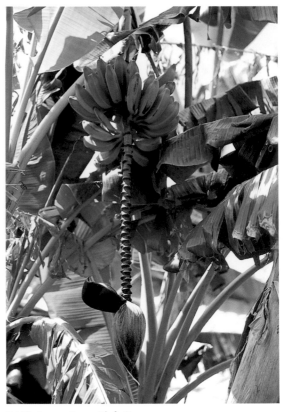

FV-19 Banana tree with fruit

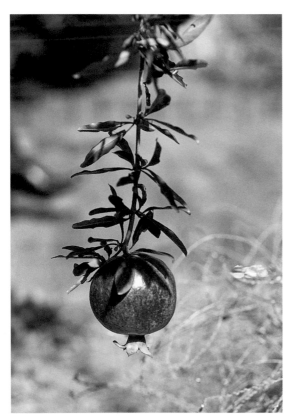

FV-20 Pomegranate branch with fruit

FV-21 Navel oranges on tree

FV-22 *Momordica,* balsam pear, tropical vine, with fruit

FV-23 Japanese persimmon

FV-24 Cherry tomatoes on the vine

FV-25 Quince tree with fruit

FV-26 Parsnip and carrots

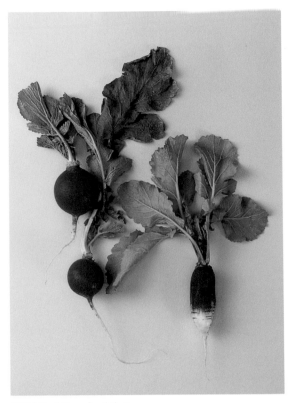

FV-27 Varieties of radishes

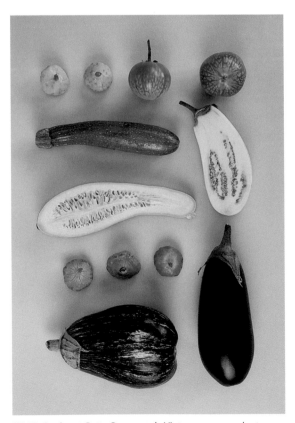

FV-28 Sunburst Patty-Pan squash, Vietnamese eggplant, white eggplant (aubergine) section, purple eggplant, striped eggplant, scalloped squash, section of summer squash, zucchini (courgette)

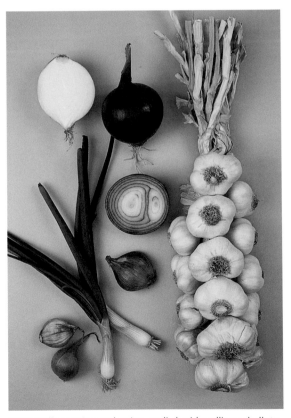

FV-29 Yellow onion, red onion, garlic braid, scallions, shallots

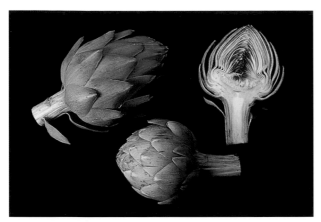

FV-30 Artichokes

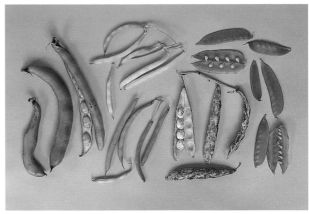

FV-31 Beans: Fava, yellow wax, Red Barlotti shell, snow peas, green pole

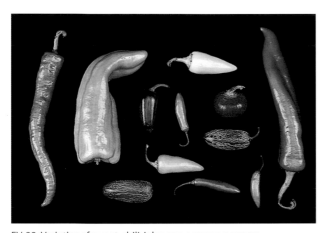

FV-32 Varieties of sweet, chili, jalapeno, serrano peppers

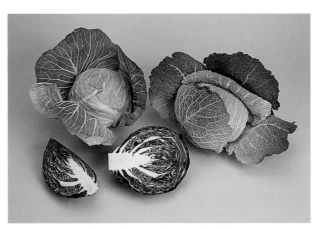

FV-33 Common cabbage, Savoy cabbage, red cabbage

FV-34 Decorative peppers

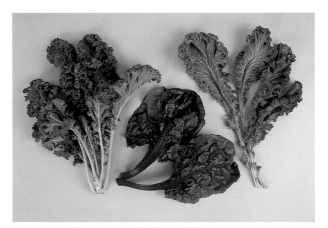

FV-35 Mustard greens, red chard, curly kale

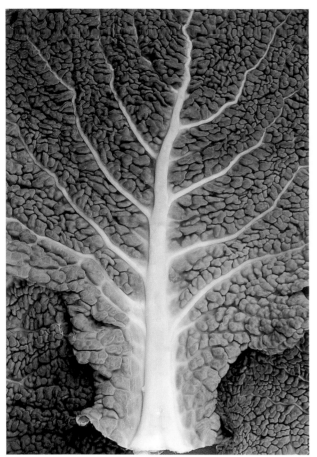

FV-36 Savoy cabbage leaf, detail

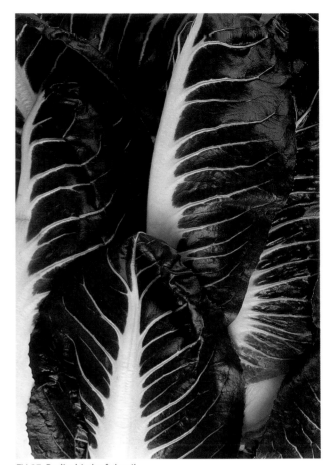

FV-37 Radicchio leaf, detail

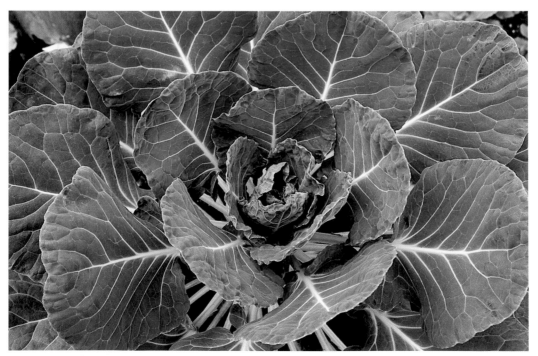

FV-38 Foliage of Brussels sprouts

FV-39 Ornamental kale

FV-40 Bunches of radishes

FV-41 Ornamental cabbage

FV-42 Celery root, ginger root, kohlrabi

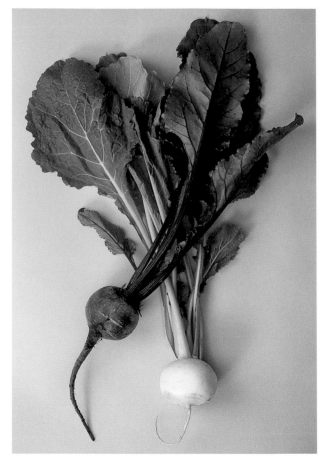

FV-43 Red and white beets

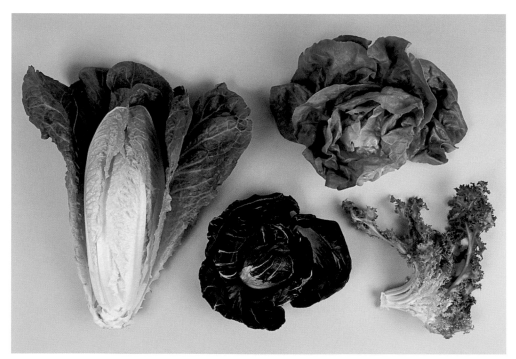

FV-44 Lettuce: romaine, Boston, chicory, radicchio

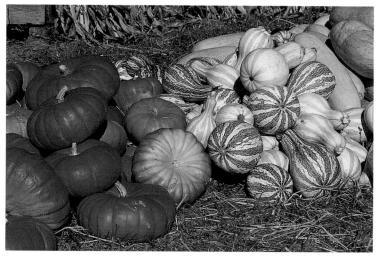

FV-45 Rouge Vif d'Etampes pumpkins and other winter squash

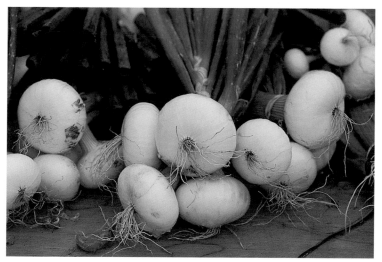

FV-46 White onions

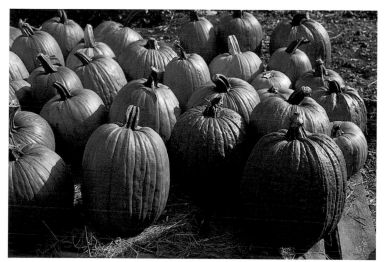

FV-47 American pumpkins

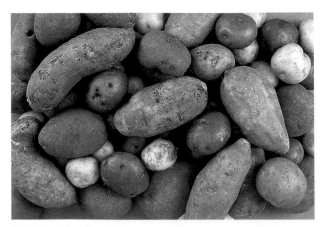

FV-48 Varieties of potatoes

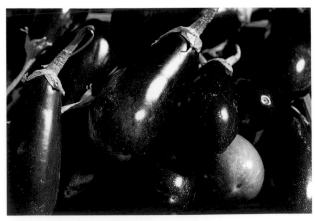

FV-49 Eggplant (aubergine)

FV-50 Red bell peppers

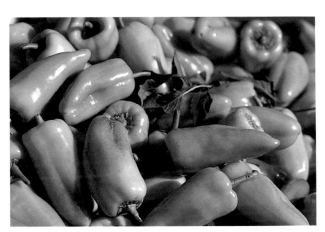

FV-51 Sweet Italian green peppers

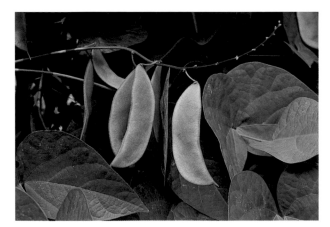

FV-52 Lima beans on the vine

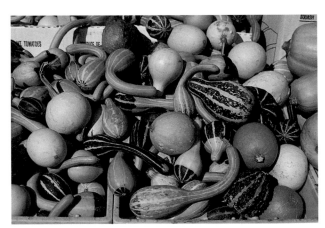

FV-53 Varieties of gourds

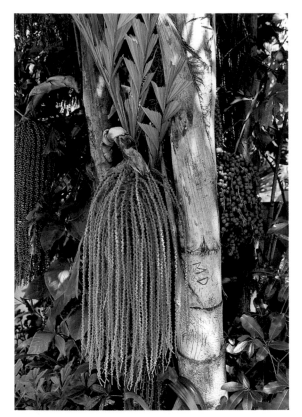

FV-54 Inflorescence of palm, *Caryota urens*

FV-55 Pyracantha shrub with berries

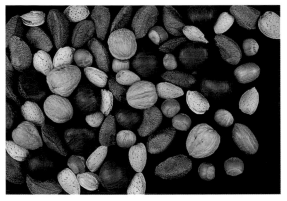

FV-56 Nuts: almond, pecan, Brazil nut, walnuts, butternut, chestnut, pistachio

FV-57 Holly with berries

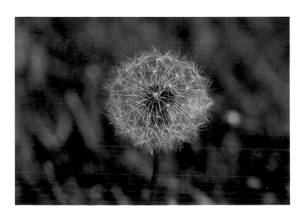

FV-58 Dandelion in seed

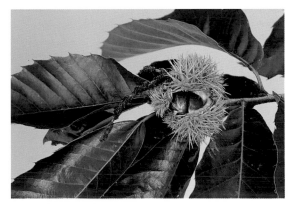

FV-59 Chestnut in bur

NUTS, SEEDS, CONES

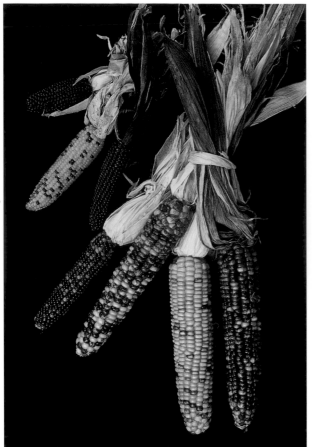

FV-60 "Indian" corn

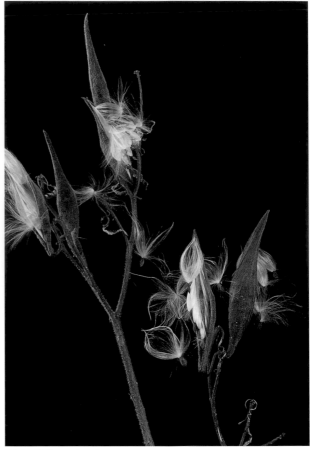

FV-61 Milkweed pods

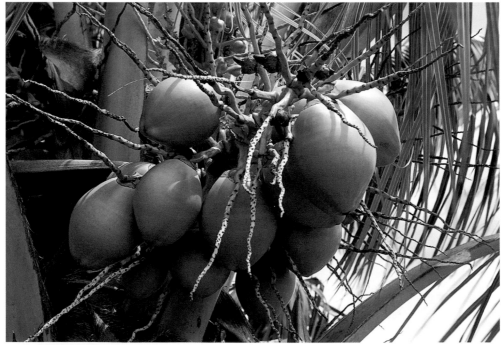

FV-62 Palm tree with coconuts, detail

NUTS, SEEDS, CONES

FV-63 Rose hips, fruit of wild brier rose (dog rose)

FV-64 Ripe fruit and leaves of Kousa dogwood

FV-65 Acorns with oak leaves

FV-66 Viburnum bush with berries

FV-67 Terminal cone of female cycad

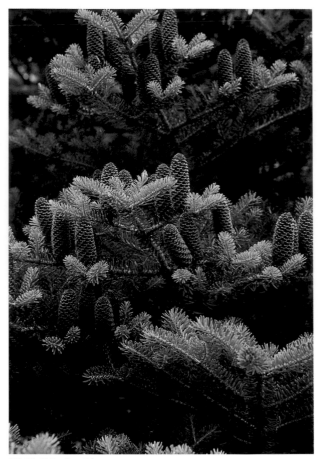

FV-68 *Abies*, fir, with cones

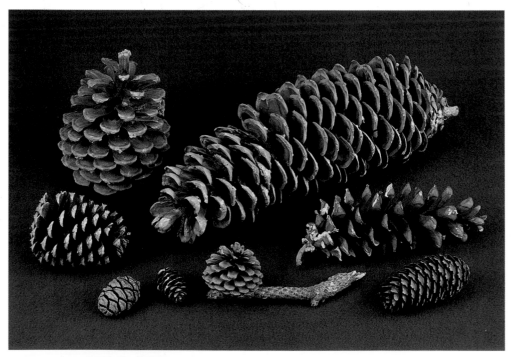

FV-69 Clockwise from top left: *Pinus sp.*; *Pinus lambertiana*, sugar pine; *Pinus strobus*, eastern white pine; *Picea sp.*, spruce; *Pinus, sp.*; *Pseudotsuga*, Douglas fir; unknown; *Pinus sp.*

NUTS, SEEDS, CONES

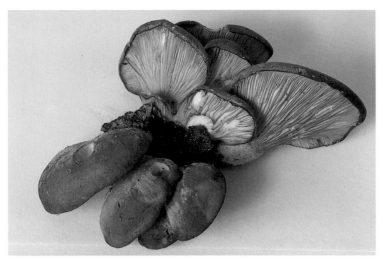

FV-70 *Basidiomycetic*, gill fungi

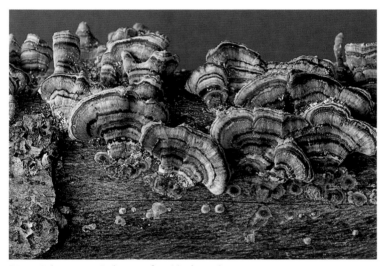

FV-71 *Polyporus versicolor*, pore fungi (polypore)

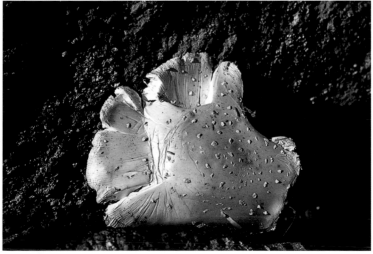

FV-72 Wild fungi

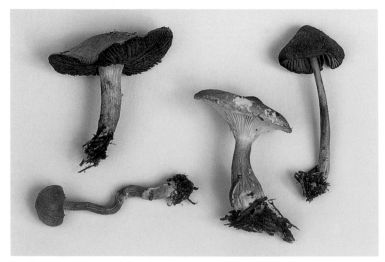

FV-73 Wild *basidiomycetic* fungi

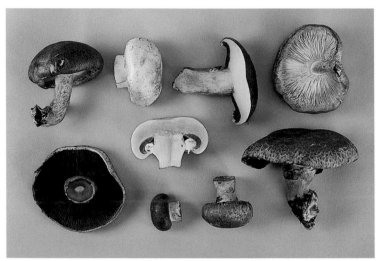

FV-74 Edible fungi: shiitake, button mushroom, crimini, Portobella

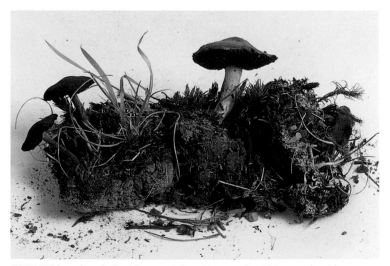

FV-75 Wild toadstools (*basidiomycetic* fungi) in woodland bio-sample with mosses, lichens, and grasses

STONE, SAND, LAND

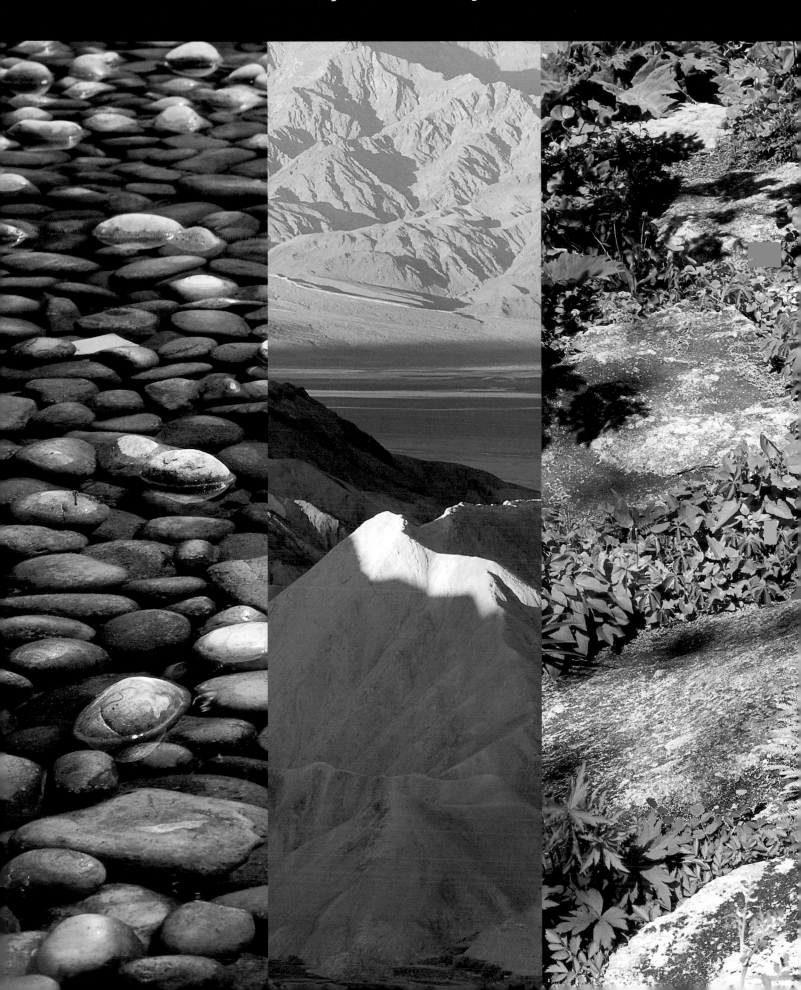

STONE, SAND, LAND

Unless otherwise noted, S-1–S-29 are polished.

S-1 Limestone with fossil turretella

S-2 Petrified wood; fossilized by silica replacement

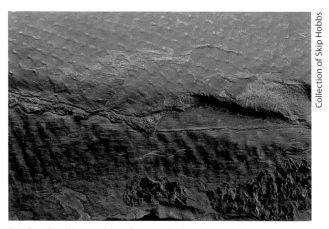

S-3 Fossilized lycopod tree from coal deposit; natural state

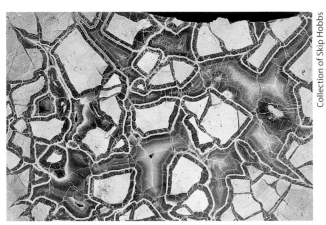

S-4 Limestone settarian concretion

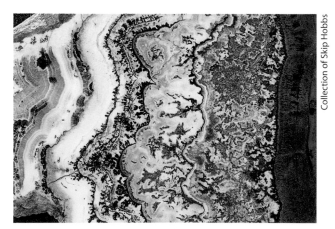

S-5 Agate with tiny manganese dendrites

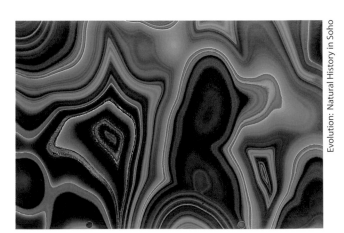

S-6 Malachite

TYPES OF STONE & MINERALS

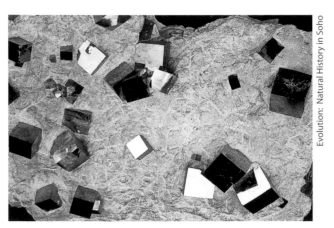

Evolution: Natural History in Soho

S-7 Pyrite crystals in natural state

Collection of Skip Hobbs

S-8 Copper ore consisting of chalcopyrite (gold) and bornite (left) and limonite with iron oxide ore (right); natural state

Collection of Skip Hobbs

S-9 Quartz and amethyst; natural state

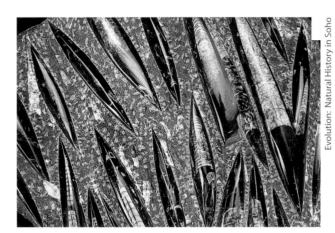

Evolution: Natural History in Soho

S-10 Fossil nautoloids

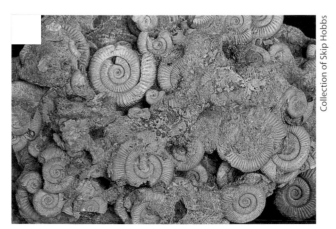

Collection of Skip Hobbs

S-11 Fossil ammonite death assemblage; natural state

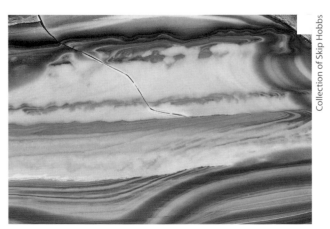

Collection of Skip Hobbs

S-12 Sandstone with manganese oxidation-reduction phenomena

TYPES OF STONE & MINERALS

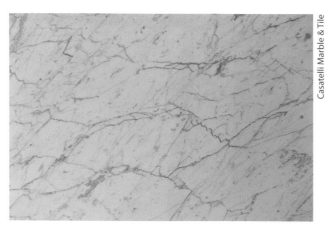

Casatelli Marble & Tile

S-13 Carrara marble

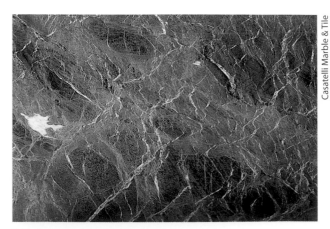

Casatelli Marble & Tile

S-14 Vermont Verde marble

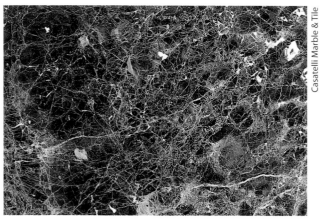

Casatelli Marble & Tile

S-15 Emperador dark marble

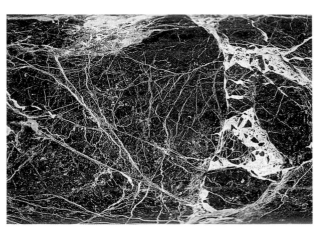

Casatelli Marble & Tile

S-16 Probably Elazig Cherry marble

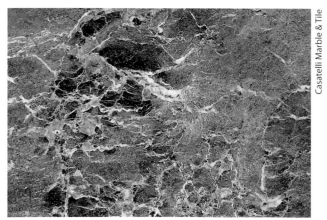

Casatelli Marble & Tile

S-17 Empress Green marble

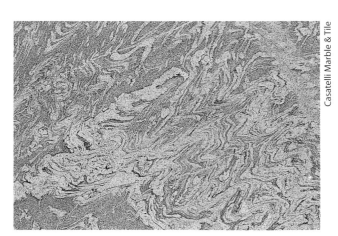

Casatelli Marble & Tile

S-18 Juparana Colombo granite

S 19 Onyx

S-20 Aramcio di Selva marble

Casatelli Marble & Tile

S-21 Fior di Pesco marble

Casatelli Marble & Tile

S-22 Quartzite

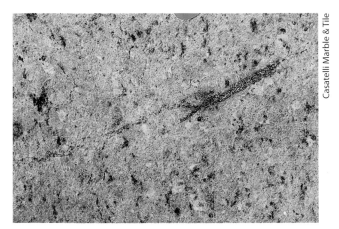

S-23 St. Cecilia Peach marble

Casatelli Marble & Tile

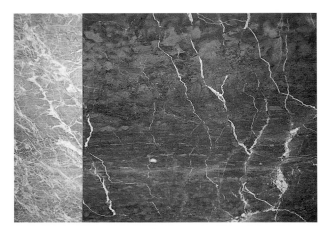

S-24 Gray and red veined marbles

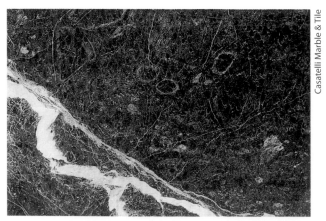

S-25 St. Laurentis marble

Casatelli Marble & Tile

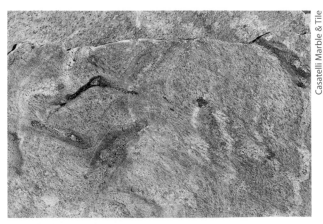

S-26 Elio Doro granite

Casatelli Marble & Tile

S-27 Blu Bahai granite

Casatelli Marble & Tile

S-28 Green brecciated marble

Casatelli Marble & Tile

S-29 Breccia Damascata marble

S-30 Weathered exterior stone floor

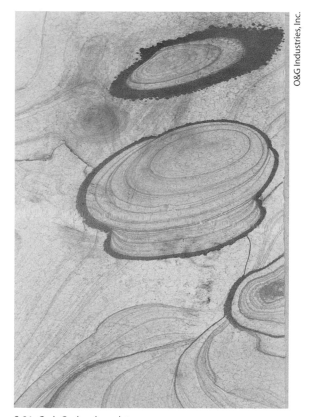

S-31 Crab Orchard sandstone

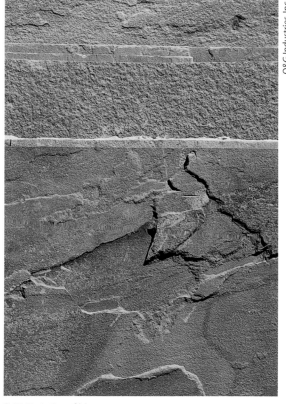

S-32 Varieties of bluestone

S-33 Aramosa limestone

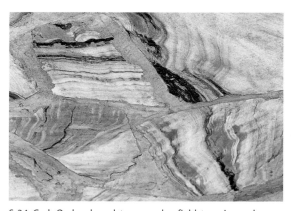

S-34 Crab Orchard sandstone used as fieldstone in garden path

S-35 Possibly bluestone, weathered

S-36 Rusticated marble

TYPES OF STONE & MINERALS

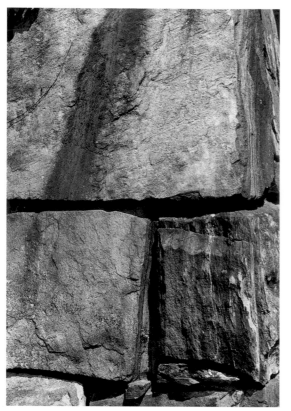

S-37 Shaped fieldstone with high iron content, showing rust marks

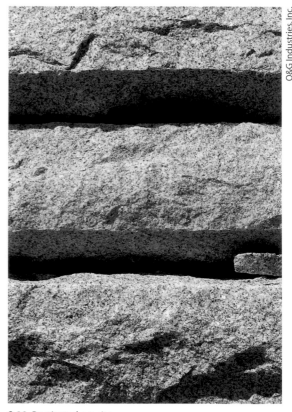

O&G Industries, Inc.

S-38 Rusticated granite

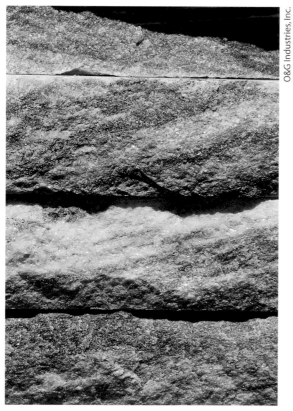

O&G Industries, Inc.

S-39 Rusticated Georgian marble

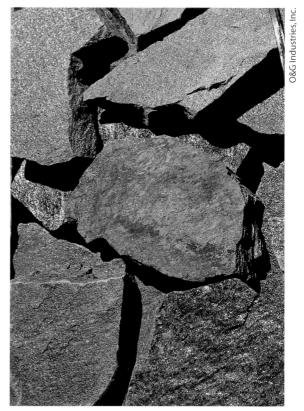

O&G Industries, Inc.

S-40 Yankee Hill flagstone

TYPES OF STONE & MINERALS

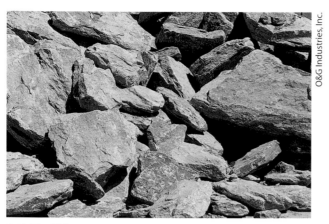

O&G Industries, Inc.

S-41 Blue Ridge veneer granite

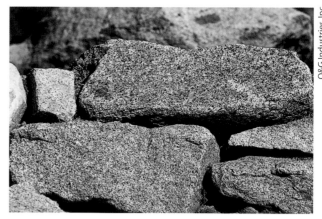

O&G Industries, Inc.

S-42 Fieldstone

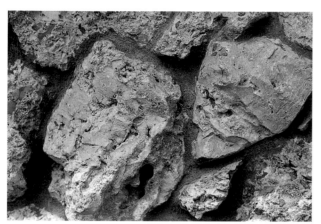

S-43 Fossil stone

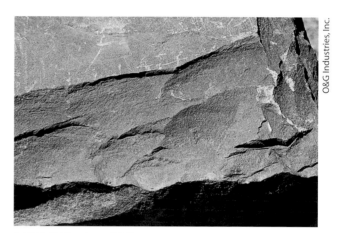

O&G Industries, Inc.

S-44 Split bluestone, detail

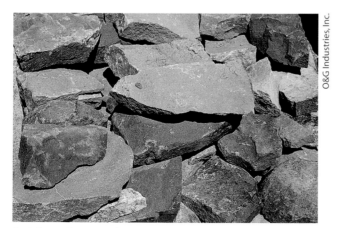

O&G Industries, Inc.

S-45 Pennsylvania sandstone, Cherokee blend

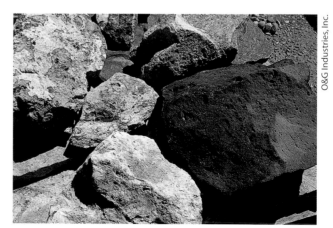

O&G Industries, Inc.

S-46 Assorted fieldstone, including black lava rock

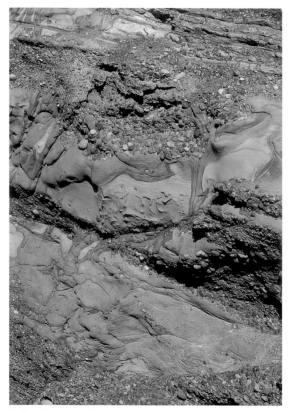

S-47 Pebbly conglomerate and sandstone in sea cliff

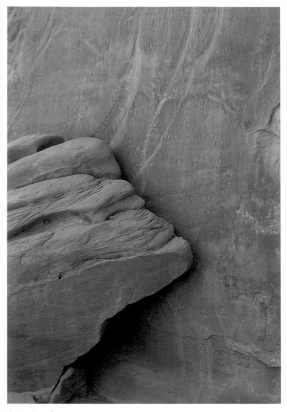

S-48 Sandstone

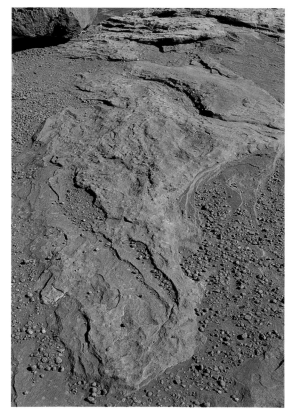

S-49 Weathered sandstone

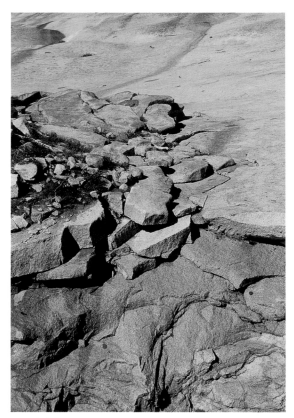

S-50 Exfoliating granite

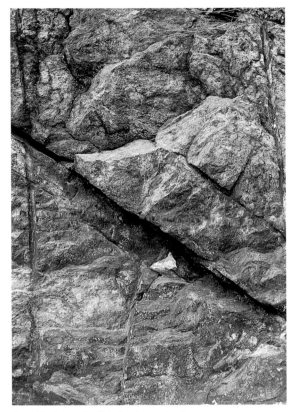

S-51 Biotite gneiss (black mica variety)

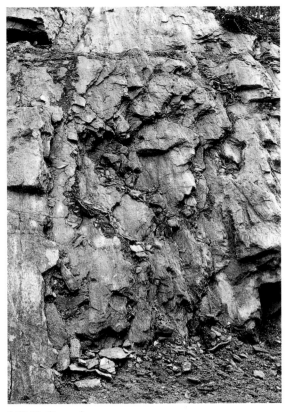

S-52 Biotite gneiss

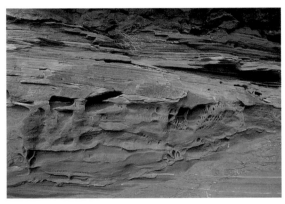

S-53 Weathering bedded sandstone

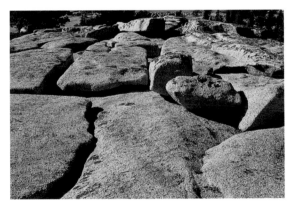

S-54 Granite with weathering in joints

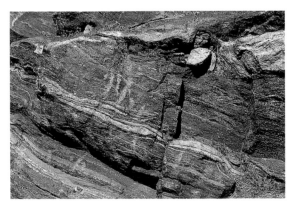

S-55 Gneiss with quartz banding

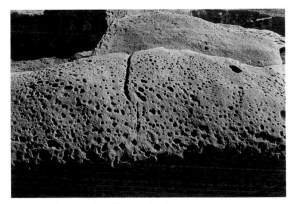

S-56 Sandstone, pitted by weathering

TYPES OF STONE & MINERALS

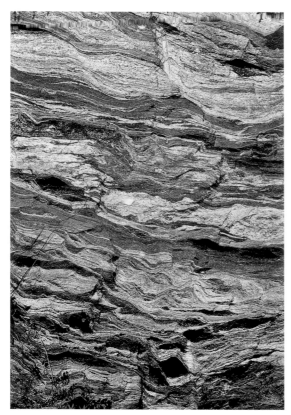

S-57 Granite gneiss

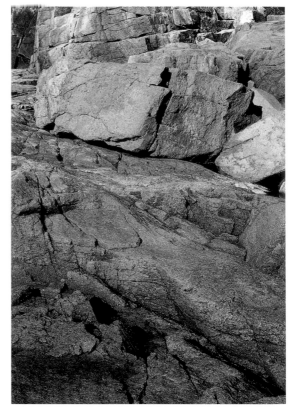

S-58 Pink granite weathered along joints

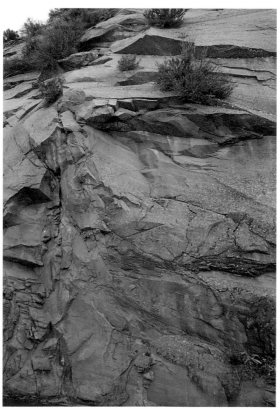

S-59 Sandstone cliff

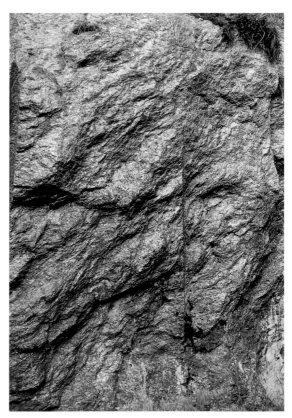

S-60 Manhattan schist

TYPES OF STONE & MINERALS

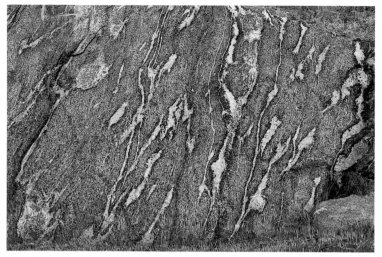

S-61 Biotite gneiss with feldspar or quartz veining

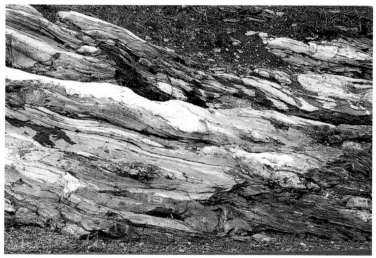

S-62 Weathering gneiss

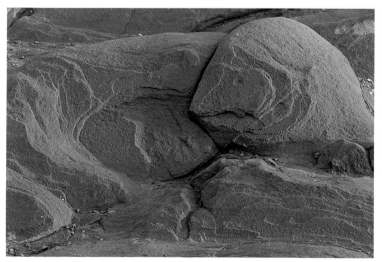

S-63 Sandstone weathered by wind

TYPES OF STONE & MINERALS

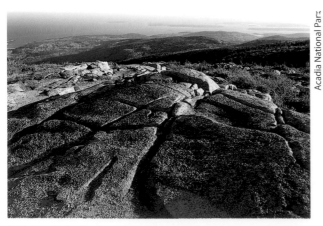

Acadia National Park

S-64 Granite bedrock summit with natural fractures and exfoliation joints

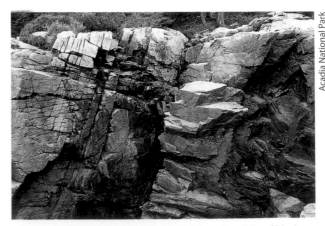

Acadia National Park

S-65 Jointed weathered pink granite with intrusion dyke of black diabase

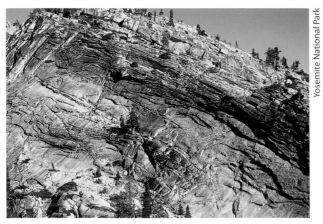

Yosemite National Park

S-66 Granite cliff

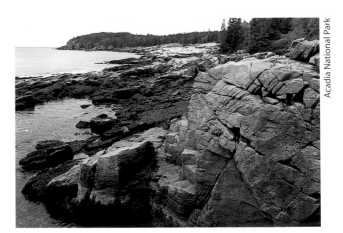

Acadia National Park

S-67 Jointed weathered pink granite cliffs

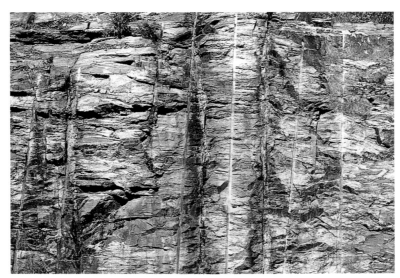

S-68 Gneiss with rust from iron content

ROCK FORMATIONS

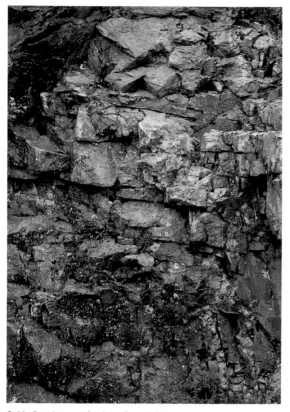

S-69 Granite weathering along joints

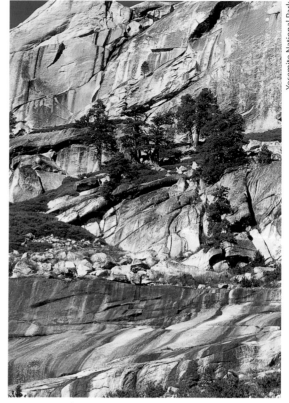

Yosemite National Park

S-70 Gray granite with conifer trees growing in fissures

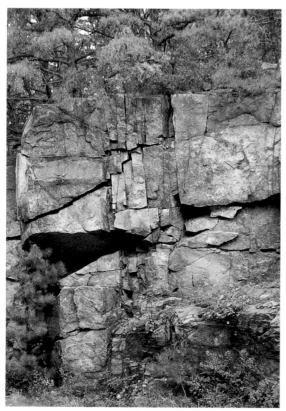

S-71 Pink granite with horizontal jointing and weathering

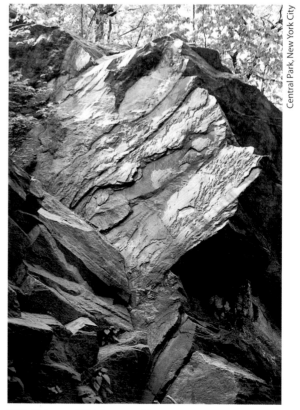

Central Park, New York City

S-72 Outcrop of Manhattan schist

ROCK FORMATIONS

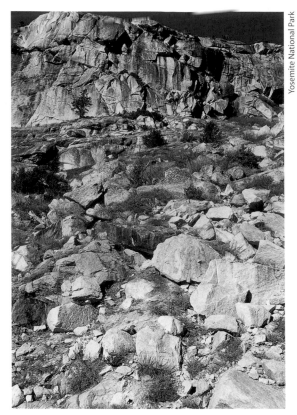

Yosemite National Park

S-73 Granite summit surrounded by rocks and boulders

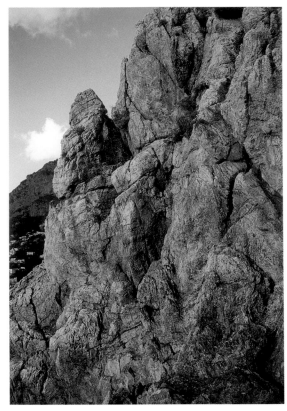

S-74 Bedded limestone

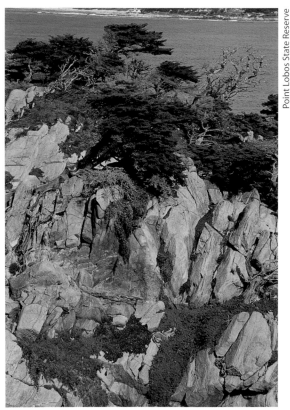

Point Lobos State Reserve

S-75 Granite coastal cliffs with wind-shaped conifers

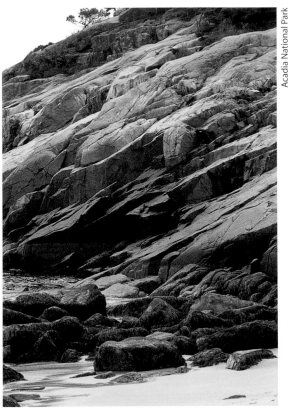

Acadia National Park

S-76 Granite coastal cliffs with sand beach

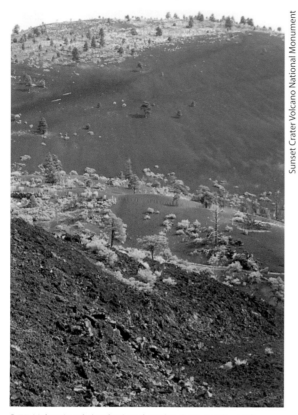

Sunset Crater Volcano National Monument

S-77 Volcanic ash (tephra) and cinder dunes with conifers

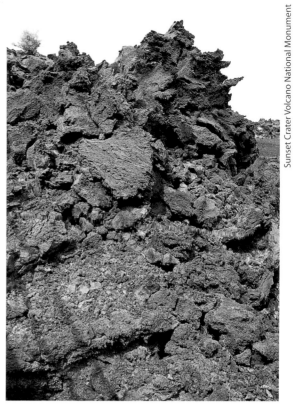

Sunset Crater Volcano National Monument

S-78 Twisted shapes of volcanic rubble

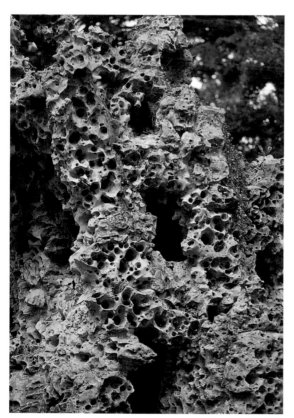

S-79 Artificial volcanic rock made from hypertufa

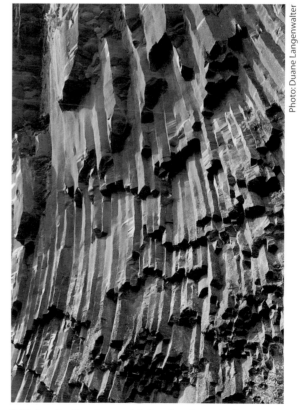

Photo: Duane Langenwalter

S-80 Basalt with columnar jointing (lava formation)

ROCK FORMATIONS

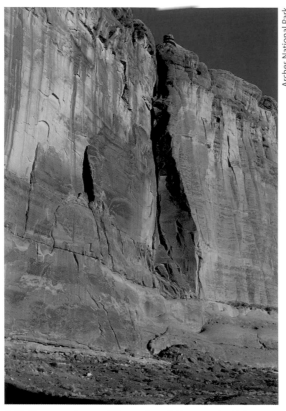

Arches National Park

S-81 Sheer sandstone cliff, weathered along vertical joint planes

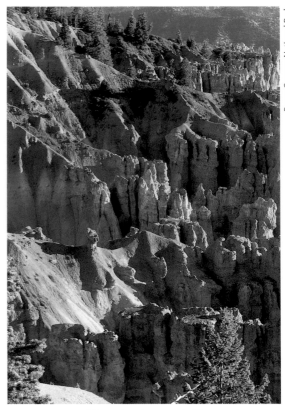

Bryce Canyon National Park

S-82 Limestone cliffs eroded along vertical joints colored with red, yellow, and tan iron oxides and lavender manganese

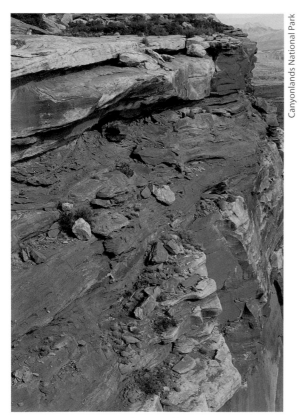

Canyonlands National Park

S-83 Layers in bedded sandstone cliff

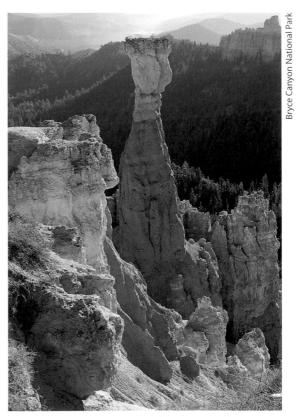

Bryce Canyon National Park

S-84 Pinnacles and "monuments" from erosion of limestone, silt, and mudstone

ROCK FORMATIONS

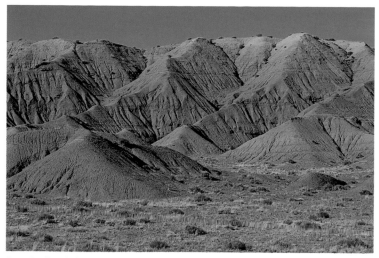

S-85 Badlands formation in desert

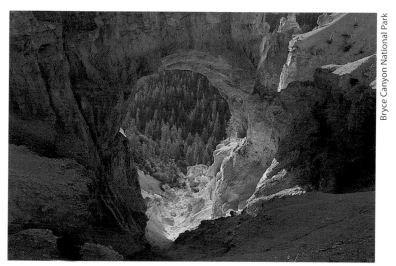

Bryce Canyon National Park

S-86 Tunnel created by erosion in iron oxide–colored limestone

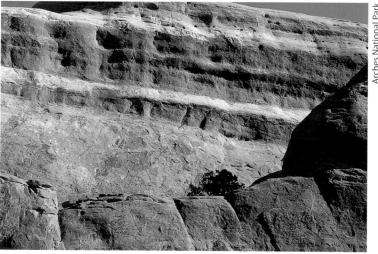

Arches National Park

S-87 Layers of sedimentary rock deposits

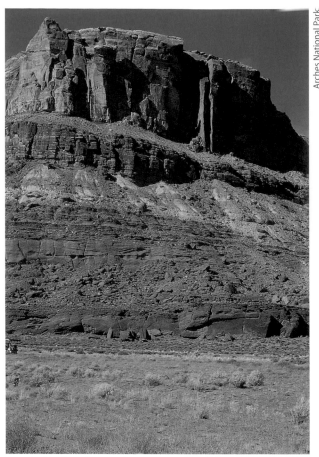

Arches National Park

S-88 Multicolored layers of sedimentary rock on table rock or mesa wall

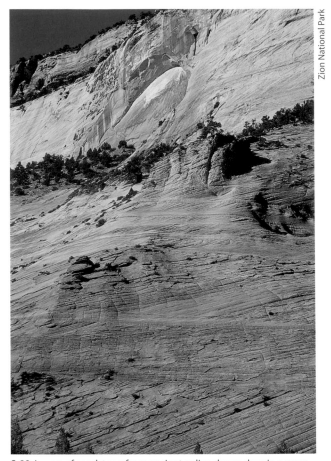

Zion National Park

S-89 Layers of sandstone from ancient eolian dunes showing cross-bedding

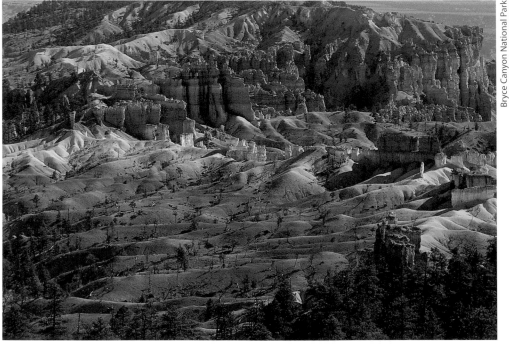

Bryce Canyon National Park

S-90 Valleys and spires in a landscape created by erosion of ancient sandstone and limestone plateau

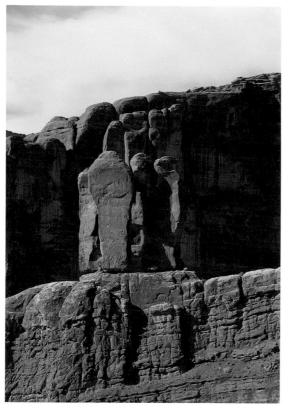

S-91 Sandstone with layers weathered along horizontal faults

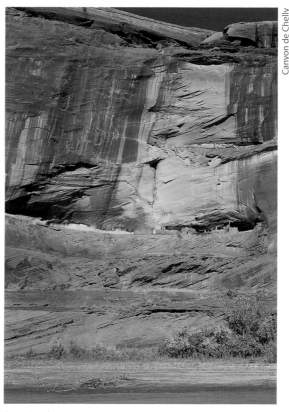

Canyon de Chelly

S-92 Sandstone canyon wall with eolian cross-bedding

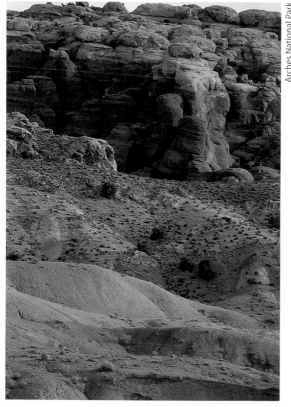

Arches National Park

S-93 Domed sandstone spires as background for deposits of ancient volcanic ash (green) and other rock formations

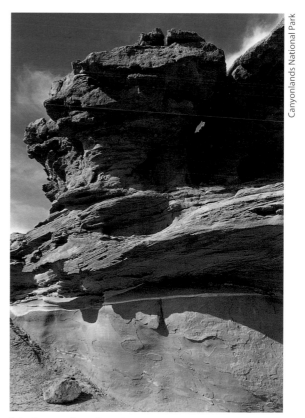

Canyonlands National Park

S-94 Layers of weathered sandstone

ROCK FORMATIONS

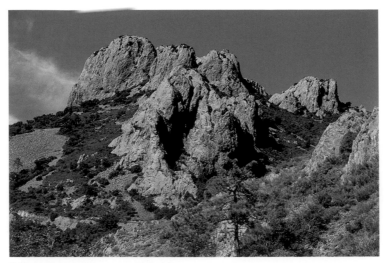

S-95 Large outcrop on mountainside

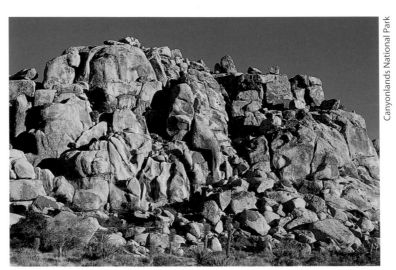

Canyonlands National Park

S-96 Large outcrop eroded along joints, with rocks and boulders

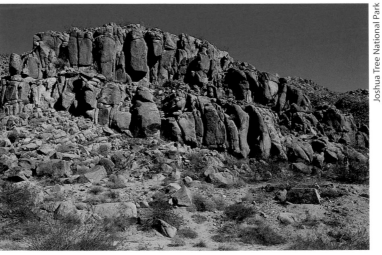

Joshua Tree National Park

S-97 Rock wall eroded along joints

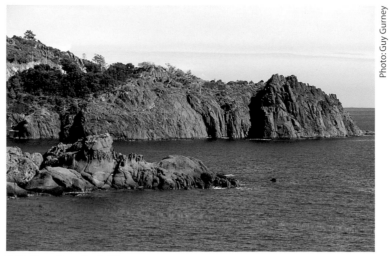

Photo: Guy Gurney

S-98 Shoreline of red cliffs

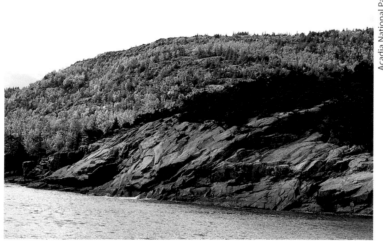

Acadia National Park

S-99 Forest in fall color behind steep black coastal cliffs

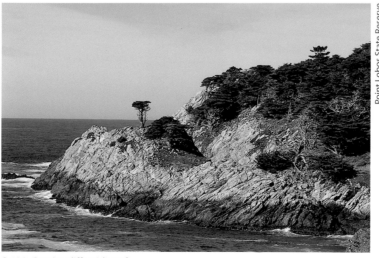

Point Lobos State Reserve

S-100 Granite cliffs with surf

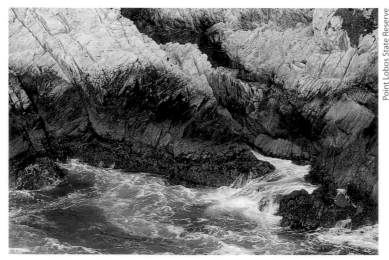

Point Lobos State Reserve

S-101 Gorge with breaking waves

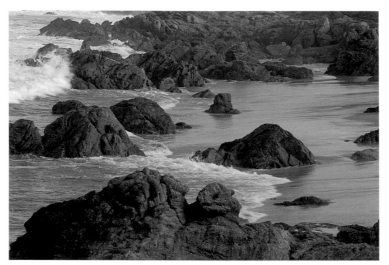

S-102 Rocky beach with outcrops surrounded by sand and surf

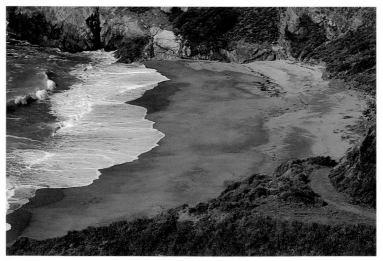

S-103 Surf on sandy beach in rocky cove

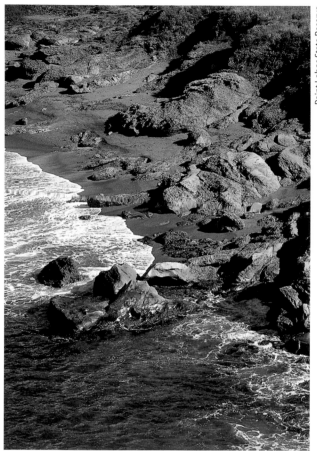

Point Lobos State Reserve

S-104 Rocky beach with outcrops surrounded by sand and surf

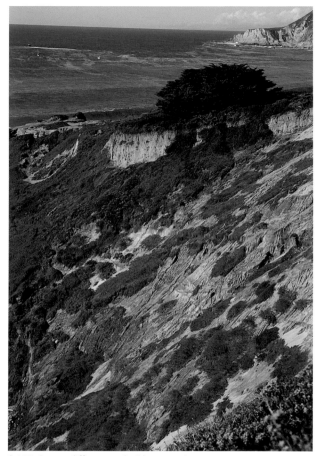

S-105 Ocean cliffs covered with vegetation

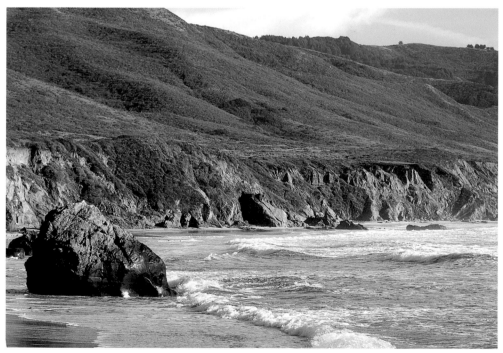

S-106 Elevated marine terrace with boulder in surf

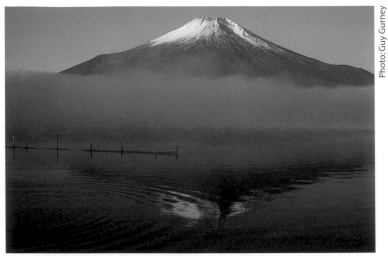

Photo: Guy Gurney

S-107 Volcanic mountain with water and fog

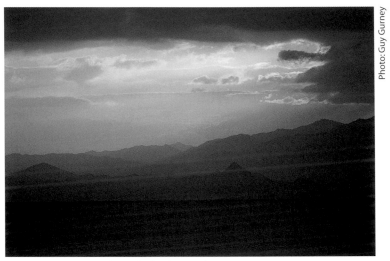

Photo: Guy Gurney

S-108 Mountain range behind inland sea at dawn

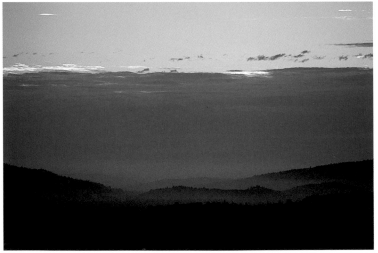

S-109 Layers of fog in mountain range with silhouette of pine trees

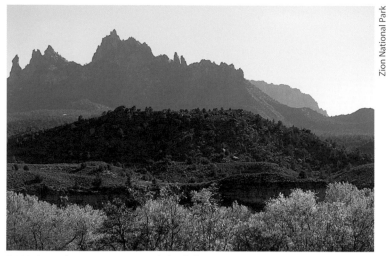

Zion National Park

S-110 Jagged mountain range with foothills and foliage in fall color

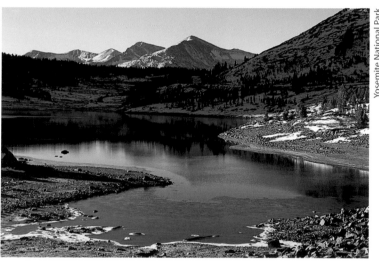

Yosemite National Park

S-111 Snow-capped mountains with lake

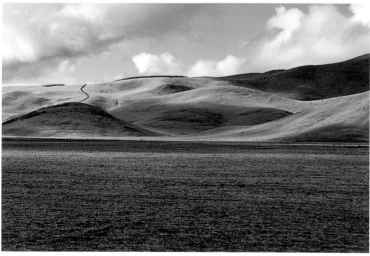

S-112 Valley at base of rolling foothills

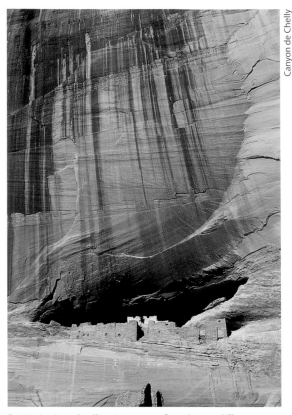

Canyon de Chelly

S-113 Ancient dwelling in terrace of sandstone cliff

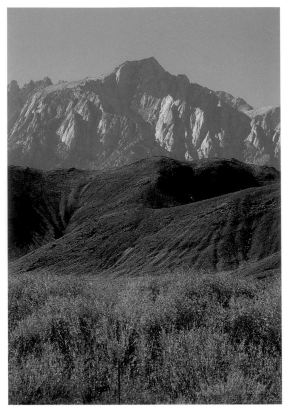

S-114 Wildflowers, foothills, and mountains

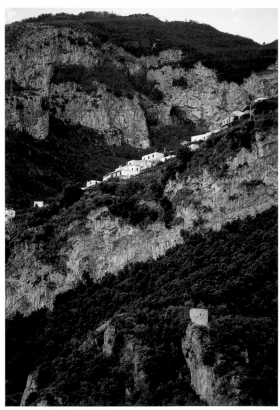

S-115 Mountain village

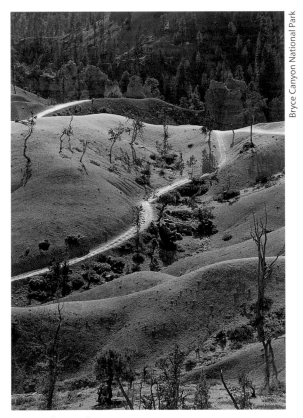

Bryce Canyon National Park

S-116 Valley road

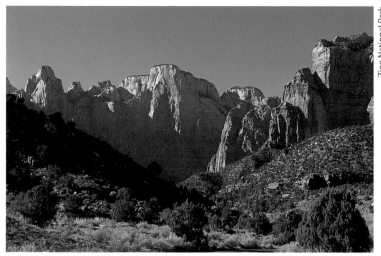

Zion National Park

S-117 Valley pass with mountains in distance

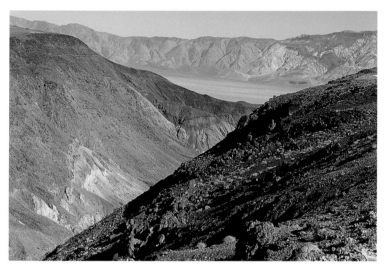

S-118 Arid mountain slopes

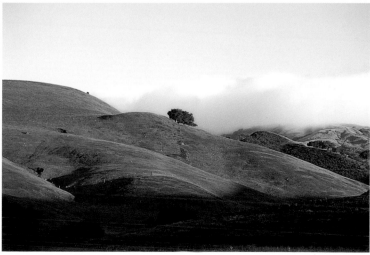

S-119 Foothills with early morning fog

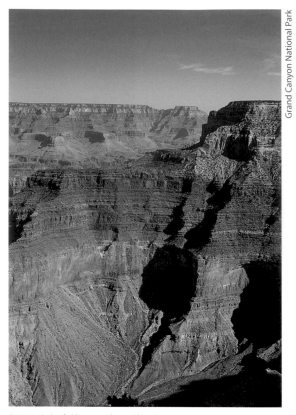

Grand Canyon National Park

S-120 Colorful layers of stratification

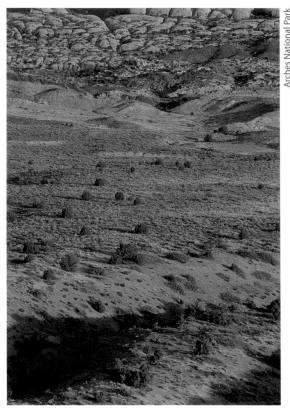

Arches National Park

S-121 Desert plateau with vegetation

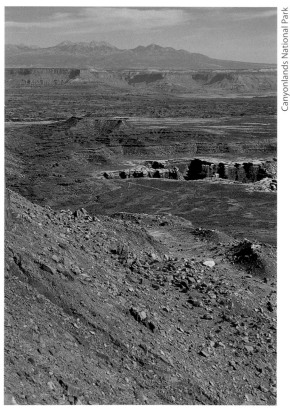

Canyonlands National Park

S-122 View of mesa and canyon opening from higher mesa

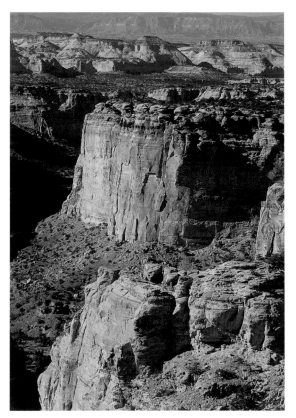

S-123 Multiple canyons and mesas

DESERTS, CANYONS, MESAS

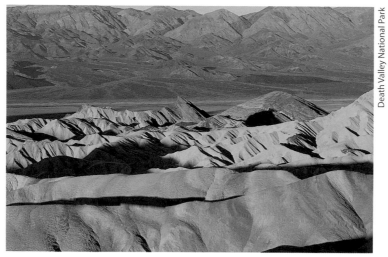

Death Valley National Park

S-124 Ridges of mudstone in badlands formation

S-125 Hilly desert landscape with arid vegetation

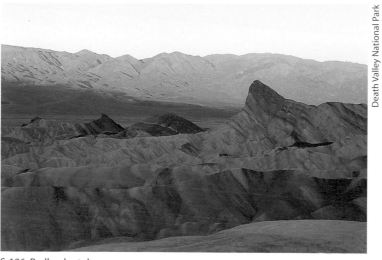

Death Valley National Park

S-126 Badlands at dawn

STONE, SAND, LAND

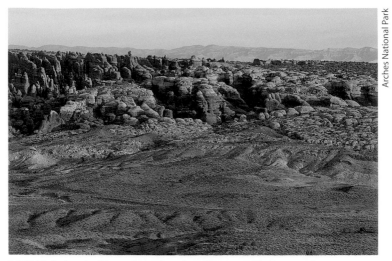

S-127 High desert with sandy wash and sandstone and limestone spires

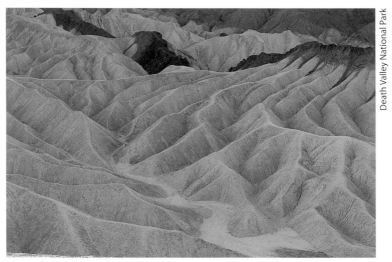

S-128 Arroyo winding through channels of alluvial gravel and sand

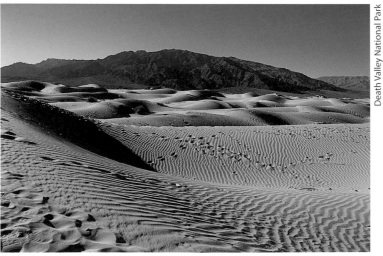

S-129 Desert sand dunes

DESERTS, CANYONS, MESAS

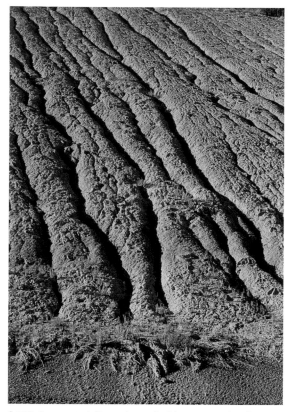

S-130 Compacted dirt and gravel with water erosion lines

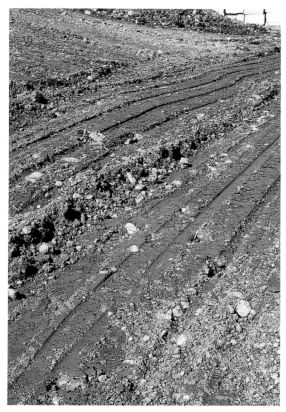

S-131 Tire tracks in rocky soil

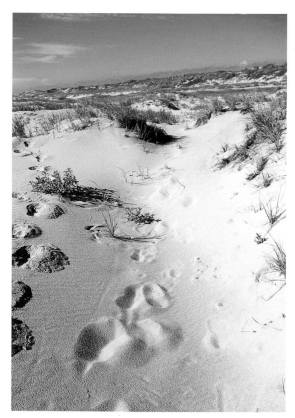

S-132 Beach sand dune with footprints

S-133 Wood chip mulch

S-134 Dry, cracked red dirt

S-135 Topsoil

S-136 Excavated section of soil showing buried stones

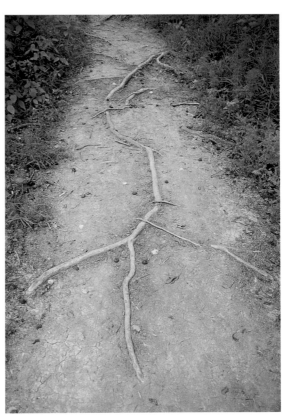

S-137 Dirt path with exposed roots

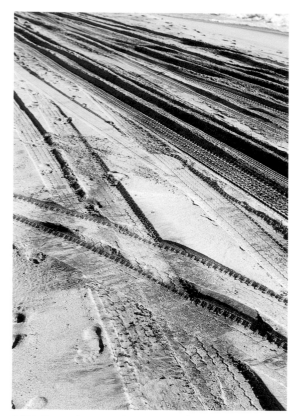

S-138 Tire tracks on sand beach

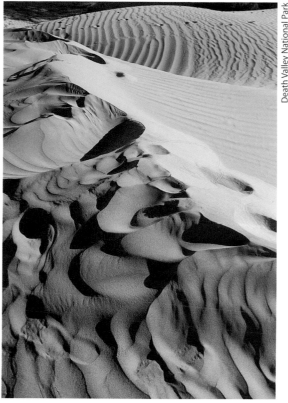

Death Valley National Park

S-139 Desert sand dune

S-140 Sand beach with clam shell

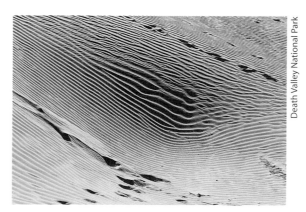

Death Valley National Park

S-141 Tracks and ripple marks in desert sand dune

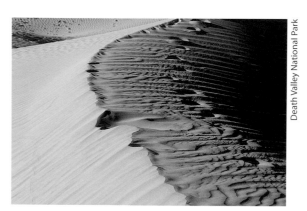

Death Valley National Park

S-142 Crescent-shaped desert sand dune

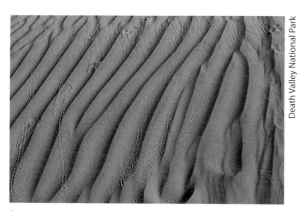

Death Valley National Park

S-143 Ripple marks and "sidewinder" tracks in desert sand dune

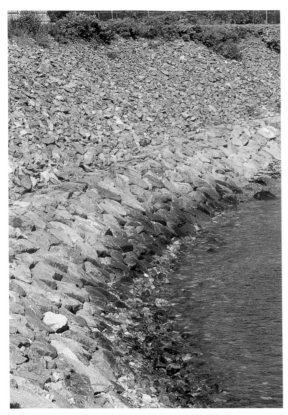

S-144 Rocks in shoreline embankment

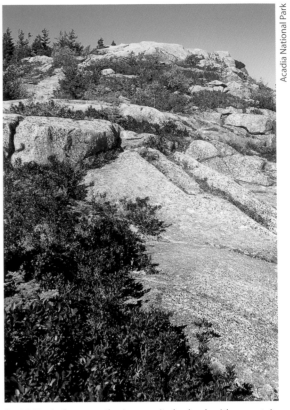

Acadia National Park

S-145 Rocks from weathering granite bedrock with mountain vegetation

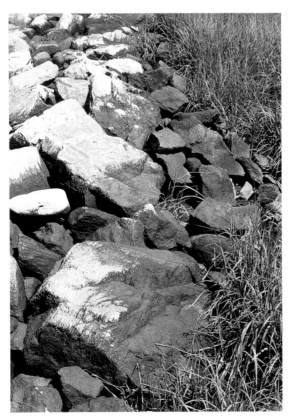

S-146 Angular rocks and grass

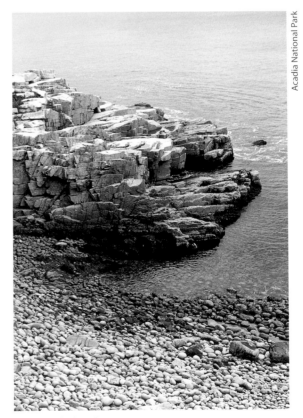

Acadia National Park

S-147 Rocky beach

S-148 Boulders surrounded by dried leaves

S-149 Lichen-covered rock

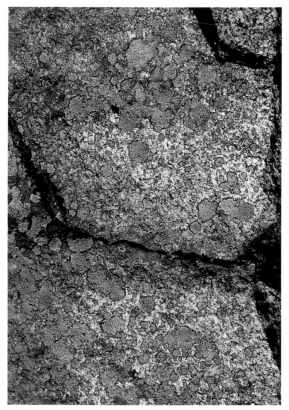

S-150 Lichen-covered rock

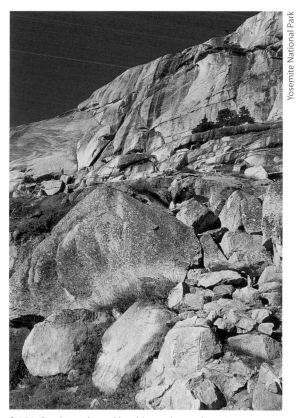

Yosemite National Park

S-151 Granite rocks and boulders at base of granite
mountain

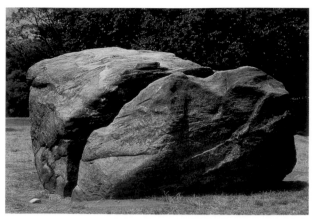

S-152 Large split boulder

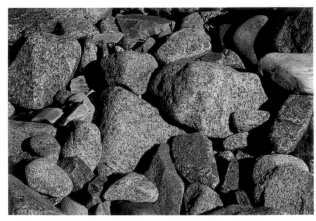

S-153 Pink granite and other rocks on rocky beach

S-154 Rocky ocean floor through water

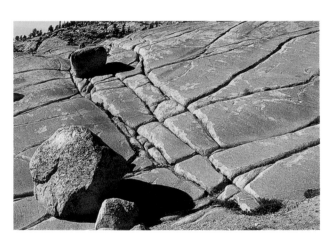

S-155 Boulders on bedrock weathered along joints

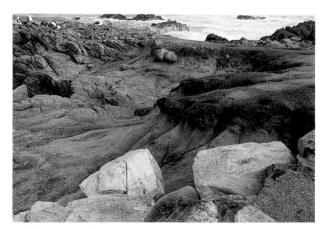

S-156 Large rock fragments on beach

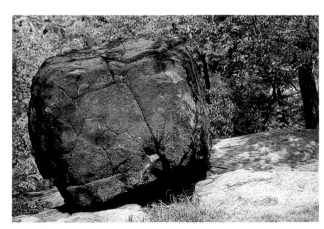

S-157 Erratic boulder (glacial deposit)

S-158 Gravel beach

S-159 Flagstone surrounded with gravel

S-160 "Bantam Egg" decorative gravel in garden pool

Photo: Duane Langenwalter

S-161 Exposed pebble aggregate concrete

PEBBLES & GRAVEL

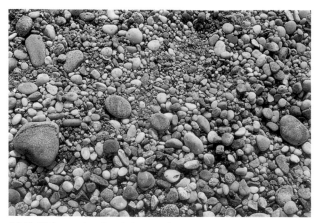

S-162 Pink gravel and rocks in mixed sizes

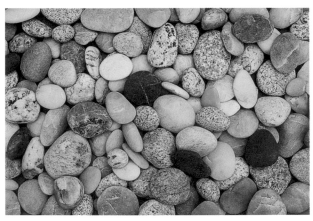

S-163 Assorted types of river rocks

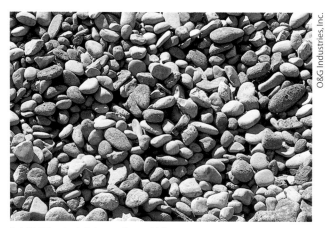

S-164 "Riverjacks" decorative pebbles

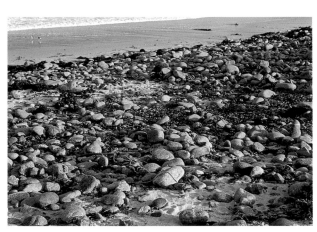

S-165 Large beach pebbles with seaweed

O&G Industries, Inc.

S-166 Large river rocks in garden pool

S-167 River rocks set in concrete

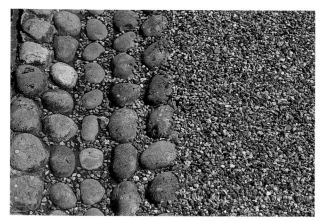

S-168 Rows of large pebbles with pea gravel

S-169 Pebbles set in concrete

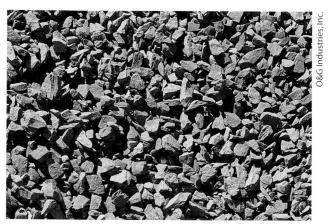

S-170 Barn-red decorative gravel

O&G Industries, Inc.

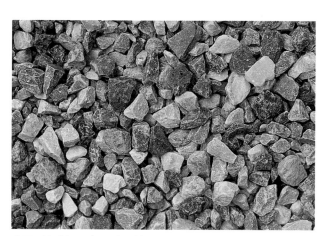

S-171 Marble and granite chip gravel

S-172 Trap rock gravel

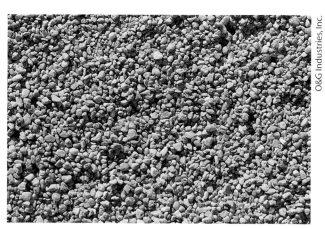

S-173 "Bantam Egg" decorative gravel

O&G Industries, Inc.

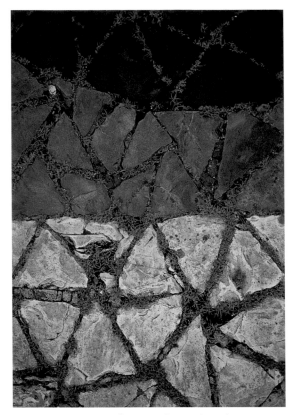

S-174 Decorative stone fragments in mosaic paving

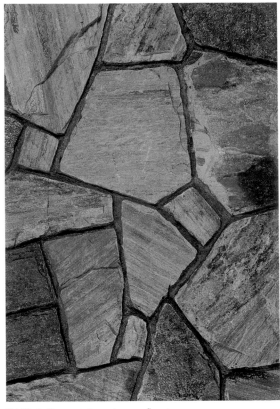

S-175 Split quartzite as terrace flagstone

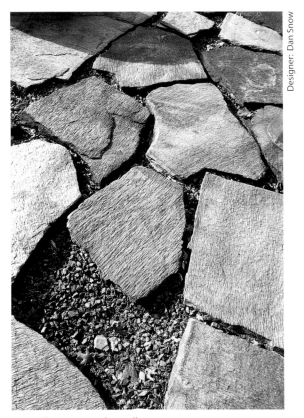

Designer: Dan Snow

S-176 Flagstone garden walk

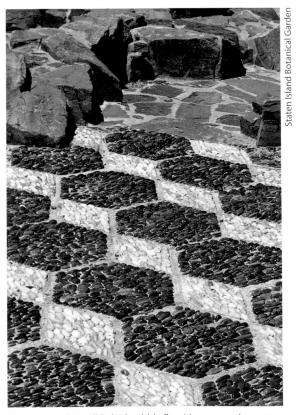

Staten Island Botanical Garden

S-177 *Luan shi pu di* (inlaid pebble floor) in geometric pattern (front) with *Huangshi* (brown granite) rocks and flagstones

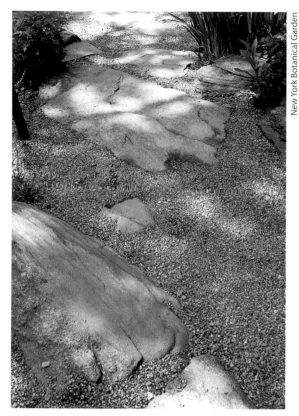

New York Botanical Garden

S-178 Garden path with large stepping stones surrounded by gravel

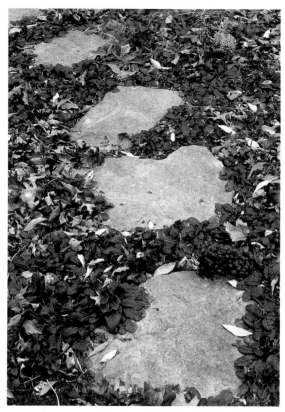

S-179 Flagstone path surrounded by autumn leaves

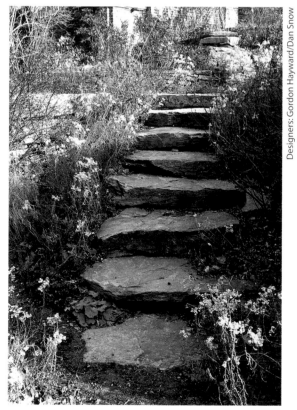

Designers: Gordon Hayward/Dan Snow

S-180 Flagstone garden steps

S-181 Cobblestone walk

Beeby Garden

S-182 Cut stone path with foliage border

DuVal Garden, Plant Specialists

S-183 Steppingstones surrounded by Mexican beach pebbles

S-184 Gravel path through lawn of formal garden

Beeby Garden

S-185 Fieldstone steps and garden boulders surrounded by pachysandra and ivy

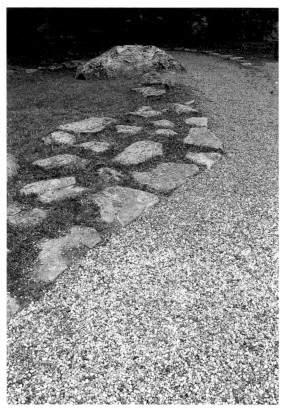

S-186 Gravel and flagstone garden path

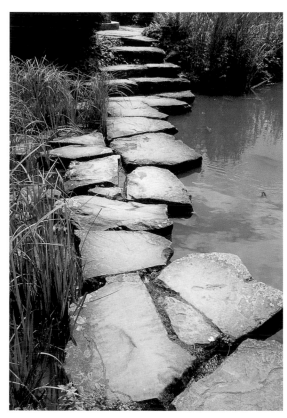

S-187 Steppingstone bridge in garden pond

Beeby Garden

S-188 Flagstones on garden path

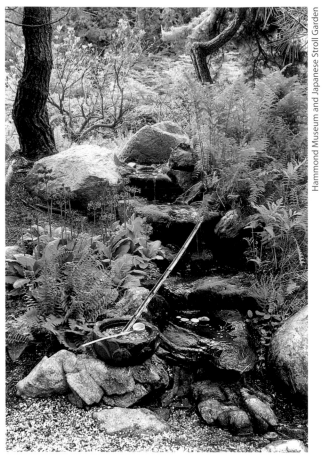

Hammond Museum and Japanese Stroll Garden

S-189 *Chozubachi* (stone basin) in Japanese garden

S-190 Fieldstone garden wall with stone steps

Battery Park Esplanade

S-191 Boulders fitted to cut granite steps lead to paving stones bordered by ornamental grass in urban park

Fort Tryon Park, New York City

S-192 Stone wall cut from large rock and augmented with shaped stone in urban park

S-193 Stone wall constructed from fieldstone and cobbles set in concrete

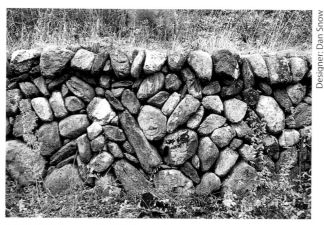

Designer: Dan Snow

S-194 Fieldstone wall laid in herringbone pattern

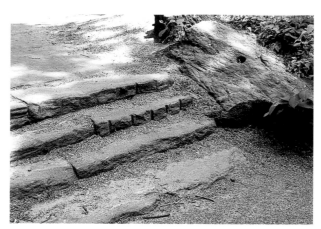

S-195 Rustic stone steps in urban park

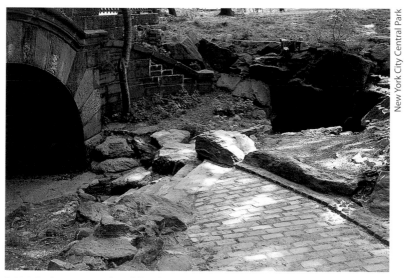

New York City Central Park

S-196 Paving stone park walk bordered with large fieldstones

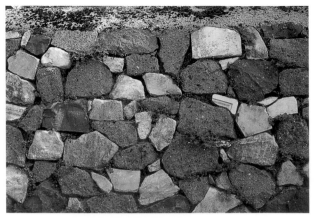

S-197 Stone and ancient marble rubble used in stone wall

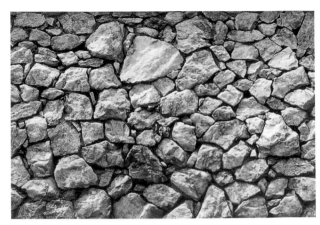

S-198 Carnation Pink marble in mortared rubble wall

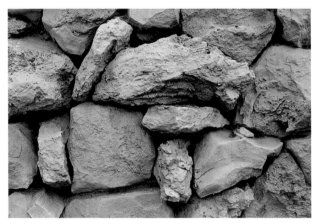

S-199 Fieldstone wall

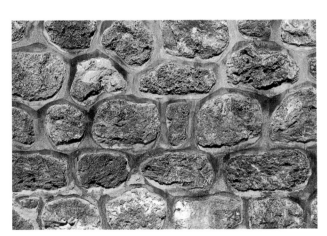

S-200 Split fieldstone in mortared wall

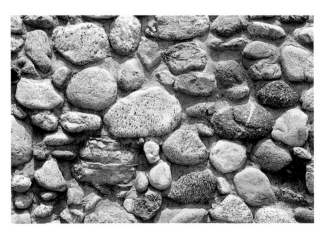

S-201 Fieldstone and cobbles in mortared stone wall

S-202 Fieldstone and cut stone in mortared wall

S-203 Fieldstone wall with old split granite fence post

Designer: Dan Snow

S-204 Fieldstone and cobbles in mortared stone wall

S-205 Bedrock and cut stone wall

S-206 Fieldstone embedded in concrete garden wall with trailing ivy leaf geranium

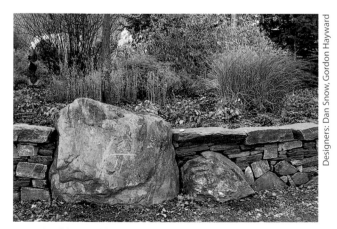

S-207 Boulders and fieldstone in garden wall

Designers: Dan Snow, Gordon Hayward

S-208 Boulders and fieldstone in dry wall

Stonecrop Gardens

S-209 Raised limestone rock garden in bloom

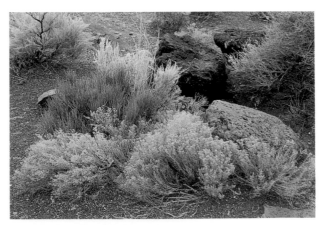

S-210 Rock garden with desert plants

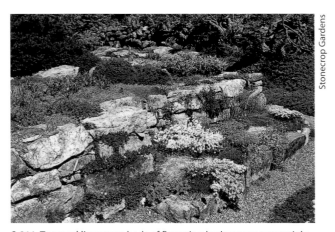

Stonecrop Gardens

S-211 Terraced limestone beds of flowering herbaceous perennials

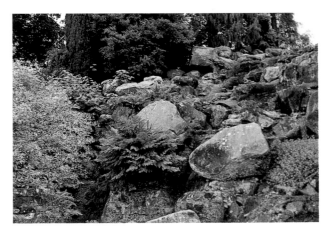

S-212 Rock garden on bedrock with perennials and evergreens

S-213 Random fieldstone retaining wall with ivy

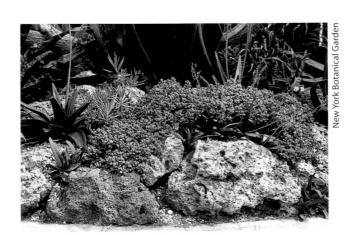

New York Botanical Garden

S-214 Rock garden with desert plants

S-215 Rocks covered with creeping plants in tropical garden

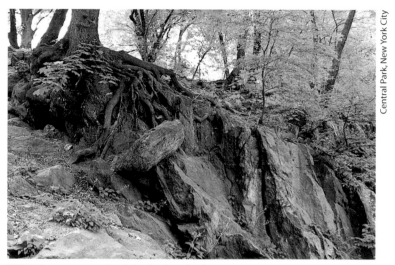

Central Park, New York City

S-216 Tree roots growing in bedrock embankment

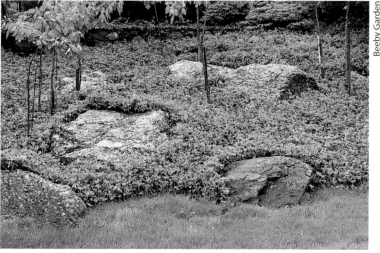

Beeby Garden

S-217 Scattered boulders surrounded with pachysandra and grass

S-218 Agave on bedrock garden

Stonecrop Gardens

S-219 Waterfall in terraced rock garden with Japanese maple in spring aspect

New York Botanical Garden

S-220 Meandering stream in rock garden bordered by flowering perennials

Central Park, New York City

S-221 Outcrop covered with ivy

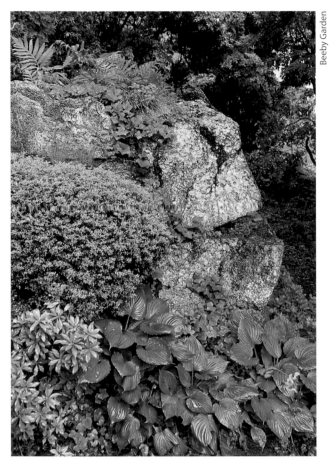

Beeby Garden

S-222 Boulders in perennial garden

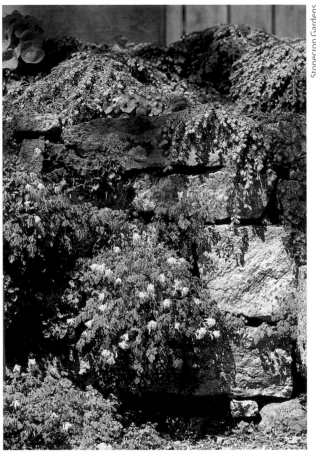

Stonecrop Gardens

S-223 Raised limestone bed with rock garden flowers and evergreens

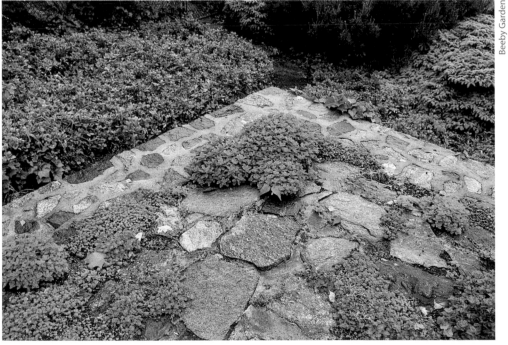

Beeby Garden

S-224 Garden walk with creeping and border perennials

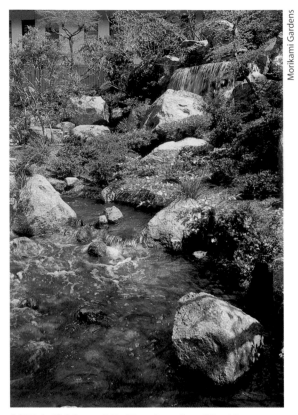

Morikami Gardens

S-225 Artificial waterfall with rocks and small boulders

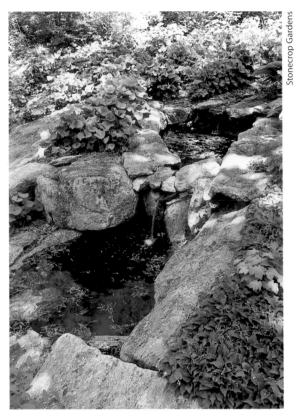

Stonecrop Gardens

S-226 Small waterfall in rock garden

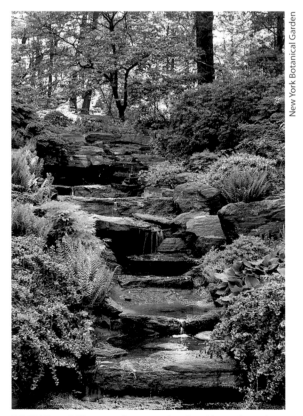

New York Botanical Garden

S-227 Water falling over flat stones bordered by rock garden plants

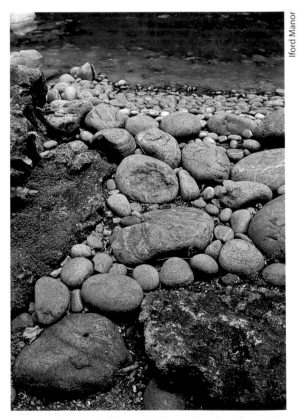

Iford Manor

S-228 Varying sized of river rocks form edge of garden pool

S-229 Bluestone swimming pool surround with bullnose edge

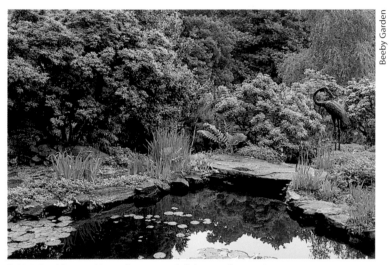

Beeby Garden

S-230 Boulders and large flat stones defining garden pool

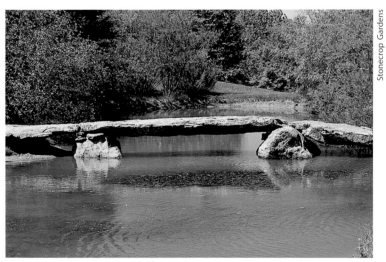

Stonecrop Gardens

S-231 Bridge made of slabs of rough-hewn stone set on boulders

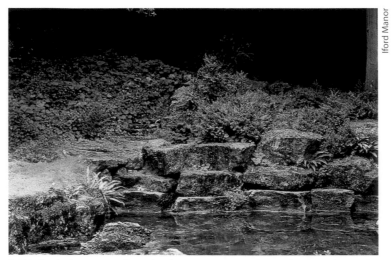

Iford Manor

S-232 Stacked cut stone planted with moss and water plants edging garden pool

S-233 Garden pool of pebbles set in concrete

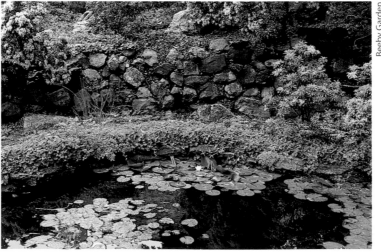

Beeby Garden

S-234 Fieldstone wall surrounds garden pool planted with water lilies

S-235 Statue in garden-wall niche carved from sedimentary bedrock

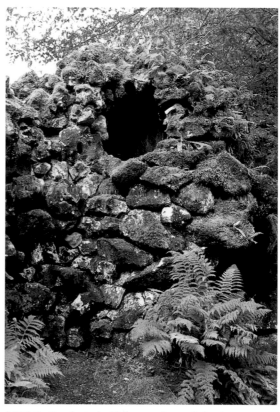

S-236 Grotto planted with ferns and moss in landscape garden

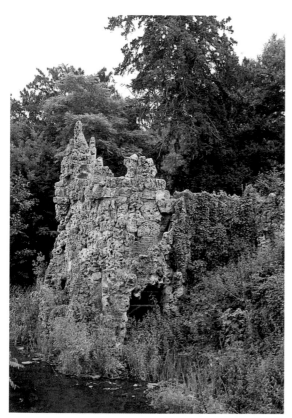

S-237 "Castle ruins" folly in landscape garden

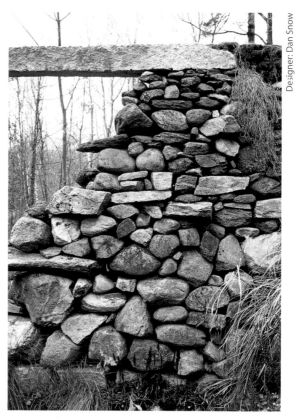

Designer: Dan Snow

S-238 Garden structure with fieldstone and cut granite beam

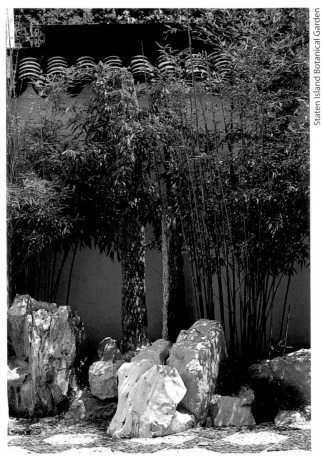

S-239 Room of *taihu shi* limestone rocks with bamboo in Chinese scholar's garden

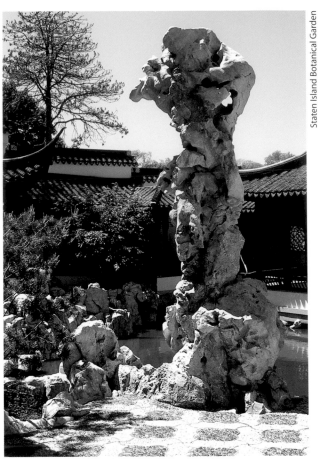

S-240 Limestone formation as sculptural focus of courtyard in Chinese scholar's garden

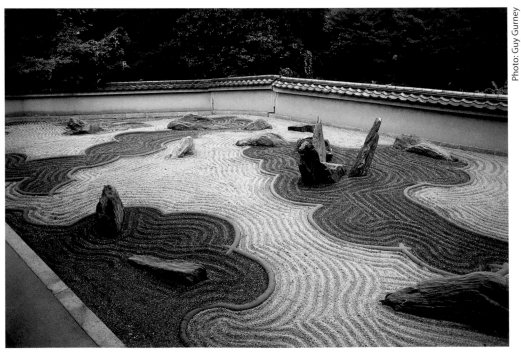

S-241 Japanese Zen garden with stones set in light and dark raked gravel

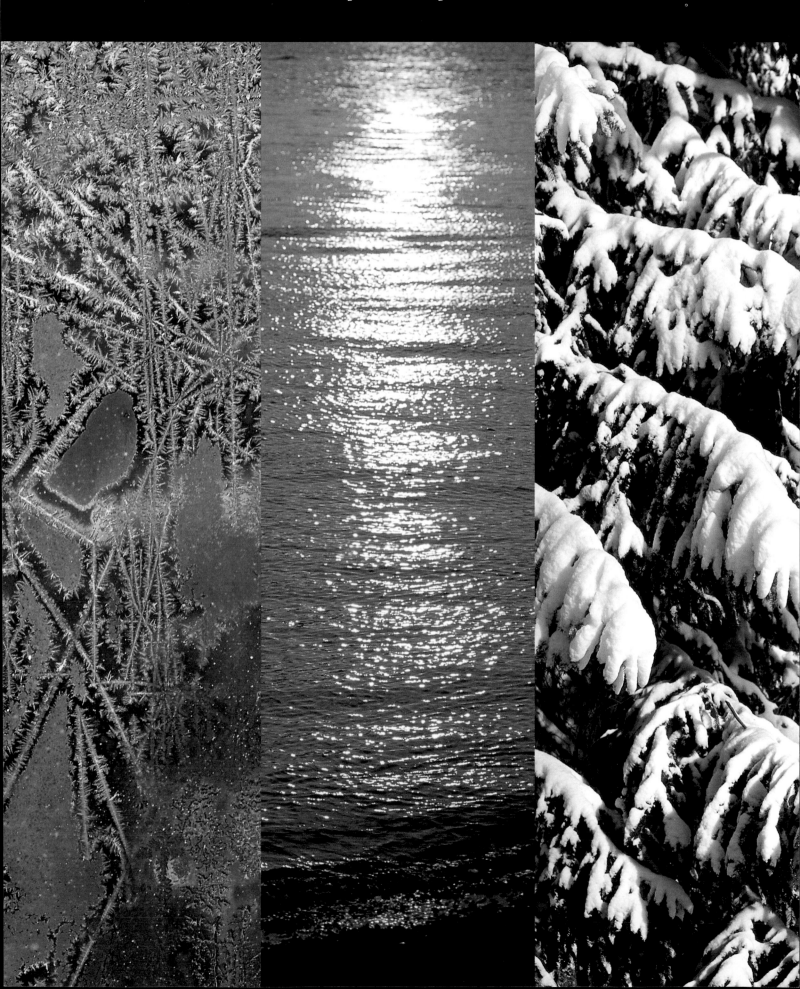

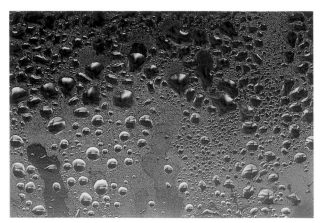

W-1 Water droplets on glass

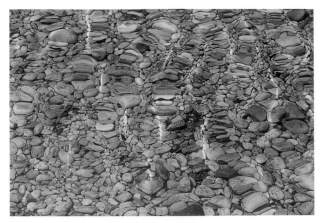

W-2 River rocks seen through water

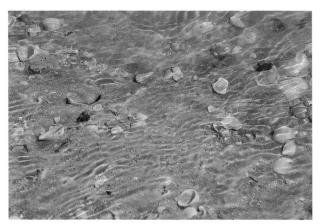

W-3 Sand and shells seen through water

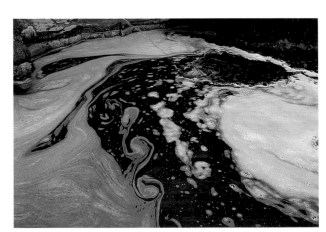

W-4 Foaming water at base of waterfall

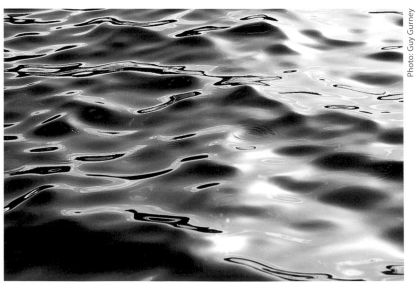

W-5 Ocean surface

Photo: Guy Gurney

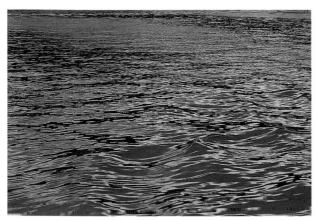

W-6 Ocean surface

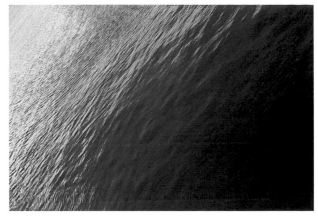

W-7 Water surface

W-8 Sandy ocean bottom

W-9 Ripples in pool

W-10 Water plants in pond

W-11 Reflections on water surface

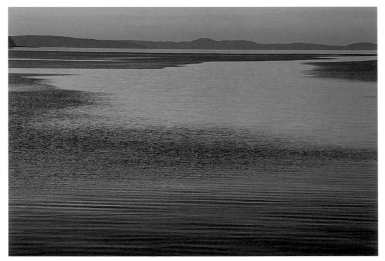

W-12 Wind ripples on water surface

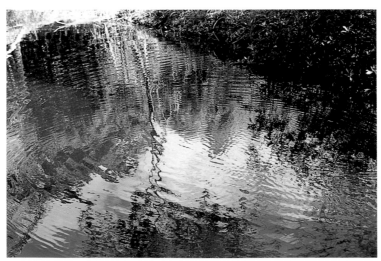

W-13 Trees reflected on pond

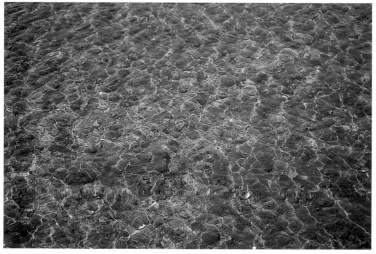

W-14 Water surface

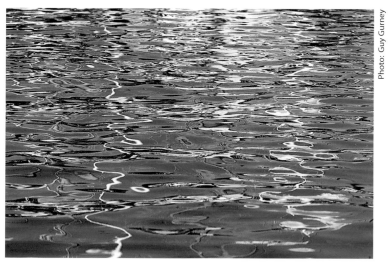

Photo: Guy Gurney

W-15 Reflections on water

W-16 Swimming pool

W-17 Reflections of dock and buildings

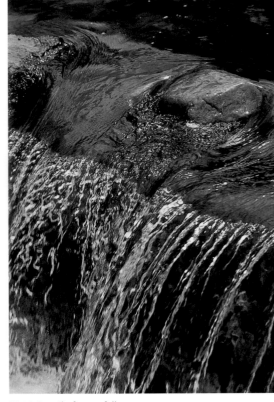

W-18 Detail of waterfall

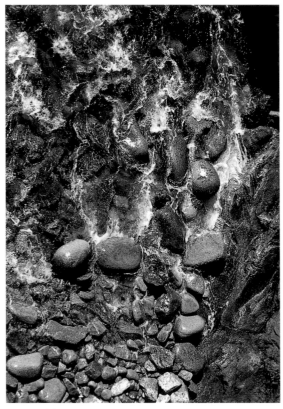

W-19 Tidal water on rocks

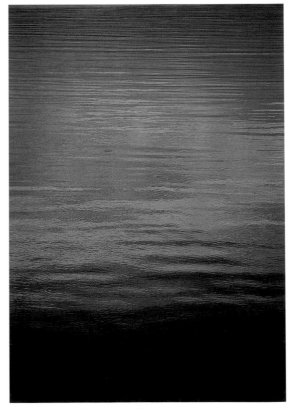

W-20 Sunset reflected on still water

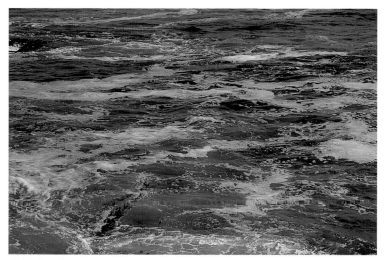

W-21 Rough water

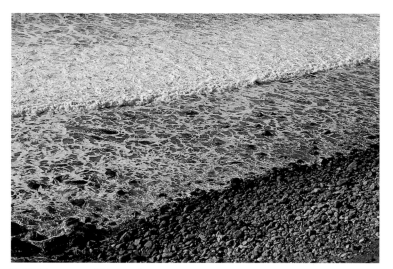

W-22 Waves on pebble beach

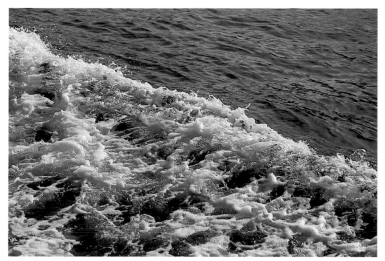

W-23 Waves breaking on shore

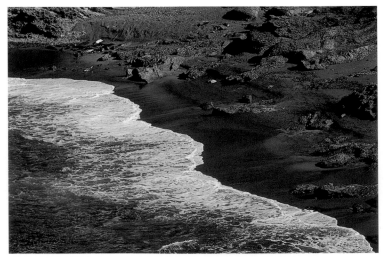

W-24 Waves on shoreline

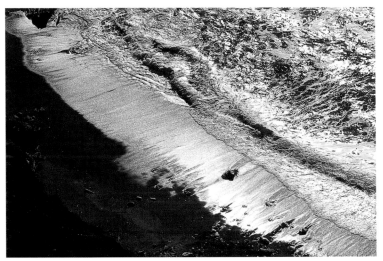

W-25 Waves on black sand beach

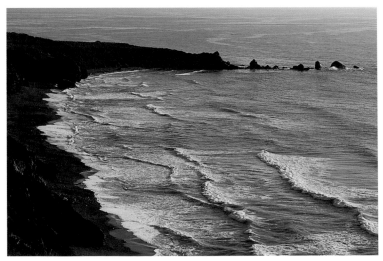

W-26 Multiple waves on shoreline

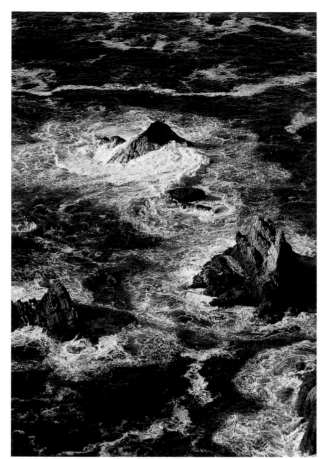

W-27 Waves breaking on rocks

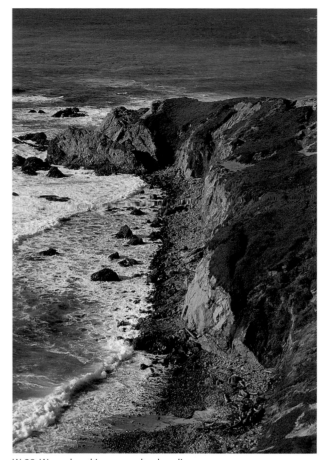

W-28 Waves breaking on rocky shoreline

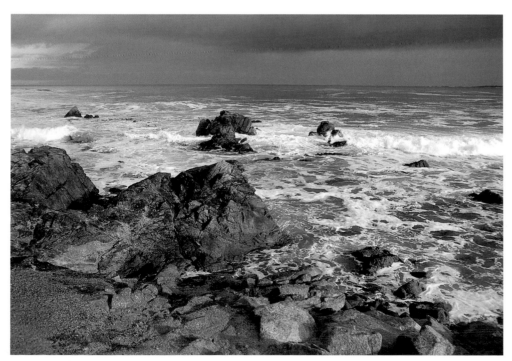

W-29 Waves breaking on rocky shoreline

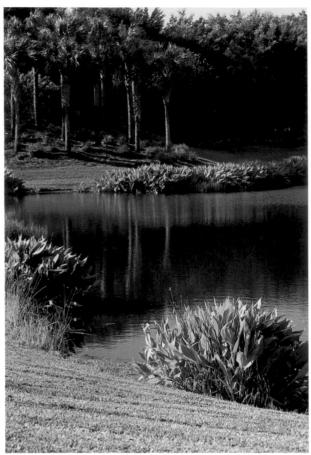

W-30 Man-made pond with tropical water plants

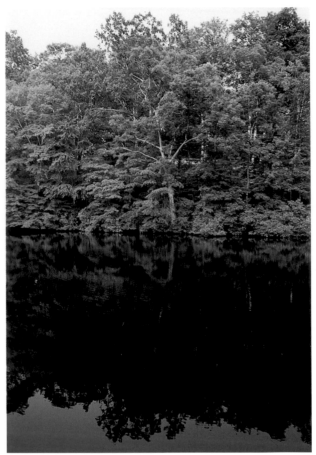

W-31 Trees reflected in river

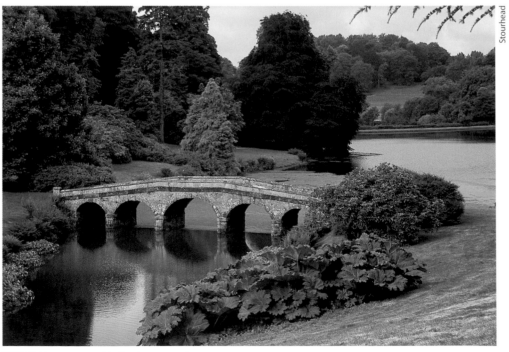

Stourhead

W-32 Bridge over pond in landscape garden

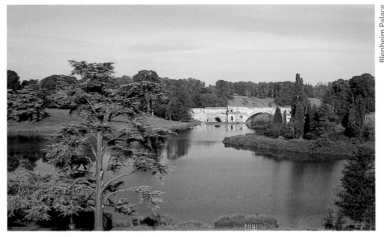

Blenheim Palace

W-33 Artificial lake in front of palace

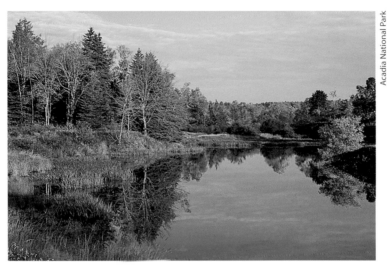

Acadia National Park

W-34 Woodland lake surrounded with trees in fall color

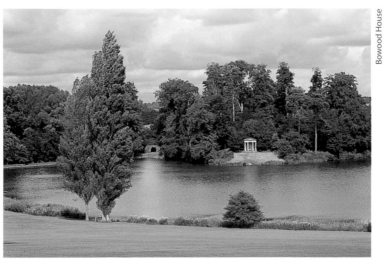

Bowood House

W-35 Lake with Doric temple folly in landscape garden

W-36 Palm trees reflected in pond

W-37 Water plants in woodland pond

W-38 Algae in woodland pond

W-39 Garden stream made from stones, bordered by wildflowers

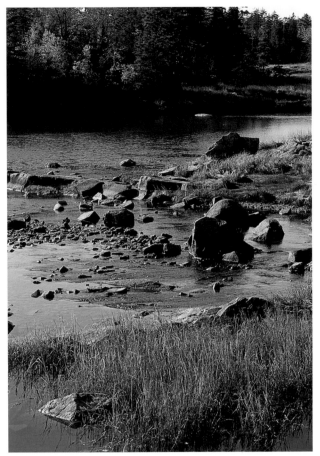

W-40 Rocky stream

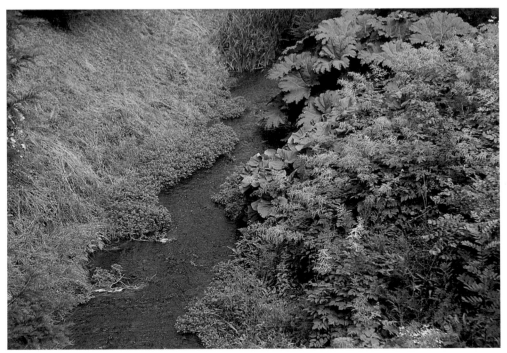

W-41 Garden stream surrounded by foliage

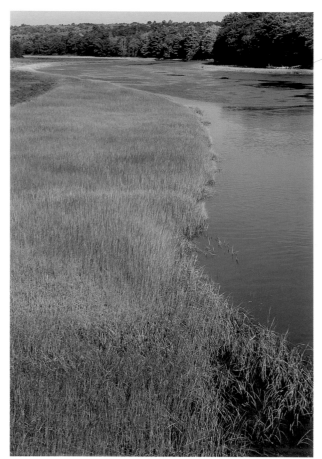

W-42 Tidal river bordered by aquatic grass

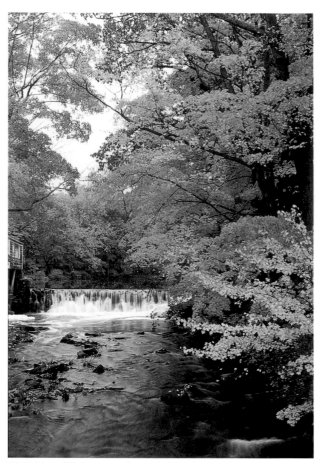

W-43 Waterfall, stream, and trees in fall color

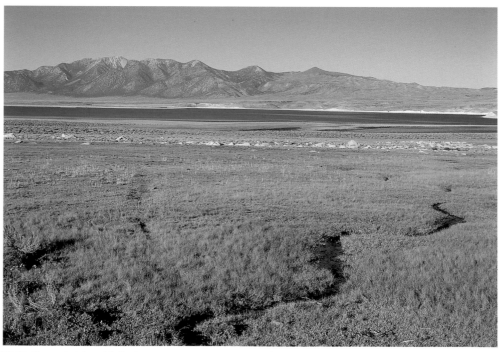

W-44 Mountain lake with feeder stream

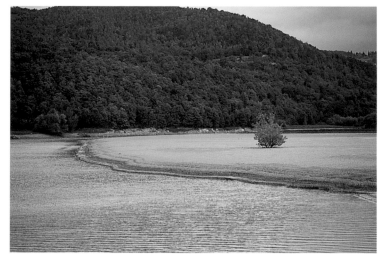

W-45 Bend in a river

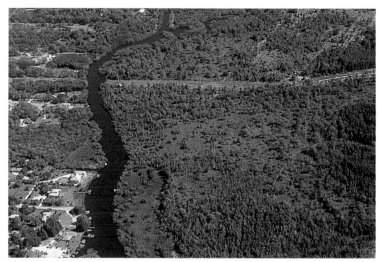

W-46 Aerial view of Everglades waterways

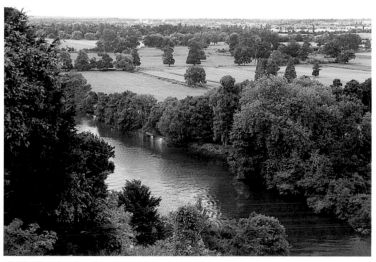

W-47 River bordered by trees and countryside

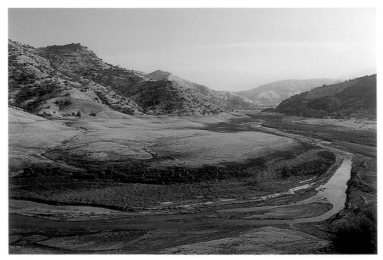

W-48 River valley surrounded by mountains

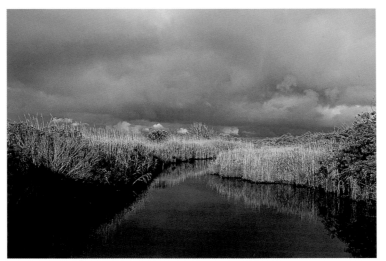

W-49 Waterway through grass marsh

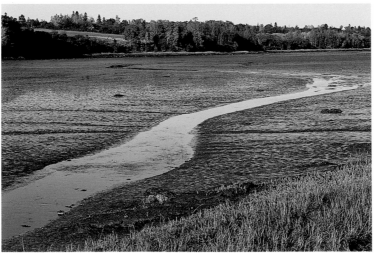

W-50 Tidal river at low tide

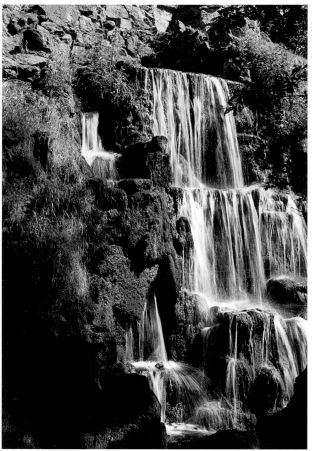

Bowood House

W-51 Waterfall with moss-covered rocks

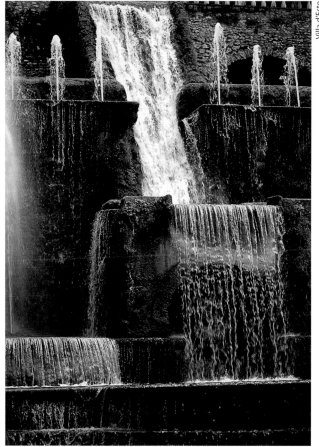

Villa d'Este

W-52 Waterfall and fountains

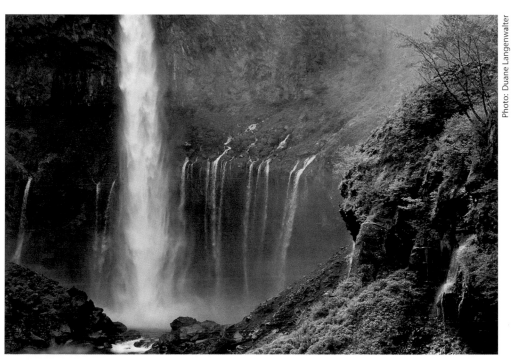

Photo: Duane Langenwalter

W-53 Multiple waterfalls in valley

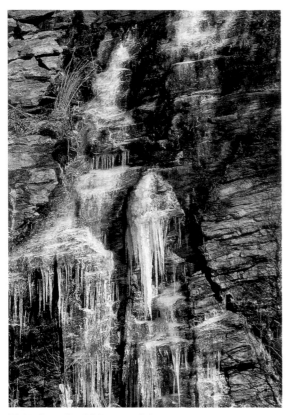

W-54 Cascading icicles on rock face

W-55 Icicles outside of window

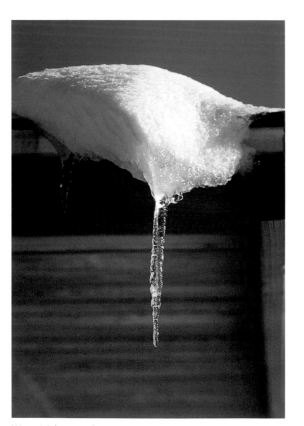

W-56 Icicle on melting snow

W-57 Icicles on rock crevice

W-58 Icicles on roof

W-59 Icicles on roof

W-60 Icicles on fountain

W-61 Detail of icicles

Photo: Guy Gurney

W-62 Snow and icicles on roof

W-63 Ice-covered branch

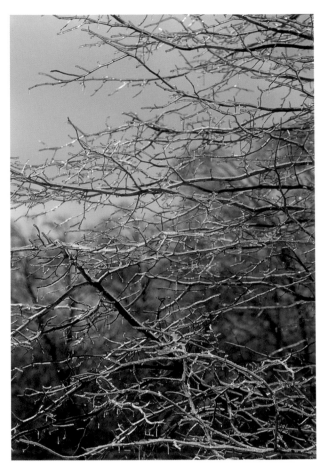

W-64 Ice-covered branches

W-65 Cracked ice on pond

ICE

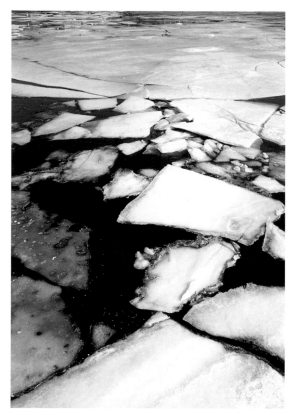

W-66 Ice breaking up in frozen river

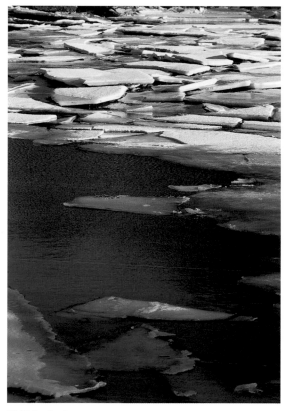

W-67 Ice in river

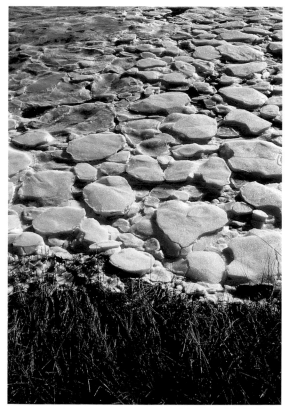

W-68 Ice dam

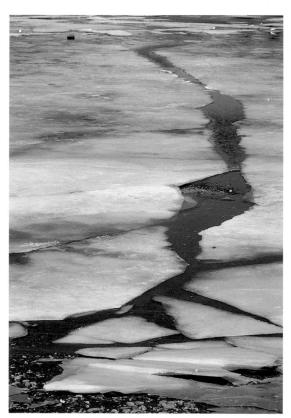

W-69 Ice breaking up in frozen river

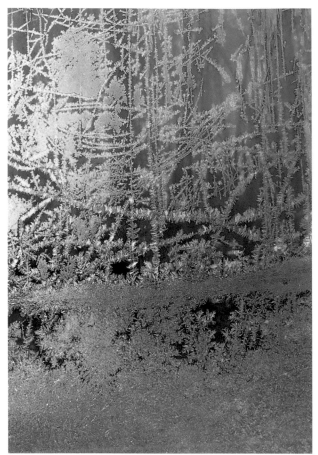

W-70 Frost crystals on glass

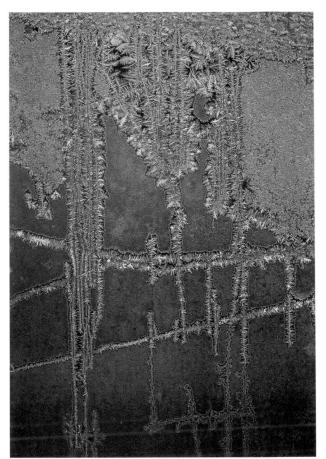

W-71 Frost crystals on glass

W-72 Frozen condensation on glass

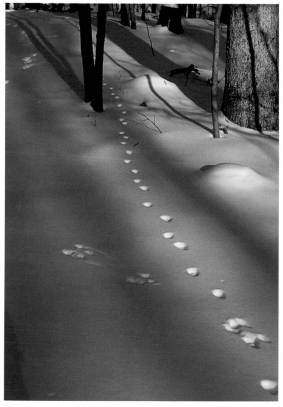

W-73 Animal tracks in snow

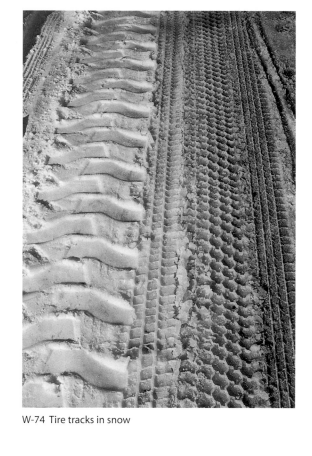

W-74 Tire tracks in snow

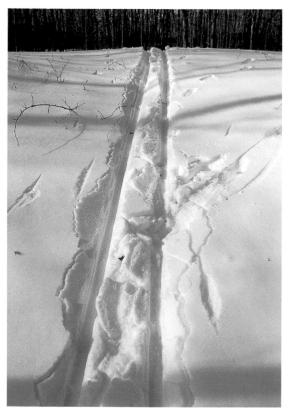

W-75 Ski tracks in snow

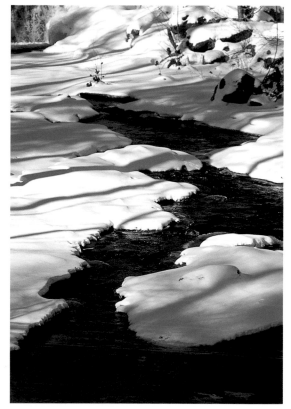

W-76 Snow-covered stream

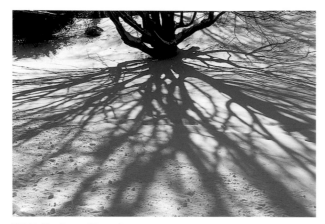

W-77 Shadows of branches on snow

W-78 Snow pile

W-79 New snow

W-80 Sunset reflected on snow

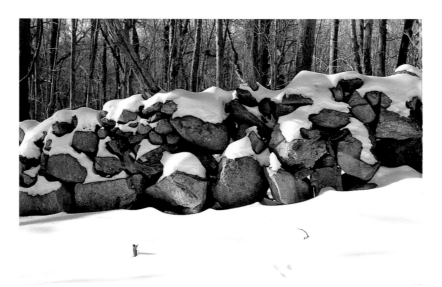

W-81 Fieldstone wall covered with snow

W-82 Detail of snow on branches

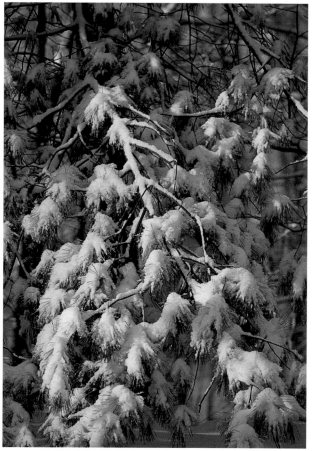

W-83 Detail of snow on pine branches

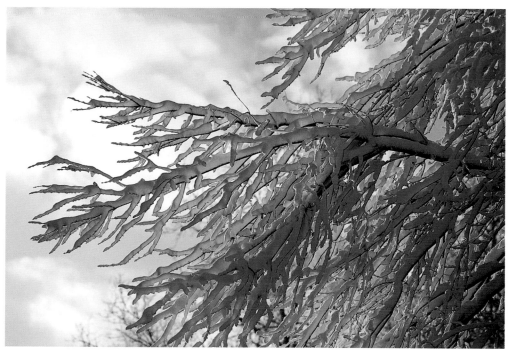

W-84 Snow-covered branches reflecting sunrise

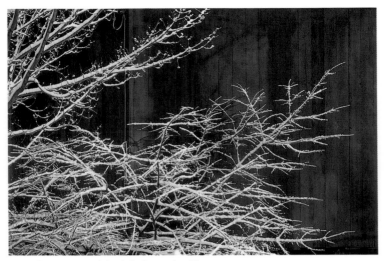

W-85 Snow-covered shrub in front of red barn

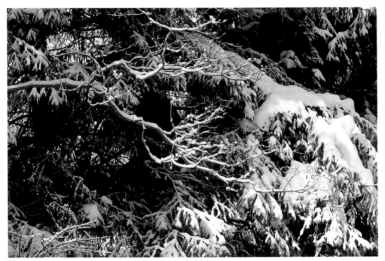

W-86 Detail of snow on pine branches

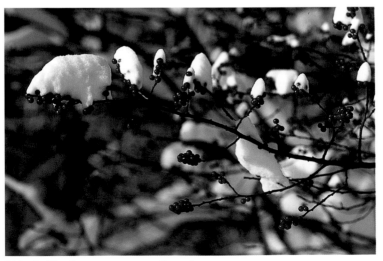

W-87 Red berries on snow-covered branch

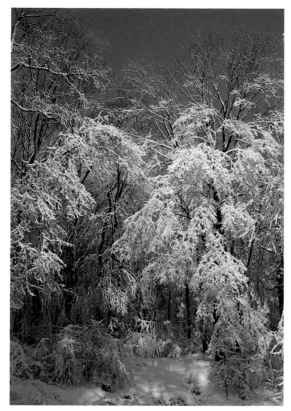

W-88 Snow-laden trees reflecting sunrise

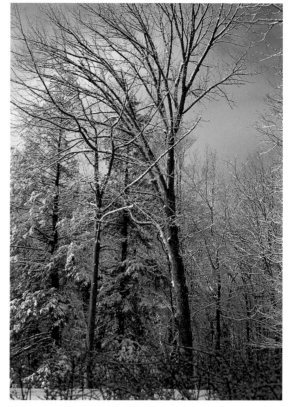

W-89 Forest in snow

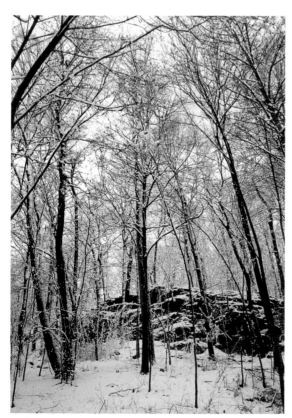

W-90 Forest in snow

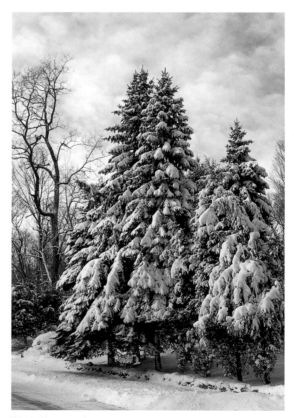

W-91 Pine trees in snow

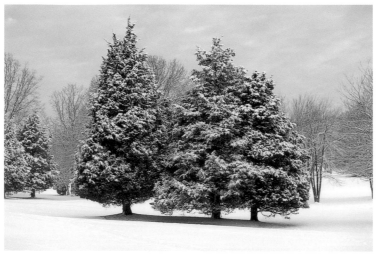

W-92 Pine trees in snow

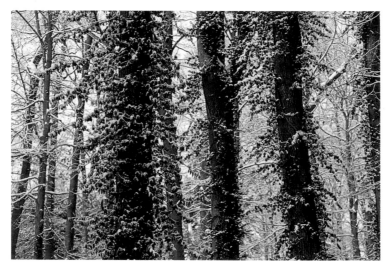

W-93 Trees covered with ivy and snow

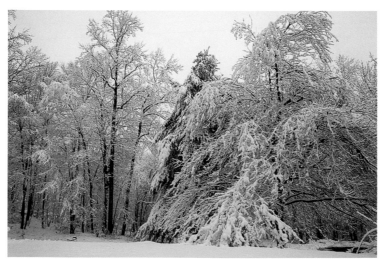

W-94 Forest in snow

W-95 Picket fence

W-96 Split-rail fence

W-97 Lattice fence and post

W-98 Cable and wood fence

W-99 Metal fence and post

W-100 Blockade-style fence with snow-covered foliage

W-101 Ornate fence post

W-102 Base of bronze-patinaed lamp post covered with snow

W-103 Fire hydrant in snow

W-104 Tombstone in snow

W-105 Snow between paving stones

W-106 Snow-covered tree in front of brick house

W-107 Snow and ice on slate roof

W-108 Snow on front stoop with icicles hanging from roof

W-109 Snow on dormer window and roof

W-110 Wreath and barn covered with snow

W-111 Snow-covered shrubs and rustic door

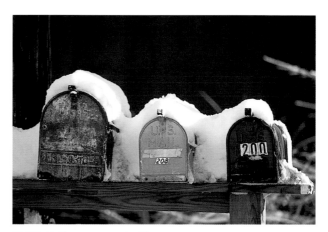

W-112 Mailboxes covered with snow

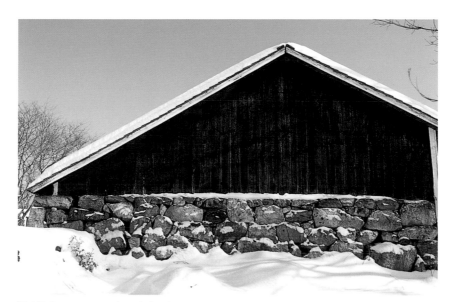

W-113 Barn on stone foundation in snow

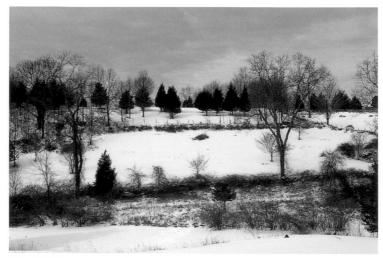

W-114 Fields and pasture in snow

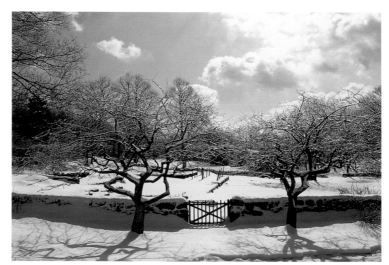

W-115 Garden entrance with ice-covered trees in snow

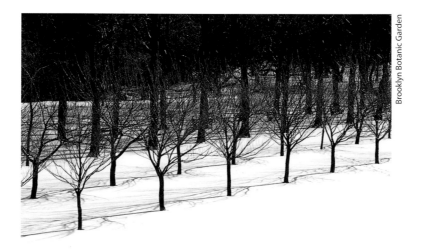

Brooklyn Botanic Garden

W-116 Allée of deciduous trees in snow

SNOW

SC-1 Blue sky with cumulus (top and right) and stratus clouds

SC-2 Blue sky with cirrocumulus clouds (top) and building thunder-head in cumulonimbus clouds

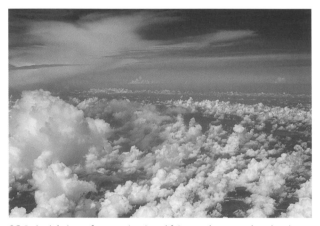

SC-3 Aerial view of stratus (top) and fair-weather cumulus clouds below

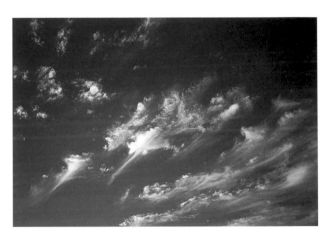

SC-4 Blue sky with cirrus clouds

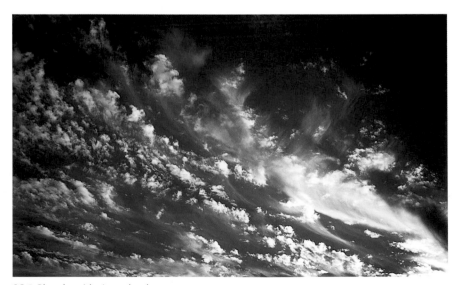

SC-5 Blue sky with cirrus clouds

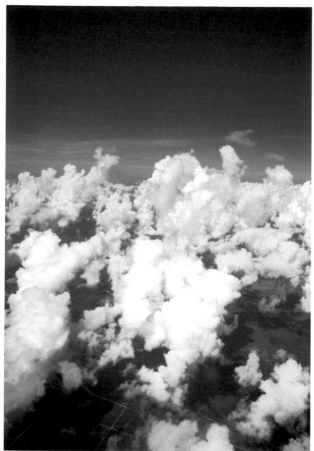

SC-6 Aerial view of blue sky with fair-weather cumulus clouds

SC-7 Fair-weather cumulus clouds

SC-8 Blue sky with cumulonimbus clouds

SC-9 Blue sky with cumulonimbus clouds

SC-10 Blue sky with cumulus clouds

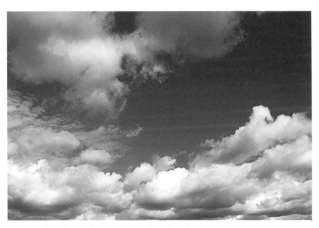

SC-11 Blue sky with stratocumulus clouds

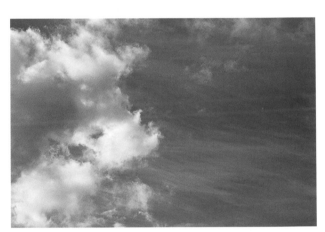

SC-12 Detail of cirrus cloud

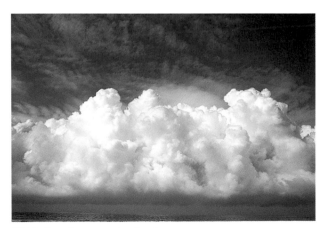

SC-13 Cumulus congestus clouds over ocean

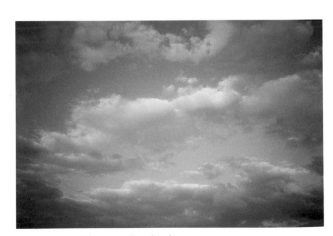

SC-14 Fair-weather cumulus clouds

SC-15 Scattered cumulus clouds in evening sky

SC-16 Cumulus clouds reflecting sunset

SC-17 Cumulus clouds reflecting sunset

SC-18 "Mare's tail" cirrus cloud in blue sky

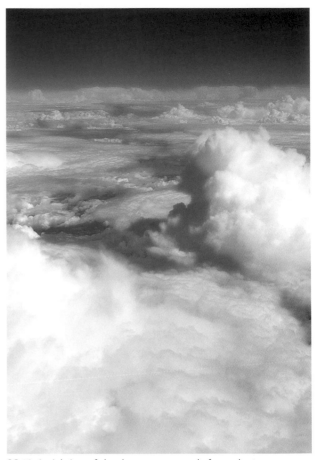

SC-19 Aerial view of cloudscape composed of cumulus towers

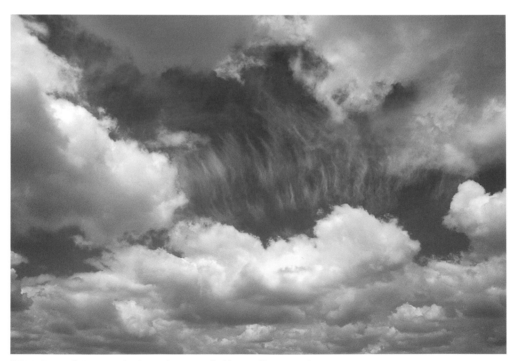

SC-20 Rows of cirrocumulus (center) surrounded by swelling cumulus

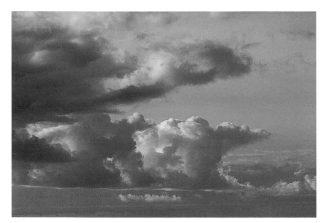

SC-21 Cumulonimbus with building anvil thunderhead

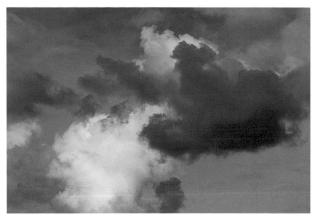

SC-22 Cumulonimbus clouds before shower

SC-23 Cumulonimbus in stormy sky

SC-24 Cumulonimbus cloud shelf in stormy sky

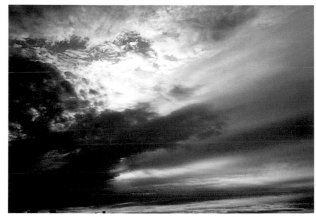

SC-25 Cirrocumulus (top right) and stratocumulus clouds in gray evening sky

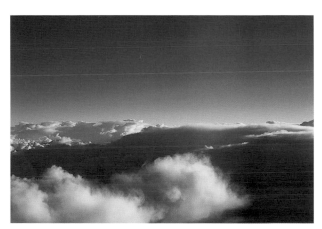

SC-26 Aerial view of cloudscape with cumulus clouds in blue sky

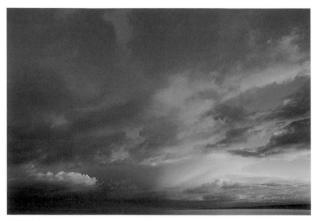

SC-27 Cumulus and stratocumulus clouds reflecting sunset

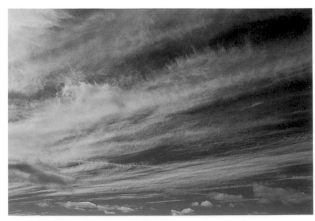

SC-28 Stratocumulus (top) and cirrostratus clouds in blue sky

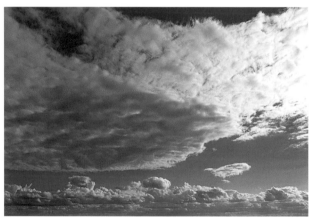

SC-29 Altocumulus (top) with fair-weather cumulus clouds

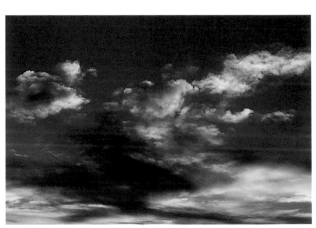

SC-30 Stratus (bottom) with cumulus clouds in evening sky

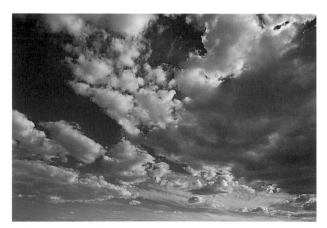

SC-31 Rapidly swelling cumulus (top) with stratus clouds

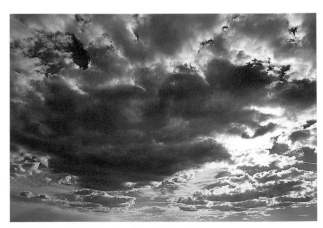

SC-32 Cumulonimbus cloud backlighted by sun

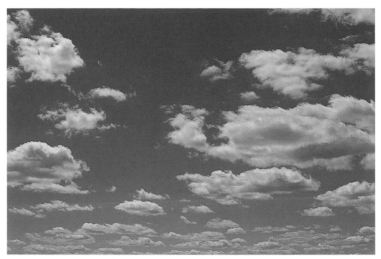

SC-33 Fair-weather cumulus clouds

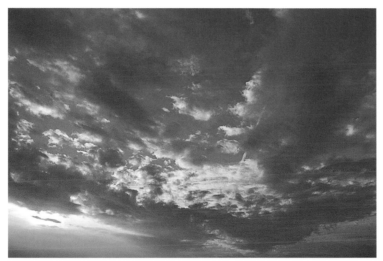

SC-34 Cumulonimbus clouds at sunset

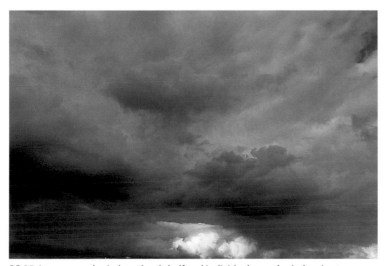

SC-35 Large cumulonimbus cloud shelf and individual cumulonimbus in stormy sky

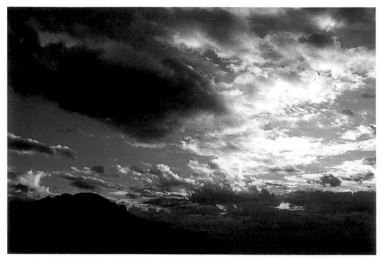

SC-36 Cumulonimbus and stratocumulus clouds in early morning sky

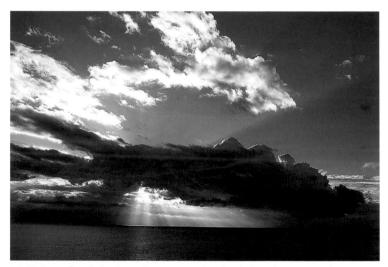

SC-37 Rays of sunlight through stratocumulus clouds in early morning sky over water

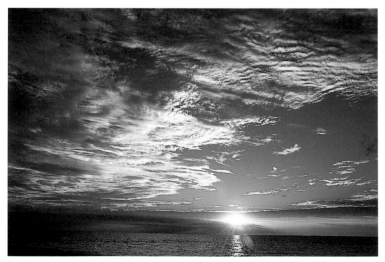

SC-38 Layers of clouds with rays of the setting sun over ocean

SC-39 Pink and lavender stratocululous clouds in blue evening sky with trees in silhouette

SC-40 Scattered puffs of fair-weather cumulus clouds reflecting sunset with tree in silhouette

SC-41 Mesa landscape against sky with cirrus and stratocumulus clouds

SC-42 Lavender sky with pink clouds

SC-43 Sky with colors from dark violet to orange

SC-44 Trees silhouetted against pink and orange clouds and blue sky

SC-45 Rapidly swelling cumulus clouds in stormy sky over sand dunes

SC-46 Cumulus and stratus clouds in blue sky over ocean

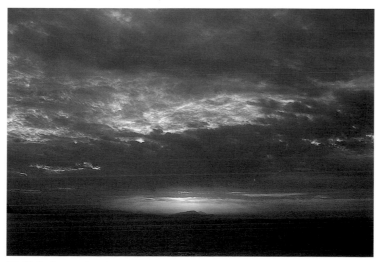

SC-47 Early morning sky

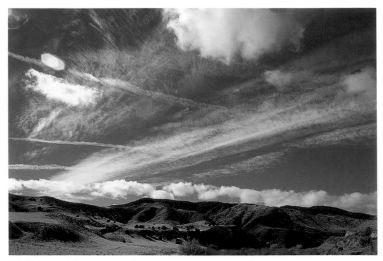

SC-48 Contrail intersecting cirrus and stratocumulus clouds

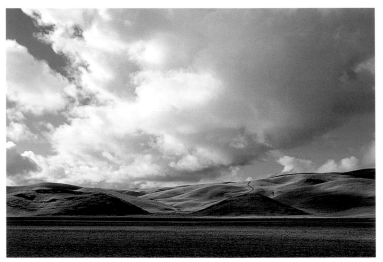

SC-49 Blue sky with swelling cumulus clouds over grass-covered foothills

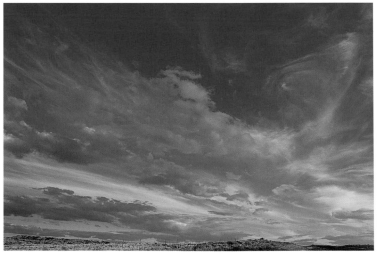

SC-50 Cirrus and stratocumulus clouds in desert sky

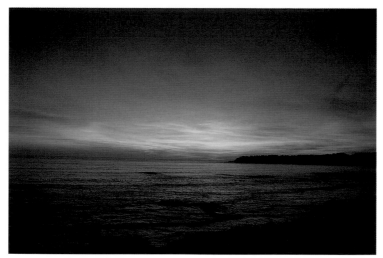

SC-51 Fiery sunset reflected on ocean

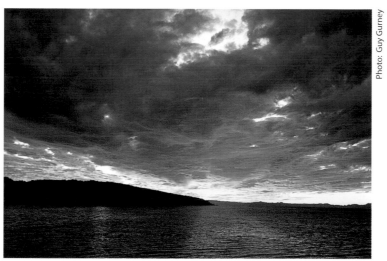

Photo: Guy Gurney

SC-52 Multicolored clouds at sunset over land and water

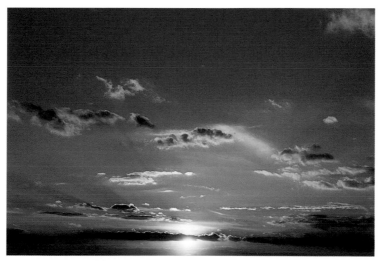

SC-53 Sun setting behind clouds

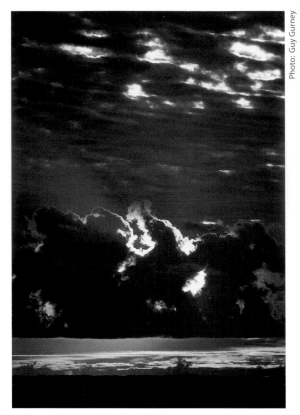

Photo: Guy Gurney

SC-54 Cumulonimbus clouds silhouetted by setting sun

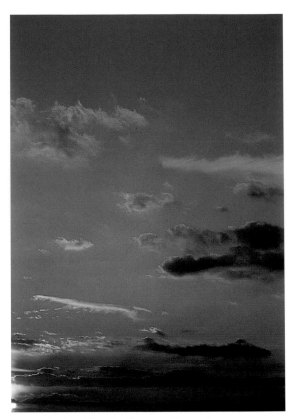

SC-55 Clouds in blue sky illuminated by setting sun

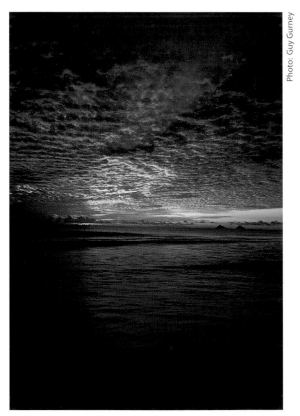

Photo: Guy Gurney

SC-56 Undersurface of billowing altocumulus cloud shelf illuminated by setting sun

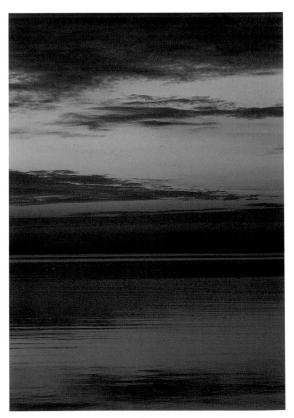

SC-57 Sun rising over tranquil water

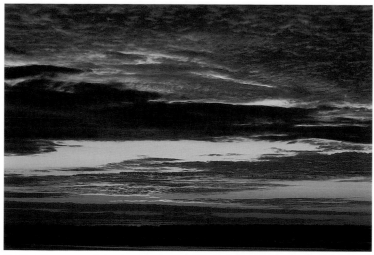

SC-58 Silhouettes of clouds against darkening sky at dusk

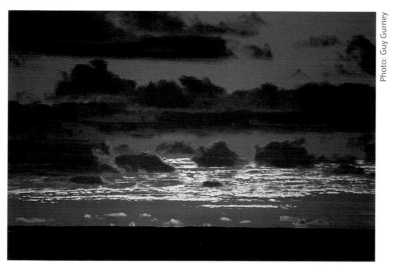

Photo: Guy Gurney

SC-59 Silhouettes of clouds against darkening sky at dusk

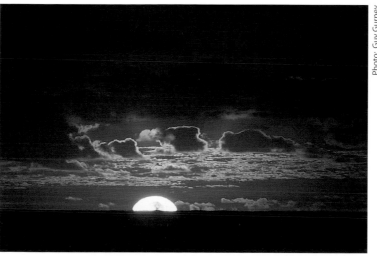

Photo: Guy Gurney

SC-60 Sun dropping below horizon

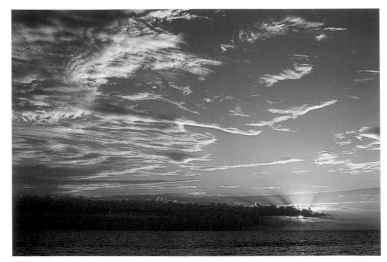

SC-61 Sun setting over ocean

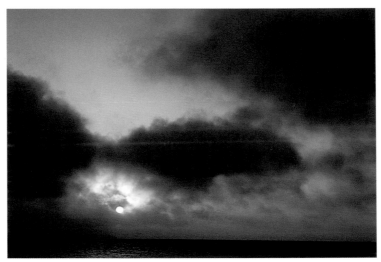

SC-62 Layers of clouds dimming rising sun

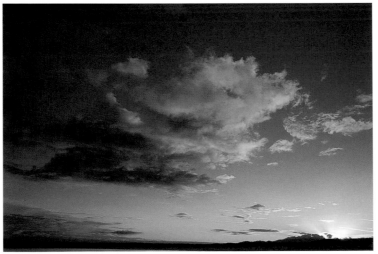

SC-63 Clouds in evening blue sky illuminated by setting sun

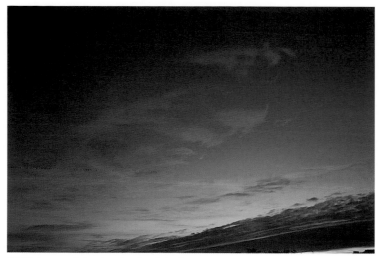

SC-64 Layers of clouds reflecting light from sunset

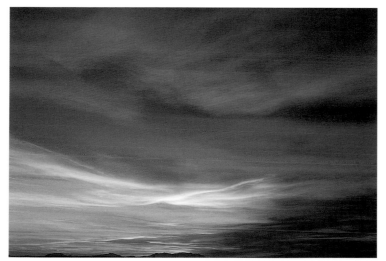

SC-65 Multicolored clouds reflecting light from sunset

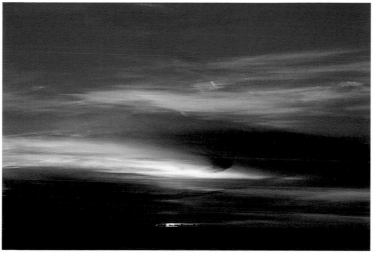

SC-66 Bands of gray clouds against sunrise

SC-67 Clear sky during sunrise

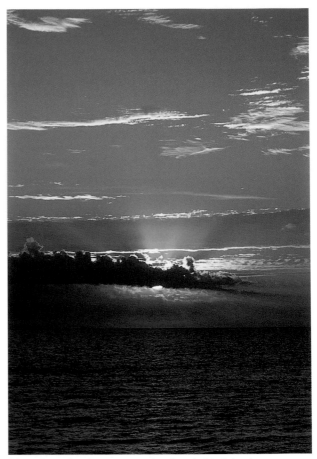

SC-68 Rays of setting sun emerging from behind clouds

SC-69 Sunrise

WORKING PAPERS

The following conversations are intended to give insight into the creative process of some professionals who interact directly with the natural world. A landscape architect, botanical illustrator, and wildlife exhibition designer use many of the same visual elements, although the specific design problems they confront demand different skills and information. These individuals all bring to their work dedication to careful observation and enthusiasm for finding the best way to use those observations in creating designs. In talking about finding research and developing techniques necessary to execute their projects, they offer a view of how they visually explore, use, and are affected by nature as artists.

INTERVIEW WITH LAURIE OLIN
LANDSCAPE DESIGNER

Laurie Olin is professor of practice at the University of Pennsylvania Department of Landscape Architecture and Regional Planning. A founding partner of the Olin Partnership, he has worked on a broad array of urban redevelopment and urban park design and restoration projects including Bryant Park and Battery Park City in New York, The Getty Center in Los Angeles, new squares in London, housing in Frankfurt, commercial development in Barcelona, and major commissions at Yale, Stanford, MIT, the University of Pennsylvania, and the University of Virginia. Mr. Olin is author of *Across the Open Field: Essays Drawn from English Landscapes*, and other publications. Among the many awards he has received are the Rome Prize in Landscape Architecture (1974), the Bradford Williams medal for best writing on landscape architecture (1991), and the award in Architecture from the American Academy of Arts and Letters (1998).

Q Would you describe your work?

A We design and plan landscapes, working with architects, institutions, developers, and government agencies. Among our projects are small and large gardens for residences and institutions, public squares and parks, urban development, and transportation plans. Our office is currently designing an estate in southern Georgia, two university campus plans, and a 240-acre urban project with a series of interlinked parks on the Mission Bay waterfront in San Francisco. We restored Bryant Park in New York. Some years ago we worked on the plan for the open spaces of Battery Park City, and worked off and on for the next fifteen years designing pieces such as the Esplanade and Wagner Park (all in New York City).

Q How do you work with architects?

A It is hard to generalize. Good landscape architects begin by trying to find out what the place is really about. How did it get to be the way it is—what is the specific ecology and what is its culture? There is no blank slate in my field. Different architects have different agendas. They have been selected by clients for particular reasons, and our method of working is to respond appropriately. When do we need to be working in harmony or when in contrast with the architect? When is it time to agree; when should we argue and say this is not in their best interest? We enjoy these collaborations very much.

Q How do you go about getting the information to make those decisions?

A First we go to the site and walk around. Sensory perceptions of the place are fundamental. We have been in the business a long time, so there are many things we just know about, but we also do research. We read a lot. We look at maps; we get data that has to do with the soil, the climate, the geology. We interview people. Some of this research we map; some of it we just keep in our heads.

Q What do you mean by "map"?

A We draw it. We plot it out. It can be hard to keep many of the relationships straight; particularly with large natural sites or complex urban projects. There are project files for everything: drawing files, paper files of records and correspondence, a financial file.

Q How much do maintenance requirements affect a design?

A To some degree, they always affect the design. No matter how sophisticated the clients, in the back of their mind are the questions: What will be the ongoing problems? How many people will it take to maintain this? What will this cost? A few years ago people were asking for no-maintenance landscapes. Well, there is no such thing. Anything in the physical world requires some sort of attention. Clients hope to find a sensible relationship between their resources and the landscape, a balance in the cost of keeping it healthy and robust. We try to find plants, select materials, and create details that are stable, durable, and long lasting to reduce meaningless maintenance and not waste resources.

This is an increasingly important area of practice. We completed a maintenance manual for the Getty Center in Los Angeles that incorporates many of the things we learned as we developed the project that suggested ideas and issues regarding its long-term maintenance.

Q Do you prefer clients with very specific demands?

A All clients want certain things. Sometimes they are unclear and we have to help them to figure it out. Other times clients will be very up-front about their program—"We want these plants and to spend twenty dollars a square foot." If their program is reasonable, we are happy to hear this. The constraints you have at the beginning of a project keep you from wandering, and help you be more effective. In an odd way they also set you free. Too many choices can be debilitating. Good designers, like artists and scientists, are always setting limits.

Q What do you show a client at the beginning of the design process?

A Diagrams. Pictures of analogous designs. Works done by ourselves or others that have elements we think may interest them. Anything that may help define a certain character or qualities. It is not unusual to meet with clients, learn about the site, and then give them your analysis and describe your possible approach without having an actual design. This gets a first reaction, and you find out whether you have understood and analyzed the situation properly, and if you have adequately expressed their goals and the program.

Q What do you show a client once you have determined the direction of a project?

A We draw a lot. We show them plans and sections and sketches. We build models: little study models and sometimes highly developed presentation models. Thanks to computers, we can show a wealth of photos of the materials we are proposing. It used to be difficult to explain how plants would look when they grew older or when in leaf or in blossom. Today, with photo archives and computers, we can actually present a lot of this material.

Q What type of visual material do you use to develop a design?

A I sketch and draw constantly, and so do many of my colleagues. Here we communicate more through drawing, from both the drawing board and the computer, than through words. We go to computer data bases and books such as recent guides to plants and geography or the classic Dirr book on plant taxonomy [see Bibliography].

For an early project, I drew by hand two species of trees we were proposing. One sketch showed how big the trees would be when installed, another what they would look like in five or six years, and yet another with the trees at full maturity on the site. There were also drawings of the leaves and the fruit. Today we usually do all of that with photographs and the computer.

Clients always want to know what a project will look like when construction stops. Will it look awful, with large stakes holding up scrawny tree trunks, or will they have large trees? Will the plants get too big? Will they meet their expectations? A tree they may know from a family farm may look quite different planted near a street. We try to be candid, know what we are doing, and have the communication skills to explain it to clients.

Q Do you encounter projects that demand a specific style of landscape design?

A Yes. Architects often come from a specific point of view. Some do eclectic or historic work, while others are extreme modernists. We think of ourselves as modernists who know a lot about history. We normally don't do historic restorations, but we have worked on historic sites that demand a sensitivity to history. For example, Victorian plants around architecture from the thirties would look strange. There are other plantings you would not put around classical buildings. The style of the architecture very much influences our work because styles reflect broad cultural issues, aspects of a moment in time as well as personality.

There are plants that are popular at one moment, only to go out of fashion and disappear. One tree that is out of favor now is the horse chestnut, partly because the climate has been warming up (global warming is a fact, as everyone who works with the environment knows). The principal varieties of horse chestnut available in the East need more rainfall and cooler temperature than we currently have, so the leaves develop brown edges before other trees. That doesn't happen in the Pacific Northwest, or here if you water them. They are wonderful trees, but are hard to find in nurseries because some have reacted to stress. Styles and trends can be wicked.

Q What determines these trends?

A It's usually visual, but can be biological, functional, or cultural. There has been a recent upsurge in the use of ornamental grasses. Ornamental grasses were used in the nineteenth century in Europe and in some of the great Victorian gardens in America, but they went out of fashion. Some years ago several landscape architects, including ourselves, began to experiment with them again. Since then many other grasses have become

available, and they have caught on as part of an interest in land-scaping with native plants. Ironically, many of these grasses are not native to the areas where they are planted.

There is currently a trend in Europe and North America in favor of native species and not to use imported plants. But just as a lot of us are immigrants, so too are many of our plants. In fact, many of the most successful plants are immigrants. So this native plant movement is a bit of a fad. There are times when it is absolutely appropriate: if you are trying to rebuild a habitat in a stream corridor, you should be working with the natural plant community because it has to do with the animals and ecology. But if you are working in the middle of a city in south-ern California, you must understand that the whole look and feel of the place has to do with plants from the Mediterranean, South Africa, Australia, New Zealand, South America. Many of the plants people think are quintessentially Los Angeles really are from other parts of the world. The same is true of south Florida—the coconut is imported. On one site near Cape Canaveral where we worked, you can grow only about four plants native to south Florida, although people think it is a tropical paradise.

Q What are the steps in designing and executing a project?

A Ideally, you help clients select the site, or you are involved in the first visit. If an architect has finished the design for a building and then wants you to design the landscape, this is the wrong way to go about it. You should start together. We begin by asking the questions: What are the ideas? Where will things go on the site? Then we start programming with the client and the architect. Programming is understanding the purpose of the site. What do they hope to do on the site? What are the elements we are going to have to arrange and com-pose: Will there be cars, walks, roads? Where will the buildings go? Are there problems of storm water management, relation-ships to other places? The first diagrams show how these things might be arranged. There is usually more than one way to do something, and quite often there are a couple of good ways. Almost inevitably there are some really wrong ways, and you have to figure out pretty fast what not to do. Different fac-tors will help determine this. Often it is the soil, sometimes it is the neighbors, sometimes it is bad geology or drainage.

In this analysis phase we try to share information with the engineers, architects, and clients. Then we come up with the first rough design, called the preliminary design or preschematics, or we may go directly to schematic design. In a schematic design you have figured out the size, shape and locations of things. You have done the first drawings of the grading, you have identified the materials, and you have enough information to figure out the general cost. You can also have outline specifications for materials and quantities, and the first images of how things go together.

At this point we need a reaction from the client adequate to help us go forward or revise. We may have drawn what the clients want, but it costs more than expected. Or the budget is okay, but the clients were hoping for something else. The schematic design forces you up against all the major issues—budget, program, design vision, the arrangement of parts, the character.

After this review with the client, we used to have two dis-tinct phases of drawing: design development and construction documents. Today, because of computers, design development has actually become a phase of the construction documents. With computer-generated drawings we are constantly building on the first data, and revising as we go along.

In any case, after some form of preliminary design studies, measurements, and corrections, we produce a set of very thor-ough, legally binding documents that are the instructions for building something. Those are called construction documents, contract documents or CDs. Our process is almost identical to that of architects, and often our packages are coordinated with theirs and presented at the same time. After that comes con-struction.

Q How do you work with contractors during the construc-tion phase?

A Design doesn't stop with the drawings. It goes right through construction. We can be on the site when the contrac-tor says: "What you drew is this, but there is a pipe here, so I can't get it in. What should I do?" You now find yourself in the field with a new condition that changes how the design looks and feels. Design is endless. This part is a little hair-raising, but fun.

We tag plants at the nursery to try to get the best material for the site. We either stake the layout in the field ourselves, or have the contractor lay it out, and then we adjust and approve it. Once the trees and large shrubs arrive on site, we turn them to take advantage of their best view and may exchange one for another, or add and subtract plants. Sometimes clients call you back to adjust things the next year or later.

Q What are the differences between residential, commer-cial, and institutional clients?

A Usually scale. And that leads to changes in procedure and relationships. Almost any residential project, whether a small townhouse garden or a huge estate, will become a close per-sonal working relationship. You often see the client on week-ends because they are busy during the week. You get intense calls at odd hours that you don't get from a developer or an institution. There is more flexibility in the field with a smaller job than you have with larger contractor projects. But then you spend more time worrying about every inch of that job, which is not the case with a corporate campus. There is a strong prob-ability that the budget for a commercial project will be tighter and lower than for a high-quality institution, but also that it will be simpler, more broad-brush in its design.

Q Could you talk a bit about how landscape design directs movement around a space?

A We design walks, steps, parapets, streets. We shape the land. Access and movement have to do with the size and scale of the numbers of people using a space, and how the space is used. If hundreds of employees are going to and from a parking lot, you have to deal with peak time area flows. If it is a garden, it is a different scale and type of movement.

Then there are the formal aspects that affect movement. Openings in the space, a smooth path in a rough surface, the hint of a view if one moves to another location, progressions of things such as shrubs or trees that lead the eye or physically direct one's progress. The pitch and steepness of the ground plane, the pattern and texture of its surface, the soft grading or abrupt placement of architectural elements all can contribute to how a person chooses to move, and at what pace.

In public work, we have enormous obligations under the Americans with Disabilities Act. All circulation must now be wheelchair accessible. Stairs have become an ornament. Steps were a great invention to solve grade change, but for social reasons, they are now a secondary device for primary circulation. That has led to a generation of designers learning about ramps, and it has forced us to reorganize how we think about the approaches and the elevations of floors. Architects have had to rethink fundamental site planning, and develop new habits, so that we are not always doing designs that have to be remodeled and retrofitted with ramps.

Q What is the reason for landscape design?

A It serves three functions. The most profound is spiritual, then come the functional and the social. The first landscape design developed to provide food, shelter, and protection from animals. It was the manipulation of the environment for our well-being. Many techniques evolved during the twentieth century still have to do with hazard planning—flooding, steep slopes, erosion of soil. But once you get past that and the arranging of land to grow food, the motives for landscape design have to do with fundamental issues of aesthetics, beauty, and the spirit.

One example is that of corporate campuses, which now include recreational facilities for their employees that are no longer considered frills. A good, attractive, interesting, and useful landscape is a fundamental aspect of site planning that allows people to operate at their highest level with the best colleagues in the most stimulating environment. The enhancement of life is simply good business. If you want talented people, you now have to offer a good environment. People are developing high standards as to what is a stimulating environment, and fundamental aspects that include being in contact with the seasons, daylight and climate, and being stimulated visually.

Q How much of your design has been affected by past experiences?

A Probably a lot. Most designers are sensitive to their environment. As a group we relate to experiences that have stimulated us, especially when young.

I grew up in Alaska, one of the great landscapes in the world, in a small town that gave me complete freedom to roam. I spent a lot of time in the environment, and became very comfortable outdoors. There was a sense of generosity of experience—a lot of weather, a lot of creatures. The landscape was at the end of every street, and the notion of being separate from nature was ridiculous. I grew up with a strong sense of the world being alive, and people being only a piece of it. I have a love of architecture and cities, and agriculture, and the wilderness, and small towns. I do have a bit of a problem with the suburbs, however.

Q Why?

A All of the other places I just mentioned are stimulating to explore and wander around on foot. The suburbs are neither fish nor fowl. They do not invite us to explore, nor reward in the same ways. One problem for the next generation is the reordering of our suburbs with more purpose and structure in terms of circulation and patterns. It is a fact that few kids actually walk anywhere any more. I have been teaching suburban kids in college, and they don't understand cities, farms, or the woods. They are lost wherever you take them.

Q How should a student prepare for a career in landscape architecture?

A There is probably no right answer. Probably 50 percent of our students come as career-change adults. They come from biology, art, science, engineering, architecture. They are people who have come to realize that our field integrates several important aspects of their personalities and interests. The students in the undergraduate and graduate programs who come straight from college into the graduate school generally also come from both the sciences and the humanities.

They have to be interested in design, culture, and science, and also have to be optimists who think they can change things for the better. Good designers realize that there are environmental problems and that even if cities have problems with resources, crime, and poverty, you can still design and lay out a place in such a way that can enhance people's lives. One must believe that art and life matter, and that we can create a beautiful, not just an adequate, environment.

INTERVIEW WITH CHRISTABEL KING
BOTANICAL ILLUSTRATOR

Christabel King is a botanical illustrator for *Curtis's Botanical* (the magazine of the Royal Botanic Gardens, Kew). Her artwork appears in monographs and books, including *Flowering Plants of the World*, edited by Professor V. Heywood, *Fine Botanical Paintings* by Gordon-Craig Gallery, and *Africa's Mountains of the Moon* by Guy Yeoman She was awarded the Jill Smythies Prize for published botanical illustrations by the Linnean Society of London. Ms. King teaches botanical artists from Brazil under the Margaret Mee Amazon Trust scholarship, and has taught in Rio de Janeiro, Sao Paulo, and Caxiuana, Para province; she also teaches at Capel Manor Horticultural and Environmental Centre in Enfield, Middlesex.

Q How would you describe botanical illustration?

A My work could be described as illustration from a scientific viewpoint—a combination of science and art.

Q How do you approach a botanical illustration?

A Here I have an illustration of a coconut palm with several stages of the inflorescence and the developing fruit. Drawings of different sizes, viewpoints, and details of the palm are arranged in one plate. This specimen actually had different stages growing simultaneously, but because it was so large, there was not one view that showed all the stages. I began in the Palm House, where the plant was growing, with a simple line drawing showing the shape of the plant. I put a small amount of color into this sketch, and drew in the positions of the various parts of the plant.

I did a tracing of it, and took photographs as well because I had an idea that I was not going to be able to get it done straight away, and I can work from this material at any time. Then I took the rough sketch, and made it more precise and refined in a way that is impossible when working in a greenhouse with people passing by.

Then I did more sketching, and began to design the whole plate. I put together a series of rough sketches, enlarged and reduced the individual parts until the composition developed, and then collaged the drawings on the page. This was the basis for the finished illustrated plate. But to really capture the fine detail you need to work from live plant material, so I went back to the plant in the garden several times to refine the colors and other details.

Q What do you do when specimens are not so accessible?

A I did an illustration of a *Liquidambar* from Turkey. It is not really warm enough here for that tree to flower, so the one at Kew never flowers. But another in Cambridge did bloom, and they sent me a specimen to use as reference. Later that year the leaves on the Kew tree turned to the usual beautiful autumn colors, so I then added a detail of the leaves in that state. And finally a botanist in Turkey sent a specimen of the fruit. We also found a pressed specimen of the male inflorescence. So we now have color plates and black-and-white drawings giving fairly complete botanical information. In some instances this may require a variety of dissection drawings from different views and in various magnifications to show internal organs and structures such as details of the seeds and how they are arranged within the fruit.

Q You are also a trained botanist. How does this affect your work as an artist?

A Quite a lot. It is very useful to have an interest in the structure of the plant as well as the appearance. My original degree was in botany, and I came to drawing afterwards. As a botany student, I did some drawing for practical recording, and after taking my botany degree, I studied scientific illustration.

This work requires patience and observation. You must learn how to look at a subject. Early on, I remember being very concerned first to match the colors, but as my technique became easier, there was more time for attention to the actual form. Now I look more at the structures and the shapes than at surface colors. The way I paint is to build up watercolor in successive stages so there is the opportunity to refine the colors as I go along.

Q Do you specialize in certain botanical subjects?

A Not really. There is a large number of botanists working here on all sorts of groups of plants, and the magazine publishes results of their work. The botanists suggest plants that are particularly interesting to be illustrated in the magazine. The plants are usually in cultivation, so we have living material for the source of the illustration. Each one is accompanied by a botanical article. The magazine is a compendium of illustrations and articles about cultivated plants.

Q Does the nature of the article affect your style of illustration or how you compose the plate?

A For an illustration of a birch tree I have decided to fill the background with the bark texture, because the accompanying article is about how the bark is used for paper. But for the most part, this particular magazine is highly traditional in its format and style of illustration. Unless the plant is very large, the plate is generally a life-size, color illustration of the part of the plant the botanist wants shown—usually the flowering part. And there are additional explanatory line drawings [of specific features] and dissection drawings made under the microscope to

show the botanical details. Each drawing has a bar scale that shows the comparative actual size. Or there may be a caption that tells the size.

Q How does the botanical tradition affect your work?

A The articles I illustrate have botanical descriptions that years ago would have been written in Latin. Now they are written in English, but still follow the traditional scientific order—beginning with the vegetative features and going through the flowers and the seeds. You are given a complete verbal scientific description of the plant. The illustration is a visual accompaniment to the botanical text.

The layout of drawings in the illustration also follows the scientific order: vegetative detail—leaves and stems first, then the inflorescences and the flowers, and finally the seed pods and fruit. The composition may focus on the most interesting part of the plant. If a part of the plant is clearly shown in the color plate, it may not require a detailed line drawing. But hidden parts of the flower may be dissected, magnified, and drawn as black-and-white line drawings. Color renderings of dissections can clarify information that can only be seen under the microscope. These images can also be visually fascinating.

Q What are the elements of a successful botanical illustration?

A Clarity distinguishes botanical illustration from botanical art such as a decorative painting of a vase with flowers. Artists specializing in botanical art are free to interpret what they see. Those artists are not concerned with showing elements in clear detail if they do not add to the artistic impression made by the plant. In contrast, a botanical illustration will home in on details because those details may be the features that distinguish one species from another.

Basic design problems must also be solved in achieving this clarity. From what angle to view the plant? How to best show a particular feature? It is very difficult to get things right the first time. For example the illustration of the coconut palm had an awkwardly placed inflorescence. In the specimen, it was foreshortened, and I put it in a position which would better show the proportion of the inflorescence on the branches. I couldn't change it too much, but it could be adapted to better illustrate the botanical feature.

Q What are other problems you confront?

A There is a drawing of a cactus in flower that was very difficult. First I reorganized two stems because it made for a more workable design. With this plant there was only one day that it would be in flower. By two o'clock in the afternoon on that day it still hadn't opened, so I put it in front of a very sunny window. An hour later it opened slightly, and I was afraid that would be all it did, so I drew that. But by later in the afternoon it did completely open, so there was the opportunity for a drawing of the complete flower. But by that time I was just about roasted. To

get it open I had to approximate desert conditions in a sunny corridor behind a glass window. So I have the drawing of the partly open flower and another drawing of the fully open flower, as it looked around four o'clock in the afternoon. Those drawings of the flower are transferred to the drawing of the stems for the finished plate.

Q What references do you use in addition to live specimens?

A Dried and pressed plants, and specimens in preserving fluid. The pickled specimens are the easiest to work from because they still have three dimensions

Here is an illustration I drew in England from a sketch done in Brazil. On this expedition I put parts of flowers under a magnifier and drew them in color in the field. The live plants only grew in Brazil, and I wanted to bring back pressed specimens, but the plant press [with the plants] got lost on the way home. I had a fairly detailed drawing, but needed more reference to complete the piece. Fortunately I found a specimen in the Kew herbarium from roughly the same place in Brazil, and could finish the leaf from that. [The herbarium at Kew is an extensive collection of preserved plants cataloged in detail including pressed specimens from Darwin's voyage which are still available for use by illustrators.]

Q So just as you composite the elements of the plants to show it in the best light, you composite your research—some information from the live specimen, some from the dried herbarium specimen, some from the pickled collection.

A Yes, anything which helps to make a clear drawing can be used.

Q When do you use photographs?

A I use photographs primarily for color information, and really don't like using them except as a last resort. Those times when you can't draw something quickly enough, the camera makes it possible to keep some information.

Q Why don't you use photographs more extensively?

A The information is never as clear as a drawing. It can be maddening. I went to a lot of trouble on an African expedition to take photographs. They were okay for the color, but they were not adequate for details of structure. You could say that I'm not a good enough photographer, or that my lens was not good enough, but it was more a matter of not being able to achieve the depth of field in the situation. Much of the time you are in the depths of the forest, so light is not sufficient, and then the wind is always moving the plant. Serious supplemental flash is a problem, because the equipment must be light enough to carry in the field. I don't think you can depend on field photographs for complete information to do clear and precise drawings.

Q Given that conditions in a photographic studio can solve the depth-of-field problems, why do you think botanical illustrations are still often preferable to photographs?

A With an illustration, you can put together chosen information, to give a more complete picture. With a photograph, if you can't see a feature of the plant you don't have the option of carefully arranging the viewpoint, or adjusting the physical elements. An illustration can show botanical features that may be separated by time and space on the same page from various angles and with magnifications of details. This is one of the chief reasons I think illustrations are better than photographs. One could probably do this by using photographic montage, but the illustration is generally more suited to presenting botanical information.

Q What you recommend as course of study to students of botanical illustration?

A There is a wide variety of work available, and it can approached from a scientific or artistic background. Some of the people who have illustrated at Kew had little formal training in botanical illustration before coming to Kew, but they were trained as they worked. Good drawing ability and an affinity for the precision of scientific work are the main require-ments. One must draw as much as possible from nature, taking care to look for the structure as well as the surface appearance. As a student, it is also very helpful to look at botanical reference works to find out the distinguishing characteristics of specific plants.

Q The magazine you work for, *Curtis's Botanical* Magazine, has a very specific style. Is that the approach you use for other botanical projects?

A Yes. I believe in it as a good way to portray a plant. In some stages this isn't so much an artistic creation: it is something with logical steps that you take through to the end. The idea of design comes in, but it is a question of using the techniques to tell people about structure, color, and other details of plants.

I also draw landscapes and architectural subjects. I think it is refreshing to draw other sorts of subjects than found in one's work. Stones are a different texture than leaves and plant material. I began drawing botanical subjects, and thought that I would concentrate only on that, but if one is interested in a subject, one wants to draw it. My reaction to things is that I like to make a record of what interests me, whether it is a landscape, a certain cloud formation, a beautiful building, or a plant.

INTERVIEW WITH JOHN GWYNNE
WILDLIFE EXHIBITION DESIGNER

John Gwynne, trained as a landscape architect, is Vice President and Chief Creative Officer of the Wildlife Conservation Society at the Bronx Zoo, where he has headed the Exhibition and Graphic Arts Department since 1982. His department is particularly interested in exhibitions that teach conservation. He is an active participant in the American Zoo and Aquarium Association and sits on the board of the Wildlife Trust. He has illustrated several bird guidebooks to promote international conservation in such places as Panama, Venezuela, and China.

Q Would you describe your work?

A I work for the Wildlife Conservation Society, best known in America for our flagship institution, the Bronx Zoo, and other New York City facilities, including the Central Park Zoo and the New York Aquarium. But we are also one of the top international wildlife conservation organizations, with 300 field science teams working in Africa, Asia, and South America. Our science-based educational programs are used throughout the United States and around the world.

Our whole world is becoming increasingly suburbanized and remote from nature. A challenge of this new century will be to get people to save nature. The Wildlife Conservation Soci-ety is committed to saving wildlife by helping set up protected areas and teaching people about its value. We can do this is by making the facilities we manage into places that inspire the visitor to care about wildlife and natural habitats, and by finding ways that people can be directly involved in the mission of wildlife conservation.

Q How as a designer do you fit into this?

A I head a team called EGAD (Exhibition and Graphics Arts Department), a centralized design service for the Wildlife Conservation Society. We design and work with curators and scientists to program the exhibits, find the appropriate architects, and help fund-raisers—all to create exhibits that bring people as close to nature as possible.

Q How do you convey this message to the average kid?

A How do you get people excited by rain forests? We have built two experimental rain-forest exhibits—"Jungle World" and "Congo Gorilla Forest." We try to take visitors on a journey to Asia or Central Africa. We immerse people in a world that is as beautiful and complex as we can make it to get them to feel that this place is fascinating and has value to them.

We have explored many venues. For instance, we asked advertising people how they sell a product, because what our exhibits do is not very different. We learned that people react and make decisions from the heart, but they need facts to support their feelings. So, our exhibits balance facts with reactions and feelings.

When students walk into "Congo Gorilla Forest," they feel they are in the middle of a rain forest surrounded by great trees soaring out of sight, sounds of the forest, and glimpses of exotic animals. Of course, we could not do anything as magical as build a real rain forest. But keeping in mind that nature is our goddess, we copy each detail and make the experience as real as possible.

Q What are some of the ways you accomplished recreating a rain forest in New York City?

A We started by planting 17,000 plants of 400 varieties, trying to approximate the complexity and exuberance of tropical nature. To provide the scale of a great forest, we sculpted dozens of large trees, hung miles of artificial vines among the planted ones. The interesting aspect is that it is a dynamic situation, bound to change as plants grow. It started out with more faux vines than real, but ten years from now, the mileage of real vines will outnumber the faux. Unlike a static museum diorama, these exhibits are alive and changing and will get better with time.

But there are also challenges with the real. Plants out-shade others. Subtle but constant maintenance and alterations are needed. This is very different from the set design that you find in most exhibits. In the living exhibit you must design around the demands of maintenance. If a water pipe breaks, it is a big problem to replace if we must remove a chunk of forest to gain access. One must be resourceful. In "Congo" we have created bypass water lines and disguised pipes as roots and vines.

Q We usually think of rain-forest plants growing large and fast. This is not appropriate for a limited space, so how did you choose plants?

A Rain-forest plants come in all shapes and sizes. We spent a great deal of time in Africa, and worked with botanists and biologists. We asked them which plants were important to show. We knew we had to combine giant palmate and pinnate leaves, and a complexity of textures, and that it was important to get plants that leafed out early in the year and which did not have bright fall foliage. We went through a rigorous process of looking for different textures and surfaces that would show the story.

Then the problem was to find them. Some we had to grow ourselves because they weren't available in nurseries. We started planting about ten years before the actual construction of the exhibit. Our nursery ended up growing 3,500 plants for "Congo."

Q Who was involved in this project?

A The team included curators, scientists, horticulturists, educators, fabricators, graphic designers, programmers, exhibit designers, and architects, as well as a large development and support staff.

Our permanent staff supplies exhibit and graphic design, fabrication, and programming. The staff designs some architecture, but it is more cost effective to employ different architectural firms with skills selected for each project. One time there may be a need for an expert on restaurants; later some other specialty is required. We usually program and concept-design a project internally, working with curators and the rest of our team, long before we hire architects.

Q What is the function of programming?

A Programming figures out what we are going to do with an exhibit or property. For example, the WCS owns a Beaux-Arts building in our Bronx Zoo that is landmarked. Here a group of New Yorkers, in 1905, made the first concerted effort to save a species—the American bison. The building has been an empty maze of old cages since the late 70s. What are we going to do there? Our job is to find what human and animal needs are most suitable for the building.

Programming defines the goals of an exhibit. "Congo Gorilla Forest" had three goals: (1) to inspire people to care about the African rain forest and its potential disappearance; (2) to make the visitor realize the importance of science in the process of conservation; (3) to enable visitors to take action to protect the rain forest. It began as a gorilla exhibit. Then we expanded it to become an African rain forest, and finally it became an exhibit on conservation using the rain forest's animals, particularly gorillas, as the stars to make it come alive.

A project planned for New York Aquarium, titled "Alien Stingers," will take people to the underwater world of jellyfish. We will test its impact upon our visitors with a preview of a primarily visual experience with minimal interpretation and interaction. Then an evaluation team will study the reactions of viewers and determine how to develop the educational potential. The final opening, several months later, will also incorporate computers and interactive elements that allow one to experience the science and discover of marine biology.

Q Would you explain the process of developing an exhibit like "Alien Stingers"?

A After the multidepartmental programming team defines the exhibit, EGAD prepares alternative concept drawings. Those evolve into study models that initially explore how the space will work. We do a great deal of three-dimensional modeling, a critical design tool because what we design is so multidimensional. These models also give our clients, the curators, and directors a sense of how the different exhibit areas might

work. For example, they can see if the space in the Beaux-Arts building will be large enough for primates or birds. The curators and directors are used to working with rough study models, but this is not the sort of model we can show to donors. They aren't used to the visual vocabulary of white foamcore rectangles representing trees or other easily created abstractions, and we want them to get the full impact of an exciting space. Detailed presentation scale models are built when the early design and development are complete.

For part of the jellyfish exhibit we will take people into an alien world under water without getting them wet. So through modeling and exploring various plastic materials, we will try to create luminous backlighted surrounds that create the feeling of being suspended in the open sea. Faux rocks or other solid materials are inappropriate, so here we will explore plastics and lighting effects on different materials that can transport the audience to an unexpected world.

Q How do you get from models to actual materials?

A One of the members of our team is an industrial designer, an expert in materials. The head of the exhibit fabrication shop will figure what works under water—what bonds, what products could produce unwanted chemicals, what paints might have problems adhering a year later.

But we keep in mind that the building materials are very much the means toward a larger end of creating an experience for visitors and a proper environment for the animals. In "Jungle World" we put a great deal of effort into faux finishes and artificial sculpted trees. We had great muralists and fabricators, but we were concerned that people might come away with the experience of a plastic forest. All the wonderful things that were sculpted and painted had to be seamlessly integrated into a landscape of living plants, so that people would not think of the exhibit as something that was constructed. We hoped our design and fabrication team would be invisible—that you would just be visiting a piece of verdant nature brought to New York from Asia intact. Of course, all of it has to work primarily for the animals.

Q At what point do you design the exhibits for the animals?

A It is the first thing we do. For example, we are exploring ideas for a Siberian tiger exhibit to create a behaviorally enriching place for tigers. There will be sounds and movement in the grass for them to pounce on; a series of scent trails that change constantly. In "Congo Gorilla Forest" we planted a thousand day lilies for the gorillas to uproot and munch on. It engages them with their surroundings.

We built an exhibit for gelada baboons that was based on the primary elements of their world: Interaction with other gelada baboons, and an expansive grassy plateau. In the wild, they form aggregations of harems that bicker and flirt with each other. They need a lot of space with an irregular terrain—places for them to hide, interact, and bluff. We built that, and

then, with great hope and trepidation, we introduced multiple harems, not knowing what would happen. And the baboons reacted just as they do in the wilds of their native Ethiopia. One flashy young male even created a peaceful palace coup, complete with all the ritualistic behaviors of a gelada, and dethroned one of the previously dominant males. The old fellow was retired from his harem in the middle of the day with the whole zoo watching.

Q How do you balance designing a space that functions both for the animals and the visitors?

A A hundred years ago, a zoo hired an architect who stuck a bunch of animals in cages. We now spend a great deal of time figuring out what works for the animals. What are the needs of a social species? For a solitary species? What will make the animals, whether they are baboons or jellyfish, happy.

Today, much of our effort also is in drawing the audience into the exhibit to teach them and inspire them to care about wildlife and vanishing wild places. We can provide gibbons with a big space with a high tangle of ropes, and they are perfectly happy. The gibbon doesn't seem to care if we have painted lichen on the faux tree trunks or made the rope look like a vine as long as it acts like a vine for locomotion and is in the right place.

Q So the design enables the audience to experience the animals' world?

A Yes. Who cares about an endangered baboon living in remote plateaus of Ethiopia? You might see one on a television nature special, but you gain a lot more by experiencing it yourself. There is nothing more amazing then going to Africa, and coming across a group of gorillas in the wild only a few feet away. How can we recreate this experience in an exhibit?

But by creating experiences that make the public come closer to the animals, design can showcase natural worlds that people never thought existed, and bring them closer to the animals. For example, in the proper aquarium environment, jellyfish relatives will engage in "Star Trek" battles propelling themselves into their neighbors with clouds of ink and fierce projectiles. It is not a movie. It is real.

Q What are some of the techniques you use to make the experience real?

A In "Congo Gorilla Forest" we wanted people to feel the power of a rain forest, but you can't have a summer crowd of a million walking through delicate ferns and tropical flora. So we contained the people in ways that are subtle and constantly varied. The paths they follow feel textured and spongy, and are defined by fallen trees and broken branches. They go through tunnels covered with vines and pass waterfalls. It is choreographed very carefully so that they don't know what is around the next tree. Every turn is a little more dramatic, and builds anticipation.

This is more than traffic management. We are creating a story that the visitor walks through, and that becomes an experience of personal discovery.

There is a lot to think about. One element is what the aquarium world calls the "first fish syndrome". When visiting an aquarium, no one goes immediately to an orientation center; they want to see a living animal first. After seeing the "fish," they are prepared to think about factual and educational information. The pull of the living creature is so great that no sophisticated technology or jazzy scenic device will direct them first to the informational kiosk. Nothing is more important than the living animals to heighten the educational goals.

Q You said that one of the goals of "Congo Gorilla Forest" was to inspire action in conservation from the audience. Has that been accomplished?

A Everyone visiting the "Congo" exhibit pays a three-dollar admission. At the end of the exhibit, using touch screen technology, they can decide how that three dollars will be spent in Africa. This comes at the end of a long exhibit, so with a tired audience, we hoped for a 50 percent rate of participation. Participation has been 70 percent, and we have raised over two million dollars to help save gorillas and parts of the rain forest.

Q What research sources do you use?

A We are always pinching ideas from museums and art exhibitions, and trying to find substantive exhibition and display techniques.

We spend a great deal of time in the wild working with our field scientists. We bring back lots of photos, sketches, actual samples. But the experience of the place is the most important thing. Last year I went to the last scrap of lowland forest in Thailand, with the hope of seeing a bird called Gurney's Pitta that was rediscovered by a WCS team fifteen years ago. There may be only twenty pairs left, and after of two days of sitting in the forest and waiting, one bright purple and gold male came hopping down the trail, and then disappeared around a tree, never to be seen again. That kind of experience can mean much more than bringing back rock fragments.

Q How did you train for this job?

A I have always been interested in nature, science, and art.

This is the perfect job—it integrates them all. I trained as a landscape architect at Harvard after getting a degree in art history. I also illustrate books—mostly about neo-tropical birds. On weekends I maintain an experimental garden to study a spectrum of plants not usually grown in the United States.

Creating exhibits at WCS is a job that cannot be done by one person. Probably the biggest part of my job is to find the best people who can work together to create something better than any one of us could make individually.

Q What is specific to the construction process of an exhibit?

A Many of the study and presentation models become working drawings; the architecture is put out to bid in the standard manner. But we have special demands. On the "Congo" project we traumatized the construction manager with an unusual time line [the construction schedule.] Normally the building is constructed, and then the grounds landscaped and habitat planted. But the habitat was going to take longer to grow than it would take the construct the building. We didn't want that look of immature plants that needed two or three years of growth, so the plantings had to begin well before the building construction.

This caused quite a few logistical problems, but one of the advantages of having a staff exhibition department, is that we have a great deal of experience in merging the living with the fabricated. Because our offices are in the park, we can also keep an eye on innumerable details. If we notice a branch of a faux tree would function better for the animals on the right rather than the left side of the trunk, the change can be made by the artist creating the tree on the spot. This enables us to stay true to the original concept, but also build something that functions as well as possible.

Teaching people to care about living nature is what makes us different from some theme park attractions that may want you to react primarily to the spectacle they have created. We want people to experience amazing animals—to remember watching a female gorilla carrying her new baby, or a big silverback male reprimanding adolescent gorillas—and inspire millions to care about gorillas and want to take action to protect them in nature. All the of hours of work of designers, curators, programmers should be invisible if we've done our job properly.

GLOSSARY

Agate. A fine-grained variety of quartz composed of alternating layers of different colors and transparencies.

Aggregate. (1) Soil or rock particles that are bonded together forming a solid mass. (2) Granular material mixed with cement to form a surface.

Air plant. *See* Epiphyte.

Algae. Primitive green plants that range in size from microscopic to large and usually grow in water. They lack roots, stems, leaves, and flowers. Example: kelp.

Allée. A walkway bordered by trees or shrubs. It may be cut through a densely wooded area or an intentionally planted tree-lined avenue.

Alluvial. Term describing material deposited by water, generally consisting of clay, silt, or gravel, that is often, but not always, stratified.

Alpine garden. A garden designed to simulate the habitat of plants native to mountain terrain between the tree line and the frost line.

Alpine plant. Vegetation that grows above the tree line in mountainous areas, but may refer to any plant suitable to rock gardens.

Altocumulus. Clouds in bands or covering a large expanse of the sky, found at altitudes between 10,000 and 21,000 feet (3–6 km), that resemble a flock of sheep.

Anemone. *See* Flower shape.

Angiosperm. A plant with a seed that develops within a protective vessel. Flowering plants are angiosperms. *See also* Gymnosperm.

Annual. A plant that completes its life within one year or less. Example: *Petunia*.

Apex. The point on a leaf that is farthest from the point of attachment, thus, the tip of a leaf. *See also* Leaf.

Aquatic plant. Vegetation that grows in water, either with roots attached to the bottom or free-floating.

Arbor. A shelter or shaded walkway formed by plants trained to follow the shape of an external framework. Also called *berceau* or *galley*.

Arboretum. A parklike area in which trees and shrubs are cultivated for study or enjoyment.

Arroyo. A stream bed with steep sides, usually dry except during rainy periods.

Awl-shaped. *See* Leaf shape.

Bark. The outermost layer of a woody stem.

Basalt. A common fine-grained, dark-colored igneous rock that is suitable for exterior walls, steps, and other garden uses.

Basidiomycetic. Term describing fungi that produce spores on spinelike projections.

Bed. (1) Geologically, a distinctive layer in a rock formation. (2) In horticulture, an area of organized planting.

Bedding. (1) Geologically, a layer or stratum of a rock formation. (2) In horticulture, organized ground plantings within a garden.

Bedding plants. Plants used for ornamental beds, selected for specific attributes such as height, texture, or color. They are usually annuals or perennials, but evergreens are also used.

Bedrock. The solid rock that is a part of the earth's surface. When exposed, it is called an *outcrop*.

Belvedere. A garden structure sited to offer views of a landscape.

Berceau. *See* Arbor.

Berm. In landscaping, an artificial mound of soil or fill introduced to add dimension to flat topography.

Berry. A fleshy multiseeded fruit lacking a pit (stone) or core.

Biennial. A plant that completes its life cycle in two years. Leaves are produced the first year; flowers and fruit the second. Example: *Digitalis*.

Biotite. A common dark green, black, or dark brown mineral found in rocks of the mica group.

Bipinnate. *See* Compound leaf.

Biserrate. *See* Leaf margin.

Blade. The main part of a leaf. *See* figure G-3.

Bloom. (1) A flower. (2) A waxy or powdery coating on fruits and leaves.

Bluestone. A fine- to medium-grained metamorphic quartz-based rock ranging in color from green and lilac to dark gray and blue. Used for paving, it splits easily and resists weathering.

Bog plant. A plant that grows in permanently damp soil.

Bonsai. The Japanese technique of dwarfing trees and shrubs and maintaining their growth in containers.

Bosquet. A small grove.

Botanical garden. A parklike place, which may include buildings, where a variety of plants are cultivated for the purposes of study or enjoyment.

Botanical name. Nomenclature that identifies individual plants by the binomial system, which gives the Latin name of genus and species, in that order. Because the botanical name is widely accepted, it is more accurate than the common or a descriptive name, and is usually preferable. Examples: *Quercus velutina* (black oak), *Quercus alba* (white oak). *See also* Classification of plants.

Boulder. A rounded rock with a diameter greater than 10 inches (254 mm); generally, any large freestanding rock, rounded or angular.

Bract. (1) A reduced leaf or leaflike structure at the base of a flower. (2) A modified leaf or a leaflike appendage of a plant that looks like a flower. Example: the colored leaves of poinsettia, dogwood, or bougainvillea.

Breccia. Rock consisting of angular fragments larger than 1 inch (25 mm) enclosed in a fine-grained matrix.

Broadleaf evergreen. Term describing trees and shrubs that are not deciduous, with wide flat leaves rather than needles. Example: *Rhododendron*.

Bulb. A modified underground bud with fleshy scale leaves in which one new plant develops. The term is often used to refer to some plants that grow from tubers, corms, and rhizomes. Examples: *Tulipa, Hyacinthus*.

Bur. Prickly covering of a seed. Example: chestnut.

Burl. Wartlike growth on a tree trunk or branch, valuable for use as veneer and decorative woodwork because of the interesting grain.

Bush. A low shrub with many stems and branches.

Buttressed trunk. A flared trunk that gives additional support. Example: *Taxodium distichum*, bald cypress.

Candle. The shoot on a conifer that becomes the new growth of needles.

Canopy. The mass of leaves and branches formed above the trunk of a tree.

Catkin. An inflorescence bearing generally unisexual flowers without petals, densely arranged around a central stalk. Examples: *Salix discolor*, pussy willow; *Betula*, birch.

Cirrocumulus. Clouds, usually in bands resembling fish scales (called a "mackerel sky"), similar to but smaller than altocumulus clouds, found above 25,000 feet (8 km).

Cirrostratus. Clouds with little or no structure, resembling a veil, covering large areas or in the form of translucent streaks, generally found above 20,000 feet (6 km).

Cirrus. Clouds that assume many patterns but have a distinctive hairlike quality, often with a curl, found at many altitudes, often with other clouds, especially cirrocumulus.

Classification of plants. A method of categorizing plants by "family tree," specifying (in the following order) the *family* (a group of plants, whose name usually ends in the suffix *–aceae*, that share broadly similar structural characteristics although the similarities are not always easily apparent); *genus* (plants that have similarities specific to the group); *species* (plants that can reproduce within their group); and *variety* (plants with distinctive characteristics within the species group) or *cultivar*, a contraction of "cultivated variety" (varieties developed by cultivation, rather than by natural selection). *See also* Botanical name.

Classical garden. A formal garden in which

plant placement and choice of garden architecture are based on the elements of design and aesthetics used in ancient Greece or Rome.

Climber. A plant that uses another object as support. Self-clinging climbers employ aerial roots or adhesive tips; tendril climbers coil leaf stalks around the support; trailing and twining climbers such as vines wind their stems around it.

Cleft. *See* Leaf margin.

Cobble. Naturally rounded rocks used for paving and construction. Sizes vary from 2$\frac{1}{2}$ to 12 inches (64–300 mm).

Cobblestones. Cobbles and other small stone units, in natural form or cut, used for paving.

Columnar. *See* Tree shape.

Columnar jointing. A variety of geological joint that breaks the rock into multiple elongated regular planes (columns) that have three to eight sides in section. It is often the result of cooling lava formations of basalt or obsidian, and is usually perpendicular. *See also* Joint

Common name. Nomenclature for plants that is vernacular and may vary regionally. Example: *Dieffenbachia spp.* (which contains toxic crystals of oxalic acid) are known as mother-in-law's tongue in the northeastern United States. Conversely, *Sanseveria spp.* (which are harmless), are called snake plant in the Northeast, and mother-in-law's tongue in the South. When speaking of mother-in-law's tongue, it is important to distinguish between the noxious plant and the harmless one; hence the importance of botanical Latin. *See also* Botanical name, Classification of plants.

Compound leaf. A leaf composed of two or more autonomous leaflets. Classification is based on the number and arrangement of leaflets: *bipinnate* (in a pinnate arrangement with an additional division); *palmate* or *digitate* (with flat extensions radiating from a single point, like fingers from the hand); *pinnate* (with the leaflets arranged on both sides of an axis, like a feather); and *trifoliate* (with three leaflets). *See* figure G-1.

Concretion. A hard, usually rounded or nodular rock mass, typically developed within sedimentary rock, that differs from the enclosing rock, and consists of substances from solution around a harder nucleus.

Cone. Multiple fruit of a gymnosperm, characterized by overlapped woodlike scales that hold seeds that are densely clustered around a central axis.

Conical. *See* Tree shape.

Conglomerate. A coarse-grained sedimentary rock of rounded rock particles that may consist of pebbles, cobbles, or boulders.

Conifer. Tree or shrub, usually an evergreen, that propagates by means of cones. Not all evergreens are conifers, nor all conifers evergreens.

Contrail. A vapor formation in the sky that curves, swells, and spreads by wind, resulting from the wake of an aircraft.

Cordate. *See* Leaf shape.

Cordon. The primary espalier shape, often applied to fruit trees—a single branch, trained to grow in a specific direction by removing the lateral branches. The resulting branch may be horizontal, vertical, or serpentine.

Corm. A fleshy, bulblike, but solid, stem. Examples: *Crocus, Gladiolus*.

Creeping plant. A plant that grows along a surface, sending out roots along the stem. Example: *Pachysandra*.

Crenate. *See* Leaf margin.

Crenulate. *See* Leaf margin.

Crisped. *See* Leaf margin.

Cross-bedding. Strata within rock formations that are at an angle to the main layers. Typically granular sandstone, the formation often indicates ancient eolian sand dunes or deltas.

Crown. (1) The point of a plant where stem and root meet. (2) The uppermost part of a tree. (3) The branched top of a standard topiary.

Cruciform. Term describing leaves or flowers assembled in the shape of a cross. Also called *cruciate*.

Cryptogram. A plant that propagates by means of spores. Example: fern.

Cultivar. *See* Classification of plants.

Cycad. The common name for palmlike families *Cycadaceae, Stageriaceae*, and *Zamiaceae*. Cycads are among the oldest plants. Example: *Cycas revoluta*, sago palm.

Deciduous. Term describing plants that seasonally shed and regrow their leaves.

Deltoid. *See* Leaf shape.

Dentate. *See* Leaf margin.

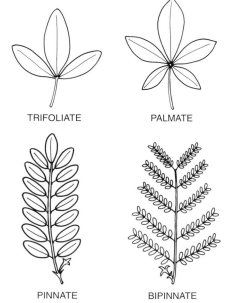

G-1 COMPOUND LEAF

Desert. A region where precipitation is less than evaporation.

Digitate. *See* Compound leaf.

Dike. A tablelike igneous mass that transects a bed of an existing rock, usually formed by the injection of magma into a fracture of the intruded rock.

Divided. *See* Leaf shape.

Dutch bulbs. A frequent name for spring-blooming bulbs originally grown in Holland. Examples: *Tulipa, Narcissus*.

Dwarf. (1) A plant that is genetically small. (2) A plant that is forced to grow smaller than normal by pruning and restricting root growth. (3) A shrub that is smaller than the normal height of the species, usually under 3 feet (1 m).

Elliptic. *See* Leaf shape.

Entire. *See* Leaf margin.

Eolian. Geologically, resulting from the wind. For example, dunes formed by windswept sand.

Epiphyte. A plant that grows on an external support with aerial roots (roots that do not touch the ground). The support may be inert or a host plant that is not harmed by the epiphyte. Examples: Spanish moss and some orchids.

Espalier. (1) A plant trained to grow in one plane. The most common shape is horizontal tiers branching off a central vertical. (2) To train or grow a plant in one plane.

Estrade. (1) Ornamental metalwork covered with plants in imitation of tiered topiary. (2) A structure that holds flowers arranged around a central pole.

Evergreen. A plant that retains its foliage for more than one growing season.

Exfoliation. Geologically, the separation of portions (usually sheets) of rock from a larger mass of rock, caused by erosion, chemical weathering, or physical pressure.

Family. *See* Classification of plants.

Fastigiate. *See* Tree shape.

Fedge. A fence so heavily covered with vines that it resembles a hedge.

Fenestrate. Term describing a leaf with holes or openings. Example: *Monstera*.

Fieldstone. Stone found, usually locally, rather than quarried, suitable for construction.

Flagstone. Thin slabs of stone suitable for wall veneer or paving. Example: slate.

Flat topiary. *See* Topiary.

Flora. (1) Plant life in general. (2) Plant life native to a region.

Floret. An individual flower that is part of a flowerhead. *See* figure G-7.

Flower. The part of a seed plant, usually surrounded by brightly colored petals, that contains the reproductive organs. Any inflorescence.

Flower shape. The arrangement of petals. Examples: *single* (4-6 petals arranged in one layer); *semi-double* (multiple petals arranged in two layers); *double* (multiple layers of petals with

many stamen obscured); *anemone* (one or more rows of large outer petals with a domed center mass of smaller petals and stamen). *See* figure G-2.

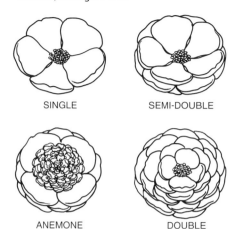

G-2 FLOWER SHAPE

Flowerhead. A flower that is composed of a cluster of florets. *See also* Raceme, Spike.

Flower whorl. See *Whorl*.

Foliage. A mass of growing leaves.

Foliage plants. Plants cultivated for their ornamental leaves rather than for flowers.

Folly. A garden structure built primarily for decoration or theatrical effect, but which may function incidentally to provide shelter. *See also* Grotto.

Formal garden. A visually structured garden in which beds and plantings are arranged and pruned into controlled designs.

Foundation planting. The selection of shrubs and non-annual plants that form the base of the landscape design adjacent to a building.

Frond. The leaf of a fern. The term is also applied to palms and other similar leaf structures.

Fruit. The seed-bearing structure of a plant.

Fungi. (Sing. fungus.) A group of diverse plants that feed on organic matter and reproduce by means of spores. Examples: mushrooms, molds, yeasts.

Gabbro. Generally, a coarse-grained igneous, usually dark-colored, rock.

Garden room. Section of a larger garden that is designed to be separate or self-contained.

Galley. *See* Arbor.

Gazebo. A garden building, usually open with columns supporting a roof used to provide shelter or a viewing arena.

Genus. *See* Classification of plants.

Glaucous. Term describing a plant covered with a white or bluish or waxy powder, or bloom.

Globe. *See* Tree shape.

Glorieta. A canopy formed by trees planted in a circle whose branches have been pruned to form arches that radiate from the center. Two arches intersecting at right angles form the most basic glorieta.

Gneiss. A common coarse-grained metamorphic rock that may be composed of multiple minerals, the most common being quartz and feldspar with lesser amounts of mica. Pieces may be used as fieldstone. The term commonly refers to the texture and structure of irregular banding. Because of its resistance to weathering, gneiss forms rough landscapes. It is often the core rock of mountain chains. *See also* Schist.

Granite. A visibly granular igneous rock composed primarily of quartz and feldspar with other minerals that is used for construction. It resists weathering and polishes easily.

Gravel. Natural or mechanically crushed stone of 1/4–1 1/2 inch (6–38 mm) diameter.

Ground cover. A group of low plants that are planted over an expanse of soil. Examples: grass; *Pachysandra*; *Juniperus sp.*, creeping juniper.

Grotto. A cavelike structure popular in landscape gardens. Often constructed from hypertufa, concrete, shells, and natural rocks, grottos were intended to provide shelter and add ambiance to a garden.

Gymnosperm. A plant that reproduces by means of exposed seeds that develop without a flower or other vessel. Cones are often the fruit. Examples: Conifers, cycads.

Ha-ha. A sunken wall and ditch around garden areas forming a barrier between wild and farm animals and the garden without impairing the view.

Half-hardy. Term describing plants that will survive light frost, but not a freeze. Example: *Antirrhinum*, snapdragon.

Hardscape. An element of a landscape design, usually excluding sculpture, that is not alive, such as gravel walkways and retaining walls.

Hardy. Term describing herbaceous or woody plants that can withstand a freeze and survive winter. Examples: *Forsythia*; *Syringa*, lilac.

Hedge. A wall or barrier formed by a dense row of trees or shrubs.

Herb. (1) A non-woody plant. (2) A plant characterized by scent, taste, and culinary or medicinal properties.

Herbaceous. Term describing non-woody plants with stalks that die back each year. Example: *Paeonia*, peony.

Herbarium. A collection of preserved plant specimens organized and identified for scientific study.

Higgledy-piggledy hedge. A hedge that is trimmed in an intentionally haphazard manner, giving the effect of jumbled shapes.

Hybrid. A plant resulting from propagation between parents of different varieties, species, or genera.

Hypertufa. A combination of concrete and peat moss used to make artificial rock that resembles volcanic formations with sponge-like openings.

Incised. *See* Leaf margin.

Igneous. *See* Rock.

Inflorescence. (1) A flower cluster around a central axis. (2) The flowering part of a plant.

Joint. Geologically, a weakness between structural planes in a rock, making cracks that form a pattern in the surface or through the rock.

Knot garden. An intricately designed formal garden of herbs and/or dwarf plants (often patterned with interlocking shapes), especially popular in sixteenth- and seventeenth-Europe, England, and colonial America. See also Parterre, Topiary.

Lanceolate. *See* Leaf shape.

Landscape garden. An area planted primarily with trees and shrubs in a naturalistic style, creating an idealized view of nature (as portrayed in idyllic landscape paintings). Features include artificial and natural land masses, lakes, and waterfalls, as well as pavilions and follies designed to appear weathered and overgrown.

Lawn. An area planted with a carpetlike ground cover, usually grass, that is durable to foot traffic and withstands frequent cutting or other forms of dwarfing.

Leader. The main stem or shoot of a plant.

Leaf. The part of a plant that is responsible for respiration and photosynthesis, connected to the plant by a petiole. A *simple leaf* is one unit; a *compound leaf* is composed of multiple parts. See figures G-1 and G-3. *See also* Compound leaf.

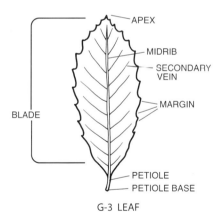

G-3 LEAF

Leaflet. An individual segment of a compound leaf. Leaflets may be classified as to margin and shape. *See* Leaf margin, Leaf shape.

Leaf margin. The edge of a leaf, which may be *biserrate (double serrate)*; *cleft* (with a cut or split that goes at least halfway to the midrib); *crenate* (with rounded teeth); *crenulate* (with very small rounded teeth), *crispate* (curly or crinkled); *dentate* (with teeth pointing outward); *entire* (with a smooth continuous margin without indentations, notches, or other interruption); *incised* (deeply cut, usually into sharp irregular shapes); *lobed* (with segments); *palmately lobed* (lobes

arranged in a palmate manner); *pinnatifid* (cleft with lobes arranged pinnately); *pinnatisect* (cut to the midrib with the lobes arranged pinnately); *repand* (with a wavy margin); and *serrate* (saw-toothed leaf with the teeth pointing toward the apex). *See* figure G-4. *See also* compound leaf.

Leaf shape. Leaves may be characterized by some of the following descriptors: *awl-shaped* (short, narrow, V-shaped); *cordate* (heart-shaped with a notch at the base); *deltoid* (triangularly shaped with the petiole attached to the base); *elliptic* (narrow oval-shaped); *lanceolate* (longer than wide, with the widest point below the middle); *linear* (long with parallel sides); *oblanceolate* (inversely lanceolate); *oblong* (longer than broad); *obovate* (having the broad end nearest the apex); *orbicular* (nearly or completely circular); *oval* (width more than one half the length); *ovate* (egg-shaped); *reniform* (kidney-shaped); *rhombic* (diamond-shaped); *saggitate* (arrow-shaped, attaching between the base lobes that are pointing down); and *spatulate* (with a long, narrow base that is rounded or oblong). *See* figure G-5.

Lichen. A composite organism of algae and fungus, lacking leaves, roots, stems, or reproductive system. The algae portion manufactures food, and the fungus protects the algae from moisture loss.

Limestone. A soft, sedimentary rock composed largely of calcium carbonate, and often grains of quartz, dolomite, or other minerals. Most limestone is marine in origin. It weathers more easily than granite, but is easily worked in construction, and often takes a polish

Luan shi pu di. Chinese term for flooring made from pebbles embedded in concrete in various designs.

Liverwort. Ancient, primitive cryptogramic land plant, 1– 2 inches (25–50 mm) in length, that grows flat and spread over rocks.

Lobed. *See* Leaf margin.

Loggia. A long, roofed colonnade open on the sides that provides shade and/or a view of a garden or landscape.

Marble. A fine- to coarse-grained metamorphic rock that consists primarily of dolomite and/or calcite but exhibits features from other minerals in veining. It resists weathering but is workable for construction and takes a polish.

Margin. *See* Leaf margin.

Mesa. A flat, wide elevated area with steep sides, usually composed of sedimentary rock and rising from lower surroundings.

Metamorphic. *See* Rock.

Moss. (1) Flowerless primitive plants, usually low-growing, that reproduce by means of spores and grow in moist environments. There are over 20,000 varieties. (2) Term describing several types of plants used in floral displays, such as mound, sheet, sphag-

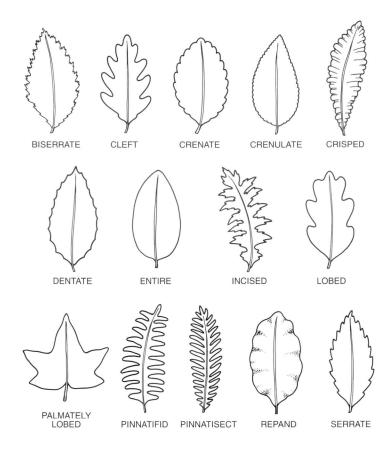

G-4 LEAF MARGIN

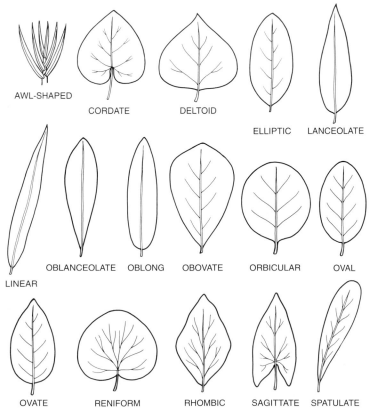

G-5 LEAF SHAPE

num, and reindeer moss. (Spanish moss is actually an epiphyte bromeliad.)

Mudstone. A sedimentary rock composed of fine clay silt and/or sand particles, often with alternating colors, and found in desert areas.

Mushrooms. *See* Fungi.

Naturalized. Term describing a non-indigenous plant that has established itself in a new habitat and no longer requires cultivation.

Needle. The thin, usually pointed leaf of some conifers.

Nut. A hard, husked fruit containing a single seed.

Oblanceolate. *See* Leaf shape.

Oblong. *See* Leaf shape.

Obovate. *See* Leaf shape.

Orbicular. *See* Leaf shape.

Ornamental grass. Varieties of grass grown for their decorative value.

Orangery. A sheltered building used to winter citrus plants in cold climates. A forerunner to the greenhouse.

Outcrop. A segment of exposed bedrock on the surface.

Ovate. *See* Leaf shape.

Palm. (1) An evergreen tree or woody shrub that is usually single-stemmed, with large divided leaves, and a member of families *Palmae* or *Arecaceae*. (2) A plant that resembles a true palm, such as *Cycas revoluta,* sago palm, actually a cycad.

Palmate. *See* Compound leaf, Leaf margin.

Parterre. A garden intended to be viewed from above, in which the plantings form patterns. It may be composed of evergreens, annuals, perennials with gravel or grass.

Pea gravel. Small, naturally rounded stone about $^1/_4$ inch (6 mm) in diameter.

Perennial. A plant that lives for more than two growing seasons, usually considered to be herbaceous. Ferns and bulbs may be included in this category.

Pergola. A walkway formed by columns or posts that support an overhead trellis covered with vines to provide shade.

Petal. The often colorful and showy outer part of a developed flower that surrounds the reproductive organs.

Petiole. The stalk that connects the leaf blade to the stem of a plant. *See also* Leaf.

Pine. (1) Common name for any member of the coniferous genus *Pinus.* (2) A plant that resembles a pine, such as the screw pine, which is an angiosperm.

Pinetum. A collection of coniferous trees.

Pinnate. *See* Compound leaf.

Pinnatifid. *See* Leaf margin.

Pinnatisect. *See* Leaf margin.

Pleach. To prune and interlace or braid the branches of adjacent trees or shrubs to train them to grow into a wall or arch.

Pleached allée. An arched, covered walkway formed by the interlaced branches of trees or shrubs.

Pole hedge. *See* Stilt hedge.

Pollard. To prune a tree so that branches are cut almost to the trunk, resulting in a dense ball of new-growth foliage atop a single trunk. The practice originated in Europe as a way to harvest firewood and basket material without destroying the tree.

Poodle topiary. *See* Topiary.

Prune. To trim or remove buds, shoots twigs, or branches from trees and shrubs to direct the plant's growth.

Pyramidal. *See* Tree shape.

Raceme. An inflorescence that bears multiple flowers (with individual stalks) on a single stalk. Example: *Clethra arborea*, lily-of-the-valley. *See* figure G-6.

FLORET

G-6 RACEME

Raised bed. An elevated structure built of wood, stone, brick, or earth in which to grow plants.

Ramble. An area in which plants are allowed to grow as if in the wild, with little or no cultivation.

Remontant. Term describing plants that bloom several times during one growing season.

Reniform. *See* Leaf shape.

Repand. *See* Leaf margin.

Rhizome. A stem that grows underground, similar to a root in that it stores food, but which bears leafy shoots. Example: *Iris. See also* Bulb.

Rhombic. *See* Leaf shape.

Rib. The primary veins of a leaf. *See also* Leaf.

River rock. Rock that is naturally round and smooth as a result of tumbling in water.

Rock. A naturally occurring aggregation of one or more minerals from the earth's crust. *Igneous* rock is formed when magma (molten rock and minerals) cools and solidifies, for example, granite and basalt. *Metamorphic* rock is igneous, sedimentary, or any rock that has been transformed by pressure or temperature, or both, for example, slate from shale, marble from limestone. *Sedimentary* rock is composed of particles (often in layers) that have settled or been deposited by water, ice, or air, and transformed to a rock mass by chemical action, cementing, or pressure, for example, limestone, sandstone, shale.

Rock garden. A collection of alpine plants cultivated in an outcropping of rocks, but the term may refer to any garden planted among rocks. The rocks may be indigenous or imported, natural or artificial.

Rosulate. Term describing leaves arranged around the base of the stem, resembling a rosette.

Rubble. Construction stone consisting of irregular, partly dressed, and/or broken field-stone.

Runner. A stem that grows out from the leader of plants and develops roots.

Rusticated. Term describing stone that has been dressed to give a natural look.

Saggitate. *See* Leaf shape.

Scale leaves. Modified or vestigial leaves that serve as a protective covering for leaf buds. *See also* Bulb.

Schist. A common medium- or coarse-grained metamorphic rock derived from a range of rocks including shale and sandstone, with mica often the dominant component. The term applies more to texture than to composition. Schist has a flaky, platelike appearance. As bedrock, it usually weathers to a subdued landscape. *See also* Gneiss.

Scree. Small angular stone fragments found at the base of a rock formation that are components of soil conducive to the growth of alpine and rock plants. Scree occurs naturally or may be mixed artificially for rock gardens.

Sedimentary. *See* Rock.

Semi-double. *See* Flower shape.

Serrate. *See* Leaf margin.

Sessile. Term describing plants with no stalk. *See* figure G-7.

Shrub. A woody plant that branches from the base with little or no apparent trunk.

Shrubby. *See* Tree shape.

Simple leaf. *See* Leaf.

Slate. Very fine-grained metamorphic rock formed from mudstone or shale. It cleaves easily into sheets and is resistant to weathering, making it a good roofing and paving material.

Spatulate. *See* Leaf shape.

Species. *See* Classification of plants.

Specific epithet. Species name. *See also* Botanical name.

Spike. A cluster of sessile flowers along a central axis; an inflorescence. *See* figure G-7.

Spiral topiary. *See* Topiary.

Spore. A reproductive cell that has no embryo, as do seeds, but rather is a mass of protoplasm with a nucleus.

SESSILE FLORET

G-7 SPIKE

Spreading. *See* Tree shape.

Standard. Term describing: (1) a plant that grows from a single stalk but needs external support to stand alone; (2) a tree with at least 6 feet (1.8 m) of trunk before the first branch; (3) a shrub that is cleared of lower branches, and is trained to have a single stem from the base to the first foliage. *See also* Tree shape.

Standard topiary. *See* Topiary.

Stilt hedge. A hedge variation in which dense

foliage is pruned above a base of bare branches. Also called *pole hedge*.

Stone. Rock selected or processed for construction or some other use.

Stone fruits. Members of the genus *Prunus,* all of which have a single pit (stone) surrounded by flesh. Examples: Plums, cherries.

Strata. (Sing. stratum.) Geologically, the layers, usually horizontal, of rock formations.

Succession. The development of plant communities after the virgin habitat and flora have been disturbed.

Succulent. A plant with fleshy stems and leaves adapted to retain water. Example: *Aloe.*

Tapestry hedge. A hedge made by intermingling two or more types of plants.

Tender. Term describing plants that will not survive a freeze. Example: *Impatiens.*

Toadstool. The common name for the fruiting body of a fungus with an umbrella-shaped cap.

Tomentose. Term describing a plant surface covered with short, soft, woolly hairs. Example: *Salvia officinalis,* common sage.

Topiary. The art of training plants to grow in specific shapes (often object-oriented) by means of pruning and clipping. *Standard topiary* consists of a single unbranched vertical stem with pruned foliage usually forming a round single crown. The shape may also be achieved by grafting rather than pruning. *Poodle topiary* is a variation of standard topiary with multiple balls of foliage rather than a single crown. *Spiral topiary* is a variation of standard topiary with the foliage clipped around the single stem so that it forms a coil. The stem may be trained to grow in a corkscrew twist. *Flat topiary* consists of low hedges or other clipped plants that form level beds, for example, knot gardens and parterres.

Tree. A perennial woody plant that has a strongly defined trunk with a head of branches, the crown or canopy.

Tree shape. Term descriptive of branch direction and canopy growth. Some common shapes are *columnar* (taller than it is wide); *conical; fastigiate* (with branches that grow erect, parallel, and close together); *globe; pyramidal, shrubby, spreading* (develops with

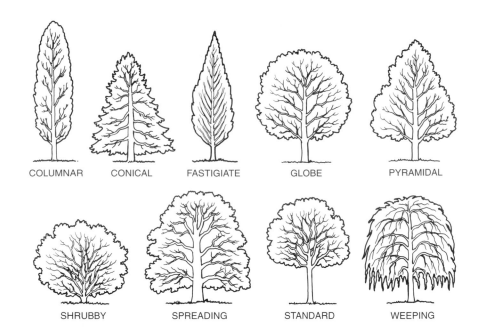

COLUMNAR CONICAL FASTIGIATE GLOBE PYRAMIDAL

SHRUBBY SPREADING STANDARD WEEPING

G-8 TREE SHAPE

predominantly lateral branches); *standard* (having at least 6 feet [1.8 m] of trunk before the first branch), *weeping. See* figure G-8.

Trellis. A framework used to support and direct vining and climbing plants. traditionally constructed in a diamond or grid pattern.

Trifoliate. *See* Compound leaf.

Tropical. Term describing plants that will not survive below 40–45 degrees F (4–7 degrees C).

Tuber. A short, thickened area of a rhizome that produces buds capable of growing into a new plant. Example: potato. *See also* Bulb.

Twig. The individual unit of new growth of a woody plant.

Twining vine. *See* Climber.

Variegated. Term describing plants with multiple areas of color.

Variety. *See* Classification of plants.

Vine. A plant that trails as it grows, but cannot grow vertically without support.

Wadi. *See* Wash.

Wash. A river or streambed that is usually dry

except during rainy periods. In contrast to an arroyo, it may be a wide flat expanse. Also called *wadi.*

Weathering. The physical adaptation of rocks by exposure to natural or man-made elements such as wind, water, temperature change, plants and bacteria, chemicals, or pollution.

Weeping. *See* Tree shape.

Whorl. Leaves, petals, or other plant parts arranged around a common center on the same plane.

Wildflower garden. An area in which flowering plants, usually indigenous to the site, are grown with minimal cultivation.

Wood. A dead hard tissue.

Woody. Term describing a plant with stems composed of tissue that does not die back.

Xeriscaping. Landscaping that reduces the need for supplemental watering by using plants whose water demands are suited to the climate of the site.

BIBLIOGRAPHY AND RESEARCH SOURCES

GENERAL REFERENCE

The American Horticultural Society A to Z Encyclopedia of Garden Plants. Christopher Brickell and Judith D. Zuk, eds. New York: DK Publishing, Inc., 1996.

The Cambridge Illustrated Glossary of Botanical Terms. Michael Hickey and Clive King. Cambridge, UK: Cambridge University Press, 2000.

The Color Encyclopedia of Ornamental Grasses: Sedges, Rushes, Restivos, Cat-tails, and Selected Bamboo. Rick Darke. Portland, Oregon: Timber Press, 1999.

The Dictionary of Garden Plants. Roy Hay, Patrick Synge, and Michael Joseph. The Royal Horticultural Society, 1969.

Dictionary of Geological Terms. The American Geological Institute. New York: Doubleday & Company, 1962.

Dirr's Hardy Trees and Shrubs: An Illustrated Encyclopedia. Michael A. Dirr. Portland, Oregon: Timber Press, 1997.

The Garden Trees Handbook. Alan Toogood. New York: Facts On File, 1991. London: Swallow Books, 1990.

The Hillier Gardener's Guide to Trees and Shrubs. John Kelly, ed. Pleasantville, New York: The Reader's Digest Association, 1995.

Hortus Third: A Concise Dictionary of Plants Cultivated in the United States and Canada. Liberty Hyde Bailey and Ethel Zoe Bailey. New York: Macmillan Publishing Company, 1976.

Manual of Woody Landscape Plants: Their Identification, Ornamental Characteristics, Culture, Propagation and Uses. Michael A. Dirr. Champaign, IL.: Stipes Publishing Company, 1990.

The National Gardening Association Dictionary of Horticulture. The Philip Lief Group, Inc. New York: Penguin Books, 1994.

The Planet We Live On: Illustrated Encyclopedia of the Earth Sciences. Cornelius S. Hurlburt, Jr., ed. New York: Harry N. Abrams, 1976.

Plant Identification Terminology: An Illustrated Glossary. James G. Harris, Melinda Woolf Harris. Spring Lake, UT: Spring Lake Publishing, 1994

Plant Names A-Z: The Complete Guide to Using the Correct Plant Names. Karen Platt. Sheffield, UK: Karen Platt, 1999.

The Royal Horticulture Society A to Z Encyclopedia of Garden Plants. Christopher Brickell, ed. London: Dorling Kindersley. London, New York: Dorling Kindersley, 1996.

Scientific and Common Names of 7,000 Vascular Plants in the United States. Lois Brako, Amy Y. Rossman and David F. Farr. St. Paul, MN: APS Press/The American Phytopathological Society, 1995.

Peterson First Guides—Clouds and Weather: A Simplified Field Guide to the Atmosphere. John A. Day and Vincent J. Schaefer. Boston: Houghton Mifflin Company, 1991.

Taylor's Encyclopedia of Gardening. Norman Taylor, ed. Boston: Houghton Mifflin Company, 1976.

Trees of the Central Hardwood Forests of North America: An Identification and Cultivation Guide. Donald J. Leopold, William C. McComb, and Robert Muller. Portland, OR: Timber Press, 1998.

Wyman's Gardening Encyclopedia. David Wyman. New York: Scribner, 1997.

SOURCE BOOKS

Gardening by Mail: A Source Book. Barbara J. Barton. New York: Houghton Mifflin Company, 1997.

House of Boughs: A Sourcebook of Garden Designs, Structures, and Suppliers. Elizabeth Wilkinson and Marjorie Henderson, eds. A Yolla Bolly Press Book, Viking. 1985.

GARDEN DIRECTORIES AND GUIDES

The American Garden Guidebook. Everitt L. Miller and Dr. Jay S. Cohen. New York: M. Evans and Company, Inc. 1987.

Blue Guide: Gardens of England. Frances Gapper, Patience Gapper, and Sally Drury. New York: W. W. Norton & Company, 1991. UK: A & C Black, 1991.

The French Country Garden. Louisa Jones. Photographs by Joëlle Caroline Mayer and Gilles Le Scanff. Boston: Bulfinch Press, 2000. UK: Thames & Hudson, 2000.

The Garden Conservancy's Open Days Directory: The Guide to Visiting Hundreds of America's Best Private Gardens. New York: The Garden Conservancy, distributed by Harry N. Abrams, 2001.

Garden Walks. Marina Harrison and Lucy D. Rosenfeld. New York: Michael Kesend Publishing, 1997.

Gardens of the National Trust. Stephen Lacey. London: The National Trust, New York: Harry N. Abrams, 1996.

Gardens of North America and Hawaii: A Travelers Guide. Irene Jacob and Walter Jacob. Portland OR: Timber Press, 1985.

Great Public Gardens of the Eastern United States. Doris Stone. New York: Pantheon Books, 1982.

The History of Garden Design: Western Tradition from the Renaissance to the Present Day. Edited by Monique Mosser and Georges Teyssot. London: Thames & Hudson, 1991.

The International Handbook of National Parks and Nature Reserves. Craig W. Allin, ed. New York: Greenwood Press, 1990.

The Modern Garden. Jane Brown. New York: Princeton Architectural Press, 2000. UK: Thames & Hudson, 2000.

One Hundred English Gardens: The Best of the English Heritage Parks and Gardens Register. Patrick Taylor. New York: Rizzoli International Press, Inc., 1996. UK: Headline Book Publishing, 1995.

Oriental Gardens in America: A Visitors Guide. Dorothy Loa McFadden. Los Angeles: Douglas-West Publishers, 1976.

Southern Gardens: A Gracious History and a Traveler's Guide. Laura C. Martin. New York: Abbeville Press, 1993.

Tropical Garden Design. Made Wijaya. New York and London: Thames & Hudson, 1999.

GARDENS AND LANDSCAPES

Balinese Gardens. Photography by Luca Invernizzi Tettonia, text by William Warren. London: Thames & Hudson, 1995.

A Celebration of Japanese Gardens. Sadao Hibi. Tokyo: Gurafikkush, 1994.

Decorating Eden: A Comprehensive Sourcebook of Classical Garden Details. Elizabeth Wilkinson, Marjorie Henderson, eds. San Francisco: Chronicle Books, 1992.

European Gardens: An Historical Atlas. Virgilio Vercelloni. New York: Rizzoli, 1990.

The Garden: A Celebration. Ed: Howard Loxton. New York: Barron's in association with David Bateman, 1991.

Gardens of America: Three Centuries of Design. Diane Kostial McGuire. Charlottesville, VA: Thomasson-Grant, 1989.

The Gardens of China: History, Art and Meanings. Edward T. Morris. New York: Scribner, 1983.

The Gardens of Europe. Penelope Hobhouse and Patrick Taylor. New York: Random House, 1990.

Gardens in France. Photos: Dedi Von Schaewen, text: Marie-Françoise Valéry. New York: Taschen, 1997.

Gardens of France. Anita Pereire and Gabrielle Van Zuylen. New York: Harmony Books, 1983.

The Gardens of Mexico. Antonio Haas. New York: Rizzoli, 1993.

Gardens of the World: The Art and Practice of Gardening. Penelope Hobhouse and Elvin McDonald, eds. New York: Macmillan, 1991.

The Golden Age of American Gardens: Proud Owners, Private Estates 1890 - 1940. Mac Griswold, Eleanor Weller. New York: Harry N. Abrams, 1991.

A History of Gardens and Gardening, Ed Hyams, New York: Praeger Press, 1971.

Infinite Spaces: The Art and Wisdom of the Japanese Garden. Joe Earle, Toshitsuna Fujiwara, and Julie Moir Messervy. Boston: Tuttle Pub., 2000.

Italian Gardens. Alex Ramsay and Helen Attlee. London: Robertson McCarta Limited, 1989.

Italian Gardens of the Renaissance. J.C. Shephard, G.A. Jellicoe. New York: Princeton Architectural Press, 1993.

The Japanese Garden: Islands of Serenity. Haruzo Ohashi. Tokyo: Graphic-sha Publisjing Co., Ltd., 1986.

The Landscape of Man: Shaping the Environment From Prehistory to the Present Day. Geoffery & Susan Jellico. New York: Thames & Hudson, New York and London, 1994.

The Lure of Japanese Gardens. Alison Main and Newell Platten. New York: W. W. Norton & Company, 2002.

The Medieval Garden. Sylvia Landsberg. London: Thames & Hudson, 1995.

Masterpeices of Japanese Garden Art. Mizuno Katsuhiko. Kyoto: Kyoto Shoin, 1992.

Nature Perfected: Gardens Through History, William Howard Adams, New York: Abbeville Press, 1991.

100 Years of Landscape Architecture: Some Patterns of a Century. Melanie Sime. Brookline, MA: Spacemaker Press, 1999.

The Oxford Companion to Gardens. Sir Geoffery Jellicoe, Susan Jellicoe. New York: Oxford University Press, 1986.

Penelope Hobhouse's Gardening Through the Ages: An Illustrated History of Plants and Their Influence on Garden Styles—From Ancient Egypt to the Present Day. Penelope Hobhouse. New York: Simon & Schuster, 1992.

Pictorial Library of Landscape Plants, M. Jane Coleman Helmer, Kalamazoo, MI: Merchants Publishing Company, 1979.

Pioneers of American Landscape Design. Charles A. Birmbaum and Robin Karson, ed. New York: McGraw-Hill, 2000.

The Quest for Paradise: A History of the World's Gardens. Ronald King. New York: Mayflower Books, 1979.

Reflecting Nature: Garden Designs from Wild Landscapes. Jerome and Seth Malitz. Portland Oregon: Timber Press, 1998.

Reflections of the Spirit: Japanese Gardens in America. Maggie Oster. New York: Dutton Studio Books, 1993.

Traditional English Gardens. Arabella Lennox-Boyd, Clay Perry, and Graham Stuart Thomas. New York: Rizzoli International Publications, 1987. UK: George Weidenfield & Nicolson/The National Trust, 1987.

Trees for Architecture and Landscape, Robert Zion, New York: Van Nostrand Reinhold, 1995.

The Tropical Garden. William Warren. London: Thames & Hudson, 1997.

Visions of Paradise: Themes and Variations on the Garden. Photographs: Maria Schinz, text: Susan Littlefield. New York: Stewart, Tabori & Chang, 1985. UK: Thames & Hudson, 1985.

BOTANICAL REFERENCES

The Complete Book of Bonsai. Harry Tomlinson. New York: Abbeville Press, 1990.

The Complete Book of Fruits and Vegetables. F. Bianchini and F. Corbetta, illustrations by Marilena Pistoia. New York: Crown Publishers, 1976.

The Complete Book of Topiary. Barbara Gallup and Deborah Reich. New York: Workman Publishing, 1987.

Cultivated Palms of the World. Don Ellison and Anthony Ellison. Sydney: UNSW Press, 2000.

Fruit: A Connoisseur's Guide and Cookbook. Alan Davidson, illustrations by Charlotte Knox. New York: Simon & Schuster, 1991.

Flowers of the World. Frances Perry and Leslie Greenwood. New York: Crown, 1972.

Flowering Plants of the World. V. H. Heywood. New York: Oxford University Press, 1993.

Meetings With Remarkable Trees. Thomas Pakenham, New York: Random House, 1997. UK: Phoenix Illustrated Orion Publishing Group, 1996;.

The Mushroom Book. Thomas Laessoe, Gary Lincoff, and Anna Del Conte. New York: DK Publishing, 1996.

Mushrooms and other Fungi of Great Britain and Europe. Roger Phillips. Irish Book Center, 1999.

The Random House Book of Bulbs. Roger Phillips, and Martyn Rix. New York: Random House, 1989.

The Random House Book of Perennials, Early Perennials, vol. 1; Late Perennials, vol. 2. Roger Phillips and Martyn Rix. New York: Random House, 1991.

The Random House Book of Roses. Roger Phillips and Martyn Rix. New York: Random House, 1988.

The Random House Book of Shrubs. Roger Phillips and Martyn Rix. New York: Random House, 1989.

The Random House Book of Vegetables. Roger Phillips and Martyn Rix. New York: Random House, 1993.

Shrubs and Vines. Galen Gates, Chris Graham, and Ethan Johnson. New York: Pantheon Books, Knopf Publishing Group, 1994.

Tropical Garden Plants. William Warren. Photographs by Luca Invernizzi Tettoni. New York and London: Thames & Hudson, 1997.

The Tropical Look: An Encyclopaedia of Landscape Plants for Worldwide Use. Robert Lee Riffle. Portland, OR: Timber Press, 1998. UK: Thames & Hudson, 1998.

Tropical Ornamentals: A Guide. W. Arthur Whistler. Portland, OR: Timber Press, 2000.

ARTISTS' REFERENCE

Art Foliage, For Sculpture And Decoration; With an Analysis of Geometric Form, and

Studies From Nature, of Buds, Leaves, Flowers, and Fruit. James Kellaway Colling. Boston: Osgood, 1873.

Art Forms In the Plant World. Karl Blossfeldt. (reprint). New York: Dover Publications, 1985.

The Artist & the Garden. Roy Strong. The Paul Mellon Centre Studies in British Art. New Haven, CT: Yale University Press, 2000.

The Book of Flowers—Four Centuries of Flower Illustration. Alice M. Coats. New York: McGraw-Hill. UK: Phaidon Press, 1973.

An English Florilegium: Flowers, Trees, Shrubs, Fruits, Herbs. The Tradescant Legacy. Illustrations by Mary Grierson, text by William T. Stearn.. New York: Abbeville Press, 1988. UK: Thames & Hudson, 1987.

The Gardens of William Morris. Jill Duchess of Hamilton, Penny Hart, John Simmons. New York: Stewart, Tabori & Chang, 1998.

Great Flower Painters: Four Centuries of Floral Art. Peter Mitchell. Woodstock, NY: The Overlook Press, 1973.

A History of Flower Arrangement. Julia S. Berral. New York: Viking Press, 1968. UK: Thames & Hudson, 1969.

The Impressionist Garden: Ideas and Inspiration from the Paintings and Gardens of the Impressionists. Derek Fell. New York: Carol Southern Books, 1994.

Index to Illustrations of the Natural World: Where to Find Pictures of Living Things of North America. John W. Thompson. Syracuse, NY: Gaylord Professional Publications, 1977

Index to Illustrations to Living Things Outside North America. Lucille Thompson Munz and Nedra G. Slauson. Hamden, CT: Shoestring Press, 1981.

Leonardo da Vinci on Plants and Gardens. William A Emboden. Portland, OR: Dioscorides Press, 1987.

Medieval Flowers. Miranda Innes and Clay Perry. London: Kyle Cathie, 1997.

Monet's Garden: Through the Seasons at Giverny. Vivian Russell. New York: Stewart, Tabori & Chang, 1995.

Painted Gardens: English Watercolors, 1850-1914. Penelope Hobhouse and Christopher Wood. New York: Atheneum, 1988.

Period Flowers: Designs for Today Inspired by Centuries of Floral Art. Jane Newdick. New York: Crown Publishers, 1991.

Renoir's Garden. Derek Fell. London: Frances Lincoln, 1991.

A Treasury of Flowers: Rare Illustrations from the Collection of the New York Botanical Garden. Frank J. Anderson. Boston: Little Brown & Company, 1990.

STONE REFERENCE

Dimension Stones of the World: Color Plate Books. Columbus, OH: Marble Institute of America, 1996.

Natural Stone: A Guide to Selection. Frederick Bradley/Studio Marmo. New York: W. W. Norton & Company, 1998.

Rocks, Minerals and Fossils of the World. Roger Phillips and Chris Pellant. Little Brown & Co., 1990.

Rocks and Fossils. Arthur B. Busbey III, Robert R. Coenraads, David Roots, and Paul Willis. The Nature Company Guides/Time Life Books, 1996.

Stone. Andy Goldsworthy. New York: Harry N. Abrams, 1994.

Stone in the Garden: Inspiring Designs and Practical Projects. Gordon Hayward. New York: W. W. Norton & Company, 2001.

Stonescaping: A Guide to using Stone in Your Garden. Jan Kowalczewski Whitner. Pownal, VT: A Garden Way Publishing Book; Storey Communications, Inc. 1992.

PERIODICALS

Curtis's Botanical Magazine. Published for Bentham–Moxon Trust, Royal Botanic Gardens, Kew by Blackwell Publishers, Ltd. 108 Cowley Rd. Oxford, OX4 1JF UK.

European Gardens. 34 River Court, Upper Ground, London SE1 9PE, UK.

Fine Gardening. Taunton Press. 63 South Main Street, Newtown, CT 06470-5506.

The Garden. New Perspectives Pub. Ltd. For the Royal Horticultural Society. Bretton Court, Bretton Centre, Peterborough PE3 8DZ.

Gardens Illustrated. John Brown Publishing. The New Boathouse, 136–142 Bramley Road, London W 10 6SR, UK. Fenner, Reed & Jackson, Box 754, Manhasset, NY 11030.

Horticulture. PRIMEDIA Special Interest Publications. 98 Washington Street, Boston, MA 02114.

Landscape Architecture. The American Society of Landscape Architects. 636 Eye Street, NW, Washington, DC 20001-3736.

The New Plantsman. The Royal Horticultural Society. 80 Vincent Square, London SW1 2PE, UK.

Journal of the Landscape Institute. Landscape Design Trust. 13a West Street, Reigate Surrey RH2 9BL, UK.

CD-ROMs

Architectural Textures. Textureworld.

Allan Armitage's Photo-Library of Herbaceous Plants on CD-ROM. Allan M. Armitage. PlantAmerica, 1998.

The Interactive Guide for Herbaceous Perennial Plants. Allan M. Armitage. PlantAmerica, 1998.

Horticopia: Perennials & Annuals—Edition II. 1997.

Horticopia: Trees, Shrubs & Groundcovers—Edition II. 1998.

Horticopia A–Z. 1999.

Horticopia Professional. 2000

The Interactive Manual of Woody Landscape Plants. Michael Dirr. PlantAmerica, 2000.

Michael A. Dirr's Photo-Library of Woody Landscape Plants. Michael Dirr. PlantAmerica, 1997.

Seamless Textures 4—Classic Stonework. Marlin Studios.

INSTITUTIONS, ASSOCIATIONS, SOCIETIES, AND LIBRARIES

American Association of Botanical Gardens & Arboreta (AABGA). 351 Longwood Rd., Kennett Square, PA 19348.

American Horticultural Society (AHS). 7931 East Boulevard Dr., Alexandria, VA 22308.

American Society of Botanical Artists (ASBA). 47 Fifth Ave., New York, NY 10003.

American Society of Landscape Architects (ASLA). 636 Eye St., Washington, DC 20001-3736.

Association of Professional Landscape Designers (APLD). 1924 North Second St., Harrisburg, PA 17120.

Association of Zoological Horticulture. Allan Donges, Toledo Zoo, P.O. Box 140130, Toledo, OH 43614-0801.

The Botany Libraries, Harvard University Herbaria Building, 22 Divinity Ave., Cambridge, MA 02138.

Brooklyn Botanic Garden and Brooklyn Botanic Garden Library. 1000 Washington Ave., Brooklyn, NY 11225.

Chicago Botanical Garden and Chicago Botanical Garden Library. 1000 Lake-Cook Road, Glencoe, IL 60022

Dumbarton Oaks Garden and Garden Library. 1703–32nd Street N.W., Wash-

ington, DC 20007.

Horticultural Society of New York and Horticultural Society of New York Library. 128 W. 58th St., New York, NY 10019.

Marble Institute of America. 30 Eden Alley #301, Columbus, OH 43215.

Massachusetts Horticultural Society and The Massachusetts Horticultural Society Library. 300 Massachusetts Ave. Boston, MA 02115.

Missouri Botanical Garden and Missouri Botanical Garden Library. 2345 Tower Grove Ave. St. Louis, MO 63110.

The New York Botanical Garden and The New York Botanical Garden Library. 200th Street & Southern Boulevard, Bronx, NY 10458-5126.

Landscape Institute. 6–8 Barnard Mews, London SW11 1QU, UK.

Longwood Gardens and Longwood Gardens Library. Kennett Square, PA 19348.

Royal Botanical Gardens (Canada) and Royal Botanical Gardens Library. 680 Plains Rd., Burlington, Ontario, Canada L7T 4H4.

Royal Botanic Gardens, Kew, The Library & Archives and Herbarium. Richmond, Surrey, TW9 3AE, UK.

The Royal Horticultural Society P.O Box 313, London, SW1P 2PE, UK.

The Royal Horticultural Society—Lindley Library. 80 Vincent Square, London, UK.

The Pennsylvania Horticultural Society and the McClean Library. 100 N. 20th St.

Philadelphia, PA 19103-1495.

Smithsonian Institution Library, Horticultural Branch, Arts & Industries Building, Room 2282. 900 Jefferson Dr. SW, Washington, DC 20560-0420.

Society of Garden Designers. Institute of Horticulture, 14–15 Belgrave Square, London SW1X 8PS, UK.

Stone Federation of Great Britain. 56-64 Leonard Street, London EC2A 4JX, UK.

United States National Museum of Natural History, the United States National Herbarium. 10th St. and Constitution Ave. NW, Washington, DC 20560.

University of California Berkely Library, Environmental Design Library. Moffitt Library, 5th Floor, UC Berkeley, CA 94720.

PHOTO LOCATIONS AND CREDITS

Note: All National Parks and Monuments are properties of the
National Park Service, U.S. Department of the Interior

Acadia National Park
P.O. Box 177
Bar Harbor, ME 04609-0177

Arches National Park
P.O. Box 907
Moab, UT 84532-0907

Bartlett Arboretum
151 Brookdale Road
Stamford, CT 06903

Battery Park Esplanade
Battery Park City Park Corp.
2 South End Ave.
New York, NY 10006

Blenheim Palace
Woodstock
Oxford OX7 1PX England

Bowood House
Bowood Estate Office, Calne
Wiltshire SN11 0LZ England

Brooklyn Botanic Garden
1000 Washington Ave.
Brooklyn, NY 11225.

Bryce Canyon National Park
P.O. Box 170001
Bryce Canyon, UT 84717-0001

Canyon de Chelly National Monument
P.O. Box 588
Chinle, AZ 86503

Canyonland National Park
2282 South West Resource Boulevard
Moab, UT 84532-8000

Casatelli Marble & Tiles
34 Riverside Drive
Norwalk, CT 06850

The Central Park Conservatory Garden
Fifth Avenue between 104th St. and 105th St.
New York, NY

Château Chenonceau
Chenonceau, France

Château Villandry
Villandry, France

Cliveden Court
Taplow
Maidenhead SL6 OJA England
A property of the National Trust

Death Valley National Park
P.O. Box 579
Death Valley, CA 92328-0570

Fairchild Tropical Gardens
10901 Old Cutler Road
Miami, FL 33156

Four Arts Garden
Four Arts Plaza, Royal Palm Way
Palm Beach, Florida, FL 33480

Grand Canyon National Park
Box 129
Grand Canyon, AZ 86023-0129

Hammond Museum & Japanese Stroll Garden
Deveau Road
North Salem, NY 10560

Gordon Hayward
508 McKinnon Rd.
Putney, VT 05346

Hever Castle
near Edenbridge
Kent TN8 7NG England

The Huntington Botanical Gardens
1151 Oxford Road
San Marino, CA 91108

Iford Manor, Peto Garden
Near Bradford-on-Avon
Wiltshire BA15 2BA England

Joshua Tree National Park
74485 National Park Drive
Twentynine Palms, CA 92277-3597

Lacock Abbey
Lacock
near Chippenham SN15 2LG England
A property of the National Trust

Longwood Gardens
P.O. Box 501
Kennett Square, PA 19348-0501

Montacute House
Montacute TA 15 6XP England
A property of the National Trust

Morikami Gardens
4000 Morikami
Delray Beach, FL 33446

The New York Botanical Garden
200th Street & Southern Boulevard
Bronx, NY 10458-5126.

New York Central Park
Department of Parks & Recreation
1234 Fifth Ave.
New York, NY 10021

O & G Industries, Inc.
325 Hancock Avenue
Bridgeport, CT 06605

Old Westbury Gardens
71 Old Westbury Road
Old Westbury, NY 11568

Point Lobos State Reserve
Route 1, Box 62
Carmel, CA 93923

Plant Specialists
42–25 Vernon Blvd.
Long Island City, NY 11101

Preservation Society of Newport
424 Bellevue Ave.
Newport, RI 02840

Royal Botanic Gardens, Kew
Richmond
Surrey TW9 3AE England

Scotney Castle Garden
Lamberhurst
Tunbridge Wells TN3 8JN England
A property of the National Trust

Sequoia National Park
Three Rivers, CA 93271-9700

Sheffield Park Garden
Sheffield Park TN22 3QX England
A property of the National Trust

Sissinghurst Castle Garden
Sissinghurst
near Cranbrook TN17 2AB England
A property of the National Trust

Dan Snow
West Dummerston, VT 05357
(802) 254-2673

Staten Island Botanical Garden
Snug Harbor Cultural Center
1000 Richmond Terrace
Staten Island, NY 10301

Stonecrop Gardens
Cold Spring, New York 10516

Stourhead
The Estate Office
Stourton
Warminster BA12 6QD England

Sunset Crater Volcano National
 Monument
National Park Service, Flagstaff Areas
6400 N. Highway 89
Flagstaff, AZ 86004

Villa d'Este
Tivoli, Italy

Vizcaya Museum and Gardens
3251 South Miami Ave.
Miami, FL 33129

Waterperry Gardens
Waterperry near Wheatley
Oxon OX9 1JZ England

Yosemite National Park
Superintendent
Yosemite National Park, CA 95389-0577

Zion National Park
Superintendent
Springdale, UT 84767-1099

CREDITS

PHOTOGRAPHERS

Michael Garff
(203) 791-8408
email: mi7734@mags.net

Duane Langenwalter
477 Main Street, Suite 204
Monroe, CT 06468-1139
email: duanel@outofthinair.com

Guy Gurney
P.O. Box 7206
Wilton, CT 06897
email: gurney@optonline.net

TAXONOMIST

Scott D. Appell
83 Wooster St. #4
New York, NY 10012-4376
(212) 966-4745

ABOUT THE CD-ROM

The accompanying CD-ROM contains printable TIFF files of all the images in the book.

With the appropriate graphics software, the CD images can be used by artists and designers in developing concepts, preparing presentations for clients, and communicating visual information to others. Although the images are primarily intended for on-screen display, they can also be printed on either a black and white or color printer.

Further information about the image formats can be found on the readme.txt file on the CD.

Note: Images taken in gardens and parks where the location or photographer is credited adjacent to the printed image may not be used for any commercial application without the permission of the credited institution or individual. Contact information is listed in Photo Locations & Credits on page 340 or is available from the author.

All images except those taken by credited photographers are the property of the author, and original images may be obtained by contacting the author at www.stocksurfaces.com, or write to P.O. Box 7206, Wilton, CT 06897.